CONCEPTUAL
ODYSSEYS

CONCEPTUAL ODYSSEYS
Passages to Cultural Analysis

EDITED BY GRISELDA POLLOCK

With an introduction by Mieke Bal

I.B. TAURIS

LONDON · NEW YORK

Published in 2007 by I.B.Tauris & Co Ltd
6 Salem Road, London W2 4BU
175 Fifth Avenue, New York NY 10010
www.ibtauris.com

In the United States of America and Canada distributed by Palgrave Macmillan
a division of St. Martin's Press, 175 Fifth Avenue, New York NY 10010

ISBN (HB): 978 1 84511 522 7
ISBN (PB): 978 1 84511 523 4

A full CIP record for this book is available from the British Library
A full CIP record is available from the Library of Congress

Library of Congress Catalog Card Number: available

Printed and bound in the Czech Republic by FINIDR, s.r.o.
From camera-ready copy edited and supplied by the author

CONTENTS

List of Illustrations vii
Acknowledgements xi

Editor's Preface—New Encounters xiii
 Griselda Pollock

1. Working with Concepts 1
 Mieke Bal

2. Framing 11
 Eva Frojmovic

3. Visual Agency 25
 Phillipa Plock

4. Mirror 36
 Victoria Turvey Sauron

5. Trauma 51
 Itay Sapir

6. Life-Mapping 63
 Griselda Pollock

7. Puncture/Punctum 91
 Nicholas Chare

8. History 103
 Valerie Mainz

9. Nostalgia 120
 Ihab Saloul

10. Pedagogy 138
 Sue Wilks

11. Efficacity 153
 Jennifer Tennant Jackson

12. Commitment 172
 Cornelia Gräbner

Notes 187
Selected Bibliography 219
Contributors 232
Index of Authors and Artists 237
Index of Subjects and Concepts 240

ILLUSTRATIONS

2. Framing

2.1 Folio 18v, Regensburg Pentateuch, c.1300, Israel Museum, Jerusalem.

3. Visual Agency

3.1 Nicolas Poussin, *Rinaldo and Armida*, c.1629–30, oil on canvas, 82.2 × 109.2 cm, Dulwich Picture Gallery, London. By permission of the Trustees of Dulwich Picture Gallery.

4. Mirror

4.1 Giovanni Savoldo, *Mary Magdalene*, c.1535–40, oil on canvas, 89.1 × 82.4 cm, NG 1031, National Gallery, London.

4.2 Ludovicus Finson, copy of Caravaggio's lost *Magdalene in Ecstasy* of 1606 (c.1612), Musée des Beaux-Arts, Marseilles.

4.3 Michelangelo da Caravaggio, *The Conversion of the Magdalene*, c.1597–8, oil on canvas, 99.7 × 134.6 cm, The Detroit Institute of Arts, Detroit.

5. Trauma

5.1 Adam Elsheimer, *St Paul on Malta*, c.1600, oil on copper, 17.3 × 21.5 cm, NG 3535, National Gallery, London.

5.2 Adam Elsheimer, *The Baptism of Christ*, c.1599, oil on copper, 28.1 × 21 cm, NG 3904, National Gallery, London.

6. Life-mapping

6.1 Giselle Freund, *Walter Benjamin in the Bibliothèque Nationale, Paris*, 1937.

6.2 *Charlotte Salomon Sketching in the Garden of Villa L'Hermitage, Villefranche*, c.1939, photograph, Jewish Historical Museum, Amsterdam. Reproduced courtesy of the Charlotte Salomon Foundation.

6.3 Charlotte Salomon, *Leben? Oder Theater?* 1941–2, gouache on paper, 32.5 × 25 cm, JHM 4155–1, 4155–3, 4155–4, Jewish Historical Museum, Amsterdam. Reproduced courtesy of the Charlotte Salomon Foundation.

6.4 Album of photographs of Avenue Cauvin, Villefranche, and Hotel Belle Aurore, St Jean de Cap Ferrat, Côte D'Azur, 2002, Griselda Pollock.

6.5 Charlotte Salomon, *Leben? Oder Theater?* 1941–2, gouache on paper, 32.5 × 25 cm, JHM 4254, Jewish Historical Museum, Amsterdam. Reproduced courtesy of the Charlotte Salomon Foundation.

6.6 Charlotte Salomon, *Leben? Oder Theater?* 1941–2, gouache on paper, 32.5 × 25 cm, JHM 4300 and 4300–T, Jewish Historical Museum, Amsterdam. Reproduced courtesy of the Charlotte Salomon Foundation.

6.7 Charlotte Salomon, *Leben? Oder Theater?* 1941–2, gouache on paper, 32.5 × 25 cm, JHM 4286, 4288, Jewish Historical Museum, Amsterdam. Reproduced courtesy of the Charlotte Salomon Foundation.

6.8 Charlotte Salomon *Leben? Oder Theater?* 1941–2, gouache on paper, 32.5 × 25 cm, JHM 4289, 4290, 4291, Jewish Historical Museum, Amsterdam. Reproduced courtesy of the Charlotte Salomon Foundation.

6.9 Photograph of the view from the window of the Hotel Belle Aurore, St Jean de Cap Ferrat, 2002, Griselda Pollock.

6.10 Charlotte Salomon, *Leben? Oder Theater?* 1941–2, gouache on paper, 32.5 × 25 cm, JHM 4925, Jewish Historical Museum, Amsterdam. Reproduced courtesy of the Charlotte Salomon Foundation.

6.11 Two views of the concentration camp at Gurs, near Pau, c.1941–2.

6.12 Charlotte Salomon, *Leben? Oder Theater?* 1941–2, gouache on paper, 32.5 × 25 cm, JHM 4915, Jewish Historical Museum, Amsterdam. Reproduced courtesy of the Charlotte Salomon Foundation.

6.13 Dani Karavan, *Passages: Hommage to Walter Benjamin*, 1990–4, Port Bou. Courtesy Atelier Dani Karavan, Paris.

7. Puncture/Punctum

7.1 Francesco Scavullo, 'The Start of Something Pretty', *American Vogue*, November 1980.

7.2 Francesco Scavullo, 'The Start of Something Pretty'. Detail.

7.3 Francesco Scavullo, 'The Start of Something Pretty'. Detail.

7.4 Francesco Scavullo, 'The Start of Something Pretty'. Detail.

8. History

8.1 Auguste Couder, *Le Serment du Jeu de Paume à Versailles le 20 juin 1789*, 1848, MRF D 1995–1, Vizille, Musée de la Révolution française.

8.2 Alexandre Debelle, *L'Assemblée des trois ordres du Dauphiné réunie dans la salle du jeu de paume du château de Vizille, le 21 juillet 1788*, 1862, MRF 1983–7, Vizille, Musée de la Révolution française.

8.3 View of the Faience Gallery, Musée de la Révolution française, Vizille.

8.4 Claude-André Deseine, *Maximilien Robespierre*, 1791, MRF 1986–243, Vizille, Musée de la Révolution française.

8.5 Charles-Louis Müller, *L'Appel des dernières victimes de la Terreur*, 1850, MRF D 1992–2, Vizille, Musée de la Révolution française.

10. Pedagogy

10.1 Figure 01, *2D Visual Language Examination Paper: Question 8*, U1021061, 1997, print on paper, 29.7 × 21 cm, Edexcel, United Kingdom.

The author and publisher are grateful to all those individuals and organizations listed above who have granted permission to reproduce pictures. Every effort has been made to obtain permission to use copyright material but if for any reason a request has not been received the copyright holder should contact the publisher.

ACKNOWLEDGEMENTS

This book is a product of a five-year project supported by the Arts and Humanities Research Council and the University of Leeds. We gratefully acknowledge their financial support.

Much of the initial work for the events out of which this series of books emerged was assisted by Josine Opmeer, a gifted and far-sighted research administrator without whom CentreCATH would not have become the creative laboratory it is.

In the final stages of preparation, Anna Johnson's calm and dedicated editorial skills enabled the production of this book.

We are grateful to the vision of Susan Lawson and the editorial team at I.B.Tauris for understanding the project and enabling this series to come into being.

EDITOR'S PREFACE

NEW ENCOUNTERS
Arts, Cultures, Concepts
Griselda Pollock

How do we think about visual art these days? What is happening to art history? Is visual culture taking its place? What is the status of cultural studies, in itself or in relation to its possible neighbours art, art history and visual studies? What is going on? What are the new directions? To what should we remain loyal?

New Encounters: Arts, Cultures, Concepts proposes some possible ways of thinking through these questions. Firstly, the series introduces and works with the concept of the *transdisciplinary initiative*. This is not a synonym for the interdisciplinary combination that has become de rigueur. It is related to a second concept: research as *encounter*. Together transdisciplinary and encounter mark the interaction between ways of thinking, doing and making in the arts and humanities that retain distinctive features associated with disciplinary practices and objects: art, history, culture, practice, and the new knowledge that is produced when these different ways of doing and thinking encounter one another across, and this is the third intervention, *concepts*, circulating between different intellectual or aesthetic cultures, inflecting them, finding common questions in distinctively articulated practices. The aim is to place these different practices in productive relation to one another mediated by the circulation of concepts.

We stand at several cross-roads at the moment in relation to the visual arts and cultures, historical, and contemporary, and to theories and methods of analysis. *Cultural Analysis, Theory and History* (CATH) is offered as one experiment in thinking about how to maintain the momentum of the momentous intellectual, cultural revolution in the arts and humanities that characterized the last quarter of the twentieth century while adjusting to the different field of analysis created by it.

In the 1970s–1990s, the necessity, or the intrusion, according to one's position, was Theory: a mythic concept with a capital T that homogenized vastly different undertakings. Over those decades, research in the arts and humanities was undoubtedly reconfigured by the engagement with structuralist and poststructuralist theories of the sign, the social, the text, the letter, the image, the subject, the post-colonial, and above all, difference. Old disciplines were deeply challenged and new interdisciplines—called studies—emerged to contest the academic field of knowledge production. These changes were wrought through specific engagements with Marxist, feminist, deconstructionist, psychoanalytical and discourse theory. Texts and authors were branded according to their theoretical engagements. Such mapping produced divisions between the proliferating theoretical models. (Could one be a Marxist, and feminist, and use psychoanalysis?) A deeper split, however, emerged between those who, in general, were theoretically oriented, and those who apparently did without theory: a position easily critiqued by the theoretically minded because being atheoretical is, of course, a theoretical position, if one that did not carry a novel identity associated with the intellectual shifts of the post-1968 university.

The impact of 'the theoretical turn' has been creative; it has radically reshaped work in the arts and humanities in terms of what is studied (content, topics, groups, questions) and also how it is studied (theories and methods). Yet some scholars currently argue that work done under such overt theoretical rubrics now appears tired; theory constrains the creativity of the new generation of scholars familiar, perhaps too familiar, with the legacies of the preceding intellectual revolution that can too easily be reduced to Theory 101 slogans (the author is dead, the gaze is male, the subject is split, there is nothing but text, etc.). The enormity of the initial struggles—the paradigm shifting—to be able to speak of sexual difference, subjectivity, the image, representation, sexuality, power, the gaze, postcoloniality, textuality, difference, fades before a new phase of normalization in which every student seems to bandy around terms that were once, and in fact, still are, challengingly difficult and provocative.

Theory, of course, just means thinking about things, puzzling over what is going on, and reflecting on the process of that puzzling and thinking. A reactive turn away from active engagement with theoretical developments in the arts and humanities is increasingly evident in our area of academe. It is, however, dangerous and misleading to talk of a post-theory moment, as if we can relax after so much intellectual gymnastics and once again become academic couch-potatoes. The job of thinking critically is even more urgent as the issues we confront are so complex, and we now have extended means of analysis that make us

appreciate even more the complexity of language, subjectivity, symbolic practices, affects and aesthetics. So how to continue the creative and critical enterprise fostered by the theoretical turn of the late twentieth century beyond the initial engagement determined by specific theoretical paradigms? How does this translate into *a practice of analysis that can be consistently productive?*

This series argues that we can go forward, with and beyond, by *transdisciplinary encounters with and through concepts.* Concepts themselves arose inside specific theoretical projects. They now move out of—*travel from*—their own originating site to become tools for thinking within the larger domain of cultural analysis, a domain that seeks to create a space of encounter between the many practices that constitute the arts and humanities: the fields of thought that puzzle over what we are and what it is that we do, think, feel, say, understand and live.

We owe the idea of 'travelling concepts' to Mieke Bal, the leading feminist narratologist and semiotician, who launched an inclusive, interdisciplinary project of cultural analysis in the 1990s with *The Point of Theory: Practices of Cultural Analysis* and *The Practice of Cultural Analysis: Exposing Interdisciplinary Interpretation.*[1] In founding the Amsterdam School of Cultural Analysis (ASCA), Bal turned the focus from our accumulating theoretical resources to the work—the practice of interpretation—we do on cultural practices, informed not only by major bodies of theory (that we still need to study and extend), but by the concepts generated within those theories that can now travel across disciplines creating an extended field of contemporary cultural thinking. Cultural analysis is theoretically informed and critically situated, ethically oriented toward 'cultural memory in the present'.[2] Cultural analysis works with 'travelling concepts' to produce new readings of images, texts, objects, buildings, practices, gestures, and actions.

In 2001, a Centre for Cultural Analysis, Theory and History was founded at the University of Leeds to undertake its own transdisciplinary initiative that would bring together and advance research in and between fine art, histories of art and cultural studies: three areas that seem close and yet can be divided from one another through their distinguishing commitments to practice, history and theory respectively. Centre CATH was founded at a moment when emerging visual studies/visual culture was contesting its field of studies with art history or inventing a new one, a moment of intense questioning about what constitutes the *historical* analysis of art practices as a greater interest in the contemporary seemed to eclipse historical consciousness, a moment of puzzling over the nature of research through art practice, and a moment of reassessing the status of the now institutionalized, once new kid on the block, Cultural Studies. CentreCATH responded to Mieke

Bal's ASCA with its own exploration of the relations between history, practice and theory through an exploration of transdisciplinary cultural analysis. Choosing five themes that are at the same time concepts: hospitality and social alienation, musicality/aurality/textuality, architecture of philosophy/philosophy of architecture, indexicality and virtuality, memory/amnesia/history, we initiated a series of encounters between artists, art historians, and cultural theorists (see www.leeds.ac.uk/cath/ahrc/index.html). Each encounter also required the exploration of a range of differences: feminist, Jewish, postcolonial, ethnic, sexual, politico-geographical, historical.

Each book in this new series is the outcome of that research laboratory, exploring the creative possibilities of a transdisciplinary forum, not a new interdisciplinary entity. This means each author or artist enters the forum with his/her own specific sets of practices, resources and objectives. While each writer attends to a different archive: photography, literature, exhibitions, manuscripts, images, bodies, trauma, and so forth, they share a set of concerns that defy disciplinary definition: concerns with the production of meaning, with the production of subjectivities in relation to meanings, narratives, situations, with the questions of power and resistance. The form of each book is itself a demonstration of the intellectual community at work. It is a response to teaching, taken up and processed by younger scholars, a teaching that itself is a creative translation and explication of a massive and challenging body of later twentieth-century thought, which, transformed by critical examination and distillation, enables new scholars to produce their own innovatory and powerfully engaged readings of contemporary and historical cultural practices and systems of meaning. The model offered here is a creative covenant that utterly rejects the typically Oedipal, destructive relation between old and young, old and new, while equally resisting academic adulation. An ethics of intellectual respect—Spivak's critical intimacy is one of Bal's useful concepts—is actively performed in an engagement between generations of scholars, all concerned with the challenge of reading the complexities of culture.

The first volume in the series—*Conceptual Odysseys*—takes off from Mieke Bal's *Travelling Concepts in the Humanities: A Rough Guide*.[3] Bal's introduction here gives an abbreviated account of what she argues there about working with concepts. There follow chapters in which, shaped by varied disciplinary backgrounds and different 'objects of analysis'—paintings, photographs, museums, ideas, pedagogies, historical catastrophes, maps—each writer thinks through a specified concept.

Conceptual Odysseys ranges from analysis of woman as resistant reader in medieval Hebrew manuscripts (Framing) to the problems of what is or can be a historical museum, caught between pedagogical and polit-

ically charged historical narration and display of visual arts and arte-
facts, in the context of the Museum of the French Revolution at Vizille
(History), to essays on visual structuring of dissonant gazing positions
in a single painting by Poussin (Visual Agency), on the meaning of
night in Elsheimer (Trauma) and the ambiguities of the representation
of Mary Magdalene in sixteenth- and seventeenth-century painting
(Mirror). Walter Benjamin's suggestion for a mapping of the *bios* pro-
vides the concept for an analysis of a painting cycle by Charlotte Sa-
lomon (Life-Mapping), while the formations of shattered memory of
'the catastrophe' in contemporary Palestinian fiction is considered
under the concept of Nostalgia. A photo shoot of the first supermodel
to die of AIDS resumes the ideas of trauma and detail (Punctum/
Puncture). The concept of critical intimacy is deployed by a artist in ed-
ucation to critique the effects of audit culture on art education (Peda-
gogy). Moving between Foucaultian discourse analysis and the
epistemic uncertainties of contemporary physics, the impossibility of
knowing what we are saying as art historians is explored through the
borrrowed concept of Efficacity. The collection closes with an engage-
ment with the troubled concept of Commitment, traversing the theo-
retical ground from Adorno to Bhabha and concluding with the
necessity of conceptual travel if the nature of cultural theory and analy-
sis is to have purchase on the world in which it is formed and prac-
tised.

Clearly, this volume is not united by topic, theme, period or disci-
pline. What the chapters share, however, is the practice of close reading
specific archives/texts/images. They are case studies. They are also in-
dications of what can now be done by *working with concepts—conceptual
odysseys—in cultural analysis* that forms a genuinely transdisciplinary prac-
tice, not a mixing or combining in the older sense of interdisciplinary,
but a sense of shared practices that allow for differences in the actual
objects and even disciplinary backgrounds. Bringing them together in
a transdisciplinary space of the collection allows the reader to plot out
a field of encounters and exchanges that traverse borders without dis-
solving them.

In the successive volumes of this series, further collections and
monographs will offer more demonstrations and performances of the-
oretically informed, concept-led transdisciplinary research that will
show artists, art historians, and cultural theorists at work, putting con-
cepts to work through new encounters between arts, cultures and con-
cepts.

<div align="right">

Centre for Cultural Analysis, Theory and History
University of Leeds, 2007

</div>

1

WORKING WITH CONCEPTS
Mieke Bal

In one of those extremely useful articles for which he is rightly famous, Jonathan Culler wrote the following about the concept of the performative:

> This point of arrival, with talk of a performative concept of gender, is very different from the point of departure, Austin's conception of performative utterances, but to make your fortune, as the genre of the picaresque has long shown us, you have to leave home and, often, to travel a long way.[1]

He uses the metaphor of travel. In a book from which most of these introductory notes are taken, I have used that metaphor to reflect on the specificity of cultural analysis as a critical and theoretical activity of the humanities in an interdisciplinary perspective.[2] At the Amsterdam School of Cultural Analysis, ASCA, one of the two partners in the collaborative endeavour of this volume, we have termed this perspective, simply, 'cultural analysis'.[3] Cultural analysis is an interdisciplinary endeavour and as such, it needs some adjustments compared to the more established disciplines. The fundamental elements that define a discipline can no longer be taken for granted: the field, the methods, the objects.

The *field* of cultural analysis is not delimited because the traditional delimitations must be suspended; by selecting an object, you *question* a field. Nor are its *methods* sitting in a toolbox waiting to be applied; they, too, are part of the exploration. You do not apply one method; you conduct a meeting between several, a meeting in which the object participates so that, together, object and methods can become a new, not firmly delineated, field. This is where travel becomes the unstable ground of cultural analysis. Cultural analysis does construct an object,

albeit with a slightly different sense of what that object is from the usual. At first sight, the object is simple enough: a text, a piece of music, a film, a painting. After returning from your travels, however, the object constructed turns out to no longer be the 'thing' that so fascinated you when you chose it. It has become a living creature, embedded in all the questions and considerations that the mud of your travel splattered onto it, and that surround it like a 'field'.

Culler's reference to the picaresque tradition inserts an element of fictionality into the academic 'travels'. The travels proposed here do, indeed, appear like armchair trips. Perhaps they just happen on a stage: in a classroom, in a study. In this sense, then, the fictional theatricality of *mise en scène* subtends the metaphor of travel, as a reminder of the basis of humanist study in that large, unmanageable field called 'culture'. To accommodate these differences, it is our view that interdisciplinarity in the humanities, necessary, exciting, serious, must seek its heuristic and methodological basis in *concepts* rather than in *methods*.

The turn to methodology in the 1980s and 1990s was partly a reaction to the cultivation of the object and its details, in critical movements such as the new, literary hermeneutics in Germany, the *explication de texte* in France, and the New Criticism in the Anglo-Saxon world. The general term *close reading* is still with us, but the practice of it, I am afraid, is not. This loss is due to practical changes, in particular, the reduction of programmes. It is also due to the loss of innocence that came with the awareness that no text yields meaning outside of the social world and cultural makeup of the reader. Nevertheless, we must also regret the loss of analytical skills that accompanied the disenchantment with the illusion that 'the text speaks for itself'. True enough, a text does not speak for itself. We surround it, or *frame* it, before we let it speak at all. However, rejecting close reading for that reason has been an unfortunate case of throwing out the baby with the bath water. For, in the tripartite relationship between student, frame, and object, the latter must still have the last word.

The conviction that this is so binds the articles in this volume together. Concepts function not so much as firmly established univocal terms but as dynamic in themselves. While groping to define, provisionally and partly, what a particular concept may *mean*, we gain insight into what it can *do*. It is in the groping that the valuable work lies. This is why I have come to value concepts. The groping is a collective endeavour. Hence this volume, in which a number of scholars from two collaborating institutions put concepts to work—while they work with these concepts. Even those concepts that are tenuously established, suspended between questioning and certainty, hovering between ordinary word and theoretical tool, constitute the backbone of the interdis-

ciplinary study of culture—primarily because of their potential *inter-subjectivity*. This is not because they mean the same thing for everyone, but because they do not.

Intersubjectivity is a concern that binds procedure with power and empowerment, with pedagogy and the transmittability of knowledge, and with inclusiveness and exclusion. Thus it connects heuristic with methodological grounding. The power of concepts to facilitate invention cannot be thought of without the intersubjectivity of which power is a factor. The concept of intersubjectivity, I believe, can combine a concern for clarity with something more geared towards the social aspect of knowledge as foregrounded by Habermas and others in his wake. For me, it became a word again, one that I unpacked into 'inter-', as in interdisciplinarity, international, and intercultural, and 'subjectivity', as in Lacan, Althusser, or 'person'.

When both of us began to discuss the best, most productive ways to teach cultural analysis, Griselda Pollock and I shared an interest in developing concepts we could all agree on and use, or at the very least disagree on, in order to make what has become labelled 'theory' accessible to every participant in cultural analysis, both within and outside the academy. First in the context of the new research institute for cultural analysis at the University of Amsterdam, ASCA, on the Board of which Griselda served, then in several collaborative workshops at Centre-CATH, of which she was founding director, we developed a coherent direction for researchers to work in, without losing sight of methodological responsibility, yet outside of confining and unquestioned methodological dogma. The new basis was *concepts*.

Concepts are the sites of debate, awareness of difference, and tentative exchange. Agreeing does not mean agreeing on content, but agreeing on the basic rules of the game: if you use a concept at all, you use it in a particular way, so that you can meaningfully disagree on content. That use does not go without saying. Intersubjectivity in this sense remains the most important standard for teaching and writing. Whatever else it does, cultural studies owes it to its principles of anti-elitism, to its firm position against exclusion of everything that is non-canonical and everyone who is not mainstream, to take this standard seriously. Concepts help to conduct such discussions, rationally and in a spirit of constructive debate. *Conceptual Odysseys* offers some examples of such deployments of concepts.

In ordinary, dictionary-based usage, a concept is 'something conceived in the mind; a thought, notion; a general idea covering many similar things derived from study of particular instances; Synonyms: see IDEA.'[4] Mostly, they are considered abstract representations of an object. Like all representations, concepts are neither simple nor ade-

quate in themselves. They distort, unfix, and inflect the object. To say something is an image, metaphor, story, or what have you—that is, to use concepts to label something—is not a very useful act. Nor can the language of equation—'is'—hide the interpretive choices made. In fact, concepts are, or rather *do*, much more. If well thought through, they offer miniature theories, and in that guise, help in the analysis of objects, situations, states, and other theories.

Because they are key to intersubjective understanding, more than anything concepts need to be explicit, clear, and defined. In this way everyone can take them up and work with them. This is not as easy as it sounds, because concepts are flexible: each is part of a framework, a systematic set of distinctions, *not* oppositions, that can sometimes be bracketed or even ignored but that can never be transgressed or contradicted without serious damage to the analysis at hand. Concepts, often precisely those words outsiders consider jargon, can be tremendously productive. If explicit, clear, and defined, they can help to articulate an understanding, convey an interpretation, check an imagination-run-wild, and enable a discussion, on the basis of common terms and in the awareness of absences and exclusions. Seen in this light, concepts are not simply labels easily replaced by more common words.

Concepts, in the first place, look like words. As Deleuze and Guattari note in their introduction to *What is Philosophy?*, some need etymological fancy, archaic resonance, or idiosyncratic folly to do their work; others require a Wittgensteinian family resemblance to their relatives; still others are the spitting image of ordinary words.[5] 'Meaning' is a case of just such an ordinary word-concept that casually walks back and forth between semantics and intention. Because of this flexibility that makes semantics appear as intention, one of the points of the present book is to convey the notion that the pervasive predominance of intentionalism— the conflation of meaning with the author's or the artist's intention—with all its problems, is due to this unreflective conflation of words and concepts.

To say that concepts can work as shorthand theories has several consequences. Concepts are not ordinary words, even if words are used to speak (of) them. This realization should be balm to the heart of those who hate jargon. Nor are they labels. Concepts (mis)used in this way lose their working force; they are subject to fashion and quickly become meaningless. When deployed as I think they should be—and the remainder of this book articulates, demonstrates, and justifies how that might be—concepts can become a third partner in the otherwise totally unverifiable and symbiotic interaction between critic and object. This is most useful, especially when the critic has no disciplinary traditions

to fall back on and the object no canonical or historical status.

Concepts can only do this work, the methodological work that disciplinary traditions used to do, on one condition: that they are kept under scrutiny through a confrontation with, not application to, the cultural objects being examined, for these objects themselves are amenable to change and apt to illuminate historical and cultural differences.

The shift in methodology we are arguing for here is founded on a particular relationship between subject and object, one that is not predicated on a vertical and binary opposition between the two. Instead, the model for this relationship is interaction, as in 'interactivity'. It is because of this potential interactivity—not because of an obsession with 'proper' usage—that every academic field, but especially one like the humanities that has so little in the way of binding traditions, can gain from taking concepts seriously.

Concepts are not fixed. They travel—between disciplines, between individual scholars, between historical periods, and between geographically dispersed academic communities. Between disciplines, their meaning, reach, and operational value differ. These processes of differing need to be assessed before, during, and after each 'trip'. The bulk of this book, and much of my previous work, is devoted to such assessments. Between individual scholars, each user of a concept constantly wavers between unreflected assumptions and threatening misunderstandings in communication with others. The two forms of travel—group and individual—come together in past practices of scholarship. Disciplinary traditions did not really help resolve that ambiguity, although they certainly did help scholars to *feel* secure in their use of concepts, a security that can, of course, just as easily turn deceptive. As we see it, disciplinary traditionalism and rigid attitudes towards concepts tend to go hand in hand, together with the hostility to jargon, which, more often than not, is an anti-intellectual hostility to methodological rigour and a defence of a humanistic critical style.

Between historical periods, the meaning and use of concepts change dramatically. Take *hybridity*, for example. How did this concept from biology, implying as its 'other' an authentic or pure specimen and presuming that hybridity leads to sterility, that was current in imperialist discourse, with its racist overtones, come to indicate an idealized state of postcolonial diversity? Because it travelled. Originating in nineteenth-century biology, it was first used in a racist sense. Then it changed, moving through time, to Eastern Europe, where it encountered the literary critic Mikhail Bakhtin. Travelling west again, it eventually came to play a brief but starry role in postcolonial studies, where

it was taken to task for its disturbing implications, including the historical remnants of colonial epistemology.

Far from decrying such a long journey to a provisional dead end, we see how important such a concept is for the development and innovation of the very field that now rejects it. History—here the history of concepts and their successive networks—can be a dead weight if endorsed uncritically in the name of tradition, but it can also be an extremely powerful force that activates rather than stultifies interactive concepts. Finally, concepts function differently in geographically dispersed academic communities with their different traditions. This is as true for the choice and use of concepts as for their definitions and the traditions within the different disciplines, even the newer ones like cultural studies. All these forms of travel render concepts flexible. It is this changeability that becomes part of their usefulness for a new methodology that is neither stultifying and rigid nor arbitrary nor 'sloppy'. What this book offers is a glimpse of scholars working with concepts—working through them as much as using them as tools.

In the cultural disciplines, a variety of concepts are used to frame, articulate, and specify different analyses. The most confusing ones are the overarching concepts we tend to use, as if their meanings were as clear-cut and common as those of any word in any given language. Depending on the background in which the analyst was initially trained and the cultural genre to which the object belongs, each analysis tends to take for granted a certain use of concepts. Others may not agree with that use, or may even perceive it as not being specific enough to merit arguing about. Such confusion tends to increase with those concepts that are close to ordinary language. The concept of 'text' will serve as a convincing example of this confusion.

A word from everyday language, self-evident in literary studies, metaphorically used in anthropology, generalized in semiotics, ambivalently circulating in art history and film studies, and shunned in musicology, the concept of text seems to ask for trouble. It also, however, invokes disputes and controversies that can be wonderfully stimulating if 'worked through'. If this working through fails to take place, the disputes and controversies can become sources of misunderstanding or, worse, enticements to ill-conceived partisanship, including disciplinebased conservatism. There are, for example, many reasons for referring to images or films as 'texts'. Such references entail various assumptions, including the idea that images have, or produce, meaning, and that they promote such analytical activities as reading. To make a long story short, the advantage of speaking of 'visual texts' is that it reminds the analyst that lines, motifs, colours, and surfaces, like words, contribute to the production of meaning; hence, that form and meaning cannot be dis-

entangled. Neither texts nor images yield their meanings immediately. They are not transparent, so that images, like texts, require the labour of reading.

Many fear that to speak of images as texts is to turn the image into a piece of language. By shunning the linguistic analogy, however, (as in many ways we should) we also engage resistance—to meaning, to analysis, and to close, detailed engagement with the object. That resistance we should, in turn, resist, or at least discuss. The concept of text helps rather than hinders such a discussion *precisely because it is controversial*. Hence its use should be encouraged, especially in areas where it is not self-evident, so that it can regain its analytical and theoretical force.

'Text' is perhaps already an example that leads too much. In its travels, it has become dirty, come to imply too much, to resist too much; hence it has become liable to deepen the divide between the enthusiasts and the sceptics. What about 'meaning', then? No academic discipline can function without a notion of this concept. In the humanities, it is a key word. Or a key concept, perhaps? Sometimes. Let me call it a 'word-concept'. This casual use, now as word, then as concept, has two major drawbacks. One drawback of its casual use as a word is the resulting reluctance to discuss 'meaning' as an academic issue. The other is its over-extended use. More often than not, scholars and students speak of 'meaning' without even specifying whether they mean (*sic*) intention, origin, context, or semantic content. This is normal, inevitable. Just now I couldn't avoid using the verb 'to mean' because I was unable to choose between 'intending' and 'referring'. This confusion is largely responsible for a major problem in all the humanities. For, as a result, students are trained to say that 'the meaning of a picture' is identical either to the artist's intention, or to what its constitutive motifs originally meant, or to the contemporary audience's understanding, or to the dictionary's synonym. My suggestion here is that students ought to be trained to choose—and justify—one of the meanings of 'meaning', and to make that choice a methodological starting-point.

Other concepts or sets of concepts that come to mind—which are implicit but central to the case-studies here—are history (and its relation to the present); identity and alterity; subject(ivity) and agency; hybridity and ethnicity; individual, singular, different; cognitive, scientific, and technological metaphors; medium, mode, genre, type; fact and objectivity; and last but not least, culture(s). The project here is not to provide an overview of key concepts in cultural analysis. Instead, the pages of this volume contain a demonstration of how a number of scholars work with and through concepts in interaction with cultural artefacts or objects. The purpose of each chapter is not to define, discuss, or offer the history of the concept central to it. Rather, the case the au-

thors try to make is for a flexible, close attention to what concepts can (help us) do. Hence, not the concepts but the way the authors propose to handle them is the point.

The mission of concepts is vital if the social climate in the academy is to be maintained and improved, if disputes are to promote rather than preclude the production of knowledge and insight. It is around concepts that we see cultural analysis achieving a consensus comparable to the paradigmatic consistency that has kept the traditional disciplines vital—albeit, simultaneously, dogmatic. Rejecting dogmatism without sacrificing consistency is a way of improving the human *ambiance* while increasing the intellectual yield. For this reason we consider the discussion of concepts an alternative methodological base for 'cultural studies' or 'analysis'. We are happy to notice that the collaboration, reflected in this volume, between participants in two experimental research institutes, has led to such productive discussions.

Working with concepts is a task comparable to working within complex methodologies. Concepts are never simply descriptive; they are also programmatic and normative. Hence, their use has specific effects. Nor are they stable; they are related to a tradition. Their use never has simple continuity, however. For 'tradition', closer to a word that moves about, is not the same as (Kuhnian) 'paradigm', itself a concept threatened with word-status when used too casually. 'Tradition' appeals to 'the way we always did things', as a value. 'Paradigm' makes explicit the theses and methods that have acquired axiomatic status so that they can be used without being constantly challenged. This rigidity is strategic and reflected. 'Tradition' does not question its tenets; hence, those tenets become dogmatic. Traditions change slowly, paradigms suddenly; the former without its inhabitants knowing it, the latter against their resistance. It is the same difference as between subliminal change and revolution.

Nor are concepts ever simple. Their various aspects can be unpacked, the ramifications, traditions, and histories conflated in their current usages can be separated out and evaluated piece by piece. Concepts are hardly ever used in exactly the same sense. Hence their usages can be debated and referred back to the different traditions and schools from which they emerged, thus allowing an assessment of the validity of their implications. This would greatly help the discussion between participating disciplines. Concepts are not just tools. They raise the underlying issues of instrumentalism, realism, and nominalism, and the possibility of interaction between the analyst and the object. Precisely because they travel between ordinary words and condensed theories, concepts can trigger and facilitate reflection and debate on all levels of methodology in the humanities.

What does the work of analysis have to do with it, and how does theory come into it? Making sweeping statements about objects, or citing them as examples, renders them dumb. Detailed analysis—where no quotation can serve as an illustration but where it will always be scrutinized in depth and detail, with a suspension of certainties—resists reduction. Even though, obviously, objects cannot speak, they can be treated with enough respect for their irreducible complexity and unyielding muteness—but not mystery—to allow them to check the thrust of an interpretation, and to divert and complicate it. This holds for objects of culture in the broadest sense, not just for objects that we call art. Thus, the objects we analyse enrich both interpretation and theory. This is how theory can change from a rigid master discourse into a live cultural object in its own right. This is how we can learn from the objects that constitute our area of study. And this is why we can as well consider them subjects.

Philosophy creates, analyses, and offers concepts. Analysis, in pursuing its goal—which is to articulate the 'best' (most effective, reliable, useful?) way to 'do', perform, the pursuit of knowledge—puts them together with potential objects that we wish to get to know. Disciplines 'use' them, 'apply' and deploy them, in interaction with an object, in their pursuit of specialized knowledge. In the best of situations, though, this division of tasks does not imply a rigid division of people or groups of people along the lines of disciplines or departments. For such a division deprives all participants of the key to a genuine practice of *cultural analysis*: a *sensitivity to the provisional nature of concepts*. Without claiming to know it all, each participant learns to move about, travel, between these areas of activity. In our travel in this book, we will constantly negotiate these differences. We will select one path and bracket others, but eliminate none. This is the basis of interdisciplinary work.

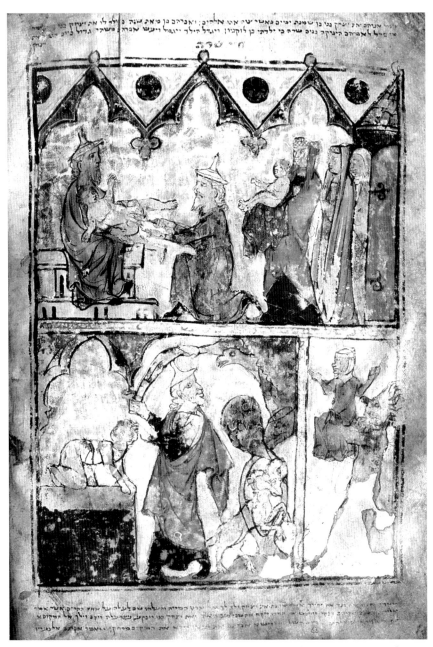

2.1 Folio 18v, Regensburg Pentateuch, c.1300, Israel Museum, Jerusalem.

2

FRAMING

The resisting viewer in a medieval Jewish image
of the circumcision ritual

Eva Frojmovic

Introduction

The aim of this essay is to explore framing as a form of intervention
across the disciplines of art history, medieval studies and Jewish Studies.
I shall examine the devices of framing female figures in an illuminated
Hebrew Bible manuscript from late thirteenth century Regensburg as
ways of turning them into figures of viewing. Attention to framing al-
lows us to explore spaces for 'resisting' feminine viewing and subjec-
tivity. The concept of the resisting viewer is derived from that of the
resisting reader in feminist literary studies, and combined with studies
of inscribed reader figures in medieval romances.[1] Transposed to the
field of medieval manuscript illumination, I identify a visual space for
resisting viewing that serves to reframe a miniature representing the
circumcision of Isaac, an image that has been positioned in normative
terms that exclude feminine subjectivity.

In the chapter in *Travelling Concepts in the Humanities* titled 'Framing',
Mieke Bal draws a sharp distinction between framing, an acknowledged
active intervention on the part of the scholar/critic, and context, entail-
ing an objectivist appeal to an allegedly pre-existing set of historical
data.[2] This distinction is crucial, because it enables the interpretative
work of the historian to emerge as an active intervention. Such active
intervention through interpretation contrasts with traditional notions
of contextual historical interpretation, and reveals the latter as indebted
to the legacy of positivism. Of necessity, my own use of framing differs
from that presented in Bal's essay. Where she reflects on an exhibition,
I study a single miniature from a thirteenth-century illuminated Hebrew
manuscript. Where she, in quite material terms, makes frames, a grid of

material frames present in this miniature will be my point of departure for identifying the space of a resisting, feminist subjectivity and viewership. Yet, I share Mieke Bal's interest in the materiality of the frame and the possibilities frames offer for a conceptual framing.

In my analysis, I understand the frame quite literally as something that is (super)imposed on the image and can be inclusive or exclusive of its marginal spaces. These processes of framing-in or framing-out of marginal spaces of the image are the processes that generate and change our interpretive focus, and which change the historical context one might mobilize for an interpretation. I am also interested in the way in which artists may be using framing devices to control the making of meaning by the viewer. I see my own acts of framing as a process of expanding frames that I consider too narrow and normative. This is undoubtedly a feminist intervention born out of dissatisfaction with normative impositions of context. Because the expanded frame always retains the traces of previous acts of framing, I think of my own interpretive work as re-framing.

Such work is a form of visual reading, and it draws attention to the many preceding acts of reading that have intervened between the artist's own reading of the narrative through the design of the image, and our own reading of it in the present. Perhaps, however, following Mieke Bal's examples, I need to reverse this order, and pursue instead a chain of readings that have preceded mine, until, moving backwards along time's arrow, I encounter the contemporary viewers and readers, men and women, of the Regensburg Pentateuch, a Hebrew illuminated Bible from late thirteenth-century Germany.

Here we stumble across an obstacle. Arguably, the subjectivities of 'real' women readers and viewers of the thirteenth and fourteenth centuries are in the final analysis not recoverable, because the 'real' woman reader and viewer is mostly absent from our archive. Moreover, meaning is made, and always remade, at the point of reception, a never-ending chain of reception events. But all that we have in literary texts and in painted images is representations. Generally speaking, two theories have been formed to cope with our inability to encounter directly the medieval readers and viewers of the manuscripts that have come down to us. The first one is known as Reflection theory, and the second one as Sign theory.[3] Reflection theory reads literary texts and artistic images as realistic reflections of real women's lives. This is overly simple and a-historical. Sign theory, by contrast, conceives of 'woman' as a sign, a metaphorical currency of exchange between writing and painting men. This view can easily lead to the erasure of medieval women readers and viewers. I do not wish to short-circuit representations and realities through the reflection theory; but equally, I do not want to repeat the

erasure of women. My solution to this dilemma—being caught between the reflection theory and the 'woman as sign' theory is to try and locate the inscribed female viewer in the visual image.

This inscribed female viewer becomes the fulcrum for the self-transgression and undermining of any overt male-centred intentionality in text and image. Here, I am translating some insights from feminist literary theory into visual analysis: from reader to viewer. It is an incomplete translation, because the term 'inscribed' remains untranslated; should it be 'engraved'? I will demonstrate, however, that the gain is greater than the loss. Moreover, my analysis is of illuminated manuscripts, books where the work of the (in)scribe(r) is never far. Where medievalists like Roberta Krueger and Tova Rosen have identified an inscribed woman reader in the text, I locate an inscribed female viewer within the image, a viewer that becomes tangible because of the material framing performed within the image.[4] It is my contention that these inscribed female viewers could have formed the bridgeheads or points of identification that allowed viewing as a woman, modelled on Krueger and Rosen's resisting readers.[5] The resisting reader is a reader who refuses to accept patriarchal hierarchies and androcentric canons.[6] This reading and viewing as a woman is entrusted to resisting readers and viewers, figures that can serve to disturb and disrupt the patriarchal discourse.

The case

Because the real medieval woman viewer is forever absent from the historical record, we may never be able to prove conclusively that viewing as a woman ever really happened in the way defined here, in the way of resistance. That gender was at issue already in medieval Ashkenazi (German-Jewish) society, however, has been amply indicated by the research carried out by Elisheva Baumgarten, Susan Einbinder, Simha Goldin, Lawrence Hoffman, and others.[7] In brief, far-reaching social changes in both Christian and Jewish society after the year 1100 made it possible for Jewish women to become active on an unprecedented scale in business, especially money lending. Women began to question the received social hierarchies entrenched in theology and religious practice. With an awareness that some of their Christian 'sisters' (primarily nuns in women's convents, an institutional framework not available to Jewish women) were able to participate actively in religious ritual, Jewish women developed cultural practices that, while not forbidden by Jewish law, soon conflicted with gendered notions of propriety. Thus for example, women wore tefillin, the phylacteries worn in daily prayer, and, more crucially for our discussion here, they acted as godmothers at circumcisions. That is to say, baby boys could be circumcised on the laps of either their godmother or godfather, and often these

served together. In the framework of medieval Ashkenazi society, this role constituted an honour that reflected the individual's standing within a network of family and other social relationships.

Let me propose one possible frame for the framing image at stake here. The ritual of circumcision shifted in this period from being a private home ritual to becoming a communal, i.e. public and synagogue-based, liturgy of profound theological significance and symbolism. This development towards a sacralization of circumcision coincided, and eventually clashed, with a vigorous participation of women, especially as godmothers. Mothers of children to be circumcised considered it their prerogative to appoint a godmother, who was to officiate in partnership with a godfather appointed by the child's father. As Elisheva Baumgarten has shown, this latter custom was gradually perceived as tainted by association with Christian practices, where godmothers and godfathers were by now well developed roles in the rite of passage that was baptism. It also clashed with the new, heightened sacralization of circumcision.

When it was still a home ritual, it was 'natural' that mothers, grandmothers, midwives and other women were part of it. Once circumcision became a public event held in the synagogue, women's presence suddenly became problematic. For men's and women's prayer rooms were or became separate.[8] The later thirteenth and the fourteenth century were spent in the losing battle of women against a rabbinic encroachment against their customary prerogatives. By c.1400, that battle was largely lost and the godmother's role ended at the synagogue's threshold, where she delivered the baby into the hands of the godfather who alone officiated in the ritual. The image to be analysed here falls into the midst of this struggle to rescue the traditional role of the godmother.

What I want to show is that gender trouble is inscribed within the images in illuminated medieval Hebrew manuscripts and that these gender tensions are articulated through the figure of the viewer within the image, the inscribed viewer. The inscribed viewer in turn implies a viewership outside the image. So, the inscribed viewer is a painted figure that we can see but is just a fiction, while the implied viewer would be real if we could enter the thirteenth century again, but is not directly accessible to us any more. The figure of the viewer, i.e. the inscribed viewer, is a potentially problematic figure in feminist terms. It could be a figure of passive spectatorship as opposed to action, but it can equally well be a figure of subversion and resistance by virtue of non-action. It is even possible to see it as a figure of power: the power of the gaze. In other words, at this point it is not clear what the inscribed female viewer tells us about an implied audience, which could be composed of men and women.

Let us start unravelling the possibilities of these alternative interpretations by looking at the complex triple image of the circumcision of Abraham's son Isaac, the *Akedah* or Binding of Isaac and the Temptation or Death of Sarah in the so-called Regensburg Pentateuch.[9] The Regensburg Pentateuch was made in the later thirteenth century for the lay head (Parnas) of Regensburg, Gad ben Peter ha-Levi, whose name is inscribed in the dedication inscription by one of the scribes, Jacob ben Meir, at the end of the manuscript. This patron was clearly a wealthy and influential individual in a wealthy and influential community.[10] The patron was also a man, but does that mean that women, of his household or otherwise, had no access to the manuscript? Not necessarily. What is certain is that, on textual and typological grounds, this is a household book, as opposed to a biblical scroll or liturgical book for use in the synagogue.

The manuscript is to all intents and purposes a study text for the home, containing as it does the biblical books in the arrangement (but not the format) in which they are read in the synagogue worship: the Pentateuch proper in the form of weekly pericopes, its weekly prophetic readings (Haftarot), the five festival and fast 'scrolls' (Megillot), Job, and the so-called passages of doom in the book of Jeremiah. The biblical text is fully vocalized (which would not be the case in a biblical scroll read from the synagogue reading-pulpit or *bimah*), and the apparatus of the *Massorah Magna* at the top and bottom margins provides a running concordance of words and phrases, or sometimes a decorative challenge to the reader when it is shaped into floral and geometric micrography. There are some additional texts, a poem at the end of Deuteronomy and a Massoretic (concordance) treatise before the incipit of the book of Esther (one of the above-named five scrolls). There are also the miniatures, a highly programmatic set of mostly full-page images.

Inspection of the original manuscript shows that these were 'outsourced', i.e. produced separately from the textual part of the manuscript: they are painted on individual folios and gatherings, with the reverse sides blank, and are bound into the text volume separately. This means that the system of written quires takes no account of the miniatures—with one exception, that of the miniature of Job, implying that at a late stage the scribe and painter had to coordinate their efforts.[11] Yet the text itself is not unadorned, but furnished with an extensive series of illuminated initials, again indicating that the scribe had access to a professional illuminator's services from the outset. The illuminated pages are carefully inserted into the book: firstly a single full-page miniature on folio 18v. after the pericope describing the death of Sarah; this is the object of my analysis in the present essay. After that there is

a bifolio bound at the end of Deuteronomy and before the beginning
of the book of Esther, containing the following images:

- Folio 154v. Moses transmitting the Law to the Israelites: the Is-
 raelites are figured here as a group of men only, and much empha-
 sis is laid on the physically uninterrupted transmission of the
 Torah tablets from Moses to the Israelites.
- Folio 155v–156. The tabernacle with the high priest Aaron lighting
 the Menorah (seven-branched golden candelabrum). This com-
 position is derived from contemporary Spanish Hebrew manu-
 scripts featuring tabernacle frontispieces. However, the figure of
 Aaron lighting the Menorah is an original Ashkenazi addition to a
 non-figurative composition. By contrast, the Cherubim are figured
 as a pair of Syrens (birdlike creatures) wearing Jews' hats.
- Folio 157. Esther in front of Ahasvuerus, Hanging of Haman,
 Triumph of Mordekhai: similarly to folio 18v, this is a composite
 picture made up of three scenes divided by frames.
- Folio 225v. Job on the dungheap and his friends, this time not a
 full-page miniature but part of a full-page initial word panel.

A coherent programme was implemented in the Regensburg Penta-
teuch, a programme that arguably included references to Jewish mar-
tyrdom (Binding of Isaac), dreams of revenge (Esther and Mordekhai's
triumph over Haman) and hopes of messianic restoration (the Sanctu-
ary pages). All in all, this is a manuscript whose imagery was not left to
the whim of an ignorant artist. It is a manuscript whose illuminated
pages have something to say over and above the biblical text in its plain
meaning. That is to say, the miniatures provide contemporary commen-
tary in a form not possible in the traditional standard Bible text. Hence,
they might also provide insight into acts of viewing by women.

The Circumcision of Isaac and the Death of Sarah

Folio 18v of the Regensburg Pentateuch (2.1) combines three smaller
scenes, divided by simple frames, into a full-page composition: Isaac's
circumcision, his Binding, and Sarah's death through Satan's agency.
The first two are biblical events; but the tale about Satan visiting Sarah
and causing her death is post-biblical: it is transmitted in a number of
Midrashim, ancient Jewish commentaries on the biblical books. The
whole page, despite its careful composition aimed at giving an impres-
sion of balance and symmetry, raises a number of issues related to my
probing of framing. For instance, a full-page miniature has been in-
serted at this juncture, in the middle of the book of Genesis, even in
the middle of the stories of the patriarchs, whereas other miniatures

come at the end or beginning of books. The placement implies that this theme of Isaac's circumcision and binding, and Sarah's death, had a particular significance. Moreoever, Isaac's circumcision is a minor event mentioned in one passing line in the book of Genesis;[12] yet this topic is given prominent space in the miniature under discussion, to fill the upper half of the page. It thus comes to introduce and match the Binding of Isaac (*Akedah*), a central myth in Judaism (as well as in Christian typology, where it prefigures Christ's supreme sacrifice). Why are such unequal stories made into matching images and given equal weight?

Furthermore, the circumcision scene is not only given prominence on a par with the Binding of Isaac, but expanded into a kind of symmetrical composition of two scenes to include the procession of women bringing Isaac in to be circumcised. There is no biblical text to justify this iconography, but it can be shown that this scene corresponds to godmother customs probably first observed in twelfth and thirteenth-century Ashkenaz and bitterly embattled during the thirteenth and fourteenth centuries. The Binding of Isaac, by contrast, one of the most significant tales about the Hebrew patriarchs, was slightly contracted to make space for an additional image in its own separate frame on the right, which contains the apocryphal death of Sarah. Since the story of Sarah's death is midrashic, its inclusion for representation in itself calls for some comment.

Altogether, it could be argued that in terms of visual economy, the right half of both the upper and the lower registers exceeds the strict requirement of biblical illustration. Quite remarkably, this right-hand side is the side of the women: to the godmothers above corresponds Sarah below, and it is hard to say which took priority in the compositional process; but clearly this was carefully planned to achieve a system of correspondences.

Looking at the formal composition we can perhaps agree that the upper and lower portions exhibit a carefully balanced composition. It could be shown that some of the compositional principles are actually indebted to the contemporary illumination of secular texts in thirteenth-century Germany. As Norbert Ott has shown, the illuminated German epics were reconfigured to achieve a balance and symmetry proper to pictorial composition.[13] To a lesser degree, this symmetry is also palpable in the miniatures of the Regensburg Pentateuch, where these vernacular compositional principles meet with traditional formulas for biblical visual narratives.

The page relies for its effect on a web of mirrorings, repetitions and variations which together add up to a system of typological correspondences. These formal devices tell us that there is a connection between

the upper and lower parts, a connection that is more than a mere progression in time, and more than an aesthetic device. Typology establishes meaning to a degree which the biblical text itself does not. In other words, typological relationships are a visual method of biblical interpretation and commentary. As Simha Goldin has shown extensively in his book about Jewish martyrdom during the crusades, the parallelism between the Circumcision and the Binding of Isaac can be understood as that between two symbolic sacrifices which were understood during the crusade period, and I would argue throughout the thirteenth century and possibly later, as the great ideal types for the contemporary ideal of Jewish life and death. Isaac's circumcision prefigures his willingness to undergo martyrdom. Every baby boy circumcised re-enacts Isaac's heroic life. And Isaac's *Akedah* was a model for martyrdom. Some medieval Jewish commentaries claimed that Isaac was indeed sacrificed but afterwards revived by God, and thus a witness to the belief in resurrection.[14]

The right-hand side of the page, the death of Sarah, raises some questions about the project of illuminating the life of Isaac. One wonders if the inclusion of the Midrash about Sarah's death was decided first, and then a corresponding scene was needed for the top half, a scene that would also feature a woman or women, and that also incidentally involves an act of lifting and carrying. Or it may have been the other way round, the expansion of the circumcision into a full ritual performance necessitated something else for the lower half, something rather more significant and symmetrical than Abraham's servants with their donkeys waiting at the bottom of the mountain; which would be why Sarah's death was included. Clearly, the intention is irretrievable, but we can speak, instead, about the effect of including these female figures on the right-hand side. This inclusion introduces a gender tension into the image, inasmuch as the godmothers' procession draws attention to the struggles about women's participation in the important ritual of circumcision, and the scene of Sarah's death fills in one of the great absences in this father-and-son drama.

This gender tension is especially legible in the upper portion. What first struck me about the so-called godmothers' procession is the level of detail—three women to make up the procession, with their varied clothes and headdresses. Then, there is the fact that the women outnumber the men. Moreover, the gender separation is not effective: it is blurred, as the women almost invade the male space of the circumcision proper.

The inclusion of the godmothers' procession, an exceptional occurrence, is by no means innocent or neutral. We have growing evidence

on the contestations of the tradition of the godmother and its gradual demise from medieval German-Jewish communities.[15] The role of the godmother was a hotly debated issue. The question was whether she could be a true *Sandeket*, that is a genuine godmother with all the social implications of honour and responsibility, just like the godfather (*Sandak*) who held the baby on his lap during the operation. Custom and Law mandated that this was permissible. And yet, rabbinic authorities during the thirteenth and fourteenth centuries pressed for the abolition of the godmother, or at least her demotion to the lower rank of *Kvatterin* (from the German Gevatterin). The *Kvatterin* was a mere conveyor: she was the woman who brought the baby to synagogue but handed it over at the threshold to a man and did not participate in the ritual but waited until its end to return the baby to his mother. This protocol is first prescribed as the norm in Jacob ha-Gozer's book of circumcision laws from the (early?) thirteenth century.[16] However, the leaders of Ashkenazi Judaism in the late thirteenth century show in their legal responsa that there was far from agreement on this issue, and that the custom of the *Sandeket* continued to be practised for some time. The gradual abolition of the *Sandeket* itself and its replacement by the peripheral *Kvatterin* is part and parcel of the sacralization of Jewish rituals in general and the elevation of circumcision to a symbolic Temple sacrifice in particular, from which women were excluded. The specific depiction in the Regensburg Pentateuch could be said to visualize the compromise offered by rabbinic authorities: women were not totally excluded from the ceremony, but the new godmother was not the old godmother. The baby is held, in different moments, by both, but these moments are not equal. The image in this perspective functions as a vehicle of acculturation to this new and still disputed norm of female behaviour, but it also, in its insistence, points to the gender tensions within the community.

Locating the viewer

However, there is also a different way of considering the image. Both the godmother and other women in the procession above, and Sarah below, are figured *as viewers*. Their relationship to the main scenes, both of which are placed off-centre in the left half of the page, is one of spectators and witnesses as well as actors. In terms of the narrative plot, both the women in the godmother's procession and Sarah are actors, that is to say they are part of the narrative development and have a role in it. Yet at the same time, they are marginal to the main focus, the climax of action. Their role is one of witnessing, not of action. Both the *Milah* and the *Akedah* are ritualized acts of violence, and they

are transacted between men. In relation to these climactic violent actions, women take on a subsidiary or, to remain in the parlance of the stage, a supporting role.

While doing what they are doing—proffering Isaac for circumcision, suffering in view of the *Akedah*—the women in the right-hand side of the illuminated page are pictured as the witnesses, and therefore viewers, of the climactic scenes on the left.[17] They thereby constitute inscribed figurations of the real, external viewer of these images. Both of these painted, inscribed acts of viewing, I would argue, can be read as critical, subversive, or resistant acts of viewing. The women who participate in the ceremonial procession or delivery of Isaac are recast into witnesses of the main scene. Once again, there are several ways to view them: firstly, as independently important because they make visible the ritual of the godmother's procession, which registers the social and communal aspect of the whole circumcision ritual. Secondly, we can see them as a visualization of the restriction of women's roles and, implicitly, of the erosion of the institution of the godmother. Thirdly, they can be a visualization of a gendered division of labour in the community. Fourthly and crucially, I can see them as an inscription of the viewer, whether a woman viewer or a viewer figured as woman. In this fourth moment, then, viewing and witnessing are figured as feminine.

In the circumcision scene, the resistant or critical element is the gender tension around the evolving role of *Sandak* and the marginalization of the godmother. The godmother is reduced to a viewing position, but such a viewing position could then also include an element of resentment and resistance. For we know that women and communities as a whole resisted and resented the changes to hallowed custom that were introduced in the late thirteenth and fourteenth centuries, and which put an end to the tradition of the fully fledged godmother. The painted men and women, in their gendered division of labour, enact the gender tensions that we know surrounded the role of *Sandak* and *Sandeket* in German-Jewish society. Thus, these figures articulate female resistance through their act of viewing.

Sarah's role is just as relevant. Firstly, the fact of her presence also serves to highlight and critique her absence from the biblical text. This is the case especially since the miniature fills the gap between the story of the *Akedah* and the following pericope, *Chaye Sarah* ('Sarah's life was 127 years long ...'), which opens with Sarah's death: the mere fact of her death is a fact recorded there in isolation. No wonder that a number of *Midrashim* sought to restore the narrative flow by speculating on Sarah's relation to the cataclysmic event of the *Akedah*. The legend that interests us here exists in a number of versions. Most versions feature Satan coming to tell Sarah what her husband is up to, after he left with

Isaac without telling her where he was taking him. Sarah, the faithful wife, at first steadfastly refuses to believe Satan. Satan lifts her up high into the air so that she can see with her own eyes what is going on on top of Mount Moriah. Just at this moment Abraham lifts his knife to slaughter Isaac, so that is what Sarah sees. In some versions, she collapses and dies there and then. In others, she also witnesses the anticlimax of the divine 'amnesty'. The relief and joy are so great that she dies. In none of the Midrashic versions of Sarah's death, however, does she accept the decree that her son must rightly be sacrificed.

The miniature focuses on this awful moment of maternal witnessing. While witnessing in Christian martyrdom narratives is an affirmative act, this act of witnessing, I would argue, is a potentially critical or resistant viewing act. Sarah's viewing is unauthorized. It is diabolically engineered. It is intended to bring about doubt and finally death. It is thus possible that the double image of the *Akedah* and Sarah's temptation establishes a dialectic between faith and life on the one side versus doubt and death on the other side. In which case female curiosity would be placed squarely on the negative side.

Perhaps we need not be so moralistic after all. We know that Jewish responses to the persecutions of the eleventh to thirteenth centuries did not remain wholly unchanged. Although *Kidush ha-Shem* (martyrdom) remained the leading myth that shaped expectations and responses, its nature too evolved over time. During the first and second crusades, defiant self-martyrdom arose as the primary communal response to crusader attacks. In these acts of collective suicide, women took their place at the side of men. They had important, symbolic roles in the exemplary narratives of *Kidush ha-Shem* that circulated in commemorative prose and verse. Some of these narratives could be read in terms of the transgression of the very gender roles that they presuppose. For example they, too, were compared to Abraham at the moment of the *Akedah*. Later on, in the course of the thirteenth century, mass suicides during massacres were replaced by executions during judicial violence.[18] The heroic subject of martyrological poetry gradually metamorphosed from a collective one into a solitary scholar-hero. With the change from the collective to the individual martyr, women were written out of the poetic elaboration of traumatic events even where the corresponding chronistic, prose record included them.

If this is of any significance, then the inclusion of Sarah, over and beyond the biblical text, is a deliberate step of some importance. I would interpret Sarah as an inscribed viewer who challenges martyrdom as an increasingly male-constructed domain of action. The inclusion of Sarah as a powerfully evocative figure equates viewing and witnessing with grief. Hence, she becomes an emblematic figure of mourning.

I would like to think that while both viewing and grief are feminized in this image, Sarah's figure still offers a possibility to transcend gender boundaries. Just as it was possible to describe mothers during the crusade in terms evocative of Abraham, so the maternal figure of grief offered universal possibilities for identification, not just for women. That is to say, viewing as a woman must not in all cases be reserved for actual women.[19]

Conclusion

The inclusion of female actors on the painted stage of this sacred history offers the possibility of viewing as a woman. It offers figures for identification, figures that enable the imagining of a female subjectivity vis-à-vis this picture. I am not saying that the women in the picture validate female power or action, but even if the artist's, the scribe's, or the patron's intention was to visualize gendered norms of behaviour with the intention of policing them, the visual text is also able to undermine its male universe of discourse and imagination. It is, in other words, self-transgressive.[20] This is so because the female figures in this painted text are represented as inscribed viewers. It is their presence itself which can become the focus and echo chamber of resisting viewing. Because the women in the miniature are the inscribed viewers, that is, viewer figures within the image, figures that enable us to consider the implied viewer, that is to say, the real viewers outside the image implied by the inscribed viewer figure in the picture.

This does not mean that the implied viewer outside the picture was by necessity female. The book was made for a male patron, Gad ben Peter ha-Levi, and the community of Torah study towards which the book gestures was a homosocial community that only exceptionally admitted women at its margins.[21] The Regensburg Pentateuch, however, is also a family book not made for synagogal use, and as such it is reasonable to assume that women as well as men had access to it. There may not be an unequivocal answer to the question about the identity of the inscribed viewers in the Regensburg Pentateuch, but it is their very presence that opens up a space for female subjectivity through resisting viewing. As witnesses, they partake of a carefully calibrated system of framing that, if read backwards from modern, unacknowledged processes of normative framing, constitutes a reframing that opens up the ancient narratives to new questions. This process of framing and reframing is akin to the reframing of ancient texts by new commentaries, with all their critical potential.

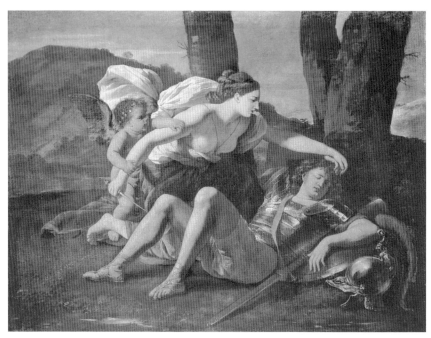

3.1 Nicolas Poussin, *Rinaldo and Armida*, c.1629–30, oil on canvas, 82.2 ×
 109.2 cm, Dulwich Picture Gallery, London. By permission of the
 Trustees of Dulwich Picture Gallery.

3

VISUAL AGENCY
in Poussin's *Rinaldo and Armida*
Phillippa Plock

Nicolas Poussin (1594–1665) painted *Rinaldo and Armida* in Rome around 1629 (3.1). One of Poussin's most visually appealing works, the arch of the woman's arms stabilizes the painting in a calm structure of circle and triangle. The unifying nature of this form is shattered, however, by its opposing end points: two contradictory gestures of hate and love. In one hand, the witch Armida firmly holds a dagger. Her arm is aggressively moving across to stab her Christian enemy: the fingers of the putto's hand rake her flesh; the effort of trying to stop her causes him to cry out. Affected through the beauty of the sleeping knight, Armida's other hand is at rest. The passive limb that parallels her gaze contradicts the assertions of her right side. Instead of restraining Rinaldo, the gentle pressure of her hand, placed on top of his inert flesh, produces a shielding, enveloping, insistent caress.

This contradiction of simultaneous bodily states is echoed in Armida's drapery. Above, her white garment billows in the wind, as if she is still coming in for the kill. Below, the putto steps on her heavy blue skirts, as if she has been calm for some time. The drapery supplements the duality of the hand gestures; both are material traces of the painter's attempts to visualize a particularly striking form. An individual figure confronted by an image has come to embody two distinct and contradictory states with neither self-combustion nor dissolution. Moved by the sight of the sleeping figure, Armida is, at once, moving murderer and static, tender lover.[1]

In its presentation of two states in one, the painting challenges the rational boundaries of classification which Foucault and others have identified as the dominant mode of perception developed during the period when this work was painted.[2] Armida's figuration of a state that confounded these nascent modes of dividing up the world was no

doubt designed to induce in seventeenth-century viewers a state of marvel, intuition and reflection. Looking at the painting today, it is still an image that seeks to move us to astonishment through an image of someone being radically altered through the activity of seeing.

Several writers have already commented upon the fact that Armida's reaction stages viewing for those who look at the painting.[3] The quality of Armida's ontological uncertainty is not merely historical, therefore: it operates as part of a movement where historical representation affects present-day experience. By figuring a viewer being moved by a passive object, which in turn still seeks to move an external viewer, the painting seems to challenge the demarcation between the worlds of things and people that has been established in recent criticisms of fetishism and reification.[4] Rhyming my own potential interaction, the painting addresses me in such a way that suggests it has a powerful agency to affect my own state of being, forcing me to merge with the image and to become a dual entity myself.

Thinking through the nature of *Rinaldo and Armida*'s agency in this essay allows an exploration of what might be at stake in an interpretative approach to painting that utilizes the agency of things. The notion that objects of material culture have the power to influence their owners' behaviours, a theory developed in anthropology during the 1980s, is becoming increasingly popular in studies of the early modern period.[5] The concept that historical objects have agency is also pertinent to the ethical approach of hermeneutics, a methodology that attempts to engage historical objects in dialogue in a manner that respects their ability to alter the prejudices of modern interpreters.[6]

Here, my encounter with *Rinaldo and Armida* provides a means for me to extend the hermeneutic concept that historical paintings' forms have the ability to lay down parameters that determine how and what a modern interpreter can say.[7] *Rinaldo and Armida*'s liveliness motions instead towards an alternative approach that involves an imaginative recreation of the address of the 'other'. As Dominique LaCapra and others have discussed, such a move inevitably carries a weighty responsibility not to turn ventriloquist but to attempt to grasp the anticipation of an answer that is contained in the work itself.[8] Throughout this process, the interpreter must try to battle against the lure of identification where the painting is subsumed into her own ego and spoken for.[9]

Armida's incessant visuality—her simultaneity encoded in visual sign —encourages a supplement to this attempt carefully to 'listen' to the painting. It also demands from me an investigation of agency that operates on a visual level, which moves this approach away from the stress on linguistic communication predominantly found in the hermeneutic model.[10]

Through attending to the means of this painting's visual address in the first part of this essay, it becomes evident that the painting communicates through a visual language composed of contradictory gendered gestures. We shall see that the simultaneity apparent in the first encounter with the painting rests in Armida's signification as both feminine and masculine. This reading extends the argument made by several scholars that Armida enters a singular masculine or neutral state.[11] Such interpretations may well have occurred because of her role as a figuration for viewers perceived to be solely masculine. Armida's body identified as one entity also signifies a residue of modernist investments in singular states of being.[12] Due to my own gender, as well as my relationship with the current demands of academic work to adopt certain pluralistic voices, for me the question posed by the figure is about the painting's possibility to induce this viewer to hold two genders in her body at once.[13]

Before I run headlong into an ecstatic communion with the painting, it is important to ask what is at stake in submitting to this fantasy. Following the hermeneutic method of interrogating the prejudices of each participant in the dialogue, this question needs to be answered by thinking about the horizon of the painting's first address. The parameters discussed in the second part of the essay are an attempt to consider the painting's intention, in the terms of what was intended for it to achieve as it signified through its wider cultural surroundings. In the logic of the hermeneutical dialogue, the image carries a legacy of these parameters that may well seek to fix this viewer in a place she does not choose to be.[14]

I. Means of visual address

In Poussin's *Rinaldo and Armida*, the difference between left and right hand reads as a binary of feminine and masculine characteristics. Torquato Tasso, a writer dear to Poussin, had related hands to gender in this way: women were 'weak and imperfect in comparison to men, similar, in fact, to the left hand', whilst men were equated with the 'virile' right hand that embodied 'absolute strength'.[15] Following such a schema, the gesture of Armida's left hand manifests connotations of nurturing motherhood. It is visually reminiscent of Mary's touch upon Christ's body, a central motif in miraculous Madonnine images and constructions of femininity in early modern Italy.[16] Armida's right hand contradicts these feminine gestures through her grasp of the dagger. In contemporary literature, women who carried armour and weapons were often mistaken for men.[17]

Such a gesture certainly transcended notions of femininity for social theorists. In Lucrezia Marinella's book *La nobiltà et eccellenza delle donne* of 1601, she advocated women's training in fighting with arms. This

argument accords with her dismissal of Tasso's equation of left/right with feminine/masculine; she wrote 'there is no difference between the right and the left [hand], as can be frequently observed in everyday use … [and the] thousand examples of strong women.'[18] Women's appropriation of virile swordplay communicated for this writer at least the potential for noblewomen to manifest traditionally masculine characteristics.[19]

Poussin may well have intended to use the gendered gestures of Armida's right and left hands in order to figure the central metaphor of his source: Torquato Tasso's poem *Gerusalemme Liberata* (1581). Tasso described Armida hanging over Rinaldo 'as Narcissus looked at the spring' (XIV.66).[20] In this moment, Armida sees herself reflected in a man, echoing an earlier description of her dual personality. Armida's uncle remarks on her abilities thus: 'under golden hair and outward beauties so delicate [you] keep concealed a manly heart and grey-haired wisdom' (IV.24).[21] The metaphor of Armida-as-Narcissus brings the earlier connotations of masculinity that were hidden in Armida's body up to the surface. Poussin's use of contradictory hand gestures captures this new visible location of Armida's dual gender.

In the visual culture within which Poussin worked, these hand gestures had the ability to impress themselves upon the soul of the viewer, persuading them to adopt the behaviour depicted. Persuasive visual language was crucial for seventeenth-century painters like Poussin to master in order to allow them to adhere to the counter-reformatory Catholic Church's requirement that painting's principles were to 'delight', 'teach' and, in addition to these two traditional functions, to 'move'. This requirement was not restricted to propagandistic works of religious art. Contemporary patrons of secular imagery also desired to use paintings to 'conserve or augment, or truly diminish and correct and convert to the contrary' certain undesirable characteristics in visitors or family members who came into contact with their domestic picture collections.[22]

Central to Poussin's ability to move his viewers was his skill at depicting the gestures of the body, known as the signs of the *affetti* or passions. The theory of *ut pictura poesis*—as is painting so is poetry—which dominated the production of painting at this time, emphasized that art should instruct people through inducing them to imitate the message of the piece. The power of forms used by painters was perceived as being analogous to the quality of rhetoric: language moved an audience to empathize with the emotions conveyed by the speaker.[23]

Hand gestures developed in the art of oratory were used by painters as visual signs in order to convey certain messages to an audience well versed in the strategies of persuasion used by preachers and lawyers.[24] These gestures were codified into visual language. In his *Trattato* on

painting, published in 1584, Giovanni Paolo Lomazzo argued that emotions and gestures in a painting, when rendered in a life-like fashion, will cause the observer to 'laugh with those who laugh, think with those who think, sorrow with those who cry, delight with those who make merry, and marvel with those who marvel'. The text outlines the correct procedures for depicting each emotion. People would imitate the realistic depiction of emotions taught by Lomazzo's text because the same effects would be aroused in their bodies.[25]

Gestures were crucial also to communicating visual messages about the gender of a person. A woman covering her genitalia with her hand expressed the feminine sexual shame of Eve, whilst a man covering his face signified Adam's masculine shame of dishonour. These gendered signs operated in the wider discourse of etiquette manuals and courtly literature that encouraged women and men to conduct themselves in ways determined by social perceptions of their sex.[26] The link between gender and gestures as signs of emotion was such that writers on the art of gesture included advice in how to depict the emotional state of 'effeminacy'.[27] Following the logic of Lomazzo, this advice suggests that painters believed in the possibility of affecting the gender of their viewers through their skill in depicting the *affetti*.

<div align="center">* * *</div>

In communicating Armida's masculinity and femininity simultaneously, Poussin stressed the specificities of his own craft to move audiences to the utmost degree. Due to the prevailing paradigm *ut pictura poesis*, the nature of *Rinaldo and Armida*'s visual address was predicated on its comparison with the possibilities of the poetic word. Poussin's reliance on visual simultaneity distinguished his painted rendition from the poetic source, where Tasso's line '*from* his enemy she *became* his lover' (XIV.67) relies on temporal movement.[28] In so doing, he came close to Leonardo da Vinci's opinion that painting was superior in being able to show an event such as a battle '*in un istante*' rather than in the many '*lunga e tediosissima*' lines of a poem. Poetry, for Leonardo, was less able to represent beauty because 'the eye cannot embrace the whole simultaneously in its field of vision.'[29]

In the early seventeenth century, the qualities inherent in visual forms were fascinating for poets. Indeed, Poussin's choice to depict Armida as a simultaneous figure may well have been inspired by the interests of his patron and collaborator, the poet Giambattista Marino.[30] Poussin's amorous murderess is reminiscent of Marino's ability to juxtapose unexpectedly two contradictory elements in his poetry.[31] In addition, the painting responds to Marino's fantasies about the possibilities of visual form. Marino praised painting for its ability to depict the rare, mon-

strous or incredible in such a manner that moved the imagination of
viewers. His long poem *La Galeria* (1619) rendered individual works of
art in verse form, in a manner that attempted to capture the sensuous
vividness of paintings that induced men to talk.[32]

This strategy related to how poets sought to integrate visual proper-
ties into their words. A theoretician of Marino's poetry close to
Poussin's patrons, Emmanuele Tesauro, believed that the sharpest
metaphors available to a poet were single words that 'contain two con-
trary conceits', as in an antiphrasis. Tesauro stressed the visual qualities
of such metaphors comparing them to a coin or medal with two faces.
In a miraculous fashion, such words allowed one to see '*l'un dentro al-
l'altro*': 'one inside the other'. These miraculous forms were important
for a poet to perfect in order to affect the audience: 'the spirit of the
listener, overwhelmed by the novelty' of the metaphor, is moved to
consider 'the acuity of the representing wit and the unexpected image
of the object represented'.[33]

Poussin's visual interpretation of Tasso's poem acts in the manner of
the optimal poetic metaphor. *Armida* forces viewers to grasp two ele-
ments in one moment by miraculously enclosing 'one inside the other'
—masculine and feminine together—in a manner that overwhelms a
viewer, encouraging contemplation of the painter's skill and the mean-
ing of the object represented.[34] Prompted by poetic fantasies about
what paintings could do, with *Rinaldo and Armida* Poussin practised his
extraordinary powers to make people see two contradictory states at
the same time.

In choosing the forms of simultaneous masculinity and femininity,
both to visualize Tasso's contradictory gendered metaphor Armida-
Narcissus, and to affect his audience in a startling manner, Poussin must
have been aware of the agency gender difference imparted to the cre-
ation of painterly-poetic marvel. The theoretician Tesauro compared
metaphors of opposition with the hermaphrodite, those people 'neither
man nor woman but both', following the dominant belief that such
people's bodies were made by an equal contribution of both mother
and father at the moment of conception.[34] The simultaneous state that
Poussin figured in the painting was therefore analogous to a person: a
living being with agency and the power to affect others. In this confla-
tion of visual language and bodies, Poussin's work emerged slippery,
alive, startling, contradictory, and full of the potential for affecting a
viewer so that she too is born masculine and feminine.

* * *

When viewing this painting, the lure to identify with Armida is strong.
In my situation, she promises the opportunity to become the woman

who bears the dagger, the phallus of knowledge; someone who suc-
cessfully embodies both masculine and feminine characteristics and ful-
fils the demands of the world I find myself in. The painting contains
a call to confirm a patriarchal ego. Through answering the address to
occupy the position of identifying viewer, the painting promises me
the fantasy of primary narcissism.[36]

In this respect, the agency of this painting is such that it seeks to de-
stroy the ethical position that is the aim of my enquiry. And so, the
threat of this object's liveliness has to be countered. To resist the col-
lapse of difference and the lure of making this painting speak through
my own voice, the hermeneutic approach suggests I pay attention to the
parameters of its own horizon of production c.1629.

Below, I offer four different encounters with the painting in a manner
that seeks to achieve this critical distance. These 'encounters' are an at-
tempt to reflect upon the vital ethical importance of conceiving works
in some sort of historical context. The use of other cultural frames in
the writing of early-modern art history sometimes provokes criticism
because it arouses in readers an uncomfortable feeling of separation
from the artwork whilst the contextual frame is set in place.[37] These
feelings are necessary: the activity of framing questions and disturbs
the interpreter's relationship with the historical object, foregrounding
her own agency in producing interpretation whilst maintaining a sepa-
ration from the object.[38]

II. A few parameters of agency

The letters written by the mother of one of Poussin's patrons offer the
first resource to reconsider *Rinaldo and Armida*'s message. Thinking
about the painting's relationship to the realities of communicating as a
woman in the early seventeenth century, it is possible to begin to ex-
plore what is at stake in this image's intention for women viewers. Bian-
camaria Cacherano, the mother of Cassiano dal Pozzo, Poussin's major
patron at this time, was a widowed noblewoman whose letters can still
be read in the archives of the Accademia dei Lincei.[39] These letters give
us an indication of women's experience in the milieu in which Poussin's
paintings were intended to be seen.

Like many widows, Biancamaria was expected to manage the family
property and to assume many of her dead husband's duties.[40] At the
same time, she had to conform to the ideal that aristocratic women
were completely dependent on men, an ideology that had strengthened
considerably during the preceding two centuries.[41] Reflecting this com-
plicated transgressive position, Biancamaria was forced to use strategies
such as using deferential language. She also used a masculine voice to
persuade her son of her own financial opinions through recalling the
authority of her dead husband, or other important men.[42]

This tightrope was not easy to walk. Sometimes Biancamaria's nec-essary 'feminine' roles conflicted with her 'masculine' economic duties. In several letters, she apologized for failing to write to her son due to her religious devotions or her duties of care.[43] Biancamaria knew this 'feminine' behaviour questioned her ability to be an agent: in one letter, written in 1622, she pleaded with her son to allow her to continue to work as a negotiator and dealer for him despite these diversions by stat-ing, 'I want to love rather than to be loved.'[44] This phrase communicates a desire that her agency be recognized through the mutual exchange of affection and understanding.

These letters demonstrate that Biancamaria wanted to serve the in-terests of the family by successfully taking over absent men's respon-sibilities. They also show that she was well aware that her femininity prevented her from being appreciated as a fully competent agent. To this woman at least, a painting that figured a woman encompassing a masculine and feminine state may well have confirmed her fears that noblewomen were sometimes positioned in such a way that they were expected to act as men but could never fully enjoy the recognized agency of their fully 'masculine' kin.

<div align="center">* * *</div>

An opinion about Marino's poetry expressed around the same time Poussin painted *Rinaldo and Armida* provides the material for a second encounter with the painting. In a book of 1627, the poet Tommaso Stigliani attacked Marino's indecorous merging of opposite behaviours, including masculinity and femininity.[45] Summing up the effects of this approach, Stigliani wrote that Marino's poem *Adone* was 'not a sole poem, but a group of poems massed together, by which monstrous conjunction it actually resembles those two twin children that today live attached by the chest, and are taken around Italian cities and dis-played for a fee.'[46] This comment indicates that a gentleman-viewer could use an artistic image of simultaneity as a sign for a living body that was used by wealthy viewers to gain a pleasurable recognition of their radical difference from monstrous others.

Reports of conjoined twins in our own society involve a feeling of one's total inability to conceive of what life must be like merged so physically into another subjectivity.[47] In the late 1620s, Stigliani may well have had similar effects in mind, though perceived through the frame of seventeenth-century notions of being. By comparing Marino's poetry to conjoined twins, Stigliani not only distinguished his own ra-tional poetry but surely also sought to frighten readers of Marino's il-legal poem: it had been placed on the Papal Index of prohibited texts in 1624.[48] The metaphor may well have been designed to bring to mind

memories of the demonic origins of a deformed baby, which a Roman priest refused to baptize in 1623.[49]

An image of simultaneity figured by a pagan witch such as Armida could have been easily read therefore as a deformed, mute, demonic body. *Rinaldo and Armida* had the potential to act as an agent that warned gentlemen to resist her powers at all costs and retain rational control for their fully masculine selves.

<p style="text-align:center">* * *</p>

A poem by Giambattista Marino, entitled *Salmacis and Hermaphroditos*, provides a third way to consider how Poussin's *Rinaldo and Armida* may have sought to affect gentlemen viewers. Marino's poem is about a now lost painting by Carracci showing the nymph Salmacis merging with her reluctant beloved, the boy Hermaphroditos, to form a hermaphrodite, in Ovid's words, 'a single form, possessed of a dual nature, which could not be called male or female, but seemed to be at once both and neither.' Afterwards, in Ovid's tale, Salmacis's pool is given the power to transform 'any man' into becoming similarly 'weak and effeminate'.[50]

Marino's poem contains similar conceits of gender simultaneity and affect to Poussin's *Rinaldo and Armida*. In the poem, Marino compared Carracci's skill to Salmacis's pool, the site of the merging of two bodies through love: the first few lines read, 'Just as the tranquil and clear waters of Salmacis had in themselves the power to make one enamoured, so through your art, CARRACCI, their appearance has in itself the power to make one marvel.'[51] Pool and painted pool have a similar power to alter radically the masculine subject. Likewise, we have seen that Armida's body, radically altered by the sight of Rinaldo to become both masculine and feminine, in turn seeks to affect the body of an external viewer through sympathetic response.

In a comparative mode to Poussin's composition, Marino staged the experience of viewing such an affective painting of gendered simultaneity as an echo of the subject matter: the poem ends 'Love in one single body conjoined two, wonder separates one from oneself.' Struck by the painter's marvellous skill, a feeling of awe separates the gentleman-viewer from himself: an experience that is both opposed to the experience of Hermaphroditos who merged with Salmacis through love and akin to the way he was separated from himself and forced to conjoin with a desirous female.

In this respect, the poem both represses and marks a masculine desire to join temporarily with a 'feminine' state through the agency of paintings. By being affected by the power of love rendered in paint, a gentleman-viewer would have mirrored Hermaphroditos' transformed state, enabling him to momentarily flirt with a type of subjectivity that

had become glorified by melancholic artists and poets. These characters
incorporated feminine characteristics into the condition of melancholia,
a figuration for an exclusively masculine genius.[52] The intersection of
masculine and feminine states was also used in the depiction of kings
to show their ability to rule using characteristics associated with both
genders.[53] In a similar mode, through affecting a gentleman-viewer to
form a sympathetic reaction, Armida's body had the potential to oper-
ate as an agent to fulfil men's fantasies about momentarily taking over
feminine characteristics in a pleasurable experience of wholeness, rap-
ture, and king-like ability.[54]

<p style="text-align:center">* * *</p>

The readings thus far have located gender simultaneity in the realms
of patriarchal imagination: as signs of incapability, irrationality, the
monstrous, the objectified and an available site for colonization. As a
depiction of a woman, *Rinaldo and Armida* reads as a technology that
maintains the connection between irrationality and femininity, leaving
rational control exclusively for the fully masculine subject whilst offer-
ing him the fantasy to experience elements of this exotic other.[50]
Through these three encounters, the painting's relationship to mascu-
line fears and strategies to retain patriarchal structures has become ap-
parent, alerting me to the danger of communion with Armida and
placing myself in her position.

It is this realization that leads me to the final consideration of the sig-
nificance of Armida's agency. The understanding of Armida's onto-
logical state as analogous to conjoined twins or hermaphrodites as
indicated by the above parameters indicates an agency that unsettles
the patriarchal economy charted thus far. Returning to the ontological
uncertainty in relation to classification raised at the start of this essay,
Rinaldo and Armida can be read as a sign of mourning the old ways of
understanding the world that were being challenged by the move to-
wards rigorous classification.

The belief that everything in the world existed in a web of similitude
was being increasingly challenged in the early seventeenth century. Fou-
cault and others have noted the importance of visual appearances to the
continuation of these ideas. Seeing marvels that were particularly strong
instances of simultaneity, like hermaphrodites or conjoined twins, were
important resources for imagining that entities could be the same as, yet
different from, each other.[56]

Poussin's patrons were certainly fascinated with simultaneity in the
living world. Cassiano dal Pozzo, Poussin's major patron at the time *Ri-
naldo and Armida* was painted, corresponded with learned friends over
such matters as a man with a tree growing out of his stomach.[57] His in-

terests related to the wider project of classifying the natural world undertaken during the 1620s by one of the academies to which he belonged, the Accademia dei Lincei. The head of the Lincei, Prince Federico Cesi, realized that rigorous classification could only occur with the resolution of entities that seemed to be simultaneously one thing and another. This was why the Academy spent much energy studying marvellous objects like conjoined twins, hermaphrodites, fossils and fungi in order to resolve their apparent ambiguity.[58]

In an environment where wonders of art were displayed alongside wonders of nature in the palaces of such erudite men, *Rinaldo and Armida* may well have operated as an exploration of this type of duality. Indeed, the presentation of a dual state through the visible marks of gender makes this connection particularly likely. The classification of gender was extremely important for Cesi's project. He believed that the key to a stable classification system was a better understanding of systems of reproduction and thus sought to resolve objects that appeared to belong to both masculine and feminine categories because of the external signs present on one body. For Cesi, the investigatory tool of dissection promised the revelation of distinct sexed body parts that countered signs of gender ambiguity manifest on the surface of the body.[59]

As a body that visually demonstrated masculine and feminine simultaneously through the external gestures of right and left hands, Armida may well have signified as a fantastical reminder of older ways of thinking. As a painted image, her mystery remains intact: she can not be dissected. Through Poussin's skill at rendering the instant address of visual language, she provides a moment of marvellous, affective simultaneity that encourages viewers to cast aside notions of temporality and exist suspended in a fantastical moment outside the change at work in the world.

In this respect, *Rinaldo and Armida*'s appeal to Poussin's patrons may well have involved an ability to soothe anxieties about the shifting relationship between self and world, men and women, humans and animals, plants and objects, and so on. The painting's potential to operate as a visual agent that joins together painting and person, woman and man, must have staged the possibility of simultaneity for its first viewers. For me, it is partly this agency which has travelled with the painting throughout its history and which addresses me now. At this moment, the painting's agency should be regarded therefore as a figuration for the desire for ethical communion rather than a means to achieve it. The painting visually 'speaks' to me of the continual need to investigate the means and meanings of dialogues between paintings and people, historical objects and present-day interpreters, in a manner where each participant acts as an agent for ethical transformation.

4

MIRROR
Mary Magdalene through the Looking Glass
Victoria Turvey Sauron

Jesus said to her, 'Mary!' She turned and said to him in Hebrew, 'Rabbouni!' (which means Teacher).

John 20:16[1]

The scene in the Gospel of John, verse 20:16, where Mary Magdalene recognizes the resurrected Christ in the Garden of Gethsemane, is one of the most poignant, and vividly visually rendered, in the New Testament. An aspect of this scene is represented in a sixteenth-century painting by Giovanni Savoldo, one version of which hangs in the National Gallery, London (4.1). In the painting, the saint, her bowed head, body and arm veiled behind a brightly reflective silver cloak, turns towards the viewer and gazes directly out of the picture frame. In front of the empty tomb, she is turning, about to see the risen Christ. The Magdalene's gaze is at once frank and mysterious, calm and intense; the remarkable cloak fills the rest of the composition.

Despite hardly being mentioned in the authorized texts, Mary Magdalene remains one of the most iconic and controversial figures of the New Testament. A saint characterized more by 'myth and metaphor' than by historical fact,[2] she has been represented not in one consistent guise but rather by multiple avatars in visual art and popular culture across the centuries.[3] One of the most common characterizations of the Magdalene, despite no such mention appearing in the Gospels, is that of the repentant prostitute.[4] Erotic interpretations of Savoldo's painting across the centuries naturally drew inspiration from this sensual image. Descriptions ranged from a 'young, warm and impulsive woman', to 'a romantically veiled beauty', to straightforward readings of the painting as a courtesan portrait.[5] It was not until the intervention of Mary Pardo, writing in 1989 in *The Art Bulletin*, that the haunting

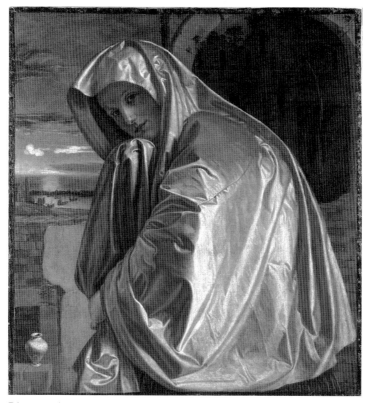

4.1 Giovanni Savoldo, *Mary Magdalene*, c.1535–40, oil on canvas, 89.1 ×
82.4 cm, NG 1031, National Gallery, London.

figure and her extraordinary reflective cloak received deeper consider-
ation.

Pardo presents Savoldo's *Magdalene* as a masterpiece of painterly ar-
tifice, intended to showcase the talent of the artist for creating ironic
invenzione, artistic sleight-of-hand. She reveals how the light reflecting in
the saint's extraordinary garment is the reflection of the risen Christ,
whom Mary Magdalene turns to meet on Easter morning in the Garden
of Gethsemane. Although the Magdalene could be posited in some
contexts as being privileged to see and speak bodily with Jesus, here, for
Pardo, the *Magdalene* is nothing more than a device, a screen upon which
to project the artist's inventiveness:

> it does not pretend to 'contain' truth, only to reflect it; its osten-
> sible content is wholly exterior to it. Yet the resultant 'emptiness'
> is also a kind of limitless potentiality (since it holds the viewer in

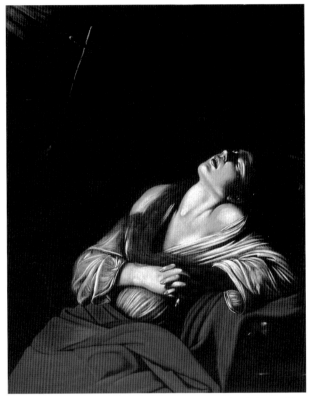

4.2 Ludovicus Finson, copy of Caravaggio's lost *Magdalene in Ecstasy* of 1606
 (c.1612), Musée des Beaux-Arts, Marseilles.

thrall) and guarantees the painter's essential autonomy in spinning
out his fiction.[6]

The figure of the Magdalene herself, for Pardo, is a cipher—a 'code'—
enabling the artist to endow his composition with meanings ranging
from the theological to the iconographic.

 While recognizing the importance of Pardo's work on this painting,
in this paper I wish to take issue with the view of the Magdalene as an
empty mediator, void of independent 'truth'. In investigating the notion
of 'Magdalene as mirror' via a case study of Savoldo's *Magdalene* (4.1)
but also a *Magdalene* originally painted by Caravaggio (4.2), I hope to
show, on the contrary, that rather than being a 'passive ... projection
screen',[7] a certain kind of early seventeenth-century *Magdalene* actively
appropriates the mirror. Somewhere in the play of body and light, paint
and canvas, the painted body becomes the agent, the instigator of the
interaction between self and other. It is therefore a 'knowing' Magda-

lene assuming both erotic bodiliness and sacredness[8] who engages and challenges the viewer's gaze: the Magdalene of the Gnostic gospels, the knower of 'truth' who said to the disciples, 'What is hidden from you, I will proclaim to you.'[9]

Mary Magdalene above all other saints transgressed the visual boundary between sensuality and spirituality; and not only in the limited sense of the depictions of her semi-naked penitence, in her guise as the repentant prostitute. In the fifteenth, sixteenth and seventeenth centuries, long before popular legend attributed a historical significance to their relationship,[10] the privilege of the Magdalene's role was her sensual relationship with Jesus. Carmen Robertson, referring to the iconography of the 'Noli me Tangere' scene from the Gospel of John,[11] notes that,

> the scene shifts from a wholly didactic and religious intent in the fourteenth and early fifteenth centuries to an emphasis upon the physical relationship between Christ and the Magdalene in the sixteenth century. Little in the sacred scripture suggests the sexual interpretations that become commonplace in portrayals of the pair in fifteenth and sixteenth-century Italy.[12]

Robertson's suggested sixteenth-century turning point is corroborated by the wealth of *Lamentations* or *Pietàs* from the period, where the Magdalene's touch is usually more dramatic or imbued with desperate passion than that of the Virgin, or where she even replaces the Virgin as the primary site of interaction with Jesus's body.[13] The Magdalene enables the figuration of a dark sexuality which is, nevertheless, firmly contextualized in the veneration of Jesus's earthly body; of course, also here a dead body, which itself carries additional multiple connotations of body and spirit, death and life. It is clear that the Renaissance Magdalene is the agent of a deeply ambiguous and paradoxical interaction with Jesus's body, the most undecidable body in the imagery of Western art.[14]

This access to the paradoxical touch of Jesus, having given the saint a strange and evocative status among other popular female saints, altered in the seventeenth century. The principal powerful guise of the Magdalene shifted from the interaction with Jesus to the moment in which she is herself between the human and the divine, where the boundaries of body and spirit, self and other, are transgressed within her own body—the experience of ecstasy.[15] Going beyond previous Christian imagery of sacred experience, it is in the tension, abandon and contortion of ecstatic bodies that intense experiences such as pain, pleasure, death, sexual ecstasy, even the experience of subjectivity, could be visually encoded in Western culture. Unlike other ecstatics, like Teresa, Agnes, or Agatha, the Magdalene was a gospel figure and not a

mystic in the traditionally understood sense. It is precisely because of the Magdalene's paradoxical status as the site of the interaction between body and spirit in relation to the body of Jesus, that the interrogation of the saint's own female gendered body on similar terms raises more specifically nuanced questions about this ultimate site of undecidability between body and spirit.

In 1606 Caravaggio is known to have painted a *Magdalene in Ecstasy*. Most scholars agree that the original is now lost. The best-known version, in the Musée des Beaux-Arts in Marseilles (4.2), is attributed to one of Caravaggio's copyists, Ludovicus Finson. In this painting, or at least in the best-known copy as we know it today, a visual rhetoric of ecstasy has been created which changes the visual status of the body of the saint. In previous *Magdalenes*, such as the seminal examples by Donatello or Titian,[16] the body was either a document of the saint's self-denial for the sake of asceticism and penitence, or a site of temptation and of the conflict between fleshly and spiritual desire. In the Marseilles *Magdalene*, however, the visual mode has shifted, and the movements, shapes or spasms of the body become exterior codes, or indicators of a profoundly interior experience. The power of this rhetoric is in the multivalence of the body's abandon; it invites readings on many different levels and it produces many different meanings; as a result, it both fascinates and disturbs viewers. The play of intense emotions written on the surface of the Magdalene's body, like the surface of a mirror, is activated and attributed meaning when it becomes subject to the gaze.

The origins of Mary Magdalene's ecstasy are left open to interpretation in Caravaggio's vision of the scene (4.2). In the painting, the absence of visual attributes to justify her experience makes this one of the most ascetic images of ecstasy of the seventeenth century, and one where the viewer is obliged to realize the intensity of the experience from the movement of her body alone. The blackness around her encloses her in privacy, and the striking realism, in particular of her eyelids and slightly visible teeth, breaks the conventions of the ideal—we could call these elements 'Caravaggesque'. There is a strong sense of intrusion, heightened by the shadows of the chiaroscuro from which the saint's skin emerges almost shockingly pale, but also by the sense that, through her half-open eyes, the saint may or may not be aware of the viewer's presence. We recall Aldous Huxley's response to Bernini's sculpture *Beata Ludovica Albertoni* (1671–4, San Francesco a Ripa, Rome): 'the spectator feels a shock of embarrassment ... one has the impression of having opened a bedroom door at the most inopportune of moments.'[17] In the paradoxical visual experience the image produces, carnal yet spiritual, intimate yet distanced, performed yet bodily, it disrupts the subject-object operation of the gaze—it must be re-framed in order to encompass these effects.

Savoldo's *Magdalene* (4.1) was described as the ultimate in artistic ar-
tifice; seen in these terms it would seem to have very little in common
with the tactile bodiliness of the lost Caravaggio painting. I propose,
however, that the term 'Caravaggesque', often understood in a general
sense to refer to the specific form of chiaroscuro and realism for which
Caravaggio is particularly known, could be expanded to encompass a
specific quality within visuality which is encapsulated both by the paint-
ing of the artist 'Caravaggio' and by the figurative phenomenon of
Mary Magdalene. I use the expression here, beyond ideas of the specific
artist and his oeuvre, in terms of a specific rhetoric of paradoxical bod-
ily 'real' performance, a quality of fictive bodily 'truth', found in rep-
resentations of the ecstatic saints, which involves a body suspended
between opposing states such as life and death, or pleasure and pain.

A viewer confronted with these two contrasting *Magdalenes*, in differ-
ent ways paradoxically situated at the cusp of a Baroque visuality, en-
counters a complicated mirroring network. A commentary referring to
Bernini's *Ecstasy of St. Teresa* (c.1645–52, Santa Maria della Vittoria,
Rome), completely out of the context of traditional academic re-
sponses, may here provide a portrayal of the functioning of visual
memory; it inadvertently broaches a complex system of mirror, empa-
thy and role model responses to the figure of the ecstatic saint, which
I have brought to the foreground. Andrew Greeley, an American priest
and sociologist who among other causes champions erotic (rather than
pornographic) art as the route to a healthy intra-marital erotic life, offers
the following fantasy scenario in a modest sexual advice article for his
parishioners:

> Thus a woman who views Bernini's St. Teresa and understands
> what the artist is doing will surely recall her own orgasmic experi-
> ences and note with interest what the metaphor implies. Moreover
> she may find herself in the beginnings of sexual arousal and yearn
> for another orgasmic experience. Whether her husband will be
> sensitive enough to the artist's designs to recognize the similarity
> between the Saint's expression and his memory of his wife's ex-
> pression may be less certain, because men are less perceptive in
> these matters than women. If he does, it is possible that he too will
> feel the beginnings of sexual arousal.[18]

The *mise en scène* inspired by the *Teresa* and fantasized by Greeley pro-
duces a rather patronizing idea of sexual arousal couched in clichéd
terms; however, the mechanisms of viewing imagined in the extract
provide an interesting counterpoint to academic responses to the sculp-
ture, for the most part locked in unproductive debate about the sexual
suggestiveness of the pose. Greeley not only explicitly imagines the

ambiguous sculpture arousing its viewers, but the way in which this arousal is operated is seen as being specifically through recognition. The wife in the scenario is assumed visually to recognize an image which she could not possibly have actually seen—that of her own pleasure.

This *mise en scène* of gaze and desire could be seen to establish the '"masculinisation" of the spectator position' when the woman observes her own pleasure from the viewpoint of a lover.[19] For Laura Mulvey in her essay 'Afterthoughts on Visual Pleasure and Narrative Cinema', Freud's portrayal of women's oscillating identity between active and passive, and the conventions of masculinity and femininity, influence the modes of identification operating in a woman's gaze upon a female protagonist—ultimately that 'the female spectator's fantasy of masculinisation [is] at cross-purposes with itself, restless in its transvestite clothes.'[20] I feel however that Greeley's fantasy scenario leaves the female spectator's means of recognition more tantalizingly complex. Beyond Mulvey's conclusion of a troubled and oscillating identity to account for the logic of identification operating here, I look to Kaja Silverman who brings the metaphor of the mirror into play. Drawing on Lacan's theory of the mirror stage, Silverman emphasizes that the ego itself is a representation of a representation.[21] Identity itself, in this view, being constructed as both other and same, the mirror can work as a metaphor for the construction of a self-image which is both visual and knowingly fictive. In this way, an 'exteriorizing' identification (the 'recognition' of the fantasized self in the *Teresa*, for instance), is accessible to a female viewer because of the monolithic nature of the masculine ego, according to the Freudian model: she has greater freedom of identification than her male counterpart,[22] and can suspend her identification on the brink between the passivity of the love object and the active nature of the gaze's subject.

Greeley reads the *Teresa* as a paradigm of the visual codification of women's pleasure, and assumes that women's visualization of their own sexual behaviour itself will inevitably conform to the trope. At the same time, while attributing to Bernini the 'design' to represent female pleasure ('what the artist is doing'), Greeley perceives that the husband will simply not make the connection. The implication of Greeley's scenario is that, for the formation of the visual discourse of pleasure, the fantasy identification performed in the 'mirror' by the female viewer is paradoxically stronger than the man's real visual experience. A gaze upon the body of the ecstatic saint does not function as a gaze into a mirror at one's own body in pleasure, but participates in the construction of a complex play of identification: an inner gaze at an interior experience, which cannot have been experienced visually except by a fictive, fantasized gaze from outside the self.

The seventeenth-century Caravaggio *Magdalene* (4.2), like Bernini's *Teresa*, also transgressed contemporary limits of reflection and empathy. It appears to have been seen as threatening even at the time of its creation because of its potential for excessive empathetic fantasy. Here, it is to the asceticism of the image that the blame is attributed. Jean Habert summarizes the controversy surrounding the painting:

> This revolutionary creation caused a considerable stir—it was the most copied of all Caravaggio's paintings, in particular amongst the Northern artists working in Italy, less inhibited than their counterparts. Among them, the Flemish painter Louis Finson (Bruges before 1580 – Amsterdam 1617) saw himself as the primary copyist of the painting. However, the painting did not in fact enjoy any real posterity: copies and subsequent adaptations no longer dared to portray the saint alone and without attributes. Instead they conformed to the 1582 recommendations of the Bishop of Bologna, the cardinal Gabriele Paleotti (1522–1597), principal advocate of the Counter-Reformation as far as iconography was concerned. He endorsed the representation of saints in ecstasy … with their attributes and lifted up by angels, in order to clearly indicate the nature of their mystical experience as being inaccessible to ordinary mortals.[23]

Indeed, the ecstasy of the Magdalene as envisioned by Caravaggio and as interpreted by his copyist Finson was so intimate and bodily—so 'Caravaggesque', as it were—as to be seen as being threatening to the Catholic church in the context of sixteenth-century religious politics. According to Bishop Paleotti, therefore, it was the threat of excessive empathy which frightened artists away from making straightforward copies of the painting and which led to the 'supernaturalization' of ecstasy. It was vital that religious experiences should be seen as being unequivocally divinely inspired—in a very Baroque spirit, however, many paintings managed to achieve the representation of an experience both bodily and divine. For instance, Giovanni Lanfranco painted a *Magdalene in Ecstasy* (1606, Galleria Nazionale di Capodimonte, Naples) where the saint is being physically carried up to heaven by angels for her daily spiritual sustenance while a penitent in the desert, just as the *Golden Legend* relates:

> our Redeemer did show it openly, that he had ordained for her refection celestial, and no bodily meats. And every day at every hour canonical she was lifted up in the air of angels, and heard the glorious song of the heavenly companies with her bodily ears. Of which she was fed and filled with right sweet meats, and then was

brought again by the angels unto her proper place, in such wise as she had no need of corporal nourishing.[24]

Interestingly, even this text, upon which many images like Lanfranco's were based, is itself ambiguous about the Magdalene's physical status— although she is to have 'no bodily meats' she hears the angels' song 'with her bodily ears'—hence perhaps the temptation in the Baroque to emphasize the physical, bodily nature of the Magdalene's ecstasy despite its apparent divine origin and purely 'ec-static' conditions.[25]

The threat posed by the *Magdalene* is that of excessive empathy with an emphatically corporeal body, experiencing an ecstasy which is ambiguous in its physical and spiritual pleasure or pain, of mysterious and ineffable origin and which may be too 'real' to be safely viewed. An autonomous pleasure, activated visually, inevitably introduces questions of the concept of the mirror. The sight of an ecstatic body, suspended both present and absent, both physical and spiritual, sets in motion a fantasized interplay of the gaze, where the viewer's own body is itself the product of the gaze network. An infinity of mirrors, where the body is simultaneously both subject and object of the gaze; gazing at another body, it constructs itself as *seen*. In this way, the body's status as a subjective *site* of the gaze is paradoxically enabled by the body's fictive identification as an *object* of a fantasized gaze.

In the lore surrounding the Magdalene, on the moment of her conversion and penitence she rejected worldly goods. Caravaggio took up this theme in his *Conversion of the Magdalene* in Detroit (4.3), where the saint touches, but does not look into, a dark convex mirror while listening to the theological persuasion of her companion Martha.[26] Mieke Bal puts this image in counterpoint with a slightly earlier *Magdalene* by Caravaggio (c.1594–7), in the Galleria Doria Pamphilj in Rome, in a chapter on the myth of Narcissus in *Quoting Caravaggio*. In the Rome *Magdalene*, the saint has abandoned worldly goods (she has let gold and pearl jewellery fall to the ground beside her) and sits, her arms in her lap forming a frame continued by her auburn hair and drooping head in melancholy. For Bal, this frame forms a metaphorical mirror where this Magdalene, having rejected the actual mirror, turns her melancholy in towards herself. Unlike Caravaggio's *Narcissus* (c.1600, Galleria Barberini, Rome), whose ego becomes fragmented in his hopeless pursuit of his own image,[27] this *Magdalene* 'is able to sustain the wholeness that the primary narcissism of the mirror experience extends to the subject …'[28]

Bal explains, citing Kaja Silverman's *The Threshold of the Visible World*, that when the Magdalene becomes the mirror, she does not enter the long-established binary of lack versus plenitude into which women are

4.3 Michelangelo da Caravaggio, *The Conversion of the Magdalene*, c.1597–8,
 oil on canvas, 99.7 × 134.6 cm, The Detroit Institute of Arts, Detroit.

traditionally coerced to fit: 'lack, so that the male subject's phallic attrib-
utes can be oppositionally articulated; plenitude, so that she can become
adequate to his desire.'[29] Bal writes, 'This sadistic, because impossible,
model is culturally embodied on the one hand by Venus, and on the
other by the Virgin-Mother.'[30]

Bal continues, however, that 'the price to pay for wholeness is the ab-
sence of consciousness …'[31] While the Rome *Magdalene* remains 'a fig-
ure of transgression and conversion', she nevertheless remains
unconscious, 'she does not "know herself"'.[32] In remaining passive,
'[the *Magdalene*] represents the passive receptivity of the mirror as a
gender-specific projection screen for the production of an illusory, ex-
terior wholeness.'[33]

This is reminiscent of Mary Pardo's characterization of Savoldo's
Magdalene (4.1) as an empty device: 'it does not pretend to "contain"
truth, only to reflect it; its ostensible content is wholly exterior to it.'[34]
While I follow Bal's analysis that the *Magdalene's* bodily wholeness is fic-
tive in the sense that she is no longer slave to the 'lack versus plenitude'
model of femininity, I feel that it is reductive to state that Caravaggio's
Rome *Magdalene* remains trapped within the unstable equilibrium which
her passivity provides in the face of her rejection of the mirror, or that

she can only be a mirror within herself at the price of 'knowing her-self'. This conclusion reminded me of Lacan's famous comment on Bernini's *Teresa*:

> you only have to go and look at Bernini's statue in Rome to under-stand immediately that she's coming [*qu'elle jouit*], there is no doubt about it. And what is her *jouissance*, her *coming* from? It is clear that the essential testimony of the mystics is that they are experiencing it but know nothing about it.[35]

It is on this question of knowing or not knowing the self, that the whole issue turns: whether the experience of ecstasy, or indeed the bodily experience of touching and recognizing the resurrected Christ, can be an embodied, as well as bodily, experience. I argue that when Caravaggio's *Magdalenes* become mirrors, it is not a passive, unknowing unconsciousness but rather an active one. This moment is captured by the artist's *Conversion of the Magdalene* in Detroit (4.3)—the dark mirror which the Magdalene is rejecting, reflects nothing but a square window —its liquid blackness seeming to absorb all light. The saint's face is misleadingly passive: a poised emptiness suspended between listening to Martha's argument and meditating her own sins, it takes the place of the empty mirror. Her downcast eyes reflect both her sister's intellectual earnestness and the light from the window being shed upon her own dissolute life.

To assume that apparent unconsciousness is passive is to overlook the body of imagery surrounding the figure of Mary Magdalene, and the extraordinary symbolic allusions which enfold her image, in terms of her transgression of body and spirit as the one who touches the risen Christ. It is her action of rejecting the physical mirror, enabling her to transgress all that it represents in terms of Narcissistic worldli-ness, which enables her to internalize and absorb its power to destabi-lize the play of focalizers in visuality.[36] The Caravaggesque Magdalene gains wholeness at the price of the 'real'. Instead the 'real' becomes an '*air de vérité*',[37] and the 'Caravaggesque' becomes a cipher at many levels, signifying a performance of fictive bodiliness in which the Magdalene is complicit.

The unconsciousness of both *Magdalenes* transgresses mere 'sleep'[38] to become, instead, an altered state where the exterior appearance of the body becomes undecidable, controversial, and multivalent, com-bining in one the visual discourses of pain, death, pleasure, sleep, melancholy, ecstasy, precisely because it is no longer attempting to sig-nify a 'real' body, but 'Caravaggesque' suspension of bodily reality. In-stead the exterior unconsciousness is a metaphor for an interior

experience which is too intense to otherwise conceive of visually. This is also what happens when the woman in Andrew Greeley's fantasy looks into the mirror of Bernini's *Teresa* and sees her memory of pleasure, whereas the man may not recognize at all a physical body he has surely seen. Pleasure is written onto the body of the ecstatic saint and also beyond that body in a fictive, symbolic layering.

Savoldo's *Magdalene* (4.1) was painted too early to interact with Caravaggio's *Magdalenes* in the discourse of ecstasy they set up. Nevertheless, the term *Caravaggesque* traverses the before and after of the Caravaggio 'moment' just as the visual discourse of ecstasy, in the Foucauldian sense, is a network of relations and connections.[39] Savoldo certainly combines these *Caravaggesque* elements in his exploration of Magdalene visuality, in the great symbolic depth of the London painting. This *Magdalene* is a mirror—but neither reflecting the viewer nor herself. Instead the viewer is implicated, via the commanding gaze of the saint, in a three-way interaction where the missing third party, the resurrected Christ, is depicted as light—incomprehensible to us, unless it is mirrored, reflected, and translated by the Magdalene.

It is, in fact, back in the dense prose of the Gospel of John that the seeds of the Magdalene's unique role lie. It is in verse 20 that the meeting between the saint and the resurrected Jesus takes place, starting with the Magdalene's failure to recognize him: 'she turned round and saw Jesus standing there, but she did not know it was Jesus.'[40] Jesus himself, this time, then seems to feign ignorance:

Jesus said to her, 'Woman, why are you weeping? For whom are you looking?' Supposing him to be the gardener, she said to him, 'Sir, if you have carried him away, tell me where you have laid him, and I will take him away.'[41]

Their meeting then proceeds by each verbally recognizing the other; 'Jesus said to her, "Mary!" She turned and said to him in Hebrew, "Rabbouni!" (which means Teacher). Jesus said to her, "Do not hold on to me, because I have not yet ascended to the Father."'[42]

This verbal recognition between them, preceded by a visual misrecognition, is then very shortly followed by the scene of the doubting of St Thomas, this time a tactile recognition of a Jesus who is still very bodily in his state between death and life, as Jesus invites the apostle to touch his wounds. Here, however, it is Jesus himself who then denigrates the visual, saying to Thomas, 'Have you believed because you have seen me? Blessed are those who have not seen and yet have come to believe.'[43]

These repeated reflections, recognitions and misrecognitions sur-
rounding the death and resurrection of Jesus as depicted in the Gospel
of John disrupt the whole mechanism of vision. The Magdalene be-
comes a holder of a knowing gaze through becoming the *object* of a
knowing gaze, which is itself enabled by her own recognizing gaze. It
is thanks to the Magdalene's recognition that the message of Jesus's
resurrection is passed on to the other disciples; in the Gnostic gospels
the Magdalene says to the disciples, 'What is hidden from you, I will
proclaim to you.'[44]

The paradoxical simultaneity of gazes in the Garden of Gethsemane
encapsulates the meaning of the Magdalene. Rather than being an
empty screen, guilelessly failing to know Jesus, the *Caravaggesque* Mag-
dalene of Savoldo's painting is an embodied site of knowledge who,
while turning *about to* meet Jesus's gaze, on the brink of seeing him,
meets the viewer's gaze and *already knows*; and 'proclaims' her under-
standing to the viewer of Savoldo's painting as that paradoxical, pow-
erful gaze smiles knowingly out of the picture frame. '*Those who have not
seen.*'

The 'Caravaggesque' *Magdalene*, whether the *Magdalene* of Savoldo,
with her reflective cloak, or the dark *Magdalene* in Marseilles in the
throes of ecstasy (4.2), transgresses the conventional opposition of the
knowing artist and submissive subject. Here the subject of the painting
has gained an effect of agency: she is complicit in the fiction of her
own painted space and her paradoxical bodily existence. The position
she assumes in the mythology of Jesus's resurrection, while her own
body in ecstasy interrogates the nature of embodied experience, is the
nucleus of knowledge at the crux of a gaze network—an embodied
knowledge which, through the trope of the mirror, conveys through re-
flection the indescribable experience of the transgression of body and
spirit.

In the last paragraph of Lewis Carroll's *Through the Looking Glass*,
Alice wonders who it was who dreamed her adventures: herself or the
Red King, since 'He was part of my dream, of course—but then I was
part of his dream, too!'[45] Magdalene through the looking glass enables
just such a bodily cross-subjectivity. Thanks to Savoldo and the *Car-
avaggesque*, she, like Alice, can step between the two worlds: 'And cer-
tainly the glass WAS beginning to melt away, just like a bright silvery
mist.'[46]

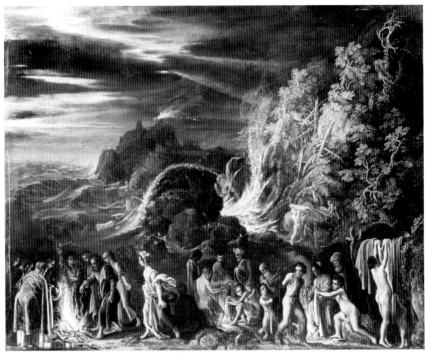

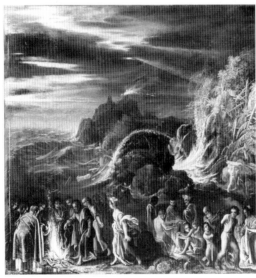

5.1 Adam Elsheimer, *St Paul on Malta*, c.1600, oil on copper, 17.3 × 21.5 cm, NG 3535, National Gallery, London.

5.2 Adam Elsheimer, *The Baptism of Christ*, c.1599, oil on copper, 28.1 × 21 cm, NG 3904, National Gallery, London.

TRAUMA

A concept 'travelling light' to a case-study of
Early Modern painting
Itay Sapir

Disciplines in the humanities often raise questions that cannot be answered within their own confines. Art history is particularly in need of external help when pictorial developments seem not to adhere to previous aesthetic norms or assumptions. The paintings of Adam Elsheimer (1578–1610), for example, break with basic art theory precepts of the Renaissance, although they do it in such a subtle way that their revolutionary stance has rarely been taken seriously.

German-born Elsheimer (Frankfurt, 1578) went to Venice at the end of the sixteenth century, and then spent the first decade of the seventeenth century in Rome, where he died in 1610. His paintings present the viewer with some peculiarities, not least their small dimensions, and a high frequency of nocturnal scenes may be Elsheimer's principal claim to fame. Of the two paintings I want to discuss here, both from the National Gallery in London, the first, *Saint Paul on Malta* (5.1), is no exception to these generalizations. As a nocturnal scene it is surprising because, as we will see, this is potentially in conflict with the narrative on which it is based. Its narrative mode is also quite exceptional, as the human figures are relegated to a tiny portion of the surface, the rest being the depiction of a chaotic, violent landscape. The second painting, *The Baptism of Christ* (5.2), is even more intriguing, mainly because of the obscure silhouette of a man in the closest foreground, blocking our view. Both paintings seem quite resistant to traditional art-historical explanations and, not surprisingly, both anomalies have hardly been discussed by art historians in their accounts of these works.[1]

When the conceptual apparatus of a discipline seems to fail in giving a plausible answer to a pressing question, importing concepts from

other fields may help. This is where the idea of 'travelling concepts' comes into play. This travel, however, is more often than not a risky business: when concepts are travelling, just like human beings, they have to respect several restrictions. Very long distances, without break, are not advisable as they may cause tiredness, dizziness and a painful adaptation process; it may be prudent to think of 'vaccinations' to prepare for radical changes of environmental conditions, in order to avoid dangerous (i.e. irrelevant) contaminations, as opposed to fertile interactions; and some concepts may be too shy and dependent to leave their homeland at all. One problem that cannot be overlooked is that of the baggage a concept may carry on its trip; for the concept that will be invited here to help 'solve' the Elsheimer mystery, the risk of overweight is always imminent.

The travels of trauma

Trauma, while being a very directly felt, emotionally charged experience, is nonetheless certainly a concept; it can even be considered a theoretical construct.[2] Most people would link it to the realm of psychology, but in fact its first apparitions were in the context of ancient Greek medicine, where it meant a piercing wound. From the medical sciences it travelled first to psychology and its different branches: psychoanalysis, psychiatry and, later, neurobiology. Cathy Caruth defines the concept of post-traumatic stress disorder (PTSD) used in these disciplines as 'an overwhelming experience of sudden or catastrophic events in which the response to the event occurs in the often uncontrolled, repetitive appearance of hallucinations and other intrusive phenomena.'[3]

Psychological concepts are rarely too shy to travel, as they relate to humans in a generalizing way, and thus can be (and are) easily applied to any field that involves the emotions, thoughts and behaviour of human beings. Thus, towards the end of the last century the concept of trauma travelled again, this time to several disciplines of the humanities, in particular literary studies and history. This often happened in cases where these fields of study started using psychoanalytic frameworks.[4] A sub-discipline of sorts called 'Trauma Studies' is even sometimes mentioned as grouping the different writings concerning trauma and PTSD: Dominick LaCapra, for one, dedicates a chapter in his book *History in Transit* to an assessment of 'Trauma Studies: Its Critics and Vicissitudes'. The interest in trauma shown by disciplines in the humanities whose main objects are representations and cultural artefacts has to do with trauma's epistemological elements; indeed, Caruth is particularly interested in 'what, in trauma, resists simple comprehension', in history that is not straightforwardly referential, and in the subtle interactions of knowing, seeing and telling.[5] While LaCapra repeatedly

warns us against fetishizing such incomprehensibility, he, too, considers the questions of processing knowledge, of experience and affect versus cognition and of representation as central to any analysis of trauma in culture.[6] As we will see below, such characteristics of trauma are particularly apt to illuminate the epistemological anomalies presented in the case of Elsheimer's paintings.

Trauma's conceptual usefulness for history and for historical disciplines in general seems doubly obvious, because history tells—represents—stories of real human beings. If trauma is useful as a psychological concept, i.e. to analyse the behaviour and the motives of, say, a patient who is sitting in front of us, why not use it to analyse people whose stories we read in documents or hear in interviews? It is, however, undeniable that in reality most cases of trauma discussed in historical analysis—that is, most of the historical themes in the discussion of which the construct of trauma is applied—are from the relatively recent past, usually from the twentieth century. In particular, studies of the Holocaust and other cases of genocide, as well as of apartheid and the aftermath of slavery, seem regularly to necessitate the use of ideas about trauma borrowed from psychology and psychoanalysis. The study of these relatively recent events has thus come to revolve, in some academic circles, around the notions of testimony and witnessing. In the case of less-recent history, however, the tendency in psychoanalysis to describe psychic structures that are supposedly prevalent in human beings as such, even if their actualizations differ according to culture and circumstances, becomes harder to substantiate when direct knowledge of trauma's subjects is lacking. The more we go back in time, the more this lack faces us, for it is not only the subjects suffering from trauma that we cannot know; their psychological environment is also less tangible. Empathy, the expected reaction to both trauma and the reading of history, becomes more difficult to achieve, and, when it does appear to exist, it may be no more than a fictional projection.

Trauma can usefully travel from psychology to history, then, but perhaps this is possible only if the time travel from the synchronic and sometimes presentist former discipline to the diachronic discourse *par excellence*, history, is kept within reasonable limits, roughly the span of a human life. In other cases, the difficulties seem insurmountable. What, then, can be the utility of the notion of trauma for historians of a more distant past? A further difficulty is that in the case of *artworks* from a distant period, this temporal problem is compounded by the question of reality and representation. Far from being a simple matter of translation, the passage from the psychological notion to its cultural appearances is a minefield, even in discussing the contemporary world. For

example, a common praxis whose coherence is doubtful is the analysis of fictional—or, more precisely, represented—human figures, using the same psychological terms that would be used to talk about trauma suffered by a real person. In this case, not only is the analogy problematic, it is also misleading regarding the purpose of the analysis. When a therapist analyses a patient, it is in order to help him or her, and ideally to cure them.[7] Cultural analysis, which obviously has different targets, and a wider selection of potential objects, cannot use the same methods.[8]

The implementation of such an analysis in the visual arts is fortunately so obviously far-fetched that it is rarely undertaken. Although art historians like sometimes to talk about the psychological penetration and pertinence of the depiction and of the artist, they usually stop at that, either because a painted or sculpted figure supplies too little information that can be psychologically or 'psychologistically' exploited, or because the incongruity of such an interpretation would be too evident even to the most naïve historian of visual images. For painting, then, psychological concepts are of little use, and trauma in particular does not seem to go a long way as an interpretative tool. Even if it could be used to analyse human figures, this would be likely to obscure the more interesting questions about representation itself, rather than the object represented.

The combination of a resistant object and a distant historical period seems, then, to promise little for the use of trauma in the analysis of Renaissance and Baroque painting, as, in our case, the work of Elsheimer. If trauma is to pack and carry the whole semantic and contextual charge that accompanies it at home (in psychology, that is, where it was most widely used during the last century), this conceptual journey seems impossible to handle and unworthy of the effort. Other, more subtle ways of talking about trauma or parallel notions in cultural analysis, however, hint at the importance that such a concept (and thus its mobility) can have nonetheless. In fact, trauma can be relevant to any work of art from any period, on the condition that it is understood independently of individual psychological considerations. It should 'travel light'. A possible objection to this would be that, deprived of its usual attributes, we are not talking about trauma any more. I am willing to accept this, because what interests me as a cultural analyst is less the source of trauma than its consequences, or what I would call *trauma-like representational elements*. These may or may not be the result of an actual, historical trauma. They are, in any case, representational phenomena whose coincidence resembles post-traumatic reactions. What we can obtain from this is, in the words of Mieke Bal, 'a cultural analysis that attends to the unsaid, the detail, the incongruity in the text'.[9]

Having said that, I also wish to propose an interpretative theory that, in parallel to the analysis of particularities of representation, would also attend to the historical environment . This theory, however, is more modest, both because its claim to causality is a weak rather than absolute one, and because, as opposed to what is usually suggested in analyses of post-traumatic representation, this link does not relate source and consequence from two different spheres. Most cases of trauma share two important characteristics: trauma is perceived as a reaction to violence, be it physical or psychological; and it is, in itself, an epistemological phenomenon: the most evident element of a post-traumatic situation is the inability to tell the tale, or to tell what would be considered by an outsider as a 'coherent' tale—the knowledge of the past, in the most literal sense of 'knowledge,' is undermined. The post-traumatic representational regime that I would like to examine, or should I say the apparent or even pseudo-post-traumatic representational regime, does not stem from any evident explosion of violence, but from a crisis that is, in itself, of an epistemic nature. An epistemic crisis leads, then, to an epistemic representational reaction—certainly a plausible process; to add another component, one can talk of an aesthetic crisis which is one of the manifestations of a cultural fracture, whose other major component is epistemic disorientation.

Epistemic crisis, representational disorder

Discussing the pictorial work of Adam Elsheimer brings us to an examination of his historical environment in the years around 1600. It is precisely in this period that, according to numerous historians and philosophers, a significant epistemic watershed can be situated. Some seminal works construct our discourse about that period and 'its' crisis: Michel Foucault's *The Order of Things*, Gilles Deleuze's *The Fold*, Walter Benjamin's *The Origin of German Tragic Drama*, Hans Blumenberg's *The Legitimacy of the Modern Age*, more historical works, such as William Bouwsma's *The Waning of the Renaissance*, as well as the actual 'source texts' of Giordano Bruno, Montaigne and Galileo Galilei, to name but a few.[10] Borrowing a term used by Elaine Scarry in an entirely different context, we can call such a crisis the 'derealization of a culture'; the question is how, in the substance of painting (rather than, as Scarry would have it, in war), can such a crisis be 'substantiated'?[11]

How, then, could this crisis, entailing a change of epistemic paradigm, bring about at the same time a new regime of discourse, and a new pictorial regime? The first possible answer is quite simple, though it risks being perceived as reductive. Art can be considered as, above all, a system of information;[12] as such, an epistemic crisis, involving the production and circulation of information, will necessarily manifest it-

self in a disturbed distribution of information in art itself. Indeed, we
will see how the principal development in early Baroque art can be
thought of as the substitution of opaqueness for transparency and clar-
ity as a praised value and a desirable quality. Memory, of course, is no
stranger to these affirmations, as it is also a matter of information-pro-
cessing, and moreover, the 'building block' of trauma (and, paradoxi-
cally, what it seems to lack more than anything else). The treatment of
memory, as is shown by Frances Yates among others, did become more
complex and more opaque around that turn of the seventeenth cen-
tury.[13] The all-important mnemonic aspect of early modern art could
not be indifferent to that. As trauma can be understood as precisely
the state in which the circulation of information—internal to the sub-
ject, in his or her memory, and from the subject outwards—does not
function regularly any more, there is an undeniable similarity between
post-traumatic symptoms and the artistic symptoms of an epistemic
crisis.

It is not by chance that I use the term 'symptom' here. This concept
(an experienced traveller in its own right) is the fulcrum of a theory of
art that may give us hints for a second answer to our question about the
possible link between epistemic crisis and an artistic reaction to it. Such
a reaction can be understood, in a conceptual metaphor, as post-trau-
matic. This answer may be considered more comprehensive as it does
not reduce art to the function of transmitting information, or indeed,
as the case may be, to the function of holding it back. The theory I am
thinking of is elaborated by Georges Didi-Huberman in his book *De-
vant l'image*.[14]

In this book, Didi-Huberman discusses the discipline of art history,
its tacit assumptions, its limitations, its saviours. The appendix to the
book, *Question de détail, question de pan*, examines the status of the detail
in the epistemology of this field. The relevant point for our discussion
is the distinction made there between, on one hand, the detail—strictly
speaking, the discrete part of the whole whose examination is supposed
to participate in the complete account of the knowledge about a paint-
ing—and, on the other hand, what the author calls in French *pan*, which
can be translated into English as 'patch' or 'blot'.[15] For Didi-Huberman,
the *pan* is a mysterious fragment which is the irruption of the materiality
of painting, an accident in the painting which shows nothing more than
the progress of figuration itself. The example he gives is Vermeer's
Lacemaker (Paris, Musée du Louvre) where the crystal-clear thread held
in the girl's hands is contrasted with the chaotic bundle of this same
thread lying on the table. The *pan* may be termed a *symptom*, because it
is the expression of the loss of representational value, like, say, the ges-

tures of a hysteric described by Freud.[16] Just like those gestures, it is actually the figuration of something significant, normally dissimulated. 'Symptom is a critical event, a singularity, an intrusion,' says Didi-Huberman, 'but it is at the same time the implementation of a significant structure, a system whose emergence the event has to trigger, but partially, contradictorily, in a way that its meaning is shown only as an enigma or a clue, not as a stable wholeness of significance.'[17]

The way Didi-Huberman uses the term *symptom* (and, more rarely, the word *trauma* itself) is ambiguous, in that it admits its psychological genealogy and rejects it at the same time. As he stresses, this has nothing to do with the artist's biography, but it is, nevertheless, a figuration that imitates, or at least simulates, a psychological effect. Using our 'tourist' vocabulary, we can say that in this case the concept's luggage was left at home, but at least some souvenirs were put in a compact suitcase for moments of *Heimweh* and feelings of foreignness. This is perhaps how trauma should travel to the realms of art theory, with its psychological profundity always taken into account, while nonetheless preventing the latter from pervading the whole analysis. It remains somewhere between a neutral model and a causal origin, oscillating between both extremes without giving up its independence to either.

Before returning to my test case, let me mention a recent study in which the question of the detail and its contribution to the significance of the whole is linked precisely to a post-traumatic or a pseudo-post-traumatic representational regime. Frank Tomasulo's article about the case of Rodney King and its filmed piece of evidence does not discuss the concept of detail in the ordinary, art-historical sense, but analyses a parallel phenomenon: slow-motion, the temporal sibling in film of the spatial pictorial detail (or, rather, *pan*).[18] Tomasulo discusses its ambiguity concerning information and message as a case of an abstract moment whose relation to the whole, to the *fabula*, is just as problematic as that of the detail to its 'source' painting. Its aesthetics uncover something completely different from that which the whole film suggests; emotionally its effect is disputable, but arguably it is symptomatic. The problem of the 'close look' focalizes in both cases the opacity of meaning, often obscured both in unifying, general analyses and in pseudo-scientific, detailed dissections.

Saint Paul on Malta

Going back to painting while going back in time, I will bring these considerations to bear on Elsheimer's *Saint Paul on Malta* (5.1), and use the travelling concept of trauma to interpret those anomalies with which we started our discussion. Although this painting may seem, at first

sight, to be a traditional version of a religious subject, I would like to claim that some elements in it can be shown to be epistemic disorders that, in a trauma-like reaction, manifest a broader cultural crisis.

We briefly mentioned some of the peculiar choices Elsheimer made in this depiction. While this is a nocturnal scene, the biblical story depicted does not take place at night. Indeed, the New Testament tells us explicitly that the fire was lit because of cold, rainy weather,[19] an explanation that would be redundant if the event had taken place at night. Even more strikingly, Elsheimer devoted about three-quarters of the painting's surface to the menacing night sky, to the destruction and chaos caused by nature, and to the infinity of the sea. Only a very small portion of this already small work is populated by numerous human figures belonging to the narrative upon which it is supposed to be based. One can detect in this painting, then, narrative incongruities between the story and its pictorial 'translation'— incongruities which call this translation into question.

Ernst van Alphen demonstrates how an experience becomes traumatic when it is impossible to fit into regular narrative and discursive frameworks.[20] Conversely, then, transgressing those frameworks in going beyond the narrative frame and acting as a painter-narrator whose position of knowledge is undermined is evidence of a basic distortion in the process of transmission of knowledge. As I said before, this distortion can be described both as the cause and as the manifestation of trauma, or of the trauma-like symptoms of representational crisis. However, it can be argued that the contradictions between the biblical story and its depiction are somewhat irrelevant because this story is not Elsheimer's 'trauma', he did not experience it himself, and in any case he shows the same representational incongruities when he treats other subjects. The case goes deeper than that.

If one thing can be considered to be Elsheimer's trauma, it will be, as I hinted, the epistemological disorientation and scepticism of his cultural environment. In painting the transmission of information is crucial. This is arguably what painting does above all, and as I have already claimed, a crisis that raises doubts about the validity of producing and transmitting information cannot remain foreign to the visual arts. Elsheimer's 'strange' elements stem precisely from this background. Most important among them is a basic contradiction, more fundamental than the modification of St Paul's story. It is painting's very essence that Elsheimer questioned, or betrayed. Painting, as it was understood in the humanist circles of the Renaissance, is the art of showing; it should be clear, narrative, and informative: this was explained explicitly by Alberti and implemented, more or less faithfully, by the greatest artists of the fifteenth and sixteenth centuries. Dedicating the best part

of a painting to an impenetrable darkness, without any textual pretext, means subverting painting's very *raison d'être*.

Elsheimer does this quite subtly; the revolution undertaken by Caravaggio will consist in doing the same, but with much more audacity and ostentation. The breakdown of an epistemic system, here the decline of humanistic culture, triggers those disorders in a way very similar to the chain of trauma and post-traumatic reaction that we have seen elsewhere. That both sides of the equation belong to epistemology does not make the concept of trauma redundant, however, for it supplies us with a precious model of interaction between external, historical circumstances and the representational regime that follows or accompanies them. In its homeland, the notion of trauma is used as an explanatory means of conceptualizing the (usually causal) link between symptoms (representational elements) and their historical-personal background. The capabilities that enable trauma to contribute in this way to the understanding of psychic phenomena are not lost when it reaches the foreign country of art history. The concept of trauma can have a similar function after travelling, and the luggage left at home should not be necessary for the handling of the explanatory missions it was first created to deal with. The only condition for this mobility is that the destination discipline is open and willing to employ without discrimination foreign workers, i.e. concepts whose origins lie in other disciplines.

Further examination of *Saint Paul on Malta* (5.1) shows us that its 'post-traumatic' character goes beyond its darkness and the important place given to nature. The character of the depicted landscape itself should also be emphasized: it is no longer the gentle, easy-to-grasp (and to control) nature so typical of Renaissance painting. Instead, Elsheimer creates an unpredictable chaos, in which the different elements cannot be put into categories, even less ordered in a clear hierarchy. More than anything else, what we see are *traces*—objects that were once something useful or alive—and *fragments*, things removed from their original environment. The orderly machine of nature is broken down, either temporally, spatially, or both. Nature itself, the object represented, seems to have become a series of *pans*, as the loss of heuristic value in its elements seems to negate their potential status as *details*. A coherent account of this nature cannot be given—it cannot be memorized other than as a 'trauma'. The human position in this context is doubly disadvantageous: the depicted figures, small and insignificant survivors of a shipwreck, are reduced to counting on a miracle and in any case fail to investigate the unfathomable nature around them; and we, the viewers, have to make a spectacular effort if we want to see something in this small, dark picture, knowing at the same time that these efforts are

doomed. The material optical difficulty that this painting creates is part of its epistemic subversion: it faces us with a wilful opacity, both as part of the phenomenal world and as a representation of it.

Here, I would like to emphasize again a feature common to all this painter's works, but which is often ignored in analyses: their size. Elsheimer's paintings are, in fact, almost miniatures. The question of size in painting, especially in our reproduction-saturated era, is often taken as non-essential to the significance of the work, in spite of its overwhelming importance for the viewer's experience of art. When we discuss knowledge and information in painting, size becomes more than just a 'sensorial' element: it is an epistemological vector of the utmost importance.[21] Claims to realism and mimesis, that is to the transparent transmission of knowledge, are seriously undermined by the smallness of Elsheimer's paintings, even if other elements may seem to show some sort of fidelity to nature. After all, if the proof of the convincing power of art is, as according to Zeuxis's story, that birds and people mistake it for reality, it would be very hard to find even birds that would try to nest among *Saint Paul on Malta's* minuscule trees. The accuracy of information is also, in spite of any miniaturist's claim to the contrary, severely limited by reducing the size of a work; quite simply, one can reproduce more information on a bigger surface. Elsheimer's consistent choice of small-scale formats is, then, central to his posttraumatic regime of representation. This choice may not be unambiguous nor even, for that matter, new and revolutionary, but joined by the other features already mentioned, it should be considered a further expression of an epistemological scepticism—or, to say the least, an epistemological *modesty*.

The Baptism of Christ

The second painting by Elsheimer, *The Baptism of Christ* (5.2), is even more interesting, in that we can see in it the concrete apparition, spatial and visible, of an incongruous, strange *symptom*. Here this is not to be found, or not mainly, in the general regime of representation, but in a detail that is, like Poe's purloined letter, so visible and close to the viewer's space that it can easily be ignored altogether, or considered as background to be passed through on the way to the representation 'itself'.[22] I am talking, of course, about the figure in the foreground, almost in the dark, that occupies about a third of the width of the work and literally blocks our view of the—narratively speaking—more important events taking place behind it. Again, in terms of classical Renaissance representation, what Elsheimer does here is at best counterproductive and strange, at worst scandalous. Instead of showing us the baptism of Christ in its complete narrative context, the painting

puts a marginal figure between us and the painting's official subject, and thus prevents the free flow of the stream of information, at the ostensible centre of Western painting. Worse still, this intermediary figure is covered with thick shadow, and so in itself is barely visible, more a *pan* of colour than anything else; this figure prevents, rather than promotes, visibility.

When such an occlusion is performed by a professional of the visible art *par excellence*, the art that is supposed to show us the visible aspect of the world, this is rather disorienting. The ideal of transparency is lost and replaced by opacity, as if a monochrome stain had covered much of the window that Renaissance painting is sometimes thought to be. This is a manifest disorder in the representational regime of painting, and as such it can be considered a corollary of other epistemic disorders, in a trauma-like chain of reactions. It should be stressed, however, that as opposed to the psychological description of trauma, the direction of causality is here less clear, its very existence more in doubt. In any case, the materiality of painting shows itself in the midst of the representation, whose illusion, as Didi-Huberman tells us, collapses; this collapse is the symptom of an epistemic crisis that questions the assumed transparency of representation itself.

The central part of the painting, where we can see Jesus and St John the Baptist, is also far from conventional or simple. Although it respects, in itself, the humanistic *mode-d'emploi* for the 'right' representation—voluminous bodies, precise chiaroscuro, classical proportions—it is somewhat strangely positioned when observed in the general context of the whole painting. The right-hand side shows a gradation of distances and sizes, but on the left-hand side, just behind the baptism itself, an abyss opens up, with no middle layer of depth at all; all we can see behind it are minuscule figures, totally incommensurable with those of Jesus and the Baptist. It seems as if the foreground figures were somehow painted on the work's surface *through* which the rest of the scene, i.e. the background, is revealed to us.

The direct consequence of this is that, taken out of its context, the baptism ceases to be an event that the spectator can relate to its surrounding space, or *a fortiori* to its narrative framework. In this sense, it is structured in the same way as a central scene bathed all around by opaque darkness; the comforting humanistic world-view in which all the components of the universe correspond and converse, in which a hierarchy of beings is clearly figured by the visible spatial relation between them—this world-view is lost. What we have instead are events and figures free-floating in an undefined space, away from mathematics, independent of the orientation that it provides. Far from being a simple 'error' of painting (Elsheimer was a skilful painter by any standard),

this phenomenon is the symptom of an epistemic subversion, of a lack of confidence in the traditional methods of representation, so self-assured in their capability to 'translate' into the material of painting a universe in which, through references and counter-references, nothing would remain unexplained. In this work of art, just like in post-traumatic situations, the whole notion of 'explanation' seems to be powerless.

* * *

Before the concept of trauma can pack its minimal luggage and head back home, it seems necessary to ask what it has gained from its journey. I have tried to show so far what the analysis of paintings can do with the supposedly distant and irrelevant concept of trauma, but the process should not be unidirectional: travelling concepts are expected in their turn to be enriched by the new encounters. This is surely the case here. The psychological concept of trauma is basically one of *figuration*: what visible (or audible, or sensible) consequences can an event from the past have, after its painful materiality has turned into the abstract matter of memory? Art history asks a similar question: how could abstract ideas, sensations and world-views be turned into visual phenomena, and in what sense do the latter represent or figure the former? Back home, the travelling concept will certainly be able to use the knowledge acquired abroad, for the sake of its original discipline and the widening of its horizons. It will be able to use art-historical tools to analyse the ways in which, in real human beings this time, violence, loss and memory are figured into visual phenomena. It will then be clear that the risky venture of travelling is indeed a worthy enterprise, when the profitable exchange enables both disciplines/countries to open up to previously unheard-of paths of exploration.

6

LIFE-MAPPING
Or, Walter Benjamin and Charlotte Salomon never met
Griselda Pollock

In 1932, on the cusp of a major political cataclysm that had unantici-
pated geographical ramifications, the German-Jewish cultural theorist
and philosopher Walter Benjamin (6.1) wrote in a memoir about his
Berlin childhood: 'I have long, indeed for years, played with the idea of
setting out the sphere of life—bios—graphically on a map.'[1] Benjamin's
image of a cultural bio-geo-graphy is immensely appealing in a culture
so infused with dislocation and memorial nostalgia. Benjamin's pro-
posed life-map, rather than a life-story, supports the creation of social
and historical memory as the register of emplacement, cultural space
and social worlding.[2] *Mapping* subjective histories undoes some of the
problems with bourgeois individualism that makes us, in cultural analy-
sis, mostly so wary of the traditional models of the biographical. I want
to use Benjamin's life-map as a frame for an art-historical but also cul-
tural-historical archive that interweaves the issues of childhood, place
and memory with the very cataclysm in which Benjamin's life was
brought to a premature and tragic end on 26 September 1940. This
was, moreover, in a place, Port Bou in Spain, that could never have
been predicted, or longed for, in all his imaginary life-mappings. Travel
is one thing, escape another. Working with Benjamin's concept that
links space and life-writing, I want to shift the dominant modes of in-
terpretation of the work of the German-Jewish artist Charlotte Sa-
lomon (1917–43, 6.2) that focus on autobiography, visual narrativity
and trauma.[3]
　'Charlotte Salomon' presents us with many methodological problems
as a figure of a series of minority, hyphenated, historically destabilized
subject-positions. In becoming known to cultural history through a sin-

6.1 Giselle Freund, *Walter Benjamin in the Bibliothèque Nationale, Paris,* 1937.

6.2 *Charlotte Salomon Sketching in the Garden of Villa L'Hermitage, Villefranche,* c.1939, photograph, Jewish Historical Museum, Amsterdam. Reproduced courtesy of the Charlotte Salomon Foundation.

gle work of art, that, nonetheless, comprises 784 paintings, several hundred overlaid with transparent sheets on which a supplementary graphic and textual element is added, and a further 570 alternative or rejected works, she defies most available categories for reintroducing her to known art historical or cultural narratives. This work titled *Leben? Oder Theater?* [*Life? Or Theatre?*] is still open, inviting us to offer our varied frames for reading an event that is at once unified and complex, narrative and conceptual, anamnesiac and repressed.

The use of the word *Leben* (which means both 'life' and 'to live') in the title invites us back to Benjamin's space of life-recall and life-writing.[4] It can also project us forward to the sombre reflections of Italian philosopher Giorgio Agamben on the concentration camp as the dystopian modernist laboratory of *Leben*, meaning here 'bare life'. Agamben distinguishes *zoë* in Greek, meaning bare life, from *bios* signifying the good, political or social living of the citizen—defined as a citizen precisely in *his* distance in the *polis,* from bare life as it is managed in the *oikos*, the home, the economy of living.[5] The extreme and cruel laboratory of reducing humans to and even beyond bare life and thus radically assaulting the very conditions of humanity itself was 'the concentrationary universe'.[6] This was a universe whose culmination as an industry of murder

was initiated in 1941–2, the moment of Charlotte Salomon's solitary exile from Berlin in St Jean de Cap Ferrat and of her isolated initiation of her interrogation of *Leben? Oder Theater?*

For us, however, Benjamin's thoughts in 1932 on *bios*—the sphere of human, social, remembered living—and its imaginary mapping are retrospectively inflected by a historical eventuality his thinking could not imagine or foresee, even if his theory of history as catastrophe and ruin might seem prophetic.[7] The industrial annihilation of minority European citizens such as the Jewish, Roma and Sinti peoples, begun in Chelmno on 7 December 1941, when mass killing by gas was first used, and confirmed as a State policy by the meeting on 20 January 1942 that the Wannsee Protocols documents, suspends a time between 1932 and 1942.[8] This between-time, and what unfolded in that decade, demands a specific mode of analysis that can approach its subjective dimension for the modern European Jewish subject whose life it was to redefine so radically.[9]

I thus propose that *Leben? Oder Theater?* by Charlotte Salomon, who was murdered by her own government in Auschwitz on 10 October 1943, can be framed by attentiveness to that moment. Furthermore, I suggest that these 1325 paintings with their texts and musical cues might be read as a Benjaminian life-map. This is, however, with the following proviso. While being constructed as a anamnesiac life-map, the living it mapped was under suspension and, if not yet fully determined, imminent erasure. Therefore, its artistic re-invention was, at the same time, as Ernst van Alphen has argued, a mode of subjective resistance to the increasing derailment of the conditions of Jewish living and dying by the unfolding events that constitute the moment between 1933 and 1941, the final date marking the moment *when* the work was begun and *where* it finished by asking its question: to live? Or to theatre?[10] Confronting the deadliness of the times, the artist created a text through which to install a subject who wrenched from that moment her Jewish, feminine right to choose life or death. This, therefore, involved Charlotte Salomon in a complementary project: death mapping, or *allothanatography*, the writing of the *deaths* of *others*. What makes this a mapping is that Salomon's work visually restaged the places of these deaths.

Walter Benjamin's Life-mapping

Walter Benjamin continues the paragraph from which I have quoted the opening sentence:

First I envisaged an ordinary map, but now I would incline to a general staff's map of a city centre, if such a thing existed. Doubt-

less it does not, because of ignorance of the theatre of future wars. I have evolved a system of signs, and on the grey background of such maps they would make a colourful show if I clearly marked in the houses of my friends and girl friends, the assembly halls of various collectives, from the 'debating chambers' of the Youth Movement to the gathering places of Communist youth, the hotel and brothel rooms that I knew for one night, the decisive benches in the Tiergarten, the ways to different schools and the graves that I saw filled, the sites of prestigious cafés whose long-forgotten names daily crossed our lips, the tennis courts where empty apartment houses stand today, and the halls emblazoned with gold and stucco that the terrors of dancing classes made almost the equal of gymnasiums. And even without this map, I still have the encouragement provided by an illustrious precursor, the Frenchman Léon Daudet, exemplary at least in the title to his work, which exactly encompasses the best that I might achieve here: *Paris vécu*. 'Lived Berlin' does not sound so good but is as real.[11]

For Walter Benjamin, Berlin, the city of his childhood, was the remembered site of his adult becoming. His fantasy is, therefore, a map of memory, conjured up, at a distance of both time and space through word-images, as a chronotope. His retravelled remembered urban spaces offer not merely the subjective perspective of 'the man on the street', the Baudelairean *flâneur* losing himself and his identity in the borrowed home of the crowd that would become such a feature of his research into the capitalist culture of nineteenth-century Paris.[12] Instead they resonate psychologically with the selective and psychically invested locations for a plethora of formative experiences which knit together to form the subject present to itself only through this tissue of remembered becomings, encounters, love affairs and, for Benjamin too, deaths.

On one hand, for Benjamin the city is an exciting relay of spaces where experience takes place. On the other hand, the spatially cued events come equally to inhabit the subject by providing the spatial coordinates by which its formation can be recalled, linked, and assembled into the subject-sustaining structure: memory. Thus we have both the representation of an urban space as lived in or moved through and the use of recollected space-pictures as a metaphor for the interior cartography of subjectivity. This double spatiality finds its correspondences in the tripartite spatiality I have proposed for the analysis of painting as visual representation: the spaces that are represented, the space of representation, and the space from which representation was produced and that inscribes one possibility of its space of reading.[13]

I want to extend Benjamin's image of the chronotopic map as the *mise en scène* of subjectivity's psycho-historical becoming and retrospective re-invention for a feminist chronotope: *Jewish Space/Women's Time*. This formulation reworks my proposition about the gendered spaces of modernity linking it to Julia Kristeva's analysis of time and sexual difference which opposed the linear, historical time of the nation to the longer durations and cyclical temporalities of reproduction, the former being gendered masculine/political and the latter feminine/sexual.[14] The history of modernity witnessed the clash and tension of the two. My intervention seeks to ground both through a moment of historical intensification of ethnic difference by a genocidal racialization that had specific gender dimensions during the 1930s and 1940s. Conjoined *Jewish Space/Women's Time* provides an extended theoretical frame for reading some of Charlotte Salomon's work, already thoughtfully analysed by its first interpreters as a form of diary or autobiography.[15] I want to extend and test this out by stressing not only the work's specific modes of visuality but particularly its disjunctive narrativity, and by focusing on a spatialization that renders the work what I have called a 'theatre of memory'.[16] I derive this concept from another passage by Walter Benjamin in *A Berlin Chronicle*: 'Language shows clearly that memory is not an instrument for exploring the past but its theatre.'[17] Benjamin makes a further distinction between reminiscence and autobiography that relates to the engagement with space that is such a distinctive feature of both Benjamin's conceit of the life-map and Charlotte Salomon's massive artistic project. Benjamin writes:

> Reminiscences, even extensive ones, do not always amount to an autobiography. And these quite certainly do not, even for the Berlin years that I am exclusively concerned with here. For autobiography has to do with time, with sequence and what makes up the continuous flow of life. Here I am talking of a space, of moments and discontinuities. For even if months and years appear here, it is in *the form they have at the moment of recollection.* This strange form—it may be called fleeting or eternal—is in neither case the stuff that life is made of.[18]

Leben? Oder Theater? was formed by selecting, sometime in 1942, 784 paintings (this includes ten painted pages and three preliminaries) out of the total of 1325 made in under a year in 1941 and then left for at least a year before being reviewed, selected or defaced.[19] The paintings in the first sections of the final assembly are complemented by transparent overlays which provide, in pencil or coloured block print, narrative, dialogue and directions for the melodies to which its

accompanying texts might be sung. I believe that the texts are to be sung in a kind of Brechtian rescripting of a range of classical and popular tunes, so that the whole could be treated as the story-boarded script for a tricoloured modernist operetta. Works in the main section and epilogue have words painted on the paper as part of the integrated composition of image and text. We no longer know what the artist's final selections and numbered order were in 1942, when the work was given to a Dr Moridis in Nice for safe keeping. The curators at the Jewish Historical Museum in Amsterdam have made a rigorous attempt to recreate the sequence (Salomon herself created two numbering systems) after the boxed work was disassembled and the work was exhibited as discrete images. The almost accidental existence in present-day art history and cultural analysis of a work by a murdered woman without professional standing in art history's record thus creates a singular challenge for the analysis of the work.

Confronting the text

Starting with a title page, the work has four preliminary pages that appear, from internal evidence, to have been written in retrospect almost a year after the paintings themselves were completed. There are also two text pages that invite us to imagine the creation of the following work: *A person is sitting beside the sea … painting and humming tunes.* These text pages use the masculine pronoun, following the gender in German of the term for human creature, *Der Mensch.* This text is signed *Der Verfasser*—'The Author'—also in the masculine form, and usually used of an engineer or constructor rather than for a poetic author—*Dichter.* The signed page is dated August 1941(1940 is visible beneath a correction)–42 'or between heaven and earth beyond our era in the year I of the new salvation'. [20] This grandiose tone confuses, and contends with the conflicting moods proposed by the two preceding preliminary pages, raising questions of the cues we are being given as addressees.

A page with a tricoloured stripe of red, yellow and blue down its left border bears the hand-painted words *Leben? Oder Theater? Ein Singespiel* [*Life? Or Theater? an operetta*] (6.3a). Above the title is a heart that looks like a strawberry and at the centre of the incorrectly spelt term *ein singespiel*—meaning musical play or operetta—is a blue and gold circle around the entwined letters CS forming the authorial monogram.[21] The monogrammed CS are the initials by which Charlotte Salomon signified her artistic identity, in distinction from the character Charlotte Kann in the work, and from a self thus marked apart from both artist and character.[22] Initials also avoid possible dangers associated with a Jewish surname. Some hesitation over the spelling of the word *Theater* is indexed by an errant bar on the first vertical of the 'H', suggesting the inclina-

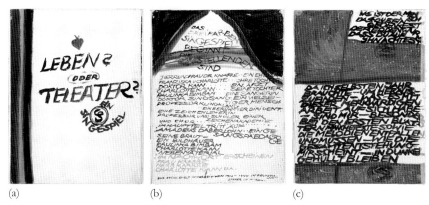

(a) (b) (c)

6.3 (a–c) Charlotte Salomon, *Leben? Oder Theater?* 1941–2, gouache on paper,
 32.5 × 25 cm, JHM 4155–1, 4155–3, 4155–4, Jewish Historical Museum,
 Amsterdam. Reproduced courtesy of the Charlotte Salomon Founda-
 tion.

tion to write 'TEATER' and a lack of paper or unwillingness to start
again.

This work, its next page tells us, is dedicated to an American, Ottilie
Moore, and contains a prelude, a main part, and an epilogue (JHM
4155–2).[23] As if appearing through the drawn curtains of a proscenium
arch, there follows a cast list (6.3b). The key actors from the German-
Jewish community in Berlin are painted in blue.[24] When these same
characters live, for some time, in the South of France, they re-appear
in Van Gogh yellow. Red is reserved for the key players in the main
part of the drama: the singing teacher, Amadeus Daberlohn (the the-
atrical renaming of a well-known voice and music theorist, Alfred Wolf-
sohn); his fiancée, a sculptor who remains unnamed; Paulinka Bimbam,
a soprano; and Charlotte Kann. These stage namings are Brechtian in
their mixture of popular humour and unforgiving irony: *Knarre*—which
means groaning or rattling—for the highly cultivated and assimilated
German-Jewish bourgeois grandparents Benda/Grunwald representing
the Wilhelmine era of willingly acculturated German-Jewish Bürger-
tum. *Kann* (meaning 'is able' or 'can') is used for the artist's family led,
from a lesser social background, by the ambitiously medical Doktor
Kann whose life is shaped by the impact of World War I and his am-
bition to become a medical professor.[25] The diminutive *Paulinka Bimbam*
names the distinguished alto-soprano Paula Lindberg née Lévy, the
artist's stepmother, whose international musical career was blighted by
Nazi boycotts on Jewish performers in 1933.

Nothing in the colourful and light-hearted wordplay of the playbill
materials with which this perplexing art work, *Leben? Oder Theater?* be-

gins, prepares us for turning the page (6.3c) to find the mournful words
of Psalm 144, used in the *Liberaal* memorial service on *The Day of
Atonement*. Reminding its readers of human frailty and mortality, the
psalm asks:

> What is man that thou art mindful of him,
> mortal man that thou shouldst care for him?

The hand-painted inscription, however, reads:

> Was is der Mensch das du sein gedenkest
> Der Erdenwurm dass du auf ihn achtest ?

> [*What is the human being that thou art mindful of him
> The earthworm that thou carest for him?*]

This inscription is set upon a decoratively golden page that further
bears, above the artist's monogram CS, the following words, hand-
painted in red letters:

> Since I myself needed a year to discover the significance of this
> strange work, many of the texts and tunes, particularly in the first
> paintings, elude my memory and must—like the creation of the
> whole, so it seems to me—remain shrouded (*gehullt*) in darkness.
> CS

This is the only usage of the first person throughout the final selection
of the work. In contrast to the impersonalized and masculine figure of
the painting *Mensch* and *Der Verfasser* of the following pages, this text
has a deeply personal and emotional tone, admitting the author's per-
plexity before the text itself as she confronted it for a year after its
completion to learn its meanings. What is most striking is the emotional
difference from the ironic Brechtian play format that precedes it. Per-
haps this page was an alternative beginning, with its biblical or liturgical
epigraph and signature, recalling the richness of the magnificently illus-
trated medieval Hebrew manuscripts of the Haggadah that recount the
story of the Exodus and Passover. The word *gehullt—shrouded—*
textually invokes burial rituals and introduces, along with the mournful
psalm that we might aurally imagine being intoned liturgically in Paula
Lindberg's sombre alto-soprano, the theme of mourning and com-
memoration of the departed in the Yom Kippur memorial service, at
which, as a mourner for her mother and already bat-mitzvah, a Jewish
adult, Charlotte Salomon would have participated annually.[26]

These contradictory opening pages thus alert us to a reflexive theatricality lined by a deeper, memorial rite associated with the dramaturgy of the awesome religious festival. Is *Leben? Oder Theater?*, amongst its many identities, imagined by 'CS' as a memorial book, or rather a modernist artistic liturgy for commemoration by a historically placed, young female mourner reassembling a lost world? If we are cued in to these multiple levels of reading, who or what was being mourned? Is death its subject? What is the relation of narrativity to death, that is, itself, impossible to narrate? Why was this dimension 'framed' in so different a tone as some kind of theatre? Do these two sets of beginnings, left to jostle and conflict, themselves perform the question of the title: *Leben? Oder Theater?*

In both exhibitions and studies of Salomon's work that claim it as autobiography, the tension Benjamin identified between linear narrative or sequential time and the discontinuous moments of reminiscence has been lost. Certainly, whether Charlotte Salomon framed the work as a play or as a memorial, the presence of narrative is irrefutable; CS established an ordered relation between connecting paintings. As a narrative cycle, this work is distinctive in its modernist moment, but perhaps not when we realize that as worlds collapsed catastrophically around persecuted Jewish subjects, a need emerged for the intelligibility and order of narrativization. There are other works by camp inmates in the French territories where artists made of their experiences informal comic books or even narrative cycles on the walls of their encampments.[27] Salomon, however, was not imposing order on her immediate experience. She was creating a series of visual scenarios for a distant childhood, a lost world; mapping another life/other lives.

Narrative as a structure, moreover, works paradoxically to tell us something that appears to take place before us in the unfurling present of storytelling. A story can only be told insofar as it presents itself as a re-telling of what has already happened; an invisible past that must return in the coming of the tale to lie ahead of its own gradual unfolding. The story's narrator stands between the story as past and the present of its unfolding: the telling is the privileged bearer of already known events. Furthermore, the relation of the biographical to narrative assumes a known and lived life whose narration is a repetition in language of remembered events. Yet life as it is lived does not necessarily follow the patterns of narrative; narrative imposes upon the chaos of life events, as Benjamin stressed, the patterning of a troped coherence that has a sequence: a beginning, a middle and an end. It has a *telos*. That is what is missing in Salomon and her other Jewish compatriots in this disaster. They could focus on the present to seek order and their own sanity by doing so. Or, they could look back. The trajectory of narrative

is, therefore, utterly different from the traumatic models of psychoan-alytical legends of the subject; where the traumatic event does not in effect 'happen' although it comes to inhabit and press upon the subject from its unknown embeddedness in the psyche beyond the reach of memory.[28] It is also radically different from the Benjaminian spatializa-tion of moments and discontinuities.

What interests me in Salomon's work, as it presents itself to us in these contradictory claims of its opening pages, is the meaning of the decision to make an art that involves memory work, and moreover, a multi-channelled creation of a theatre for—here is another peculiarity —'*invented* memories'. That which is 'staged' in Charlotte Salomon's theatre of memory is not always the memories of the artist or her own past. They are imagined memories created for, as well as of, other women. From the distance of exile and adulthood, paintings revisualize and spatially restage an interlocking series of invented and remembered life-stories of dead or absent relatives, including the artist's mother, her grandmother, her stepmother and a singing teacher/philosopher of the voice. These memories, however, concern not so much their lives but their deaths, or in the case of the singing-philosopher, a return from death.

Hence against the trope of biography, even extended to encompass Benjamin's bio-geo-graphy, I want to propose *allo-thanatography*—the writing of the deaths of [feminine] others. However CS's work is titled, it is more an allo-thanatography than an autobiography, written by someone who had neither fully lived her own life nor known that of all those whose inner memory maps she invented as a theatre of feminine melancholia, creativity and memory around her ex-centric, depersonal-ized 'self'. Presented in the double form of an *allos*—'CS' painting an other named *Charlotte Kann*—and articulated in a third person narrative with only a few exceptional lapses into a first person voice, this work does not recall the known past so much as stage a reimagined visuali-zation as a necessary summoning of lost feminine others, who are thereby invoked as the bearers of memories of and for the enunciating subject. This subject is itself suspended between life and this theatre (of memory) since the conditions for living had been politically as well as psychically eroded by bereavement and exile, by familial tragedy and historical violence.

In this case, rather than follow the confusing cues of the opening pages and the appearance of a theatrical narrative form, I want to scan the work for moments and discontinuities that might reveal purposes concealed, unconsciously or by design, purposes or questions that seemed ever to evade the returning eye of its own maker. To get closer to the text, I had to traverse for myself the life-map and its actual spaces of Charlotte Salomon when she became 'CS'.

Looking for a Window Frame

12 August 2002
Having negotiated the clogged up and badly signposted routes through Nice,
we take the coastal road to Villefranche. Hanging tenaciously to its precipitate
hillsides, the old fashioned town bursts into view as we sweep round the edge
of a vast, blue bay. Perched high above fortified sea walls, and steeply sloping
paths down to the sea, the road leads into the tiny town centre where, with a
piece of luck, I spy both a parking place and the Office of Tourist Informa-
tion. My companions are growing suspicious. 'Exactly why are we here?' they
ask. They worry that I cannot take holidays and that again I have tricked
them into a work-related outing. I did not tell them that I am here to find a
house and a hotel relevant to my current research project: a single but composite
art work of 1325 paintings made over eighteen months between 1940 and
1942, by a twenty-five-year-old German-Jewish refugee from Berlin when she
was living in this town, Villefranche and its neighbour, St Jean de Cap Ferrat.
By asking directions at the Office of Tourist Information I am hoping to
divert suspicion. The Office provides a town plan and with a yellow marker
directs me to the street I seek: Avenue Cauvin. It is not far and winds its way
back and forth up the steep hillsides where we view gracious old villas embedded
in mature gardens, while Corbusian apartment blocks provide a stark archi-
tectural counterpoint to the lush vegetation of older residences and probably
stunning panoramas. The view from the higher reaches of Avenue Cauvin
would be glorious were this not the only day of the year in the South of France
when rain and low cloud would remind me of a British summer. The promon-
tory in the distance must be St Jean de Cap Ferrat. From the villa, 'she'—
the painter—could see what would sometime be her bolt-hole across the bay.
But there is no trace of the house I have come to find: Villa L'Hermitage,
owned by an American, Ottilie Moore, who offered it as a refuge to orphaned
refugee children and an aged German-Jewish couple, the Dr and Mrs Grun-
wald from Berlin. In turn they invited their only granddaughter, Charlotte, an
art student, to join them after the pogrom of 9–11 November known in his-
tory as Kristallnacht. *The sun breaks through and the glorious blue of the*
Mediterranean flashes across the scene heightening the intense red of the tiled
roofs. Snaking out to sea like a humpbacked monster is St Jean de Cap Ferrat,
surprisingly close yet in its vegetation-covered secrecy so different from the Ed-
wardian formalities of Villefranche itself.

Following the main road we drive to St Jean de Cap Ferrat, this time hoping
to find another Office of Tourist Information, another map, and locate the
hotel Belle Aurore. I am strangely excited as we get physically closer and closer
to the actual site where in 1940–1 Charlotte Salomon painted in isolation and
desperation to produce her extraordinary project, framed by two questions
Leben? Oder Theater? *which we can translate as both noun forms* Life?
Or Theater?, *or verb forms* To Live? To Masquerade? *After several*

(a)

(b)

(c)

(d)

(e)

6.4 (a–e) Album of photographs of Avenue Cauvin, Villefranche, and Hotel Belle Aurore, St Jean de Cap Ferrat, Côte D'Azur, 2002, Griselda Pollock.

wrong turnings passed off as tourist meanderings, I get the hang of the one-
way street system on this secretive and elite peninsular where David Niven and
other cinema celebrities once lived. The hotel itself is depressing: tacky, run
down, and cheap. Of course. A refugee in Vichy France with no permit to live
anywhere but with a sexually abusive grandfather would have had to take to
the cheapest space she could. She paid for the room only. No meals. Was room
number 1 with the pink carpet the top room under the eaves? I climb upstairs
to get the view from an empty room on the first floor and to check what I have
come to confirm: what was outside these windows. The old-fashioned and
unloved, unrestored run-downness of the hotel has only laid a bad version of
sixties decor over the place once run by Marthe Pécher and her husband. They
told biographer Mary Felstiner in the 1980s that they remembered Charlotte
Salomon. She hardly ate all the winter of 1940–1 but they said she hummed
all the time she was painting.

This roughly describes a trip I made during a summer holiday to Ville-
franche and St Jean de Cap Ferrat. I went to experience, phenomeno-
logically, visually, and emotionally, a place where Charlotte Salomon
had made the paintings about which I am now writing (6.4). Why, you
might well be asking, is seeing this hotel, and being in that actual place,
relevant to the art historian when the archive of paintings in question
is in the Jewish Historical Museum in Amsterdam and apparently shows
no views of this hotel, although the garden of the Villa Hermitage, on
the Avenue Cauvin, briefly appears?[29]

On the level of history, we know that Charlotte Salomon's mother,
Fränze Grunwald Salomon, committed suicide on 24 February 1926.
This fact was, however, only revealed to her daughter in 1940, when
the girl's grandmother, Marianne Benda Grunwald, overcome with the
pain of exile, persecution and the outbreak of war that brought the
racist Germans to conquer the France that had until then seemed a
refuge, tried to kill herself with poison, finally succeeding on 20 March
1940 by leaping from the window of an apartment in Nice before Char-
lotte Salomon's eyes. The artist's mother's death in February 1926, when
she was eight, had, at the time, been explained as a result of the in-
fluenza epidemic rather than of a depressive illness. According to then
prevailing theories of inherited tendencies towards such 'degeneracy',
the reappearance of this trait in Charlotte Salomon was feared, as she
was, by then, the sole survivor of her maternal grandmother's entire
family, twelve of whom had taken their own lives.[30]

The 'event' of Charlotte Kann's mother's suicide is represented twice
in the vast work, in two separate sequences of images.[31] This interrupts
narrative because in both cases the death is represented as suicide,

6.5 Charlotte Salomon, *Leben? Oder Theater?* 1941–2, gouache on paper, 32.5 × 25 cm, JHM 4254, Jewish Historical Museum, Amsterdam. Reproduced courtesy of the Charlotte Salomon Foundation.

rather that what the child believed to have occurred. The first death is presented as part of a narrative of the prehistory of Charlotte Kann's life, visualized in a series of sequential stories that have the quality of a family chronicle painted as multiple scenes on a single, busy page. The second telling is framed by the 'women's time' of the grandmother's mournful memories.

The second death appears in the hypertextual opening of the pictorially created reminiscences of the grandmother, who has lapsed into a melancholic review of her whole life following a letter she has received blaming her for the deaths of both her own daughters. This section is framed by two radically different images of the grandmother: the first shows her curled up, on the floor, painted in depressing brown tones (6.5). The second image, with which the older woman's reverie concludes, is staged in a blue-walled room, beside a window, beyond which is a line of red-tiled roofs. Reworking place and time becomes crucial to reading these representations (6.6a, b).

This inward-turning re-vision of 'Scene 5' is visualized using the novel techniques of recently invented cinematic language, notably what is called 'shot reverse-shot'. This is a device that, according to film theorist, Stephen Heath, specifically spatializes the position of the subject in relation to a narrative art.[32] It is first used embedded in a multi-part scene when the birth of Mrs Knarre's daughter Charlotte is surrounded by scenes of Mrs Knarre's mother, demented by the suicide of her son whom she forced to marry for money, attempting to leap from a window. She is shown in one vignette being restrained, and in another, the viewer receives the reverse view, meeting her and her carers face-on at the window (JHM 4259). The close-up is also used in this section to contrasting effect. The intense bond of mother and young child is represented through a tight 'shot' of the baby being cradled in the mother's hands while her adoring face gazes down (6.7a).

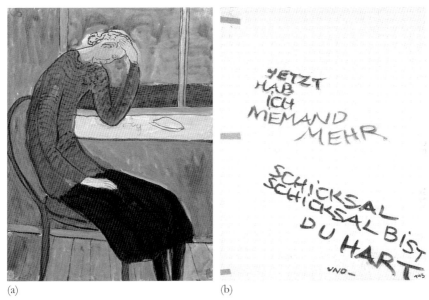

6.6 (a,b) Charlotte Salomon, *Leben? Oder Theater?* 1941–2, gouache on paper, 32.5 × 25 cm, JHM 4300 and 4300–T, Jewish Historical Museum, Amsterdam. Reproduced courtesy of the Charlotte Salomon Foundation.

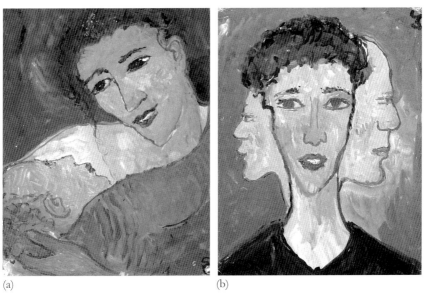

6.7 (a,b) Charlotte Salomon, *Leben? Oder Theater?* 1941–2, gouache on paper, 32.5 × 25 cm, JHM 4286, 4288, Jewish Historical Museum, Amsterdam. Reproduced courtesy of the Charlotte Salomon Foundation.

The alienation of the young mother from her ambitious husband and bumptious child is signalled precisely by the breach of both the enveloping gaze and any reciprocity. Instead the bewildered woman's face stares out of the page while the 'others,' who should hold her within their gazes, forcefully look away (6.7b). This is followed by a trio of clearly related images (6.8a–c).

Fransciska Kann appears at a window, large hands resting on its broad sill, facing the viewer in the putative nothingness of space, dreaming. The viewer is in nowhere land, meeting the outgoing gaze from a point outside the window: the void into which the dreaming woman gazes. The next frame swings the viewpoint around to the interior and places the line of sight behind the standing figure whose hands now lie inactive by her side, on this side of the sill. Beyond the window there is no view, just a flat expanse of an intense blue nothingness several tones lighter than her deep blue dress; in the previous image she was dressed in brown but set against a midnight blue interior.[33] The third image in the sequence holds the 'camera' still and in place to reveal an emptiness where the woman had formerly stood. The former opacity is lightened to enable us to note a line of roofs beyond. The text hand-painted over the scene on a transparent piece of tracing paper reads:

Now she no longer stands in place.
Ah! in another space
she now abides.

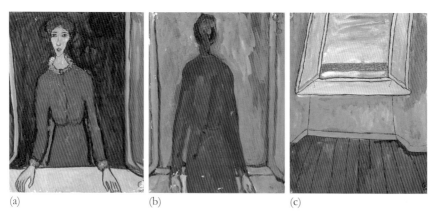

(a) (b) (c)

6.8 (a–c) Charlotte Salomon, *Leben? Oder Theater?* 1941–2, gouache on paper, 32.5 × 25 cm, JHM 4289, 4290, 4291, Jewish Historical Museum, Amsterdam. Reproduced courtesy of the Charlotte Salomon Foundation.

This complex painting, however, inscribes a subject position other than that of the painted figure, 'sie/she' of whom the poem speaks. By having vacated this space, the woman in blue becomes, through that absence, the signifier of the invisibility of death; death is nothing but perpetual absence. In Tom Stoppard's astute words, 'death is merely the endless time of never coming back.'[34] Put another way, the woman in blue's absence from the image is the means by which the artist signifies what she does not represent: the leap from the window to a suicidal death. Instead, the place from which such a leap might be taken lingers before our eyes. Or whose eyes? As importantly, this space is arrested before a meditating gaze it constructs as the reverse of the scene/seen, installing an invisible subject position that the painting now signifies as well. This image was made as part of both a theatricalized narrative about others and a signifying chain whose meanings exceed the lives recreated in this visual memorial. Its function is to recreate the ground for a subjectivity which, as that of a Jewish refugee, has lost its place and remains linked only to the deathliness of women's time. Thus a second, absent subject is momentarily glimpsed beyond the narrative disguise of a historical telling of events by an indicated speaker: the grandmother travelling in memory to recall her own child's suicide. The image plots a space for a moment of decision. An invisible feminine subject, signified negatively by the arrested painting of the open but emptied window, inherits the question formerly posed by the now absent woman in blue at the window. Hidden within and by its narrative face, the image therefore poses, as its maker's, the question: to live or to die a self-inflicted death? The core of this painting project is, I suggest, the contemplation of that question of suicide against the doubled condition of Jewish spatiality and feminine temporality, of generation and geography.

In the painted epilogue explaining the work's genesis, we read:

> And she found herself facing the question of whether to commit suicide or to undertake something wildly eccentric (JHM 4922).

The eccentric undertaking was a painted journey to meet the dead, not only visually mapping the sphere of life but also of death in the theatre of memory. Why are there two accounts of the same event? Why are they so different?

The first representation of the death of the woman in blue follows a different pictorial logic altogether. On a single page in a series of vignettes, scenes from the daily domestic life of mother and daughter are minutely chronicled: a singing lesson, a gymnastics class, a dinner party, the homecoming of a husband, and a premonitory scene: mother

and daughter side by side taking up remarkably similar poses, except for this. One sits by the window looking into the beyond, in the Romantic trope of contemplation and yearning, and the other faces the hard screen of a drawing board. Haunting these two registers, however, a face hovers at the left as the enclosing consciousness within whom these scenes are flashes of discontinuous memory, visually showing us the mental space of this feminine/maternal subject. Below them, in a red that seems to flow out of her dress, we see a repeating female figure decline into melancholy, signified visually by the increasing tension of her body's anguished withdrawal from others, for which, on the next row, medical treatment is called. Despite the doctor's visit, the woman seeks to poison herself; an action signified in the repetition of a bleached, increasingly colourless and emaciated figure along the base of the composite image. Its dense composition is held together by the female figure looming up its left side. Both narrating actions and representing a state of mind, this emotionally loaded page, imaginatively spatializing the psychological condition of a suicidal woman, is followed by a differently spatialized staging of the woman's bid to depart from a life that is no longer bearable. Against an undemarcated colour ground of agitated paint marks, awaiting a nurse's temporary absence, the melancholic invalid rises up from her bed—in a pose that reverses Michelangelo's Adam's summons into life by God's finger—and rushes to open a tiny window, embedded in the centre of the page. The painting is itself notionally opened by a second, yawning window frame that gapes at the base of the painting, mixing and vertiginously undoing our location in logical space for we look from the outside in, and in looking down we witness the trace of the suicide's lagging foot. This foot signifies her leap to a horrible death, which is given a shocking image two paintings later. A crumpled heap of dislocated body, a crushed and bleeding skull, confront the viewer now placed streetside as witness in an act of imaginative reconstruction whose necessity for this artist is hard to comprehend. The artwork demands the viewer's confrontation with the physical violence of death as an act. The visualization functions as a warning, a graphic translation of the physical meaning of the words, 'leapt to her death from a window', as fragile body smashes against stone or concrete pavement in all the humiliating disorder of violent dying. This is laid out nakedly before a witnessing called forth by the image in its lack of framing and the immediacy of its scale.

The empty window of the second telling discussed above (6.6c) replaces this atrocious image of death's physical reality. My journey to the South of France, to see for myself the geographical and urban particularity of Salomon's life-map hinged on the fact that outside the window in this painting is not the Berlin street, Kochstrasse, in which the

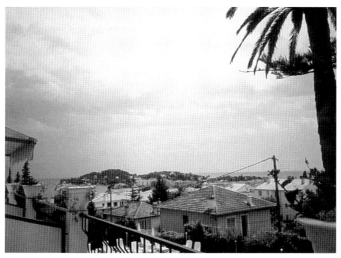

6.9 Photograph of the view from the window of the Hotel Belle Aurore, St
 Jean de Cap Ferrat, 2002, Griselda Pollock.

death of Fränze Grunwald Salomon took place on the 24 February
1926. Instead, what we see is a red-tiled roof of a house in St Jean de
Cap Ferrat in 1941 (6.9), not a topographical replication of the view, but
a clear indication that this French town, this window in this place in
1941 was also a possible site of suicide: the artist's and one which has
been embedded as a repudiated choice inside the work. This painting
of a room and an empty window reads, then, as the most intimate in-
scription of subjectivity at a point of both collapse and self-re-
invention. Painted space serves to undercut the narrative time of the
finished work to remind us of the subjective place and moment in
which this image was being made. Its life/death question is not repre-
sented but held in that frozen, time-refusing space *before* the window, in
both senses of that word.

My visiting this hotel, to stand in the room, to find this window, was
not ghoulish tourism; it echoed in some way the artist's need to bring
herself through the life and death histories of Jewish women's time-
space visualized by her paintings, to the repeated confrontation with
this window as the portal of her mother's absence. This confrontation
was the subjective point of her own maternal bereavement, whose in-
tensity was heightened by the fact she had had to endure the progressive
assault of an implacable political enemy on the conditions of her living
as a Jewish woman. It exists, however, as an image framed itself by the
paper on which it is painted, the impenetrable flat support of a visual
projection, or a mapping.

In its singular entwining of a family biography and the history of fascism's assault on the conditions of Jewish subjectivity and social living, this art work phrases a struggle to find the grounds on which to pull back from the window's ledge. Despite its title *Leben? Oder Theater?*, this work is about that threshold, frontier or lintel that marks the boundary between choosing to live or to die. The window, with its other, the plane of the artist's paper, is, therefore, a key image; throughout the many painted works it is dangerously linked by colour with the absent maternal. This identification appears early on in a painting that uses the drawing style and colour quality of a children's book. Mother and daughter lie snugly in bed while the mother promises that should she go to heaven—a very Christian image (Fra Angelico?) is offered here complete with bearded Father God—she will return as an angel to deliver a message for her child telling her what heaven is like (JHM 4175). Across the great work I can track this recurring association of the woman in blue with the window, from the centre of a key image of the expectant mother (JHM 4169), to the empty window appearing in the centre of the composite image announcing the news of her death (JHM 4180) where the window's blank beyond has inherited the blueness of the maternal figure's robe—a blueness that again punctures the flat page with a promise of a here silent beyond at which the bereaved, colourless daughter awaits the never-to-come message from her angelmother now in heaven (JHM 4188)—later to be rediscovered in painting her actual and more brutal passing as destroyed on the bloodied ground.

In a massive explosion of colour and calculated play with many contemporary visualities drawn from cinema, children's books, fairy tale illustration and modernist graphics and painting, Charlotte Salomon filled the window's void that was doubled with the piece of paper on which she projected her theatre of memory. She painted the window as the emptiness her depressive mother saw and yearned to find, but also filled its space with the intense red and blue Mediterranean actuality of St Jean de Cap Ferrat—grounding a lonely, bereaved and endangered self in the specificity of this place, concretizing a present in opposition to the lure of the theatre of memory that her paintings were creating with all the danger of identification with the melancholic feminine that was her only link with the genealogy of women in her family. Exiled into a threatened Jewish space, and endangered by the mortality in her family's women's time, Charlotte Salomon hummed to herself in a cheap hotel and painted pictures.

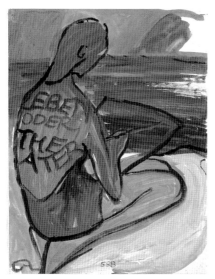

6.10 Charlotte Salomon, *Leben? Oder Theater?* 1941–2, gouache on paper, 32.5 × 25 cm, JHM 4925, Jewish Historical Museum, Amsterdam. Reproduced courtesy of the Charlotte Salomon Foundation.

Where they did not meet

The final image of *Leben? Oder Theater?* installs a young woman against that deep blue, maternally-connoted but also modernism-indexing Mediterranean sea (6.10). Her tanned body is dressed in a very modern garment, a bathing suit. She is beginning to lay in her colours over the transparent ground of her window-like paper through which the blue of that ocean and the blue of her mother's memory flows. By the chance mark of her brush a face seems to surface where the water meets the sky through the chance deposit of the loaded paint—an event the artist chose to leave just so. Her title now finds its place on her bronzed body, but without interrogatives.

This, the last painting, number 558, is the image, however, of the work's beginning: painting in the world as if in the paradisiacal beginning of a new era. It is an affirmation of the possibility of life in that place. As if taking place in a cinematic flashback, the whole art work was created from this point as the retrospective undertaking of an imaginative journey to this decision to paint beside the sea.

Charlotte Salomon had arrived in the South of France under the ruse of a two-day permit from Berlin to visit a poorly grandmother, following the worst pogrom in modern history in which her father was arrested and imprisoned in Sachsenhausen. Her painting of *Kristallnacht* (JHM 4762) focused on the invasion of the Berlin streets, watched with alarm by Walter Benjamin from his refuge in Paris. Armed with a small suitcase, a tennis racket and a recording of her diva stepmother singing the title role of Carmen, Salomon joined the swelling crowd of 40,000 German-Jewish refugees living on the Côte D'Azur—in relative safety until May 1940 when the heavens rained bloody bombs and the Germans invaded and occupied parts of France. As enemy aliens at first, and then following the *Statut de Juif* (4 September 1940) as racially-defined stateless others once the Nazi-Vichy Pact had been signed, all

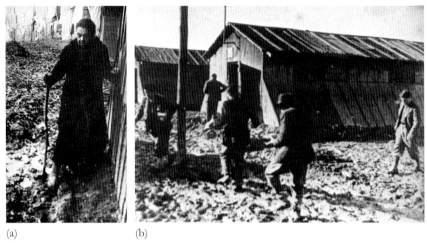

(a) (b)

6.11 (a,b) Two views of the concentration camp at Gurs, near Pau, c.1941–2.

German-Jewish refugees, first men and then women, were rounded up and sent to concentration camps. Gurs, near the city of Pau in South-West France, was the largest; it was the destination for Charlotte Salomon and her grandfather in the initial round-ups of May–June 1940.

Photographic images of the former encampment for refugees from the Spanish civil war (6.11) do not convey the horror of this sea of mud in which one might sink up to the knee in attempting to traverse the bog it rapidly became. A hideous assault on everything that makes life possible—cruel, painful and humiliating as nothing before ever encountered—Charlotte Salomon made no image of this place beyond representation. The preliminary encounter with the novelty of the concentrationary universe fell under the personal *Bilderverbot*—prohibition of the graven image—that is the mark of trauma. Instead Salomon's image sequence moves from the order to be rounded up to the image of their release. Charlotte Salomon was released to care for her ageing and dying grandfather, shown hunkered down in broken dignity in a waiting room stained faecal brown by the muddied experience of fascism (6.12). In countering the old man's frank despair, Charlotte Salomon represents her alter-ego painting, which we might call *other place making*.

That she never imaged the brief moment of her incarceration in the concentration camp suggests that this experience was the degree zero around, or rather against, which this vast colourful, musical life-map of past and present was generated, its brilliant Mediterranean blue piercing and cleansing the faecal fascist brown of recent traumatic im-

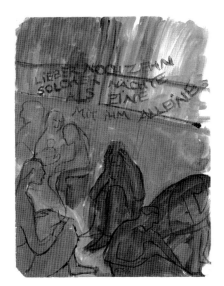

6.12 Charlotte Salomon, *Leben? Oder Theater?* 1941–2, gouache on paper, 32.5 × 25 cm, JHM 4915, Jewish Historical Museum, Amsterdam. Reproduced courtesy of the Charlotte Salomon Foundation.

prisonment in a sea of mud, to become the ground upon which this theatre of memory could be enacted as answer to that question posed to the window in the hotel at St Jean de Cap Ferrat that I had to go and see for myself: to live— *leben*, in its verb form—or to die? To give the answer *to live* meant resisting the fake theatricality of those who did not have the emotional honesty to face the pain of personal and political grief to its limit.

One man, whose path would have led him to Gurs had he lived, and no doubt to Auschwitz had he survived a winter in that hell-hole, was Walter Benjamin. Benjamin may have killed himself or may have simply died, on 26 September 1940 in the small coastal town of Port Bou in the Pyrenees overlooking the Mediterranean. The assumption has prevailed that Walter Benjamin committed suicide, joining the growing numbers of German-Jewish men and women for whom this was the only choice. But was it? Recent research by Ingrid and Konrad Scheurmann has left the question open.[35]

For many years there was nothing to see at Port Bou that marked Benjamin's passing/passage through this place; no marker on a retrospective bio-geography. In his biography of his friend, Gershom Sholem writes about learning of Benjamin's death from Hannah Arendt in late September 1940. She too passed through Port Bou only to find no grave, although one had been leased for at least five years by the friends with whom Benjamin had been travelling. Sholem writes:

Many years later a grave with Benjamin's name scrawled on a wooden enclosure was being shown to visitors. The photographs before me clearly indicate that this grave, which is completely isolated and completely separate from the actual burial places, is an invention of cemetery attendants, who in consideration of a number of inquiries wanted to assure themselves of a tip.[36]

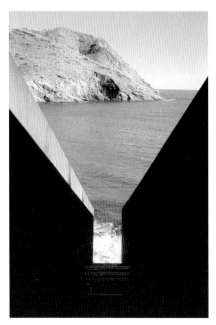

6.13 Dani Karavan, *Passages: Hommage to Walter Benjamin*, 1990–4, Port Bou. Courtesy Atelier Dani Karavan, Paris.

This story had a ghoulish tinge and I felt ashamed that I too might be part of a tourist group needing somehow to see the resting place, any one, that would mark a connection between the once-living subject and the revered author. Are such modes of hagiographic tourism part of proper research or symptoms of our refusal to look death in the face in the way the painter Charlotte Salomon, in painting, made herself look? Is the memorial a fetishism by which we seek to mark the impossible absence of the dead in our world; does the invisibility of death require a territorial reminder? Do we need to map death too?

In 1998, however, a major memorial was installed in the Spanish coastal town of Port Bou which, with Bilbao and for completely other reasons, now attracts to itself tourists and pilgrims for there is indeed something to see: a major international art work commissioned by the German government from Paris-based Israeli artist Dani Karavan (b. 1930). Karavan installed in the Port Bou cemetery, that hangs on the edge of rugged cliffs overlooking the pounding sea, a hooded, rusted steel entrance to a steep passageway that descends a staircase framed by rusted steel plates cut brutally into the cliff's edge, where they abruptly end in a gaping mouth (6.13). The staircase leads tunnel-like from the surface of the cemetery where a yawning metallic mouth opens vertiginously into the void of the crashing sea below. The visitor is protected from being precipitated onto the rocks by an invisible glass panel. On this translucent glass screen, written as if on the blue water of the Mediterranean itself, are the words of the man this anti-monument commemorates for his own thoughts on history and catastrophe, Walter Benjamin:

> It is more arduous to honour the memory of the nameless than that of the renowned. Historical construction is devoted to the memory of the nameless.

No longer an apocryphal grave, but a monument to the invisibility of the nameless and immemorialized Holocaust victims, the site of Walter Benjamin's end in Port Bou, Catalonia, is invested with the traumatic reminder of the violation of human death enshrined in the Polish place renamed Auschwitz that he was seeking to escape, where he would have met a form of death that left no trace: an erasure the Nazis intended and Holocaust deniers can exploit. Charlotte Salomon did not escape that fate and was erased from existence on her arrival at Auschwitz on 10 October 1943.

History fails and we are left with only the uncertain and invented geographical register of Benjamin's memory. The meanings projected onto the scenario of the philosopher taking his life rather than facing the prospects of renewed internment and worse shimmer before our unfocused eyes. Incompetence, political sympathy, desperation, sudden illness: this death can find no biographical meaning to cover the caesura of its biological fact. Yet it was clearly a political death, a historically conditioned end in a place that by being its location became an unanticipated part of the geography of the Holocaust: a Mediterranean extension.

After she completed her great painting cycle that ended with that assumption of her brush, like a mermaid beside the blue, blue sea, and with the decision to paint her journey to that moment, Charlotte Salomon returned to Villa L'Hermitage, Avenue Cauvin in Villefranche, and found comfort in the companionship of an Austrian Jewish refugee by whom she became pregnant. Observing the honour of his class and background, Alexander Nagler determined to marry the mother of his child. In registering a marriage he was forced to avow both their Jewishness and their address. Nagler's paternal joy unknowingly gave to the SS Officer who moved in to cleanse the Côte D'Azur of its Jewish refugee population in the September 1943 the means to discover their hiding place. The couple was arrested, deported to the transit camp at Drancy and on 7 October 1943 transported to Auschwitz. There on 10 October the 26-year-old self-declared *Zeichnerin*, graphic artist (that is the skill registered on the Transport list), was taken directly from the train to the gas chamber and horrendously killed by Zyklon B poisoning. The reason that a young and healthy woman was given on the ramp no chance to live was that she was five months pregnant. She thus carried the seeds of a Jewish future within her body.[37] Both were to be extinguished utterly. The body as the doubled site of Jewish space and women's time was annihilated from the earth. I never intend to go to there—*nach Auschwitz*. I place my work on her theatre of memory *before* it, turning Charlotte Salomon's vividly spatialized reflections on life or theatre into my own allo-thanatography: the unre-

deemed writing of the death of another, that leaves me at that window, not contemplating suicide, but facing the absence that was her unwilled death, her political murder in that place that should never have been on the life-map of anyone's history.

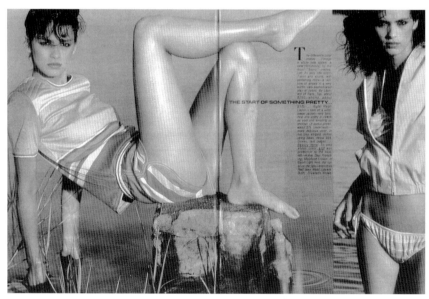

7.1 Francesco Scavullo, 'The Start of Something Pretty', *American Vogue*, November 1980.

PUNCTURE/PUNCTUM
Out of Shot
Nicholas Chare

All I want is a photo in my wallet
A small remembrance of something more solid
All I want is a picture of you.

All I want is twenty-twenty vision
A total portrait
With no omissions

All I want is a vision of you.

<div align="right">Blondie[1]</div>

In 1978 Blondie released a single called *Picture This* with words and music composed primarily by Deborah Harry, from which the above quotation is taken. '*All I want…*' not '*I want it all…*'. It seems at first that Blondie set their sights lower than a band like Queen, it seems that what *Picture This* asks for is very little. To want a photo in one's wallet does not appear an outrageous demand, but then to want '*a total portrait with no omissions*' seems similar to wanting it all; there is a desire for the image to be all of '*you*'. I do not want to ask who or what '*you*' is here, but I am interested in thinking about what we might want from a photograph and what photographs might want from us. I want to focus on one photograph in particular, from the November 1980 issue of *American Vogue*, of the model Gia Carangi (7.1). It was taken by the renowned photographer Francesco Scavullo in Southampton, in the state of New York, sometime in late August or early September of that year, as part of a fashion shoot. The make-up artist for the shoot was Sandra Linter, the hairdresser Harry King. The sixteen pages of photographs that were used by *Vogue* from the trip to Southampton were

accompanied by the repeated caption '*The Start of Something Pretty…*', as well as several short paragraphs describing what values the new look was supposed to embrace and providing details of the clothing the models are wearing, such as the designer and the price. The first two pages carried the following text:

> No question. The mood of modern dressing is changing. It's softer. More feminine. And very very pretty. You see it first in the way even 'pared down' has a gentler edge … in the turn to fresher color—porcelain-pale or candy-bright. And you see it—unmistakably!—in the strong focus on the body, the bareness. Strapless, sleeveless, low-necked, 'leggy' … always the look lets your body come through! The shape your body's in is part of the appeal. So is softer, more natural make-up; an unstudied line to hair. Where you see this new mood at its best: in the sixteen pages of wonderful warm-weather looks ahead, starting here …[2]

Warm-weather looks in November? The average temperature in New York State in August is twenty-four degrees Celsius, in September it is twenty degrees, in October thirteen degrees, and by November nine degrees. The clothes in these photographs are out of time, they are too late, they are 'so last season' if you will. The passage of time carries the photograph of an instant—of an incident—out of one season and into another. The instant in the photograph is dead. In *Camera Lucida* Roland Barthes thinks of death as this moment that is no more.[3] It is that which has ceased to exist which was the before, the before the now, the 'the' just then, the 'then' just now, the 'now', the 'ow', the 'w', the impossible-to-capture instant that is no longer as soon as we seek to speak or write it, think it even, because it is before our thought. Our thought in a sense is always afterthought when it tries to think the instant, because it is itself in time and as such is always already too late. We cannot think death. We also cannot see death because death is in an instant (whereas dying can unfortunately sometimes take an eternity). Death is too quick for the eye, yet perhaps we see it without seeing it. The photograph—as Benjamin recognized—reveals the optical unconscious, what happens in front of the I but is not perceived.[4] The photograph can make the invisible visible. The photograph might conceivably be able to capture the instant that is death, the instant beyond dying, an instant that is the time of death but before death is in time.[5] Can the photograph *perhaps* capture this unthinkable instant? Or does the photograph rescue the instant from its death? The photograph may also make the dead undead. The photograph separates what cannot be separated, parts the instant, divides it, carries the instant beyond

its instancy. The photograph is and is not the instant at which it was taken, it is never beyond the instant because as long as the photograph exists it is always the taking of that instant. The instant is somehow transported beyond its happening—brevity becomes longevity—meaning that the photograph does not write the obituary for the instant but prompts what appears to be an impossible stretching of the instant beyond its passing away. This is not an after-life but a part of life preserved after it would normally have ended—something from another time in this time—then as now. The photograph is not a memento mori, photography is not *the inventory of mortality*.[6] The photograph challenges our conventional notions of temporality, the time of its taking will not be left behind but troubles the present.[7]

This photograph is of a particular kind, it is a fashion photograph. It is also a photograph produced for particular purposes, to celebrate a certain conception of beauty and to sell specific items of clothing. In this photograph, as with the others from the Southampton shoot, there is indeed a *strong focus on the body*. The relaxed, ready-to-wear casual clothes in these pictures are typical of early 1980s fashion in that they emphasize the *dynamic and fit body as the basis for clothing*.[8] Previously the clothes made the body—a body given its contours by corsets and girdles, a body supplemented by padding and supported by underwiring, disguised and distorted—become another body. Now the clothes wear the body. The body in the 1980s shapes the clothes, and fabric is used to profile the form underneath it, to reflect rather than remould the body of the wearer. This photograph marks the beginning of a becoming visible of the body.[9]

Carangi's complicated pose seems to have been designed in fact to accentuate her figure, to display her curves as clearly as possible (7.2). Yet, the posture is an awkward one. Whilst it produces a well-balanced composition—her arms mirroring the vertical line created by her right thigh, the calf of her right leg horizontal, level with her head and with the picture plane—the pose is counter-intuitive. No one would normally sit like this. The eye-pleasing symmetries created by Carangi's contortions mask the physical discomfort required to actually hold a body in this position. On the surface it makes for a pretty picture, yet underneath it is also a painful one. For example, although her bottom is propped upon a fragment of masonry, Carangi's arms are actually working to support most of her body-weight; it requires a lot of strength and effort to maintain this pose. Her arms, which she holds out behind her—ostensibly to stop her from falling into the water that surrounds the small section of bricks and mortar, but also to help produce the impressive compositional balance the image possesses—have both an aesthetic and a functional role to play here. The pose seems a

7.2 Francesco Scavullo, 'The Start of Something Pretty'. Detail.

carefully chosen one, designed to lend emphasis to particular parts of the body. Lying back like this, Carangi's breasts are pushed upwards, pressed against the fabric of her striped cotton T-shirt, given weight and prominence. At the back, this T-shirt has become partially untucked from the matching pair of shorts; a hollow has been created, half in shadow, an accidental metonym for undress. She is taking her clothes off without wanting to.[10]

One of Carangi's legs rests upon the knee of the other, creating a triangular space through which the still, blue waters which form the backdrop to the picture can be seen. We are able to look through her body. The leg that acts as a support is bent so calf and thigh are almost touching, the shape of the limb inconspicuous, but forming a contrast with the other leg, the length and curve of which is highlighted (7.1). The way Carangi raises this visibly shapely leg above the other causes her shorts to ride up, thereby exposing her rear. Although she is clothed, the pose works to unclothe her, it centres upon revelation. The photograph reveals Carangi's body, stressing the central markers of her femininity—it is an invasive image—but the way Carangi confidently returns the gaze of the photographer, the way she looks straight at the camera, her face expressionless, unreadable, demonstrates a resistance to this process of denuding. Carangi's body is exposed to the viewer but her thoughts remain private.[11] Made to hold this uncomfortable pose for eternity, she is revealed yet unrevealing, yielding yet resistant, dead yet alive, beautiful and unresolved. A dead woman is and is not in this photograph.

Some reeds cast shadows against the hands and arms of this woman, shadows that suggest space where there is in fact none, that allow the mind to give the flat surface depth. Coming events cast their shadow before. Walter Benjamin described the photographer as an augur, a haruspex, revealing the future in the entrails of the image.[12] This image, like any other, is prophetic, it foreshadows. It is as much of the next instant as of the past one. Gia Carangi died in 1986, yet looking back to

the future I see her dead already in those white fingers beneath the water (7.2). Those fingers point towards the end of something pretty not its beginning. A photograph is prophetic after the event, indeed in retrospect this is the case with all prophecy. In this photograph the fingers now cast the shadow of death, and the photograph itself casts a thousand shadows of which this paper is but one. A dead woman is and is not in this photograph. The image is implacable in its solidity, its materiality, its thereness in the here and now, yet also in its insistence on the irrecoverable, on the no longer there, on the untouchable. Untouchable in a dual sense, the sense of that which cannot be touched and that sense of that which must not be touched. When Carangi's heroin addiction became particularly pronounced no modelling agent would touch her, and in 1986, when she was diagnosed with AIDS, she became literally untouchable for some of the hospital staff who treated her, with the ignorant wearing gloves and gowns just to take her temperature.[13] But the subject of a photograph is not usually not to be touched; the subject simply cannot be touched, the subject is 'something more solid' than the image that seeks to hold on to some part of that subject. Look at a photograph from the side instead of straight on and you see flat lines. Turn a photograph on its back and it becomes an emptiness. This is not to say that the photograph shows us nothing— if indeed 'nothing' can ever be shown—there *is* something here, we can see it, we can also touch it, smell it, taste it, even hear it should we be so inclined. We can also 'rip it to shreds'. To destroy a photograph is to do violence to a memory, old sepia-tinted photographs of people we do not know—which should have no value for us—we treat with reverence. This value, this quality possessed by the photograph which causes us to esteem 'it' seems on inspection to come from outside it, this 'it' comes from the words that shadow the image, the discourses that develop it.[14] The photograph is exposed by words: '*Water … rock … reeds … brown eyes … light … shade … legs … How out of fashion those clothes are … How uncomfortable that pose looks …*' This is a reading of the image but also an example of its writing, a writing of an image that may seem wrong to you. Of course I am not ruling out the possibility that there may be something there before the words or behind them, but it cannot be said. It is not unsaid—which would suggest words are there to say it but we choose not to use them—although of course I am leaving a lot unsaid about this image that I could say. The unsaid, it must be added, is of course not unimportant—that which is left unsaid is not unseen or unthought—it is evidence of a decision and that decision should be analysed: why has someone decided that something is best left unsaid? That which cannot be said, however, exceeds the words that are available, exceeds the sayable. The inadequacy of words in front

of an image is on many occasions a source of comfort, because it poses
a challenge to words and requires them to adapt and evolve to accom-
modate this unspeakable, to speak it. Beyond this, there will always be
that something extra which stubbornly remains outside of words—and
I do not say outside of text or free of text—even after words have re-
grouped, reformed and reinvented themselves in an effort to articulate
it. Words give directions, maps to travel by, but some places remain un-
charted. Whilst they wait to be found these are not—strictly speak-
ing—places, they are no places, yet to be places, openings outside words
… the interstices between the stars … before I wrote those words.[15]
The stubborn excess—what lies beneath the words and the shadings on
any map, or beyond the description of any image—is the wound. It is
the painful and pleasurable inadequacy of any interpretation.

Roland Barthes describes the experience of looking at some photo-
graphs in terms of a wounding. He writes:

> A Latin word exists to designate this wound, this prick, this mark
> made by a pointed instrument: the word suits me all the better in
> that it also refers to the notion of punctuation, and because the
> photographs I am speaking of are in effect punctuated, sometimes
> even speckled with these sensitive points; precisely these wounds
> are so many points.[16]

The Latin word Barthes is referring to is 'punctum'. In *Camera Lucida*
Barthes differentiates between the studium—that which is of general
interest in a photograph—and the punctum—which is a second ele-
ment (not always present) that punctuates the studium. The punctum
is like the needle of a syringe puncturing the spectator's skin, filling the
spectator with feeling … we travel through images seeking the experi-
ence that is the punctum. The art historian might be conceived of as
the image addict par excellence, hooked on punctums, continuously at-
tempting to get high on the visual. Barthes's punctum should be under-
stood as a site of resistance. He suggests that we do not seek out the
punctum, we do not understand it, rather it seeks us out, it understands
us.[17] The punctum is not part of the meanings that we give to an image,
rather it gives us meaning. Through the injury it causes, I feel something
and I must ask why have I felt and what have I felt. As punctuation it
has an asemantic element to it, an aspect … a point that resists the for-
mation of meaning that constitutes the process of reading.[18] It eludes,
evades, escapes our efforts to ensnare it and catch it in meaning. It gives
sense without being sensible. The punctum is perhaps a comma, punc-
tums are ellipses '…'. When reading and writing an image—when trav-
elling across it if you like—those details and destinations … *water* …

rock … reeds … become less important than that which exists between them, which remains unsaid and in a sense therefore invisible … *the stillness of the water … the sharpness of the reeds … the roughness of the rock …* and between the stillness and the water, for example … *the blue of the water, that forms the blue background to the image, the blue of the water, Derek Jarman's 'Blue' …* and here there is still a between, a space that always opens between the words and what is in the picture. The continual identification of this space and the effort to fill it pushes language, the effort to invest the commas and ellipses in an image with sense requires the formation of further commas and ellipses … the horizon of the ellipses recedes … the ellipses as horizon … the travelling without end. A travelling without end is not however a travelling without destination … not all spaces that are opened need to be filled.[19] The punctum is a detail which stands out … it is a sting of responsibility … a part of the picture that must be seen to and needs to be looked at. The punctum is a guide. This pain, this irritation within the image, the sty which rises up into the eye from the picture, is not yet contained within a discourse. It has not yet been mobilized to serve an end, it is not yet a vehicle for power. This space outside discourse … this experience … provides the opportunity to say something new as it negotiates its passage into that aspect of discourse which is all language. That said, this paper is not seeking to say anything new, but rather to use the space opened up by a punctum to say something which the dominant discourses of the moment are not saying, but which is not altogether unsaid.

Face to face with the sightless solitude of this image, there are three sensitive points for me, three holes, the hand beneath the water, the water that ripples (7.3), and the point that was not supposed to be there. The point which this paper points towards. This point is difficult to see, it is not as sharp as its counterparts … but the mark, the prick … is there all the same. It is the punctum which should have been, which was, but which was removed. It is the punctum which is present as absence, the hole where the hole should be. '*The shape your body's in is part of the appeal.*' When Francesco Scavullo sent his set of photographs from the shoot in Southampton to the Art Department at *Vogue* the images of Gia Carangi caused a 'big scene'.[20] They were airbrushed and edited to hide evidence of her heavy drug-use, her mainlining, the tell tale track-marks up her arms. Carangi was not in good shape at this time.

The technique of airbrushing … this overwriting … acts as a means for facilitating forgetting. Airbrushing is setting an agenda for what can and cannot be seen, for what can and cannot be known, for what can and cannot be remembered. All writing is a form of airbrushing … of overlaying … and moments must arise where the ethical act is not to

7.3 Francesco Scavullo, 'The Start of Something Pretty'. Detail.

write, to remain silent and read the writing that is already there. Of course, no one would expect *Vogue* to publish the pictures in their original state; this is after all *the start of something pretty*, and evidence of excessive drug use is seldom conceived of as having any aesthetic appeal. This act of erasure through addition, however, is a symptom of the far more substantial airbrushing of drug problems in the fashion industry as a whole in the late 1970s and early 1980s. A lot of models and their professional entourage overdosed and died around this time.[21] There is insufficient space here to consider why this is the case, except to offer the suggestion that *this* is the age of the beginning of the 'supermodel', the beginning of the becoming image of so-called 'beautiful' bodies. Gia Carangi was becoming known as an image and not a person, 'she' travelled on the cover of a magazine—travelling without moving—whilst sitting in her New York apartment enjoying another kind of motionless voyage, high on heroin. Carangi was before her time—before models became used to their roles as mnemonics of instants of light; she was ill-prepared for this transition from someone to some surface, this splitting of her body so that part of her body became a body beyond the bodily, anybody's and everybody's body, a body to be bought and sold at the news-stand. Drugs allow someone to leave their body behind, to forget. What Carangi noticed when she was off drugs was a returning corporeality: '*I'm high on being straight because now I can feel my body, I can feel my head.*'[22]

What I want to focus on here however is not the violence of the society of the spectacle but the way that this air-brushing was unsuccess-

7.4 Francesco Scavullo, 'The Start of Something Pretty'. Detail.

ful, incomplete. It demonstrates the difficulty of making something go away, there is a remainder, a reminder (7.4). This effort to cover the tracks has failed. Micke Bal makes the point in her chapter on 'Tradition' from *Travelling Concepts* that '*Forgetting entails repression, and what is repressed tends to return, often with a vengeance.*'[23] The punctum in this image possesses what Barthes terms a '*power of expansion*', but it does more in its role of metonym than simply point towards Gia Carangi's drug addiction.[24] The point is Carangi herself. Gia Carangi was a woman who died of AIDS at a time when many of those infected were men, now 50 per cent of those infected with AIDS are women. But whose names do we know? Arthur Ashe, Michel Foucault, Rock Hudson, Robert Mapplethorpe, Freddie Mercury to name but a few; all the names of men. The relatively recent death of the Israeli singer Ofra Haza provides us with the name of a well-known woman who might be added to this list, and then there is Carangi herself.[25] We do not, of course, need more famous people from different backgrounds to die of AIDS but in this age of celebrity we should question how those celebrities have helped to shape our perceptions of the AIDS pandemic. Celebrities come to symbolize AIDS, to become the face of AIDS, as if AIDS can ever have a face.

AIDS gained its visibility in the media through names such as these, and through images that were prominent in the late 1980s and early 1990s, images like Nan Goldin's photographs of Gilles and Gotscho taken in 1991 and 1992, including that final image of Gilles, or more specifically of his white emaciated arm framed against the bedsheets,

an image which for me contrasts so poignantly with Robert Map-
plethorpe's photograph *Young Man with Arm Extended*.[26] Or we might
think of the character of Beckett played by Tom Hanks in the film
Philadelphia from 1993, a film which I have not seen but which is nev-
ertheless not invisible to me. Our images of AIDS are mostly drawn
from this period, we see AIDS in the past. AIDS has travelled but we
have not.[27] This is not to say that we do not know that AIDS is a sig-
nificant problem in Africa, but we do not see images of people from
Africa infected with AIDS. Again it is true that photographs appear in
newspapers and stories run on television news bulletins about the
AIDS epidemic in the 'developing' world, but our image of AIDS has
not changed, we still *see* it as a Western illness and it is still gendered.

At this point it is important to make reference to Judith Butler's re-
cent work on grievable and ungrievable lives, specifically her emphasis
on the significance of having a name. Butler's work on the prohibitions
that exist around certain forms of public grieving in the West empha-
sizes how grievability is publicly distributed through the obituary.[28] If
you have no name you have no obituary, you cannot be grieved; she
has given as examples the dead in Afghanistan and Iraq. The obituary
is a kind of visibility, it is a form of representation with a name. The
photograph can in some respects function like an obituary, but only
when the instant it carries within it is named. A photograph with a cap-
tion in a newspaper is not necessarily a photograph with a name. A
name is something we try to remember. The punctum challenges us to
name it, to speak it, to see it, to memorize it. The name of the punctum
—present by its absence—in this photograph is AIDS, AIDS as it is
present by its absence in what we consider to be our current affairs,
AIDS as it is present in our aesthetic understanding of the epidemic.
At the level of the visible, AIDS is in the past in our society. We have
named it and known it. Ninety-five per cent of new cases of AIDS
occur in the developing world (and I use the term 'developing' here ad-
visedly), yet the image we have developed in the so-called developed
world is underexposed.[29] It covers too short a period and pays insuffi-
cient attention to the ongoing problem of AIDS; in the existing repre-
sentations of AIDS with which we we are now familiar, too much is out
of shot. The invisibility of the problem—an invisibility caused by the
declining incidences of HIV infection and AIDS-related deaths in
wealthy countries—even as it is continually named as a concern of the
now, means that we do not *see* AIDS as a problem of our time. The de-
veloping world is outside of our time, or if it is in our time it exists as
amputation or starvation, as semblances of moments from the histories
of Rwanda or Ethiopia. The danger inherent in seeing AIDS as we do
is that we become complacent and focus on more visible issues of im-

port which really require less debate simply because of their very visibility. The decline of AIDS deaths in the developed world carries with it the very real potential for a decreasing investment in the basic research necessary for new drug and vaccine development. The argument advanced by the Bush administration to the World Health Assembly's annual meeting in Geneva in 2003—that a strengthening of patents (known as Intellectual Property Protection) that protect the rights of what we might call the author of a medicine and prevent his/her work from being copied, was the best way to spur research and development—is of course flawed. Intellectual Property Protection hampered the developing world's access to antiretroviral drugs and other medicines because of the increase in prices it engendered. However, the agreement at the end of August 2003—in the run up to the World Trade Organization meeting at Cancun—to implement what are called the Doha concessions, first mooted in 2001, to allow countries in the developing world to override patent protections and produce or import generic versions of drugs to combat public health epidemics, also does not provide a long-term solution although it is a form of progress. (These concessions were implemented in a much watered-down state due to a prolonged rearguard action fought by the United States once its own anthrax scare was over, and it felt it would no longer benefit from the agreed legislation and as such then needed to limit the impact upon its domestic pharmaceutical industry.)[30] If pharmaceutical companies feel that they will not be able to recoup the millions which they would have to spend developing a new drug—in other words if there is no demand for the drug in the developed world—then they will not make that investment, there will be no new drugs with patents to override. It is also the case that little effort is being made to tackle the gender inequality and poverty which are the main contributors to HIV risk in developing nations. Fighting against the invisibility of AIDS will not change this situation, but making AIDS visible (inasmuch as we can make a syndrome visible, inasmuch as AIDS is something which we might be able to see) does provide the opportunity for continuing debate. Of course this is not without risk; the making visible of AIDS, of another AIDS, of an Other's AIDS, also carries with it the potential for inaction, as giving substance to something through images and writing often leads to a freeing of responsibility.[31] We might state it simply, as: I have made it visible so now I can forget about it. We have to remember to forget however, as there must still be a moment of recognition before any forgetting can take place.

I began this paper by suggesting that Blondie ask for more than they appear to in *Picture This*, intimating that their desire for a total portrait was an unreasonable one, perhaps even greedy. We can now see that

such a suggestion was wrong. The ethical portrait is the total portrait, anything less than 'all' involves the violence of omission. Synecdoche as a rhetorical strategy is unacceptable, unwholesome, when it comes to the representation of AIDS. The part is always at the expense of another part, it is an investment, a choice made for particular reasons. A partial representation is never impartial, but a total representation would seem to be impossible. This does not mean efforts to represent AIDS must cease, far from it, but those efforts must incorporate an acknowledgement of the impossibility of the endeavour. AIDS is not one image, nor a thousand. Representations of AIDS must accept the unrepresentability of AIDS. They must say that they cannot say, they must say what remains unsaid in them, they must acknowledge that something will always be out of shot. A photograph like this one, airbrushed so that it conceals as much as it reveals, would seem to be a good place to begin in the search for a form of representation adequate to this task, a form of representation that draws attention to its own inadequacies. The picture that admits it omits is a picture without omissions, it is the total portrait.

The photograph of Gia Carangi, through its use of airbrushing photograph, may provide an example of what John Paul Ricco has called a 'disappeared aesthetics', an aesthetics founded on imperceptibility. Ricco writes that in 'the time of AIDS, a disappeared aesthetics may be the only way to ethically relate to the historicity and sociality of AIDS; to avoid sparing loss as has occurred in the history of symbolizing, narrativizing, and putting a face to AIDS.'[32] The materiality of representation—its presence in the world—threatens to obscure the very loss it sometimes seeks to commemorate. Here we might think in terms of those who would read Carangi's photographs as in some sense causing her to still be with us, who see the paper as the flesh. In this context we can read what has been lost through the process of the airbrushing positively. In a sense, perhaps, airbrushing is the only way to remember. It works to foreground what is absent. It functions here to call attention to loss in itself; it helps to point towards the greater loss that was the death of Gia Carangi herself. It focuses on what must remain forever out of shot.

8

HISTORY
Re-viewing the French Revolution
Valerie Mainz

On 14 July 1984, the Musée de la Révolution française, the only museum in the world dedicated to the French Revolution, was officially inaugurated in the town of Vizille.[1] While it is to be expected that the French State would have a didactic and commemorative museum dedicated to its founding moment—the French Revolution—neither the event being remembered, nor the form of that remembrance, were then, or are now, static concepts sufficient to hold the terms '*musée*' and '*Révolution française*' in a fixed relationship. It is the purpose of this paper to trouble their relations at the intersection of the concepts of history and art.

It has long been recognized that the idea of history is an inherently unstable concept. This does not prevent Lionel Gossman from making a case for the testing out of historical ideas critically although this is to be done by the giving of a narrative structure to historical reasoning.[2] Gossman proposes that, within a progressive view of our understanding of the past, closer attention be given to the structures of argument and debate at the level of the historical narrative itself. Art history must similarly acknowledge that the objects of its enquiry exist as the products of an inherently unstable relationship between the present and the past. The ideas of art history arise, furthermore, out of considerations of the past and present material circumstances of a work of art and these must, too, be viewed critically. In accounting for how objects are structured, situated and narrated in time and place, we must integrate material circumstances and physical conditions within cultural and social histories that all change over time. The variable moments of the historical museum of the French Revolution and of the artwork come together in this chapter to play out concepts of cultural theory and history. Via objects and artefacts placed in a specially dedicated public mu-

seum, the changing social constructions of those who make, narrate and view the historical phenomenon known as the French Revolution will be addressed.

As a site for cultural analysis, resistance and transformations, the processes of the museum and the presentation of the museum involve the close reading of objects and are socially constructed. The housing of artefacts in a public museum, free to all at the point of entry, provides time with meaning and holds the objects to account as physical artefacts and as acts of memory.[3] The example of the Musée de la Révolution française will be used to show how a collection of material goods can be made to stand in for the absent referent of the French Revolution. This topic continues to exist in the present both as affective social memory and as hotly contested past historical phenomenon.

This study is about a series of encounters between the artworks and artefacts contained within the Musée de la Révolution française and between the making and the creating of the museum that houses and frames those objects. In addition, the problems of showing the French Revolution as a historical phenomenon and as meaningful for the present and future bring out how the past operates both fugitively and resiliently. In considering the ways in which the collection within the Musée de la Révolution française has been created and put together, I shall be addressing the ways in which the social practices of looking and seeing are themselves acts of framing that give rise to knowledge and meaning.

Presenting the Museum of the French Revolution at Vizille

No location is ever historically or geographically neutral, or without referents that offer possibility for interpretation. Some locations, however, can signify to a greater extent than others as sites of social and cultural memory invested with a symbolic aura. In *Les Lieux de mémoire*, Pierre Nora has made distinctions between memory as the sacred, affective and continuous experience of the past in the present and history, once memory is over, as a relativizing critical discourse about the past.[4] In what follows, I shall show the breaking down of such distinctions by considering how a museum and the material objects it contains can incorporate and commemorate events within history. At the same time and alongside the immediate and affective responses that a building and its artworks can provoke, an enquiry into why the Musée de la Révolution française exists at Vizille reveals much about the social processes that are activated in the making of a nation's cultural history. These processes involve interested participants who operate at the bureaucratic, institutional level in attempting to put into effect signifying systems and structures that have far-reaching cultural and social impli-

cations. In the case of the location of the Musée de la Révolution française at Vizille, a local initiative in a depressed area used to its advantage the national government's policies of decentralization.

Vizille is a town of around 10,000 inhabitants in the alpine administrative department of Isère on the outskirts of the more prosperous and expanding industrial city of Grenoble. The town square is dominated by the largest château in the Dauphiné region of Eastern France. Although the external stone walls of this castle date to the early seventeenth century, the interior has been completely changed because of the ravages of major fires and the alterations and conversions of the successive owners of the domain.[5]

Before the making of the Musée de la Révolution française in the building, this site had housed four existences of some significance to the French nation.[6] In the early seventeenth century, the château had been the major residence of François de Bonne, Duc de Lesdiguières, who ended up as the last High Constable of France but who, for much of his life, had been the leader of the Huguenot forces in the Dauphiné. On 21 July 1788, the château had housed an Assembly of the Estates of the Dauphiné. The members of this Assembly had called for the meeting of the Estates General at Versailles, an event that took place the following year and which is generally considered to be a founding moment of the first French Revolution and of the birth of the modern French nation. The Perier/Casimir-Perier family had owned the château from 1780 to 1885 and installed a manufactory of printed calico there. During the nineteenth century, members of this family included bankers, industrialists and government ministers. Between 1924 and 1970 the château had been the official summer residence of the Presidents of the French Republic. So, far from being a neutral site, the pile of the castle already had much symbolic historical baggage in the French imagination before the founding of the Musée de la Révolution française there. Michel Vovelle, the President of the museum's first advisory board, noted this historical baggage, or experience of a series of events or fabula, on the occasion of the museum's inauguration. He announced that the Musée de la Révolution française 'is a wager on cultural decentralization, but a wager justified by the historical heritage of this locality and by the frame itself of the castle and its park'.[7]

In the museum, a large painting of *Le Serment du Jeu de Paume à Versailles le 20 juin 1789* by Auguste Couder (8.1) faces, over a stairwell, a painting of *L'Assemblée des trois ordres du Dauphiné réunie dans la salle du jeu de paume du château de Vizille, le 21 juillet 1788* by Alexandre Debelle (8.2). The painting by Debelle is a copy of a larger work that now hangs in the council chamber of the Conseil Général de l'Isère.[8] It was one of the very first of the new museum's acquisitions in 1983 when it was

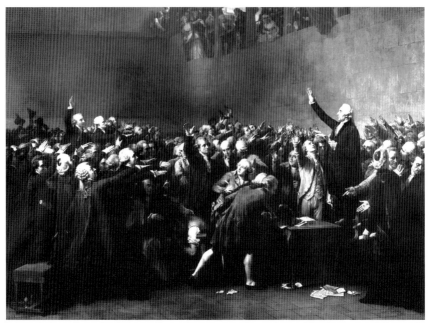

8.1 Auguste Couder, *Le Serment du Jeu de Paume le 20 juin à Versailles 1789*, 1848, MRF D 1995–1, Vizille, Musée de la Révolution française.

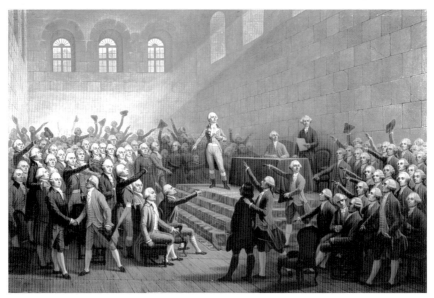

8.2 Alexandre Debelle, L'*Assemblée des trois ordres du Dauphiné réunie dans la salle du jeu de paume du château de Vizille, le 21 juillet 1788*, 1862, MRF 1983–7, Vizille, Musée de la Révolution française.

purchased with the Perier family archives in advance of the museum's opening.[9] In its artistic expression and aesthetic values it cannot compete with its more monumental counterpart that was exhibited at the Paris salon of 1848.[10] Both these paintings follow on from the revolutionary intervention of Jacques-Louis David's drawing of 1791 for *Le Serment du Jeu de Paume* project (Paris, Musée du Louvre, Cabinet des Dessins, en dépôt à Versailles, Musée national du Château) although they are composed more realistically than is the earlier heroic and evocatively emotive prototype.[11] The hanging of the two nineteenth-century paintings at Vizille produces, in the twentieth and twenty-first centuries, a clear visual filiation back to the separate events that took place in June 1789 at Versailles and in July 1788 at Vizille. The two paintings commemorate two separate moments from the past. Their placement and hanging in the museum can also evoke the French Revolution as a striking, unified and less disparate, more simultaneous event in history. Both compositions have the representatives clustered together around recognizable leaders in a moment of patriotic group unity within the extraordinary surroundings of a tennis court. In commemorating the meeting of the representatives from the Estates of the Dauphiné, the event of Debelle's work is thus now to be seen as a forerunner of what was to take place on the national stage the following year. The monument of 1888 erected in the town square outside the main gates of the château has the inscription: 'To the glory of the Assembly of Vizille, 21 July 1788, to the representatives of the three orders of the Dauphiné who were the first to affirm the rights of the nation and prepared the French Revolution/*A la gloire de l'Assemblée de Vizille, 21 juillet 1788, aux représentants des trois ordres du Dauphiné qui ont les premiers affirmé les droits de la nation et préparé la Révolution française.*'[12]

Robert Chagny has examined the ways in which the myth of Vizille was played out during the nineteenth and twentieth centuries.[13] In the case of the meeting at Versailles, we know that the deputies to the recently formed National Assembly, who had congregated there, swore an oath not to disperse until a constitution for the realm had been fixed.[14] In the case of the Assembly at Vizille there is, however, no evidence that an oath was ever taken at the meeting and its location in the tennis court is only a traditional association that gained credence in the nineteenth and twentieth centuries.[15] The tennis court of the château of Vizille burnt down in a great fire of 1865.[16] Indeed, tensions other than those of a spontaneous show of patriotic unity were at the heart of the Vizille Assembly that dealt with rights of representation in a political compromise between the conflicting interests of the nobility, the clergy, prosperous town dwellers and the rural peasantry.[17] For their own political interests and advancement, members of the

Perier/Casimir-Perier dynasty were, though, keen to promote their château as the birthplace of a great revolution founded on élite, liberal principles of representative government.[18] In the painting by Debelle (8.2), Claude Perier, proprietor of the château in 1788, is shown bottom left in the role of a dignified host. Perier's presence provides justification for the marking out of the present site as of special significance in the commemoration of the French Revolution. The renovation of a large, imposing ancient château in a rather neglected dormitory town has entailed the making of a museum. The renovation of this particular château has also made out of a museum of the French Revolution a monument to its own making. The making and presentation of this museum have involved processes that are selective, continuous and that vary over time according to continuously changing contingent circumstances.

Time specifics

Just as no location can ever be situated as a wholly neutral site in time and in place, so can no object of historical study ever be wholly divorced from conditions of time and place in which it comes to light and continues to exist. The opening of the Musée de la Révolution française in Vizille in 1984 has to be considered within the varying frameworks of what the French Revolution has come to stand for in that time and in that place, as well as in later times and places.

It is no mere coincidence that the initiative for the museum took off in the lead up to the bicentennial celebrations, for this was a time in which the historical phenomenon of the French Revolution as a site of competing discourses was being reinvigorated. The pronounced left-wing sympathies and comments on the Revolution that its instigators, such as Louis Mermaz and Michel Vovelle, were making in the early 1980s, shed light on the making of this institution. These views have also to be situated in the years leading up to the fall of the Berlin Wall and the increasingly active attacks against these left-wingers as to the position of the French Revolution in world history.

The proposal that a museum of the French Revolution should be housed in the château at Vizille dates back to 1924 when the castle and its domain were taken over by the French state. A local newspaper, the *Gazette des Alpes* contained, in a special edition, the proposal noting that Vizille was '*berceau même du grand movement de 89*'.[19] The proposal was cited as the opening thrust of what is to be considered the founding document of the present institution, an *Avant-Projet* of November 1982.[20] This report was for the Conseil Général de l'Isère, the department that still provides the bulk of the museum's funding. It was drawn up by Robert Chagny, a historian from Grenoble University, Vital Chomel, the head of the Isère archives and Michel Vovelle, Professor

of History at the University of Aix-en-Provence but soon to hold the prestigious chair in the History of the French Revolution at the Sorbonne. The report admitted that commemorating the Assembly at Vizille as the cradle of the French Revolution had considerable symbolic value that would not hold up to historical scrutiny. This symbolic value was, though, still considered to be an asset, not a hindrance, to the creation of the new institution.[21] The views here belong to the approach of Michel Vovelle who had achieved distinction as an avowedly Marxist interpreter of *mentalités* and cultural histories.[22] The report went on to give details of how the museum was to develop in stages to be marked by exhibitions and accompanying colloquia and conferences for different publics, including schools, clubs of the Third Age and works' committees.[23] The first three exhibitions were planned out as, in 1984, *Une dynastie bourgeoise à l'époque de la Révolution: les PERIER*, in 1986, *Les droits de l'Homme ou la conquête des Libertés* and in 1988, *La Révolution commence à Vizille*.[24]

The *Avant-Projet* of November 1982 did not, however, treat the ideological foundation of the museum in isolation from other, more pragmatic considerations as it also contains practical reasons for why the pile of castle should be turned into a museum. The building had space, some of its rooms could quite easily accommodate the requirements of a museum and around 50,000 people were already visiting its grounds annually.[25] The project would, furthermore, fit in to a political policy of decentralization by not competing with what Paris had to offer and by using, instead, modern museographic techniques so as to allow the Revolution to be rediscovered in the regions. Final justification for the museum in the preliminary report was provided by the forthcoming bicentennial celebrations.[26]

The first exhibition, whose opening also marked the museum's official inauguration, closely adhered to the principles of the 1982 project. It began by documenting the involvement of the Periers in the slave trade and in their creation of the calico venture at Vizille as evidence of the rising bourgeoisie and the expansion of capitalist commercial enterprise.[27] It then went on to treat the Revolution mainly as a moment of national unity in line with the principles and events of 1789, although there were also sections on the siege of Lyons and the monetary crisis.[28] The role of Claude Perier in founding the Banque de France and in taking advantage of the opportunities opened up by the Revolution led on to the continuing national importance of the Perier dynasty as major industrialists and politicians of the nineteenth century.[29] One of their number, Augustin Casimir Perier had become President of the Conseil under Louis-Philippe and had even been instrumental in crushing an uprising of silk workers in Lyons in 1831.[30]

At the opening of this exhibition, the socialist politician Louis Mermaz—who was, at the time, President of France's National Assembly as well as of the department of Isère and who had been a prime motivator in forcing through the institution of the new museum—gave the opening address.[31] The speech began by stating that the 500 delegates to the Vizille Assembly could not have foreseen that the Revolution had begun on 21 July 1788 at Vizille, but all knew that from that date the history of the country had swung into the new, the unprecedented, the irreversible.[32] The speech contained fulsome praise for the Revolution as *'fruit d'une perpétuelle tension entre le passé et les préoccupations du présent'*.[33] It had universal, long-term significance and had brought a new era of liberty to the oppressed of the world, in contrast to today's individualism, corporatism and excessive wealth for some, urban marginality for others.[34] This rhetoric gives to the foundation of the museum a clear political significance and undoubted left-wing focus.

In its promises of equality, fraternity and liberty, of universal truth and of happiness, socialists of the nineteenth century and beyond had seen in the first French Revolution a source of obvious inspiration for future revolutions to come.[35] Counter-revolutionary sympathizers, on the other hand, treated the historical phenomenon as an aberrant social crisis that had fostered only destruction and terror.[36] Reinvigorating this polemic in the 1970s and 1980s, François Furet urged a more self-critical historiographical and philosophical focus. Following on from de Tocqueville, he proposed that the divorce between the stated aims, objectives and rhetoric of those who promoted the causes of revolution on the one hand, and what the Revolution actually achieved on the other, should be highlighted.[37] This revisionist approach separated off the understanding of the historical phenomenon from its celebration. Right-wing sympathizers of Furet's position placed the Revolution within a trajectory that led from the Enlightenment to the modernizing, controlling, centralizing, totalitarian bureaucracies of the twentieth century.[38]

More recently Steven Kaplan has analysed the bicentennial celebrations of 1989 in France and the processes of creating those celebrations as phenomena of the heritage industry within the cultural consumption of postmodernism, whilst also suggesting that the issue of the French Revolution belongs to France's own *Historikerstreit*.[39] For Kaplan, the subject of the Revolution was debated in France with less visceral intensity and without the recent spectre of collective, national guilt that the experience of the Third Reich and the Holocaust had prompted in Germany. As with the arguments in Germany, however, interest in the workings of history had spilled out beyond the academic forum into the arenas of public opinion and media coverage. These historical arguments were also used to achieve political purposes and had arisen

out of what was perceived to have been the exceptional nature of the Revolution.[40]

When Michel Vovelle returned to the Musée de la Révolution française in 2001 after an absence of eight years, he talked of himself as a ghost and lamented the closure by ministerial decree of the Commission of the History of the French Revolution within the Comité des sciences historiques.[41] This commission had been named the commission Jaurès after the socialist historian and politician who had founded it in 1903. During Vovelle's absence, the museum has, however, faced the challenges that a turning away from an overtly Marxist agenda might entail. Firstly, the institution placed a premium on an astute amassing of treasured artworks with the potential for high market value. Subsequently, the collection has been opened up to scholarship and debate about the very nature of the enterprise it seeks to pursue.

From historical museum to art museum

The transition from museum of history to fine art museum and then on to a more self-consciously framed *mise en scène* with more visible curatorial acts problematizes the act of looking within concepts of the French Revolution.[42] The constitution and display of a collection within a museum can no longer be presented as a seemingly direct, unmediated, transparent holder of art works or within a master narrative of history 'as it was'.[43] As Eleanor Hooper-Greenhill has explained, objects do not just speak for themselves nor can they be seen as ideologically neutral.[44] Rather we need to disturb conventional notions of the transparency of the visible by considering the framing roles of the museum in structuring and giving meaning to the objects that have been grouped together and to relationships between the viewer and to what is being viewed.[45] The processes of the museum and of the presentation of the museum are travelling concepts. They involve the close reading of objects, are socially constructed and are also meaningful in history and change over time.

One of the major impediments to the founding of the new museum had for many years been the absence of a permanent collection to put in it. Mermaz had ended his opening address of 1984 with a citation from the nineteenth-century historian Jules Michelet who was, in the opinion of Mermaz, '*le plus grand historien de notre peuple*'.[46] The citation from Michelet noted that the Revolution was to be celebrated within our souls for, whilst the Empire had the Arc de Triomphe and royalty had the Louvre and the Invalides as monuments, the Revolution had for its monument only a void.[47] In celebrating the initiative of the new museum, Mermaz was also thus openly acknowledging that the initiative was to rectify a perceived commemorative, monumental void.

Hubert Landais, Director of French Museums, had, for instance, raised precisely this objection in January 1983, in a letter to Louis Mermaz suggesting that the way forward should instead be a centre of documentation on the model of the Diaspora Museum in Tel Aviv.[48] In envisaging that computers, videodiscs and films could be consulted for the most remarkable achievements of the Revolution in the provinces and in Paris, Landais was promoting the viewing of history as a collective memory and trauma to be overcome. The visual aids and the documents they incorporated would have an overtly educational purpose and content would be prized for its value as illustration, reportage, witness and testimony. The museum was precisely not to be about the amassing of expensive treasure and the display of a tastefully arranged array of fine art objects, that were to be valued for their high monetary value and for their enduring and unique aesthetic qualities. Landais may also have been mindful of the financial requirements that the building up of such a new art collection might entail. It is notable that the curators of rival collections, Pascal de la Vaissière, of the Musée Carnavalet in Paris, and Jean-Pierre Laurent of the Musée Dauphinois in Grenoble had responded negatively to the proposed creation of the new museum.[49]

Connoisseurial appreciation, wealthy patronage and the fine art market have for centuries been mutually reinforcing.[50] That the society, culture and political system which decisively ruptured the rule of the privileged in France should be given short shrift by those who promote formal aesthetic values, great art, great artists and specialist expertise is, therefore, hardly surprising. The brothers de Goncourt, who were such enthusiastic advocates of the arts of the Ancien Régime, considered, for instance, that the Republic of Year II had worked towards the annihilation of civilization and of everything that sweetened, ennobled, beautified and polished.[51] For most of the twentieth century, academic scholarship and art historical discourse have, in the main, followed on from the damning perceptions of Edmond and Jules de Goncourt in characterizing negatively the cultural production of the Revolution in spite of its marking a moment of significant transition from the Enlightenment to Romanticism. In his survey of Neo-classicism, Hugh Honour still considers that the great works of art of this period, such as Goya's prints and paintings and David's *Marat à son dernier soupir* (Brussels, Royal Museums of Fine Arts) and *La Mort de Bara* (Avignon, Musée Calvet), are marked out not by their contemporary allusions but by their universal significance.[52]

When the first director of the new museum, the art historian Philippe Bordes, took up his appointment in October 1984, the challenge of assembling and creating a permanent collection of works to

be associated with the French Revolution was addressed head on.[53] By July 1985, Bordes had put together a rather eclectic collection and exhibition of around 200 items purchased at a cost of around £100,000.[54] These first acquisitions included prints, medals, coins, playing cards, books, swords, wallpaper, fans, items of clothing, furniture, earthenware as well as sculpture, drawings and paintings. They proved that far from there being little available evidence of the material culture of the period, the French Revolution had, in fact, prompted an overwhelming amount of visual production that was still accessible to the collector. After amassing this initial hoard, Bordes went on to build up a collection of fine art works that have the values of the authentic and the aesthetically elevated. From a history painting like *La Mort de Brutus* by Pierre-Narcisse Guérin (Vizille, Musée de la Révolution française), to the terracotta statuette of *Le Peuple français éclairant le monde* (Vizille, Musée de la Révolution française) with its torch brandishing male nude attributed to Robert-Guillaume Dardel, to a drawing of *La Mort de Bara* by Jacques-Louis David (Vizille, Musée de la Révolution française), the contents of the collection demonstrate the visual and conceptual richness of this period's 'high art' artistic production.

In re-orientating the ideological premises of the institution's founders and founding moments, the policy has also provided some safeguard against future re-evaluations about the significance, or otherwise, of the first French Revolution in history. Just as the historical phenomenon of the French Revolution might come to be increasingly discredited in future histories, so a museum, solely dedicated to such a historical phenomenon and funded at public cost, might be vulnerable to closure and erasure. A collection of unique, material objects of real monetary value is much harder to do away with when governing authorities and concomitant ruling ideologies and priorities change. The physical presence of so many art works situated together as a substantial collection should, furthermore, act as a deterrent against a turning away from the museum's overall subject matter of the French Revolution. And, given the chequered history of the château, the collection it houses is now also a substantial investment in the building's long-term future in the town of Vizille and in the social fabrics and infrastructures that support the initiative.

A gallery devoted to earthenware in the renovated former orangery (8.3) demonstrates the modernist fine art approach well. Like the print media, earthenware or *faience* was relatively inexpensive and easy to reproduce. It was to be found in relatively modest households rather than in the castles and mansions of the wealthy, who preferred the finer qualities of porcelain.[55] Unlike the perishable qualities of works on paper, earthenware is not damaged by prolonged exposure to light. In

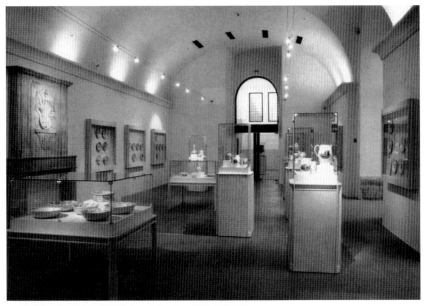

8.3 View of the Faience Gallery, Musée de la Révolution française, Vizille.

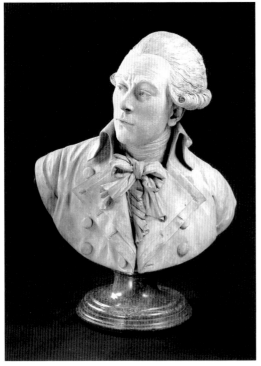

8.4 Claude-André Deseine, *Maximilien Robespierre*, 1791, MRF 1986–243, Vizille, Musée de la Révolution française.

the gallery over 70 pieces of earthenware with revolutionary motifs, emblems and allegories have been displayed in pristine glass cases, within their own aura of carefully focused lighting. Each of these objects had cost the museum between £300 and £1,500 depending on condition, iconography and the rarity value of the iconography, but the display implies a measured, abstract, systematic, tasteful visual order.

By 1996 it was possible to publish an authoritative *Catalogue des peintures, sculptures, dessins* documenting, publicizing, providing a rationale and systematically justifying the museum's holdings of fine art works by medium, maker, provenance and financial investment. An example of Bordes's farsighted acquisitions policy is the purchase in 1986 of Claude Deseine's terracotta bust of Maximilien Robespierre (8.4).[56] The bust is likely to have been a preparatory model for a sculpture that was offered by Deseine to the Jacobin club of Paris in December 1791.[57] It shows the Jacobin leader not as the incorruptible dictator and future begetter of the Reign of Terror, or even as the eloquent orator, but as an alert great man of thought. In displaying this bust of Robespierre, the museum retrieves what had been rendered invisible—the notion that Robespierre might have been sensitive and far-sighted—whilst, at the same time, creating anew. The presence of the absent politician Robespierre is given tangible form within the conservationist, patrimonial bias of the fine art museum.

The securing of artworks purchased at auction, from specialist dealers or, more rarely, through private agreements with a concomitant policy of financial investment, has secured the institution's long-term future. During the bicentennial of 1789, the institution gained a name and international prestige for itself as a fine arts museum by loaning works worldwide to more than 40 different exhibitions. The museum is now a custodian of especially inspired artistic treasure.

The Musée de la Révolution française in post-modernity

In the years 1986–92, a challenging and innovative dynamic was further opened up within the building of the Musée de la Révolution française, when a new space was hewn out of the bowels of its enframing seventeenth-century château. This new space transforms the modernist orientation of the fine art museum into something that is much more consciously dialogic and self-reflexive. Prompted by Philippe Bordes and designed by the chief architect of the department of Isère, Jean-Louis Taupin, the new galleries used the foundations of the château that are subsumed into the rock on which the building stands.[58] The architecture of these display spaces now serves as an additional object and vehicle of meaning within the collection as a whole. The museum is no longer merely a place of objects confined by material constraints,

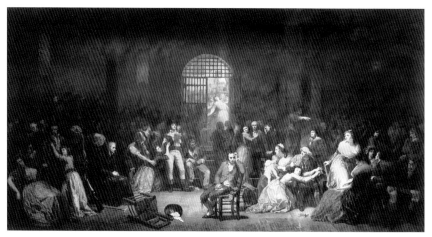

8.5 Charles-Louis Müller, *L'Appel des dernières victimes de la Terreur*, 1850, MRF
 D 1992–2, Vizille, Musée de la Révolution française.

but becomes a framing *mise en scène*, actively giving shape in the present
to the past by narratively linking and bridging the present with the past.
The art works are now shown not as separate and isolated and as merely
having been deposited within the building. Rather the ways in which the
objects and artefacts are juxtaposed and grouped together within the
carefully constructed surroundings and display spaces foster a sense of
critical engagement between viewer and what is being viewed.

 In the large Salle de la République, measuring 28 metres by 18 metres,
there are four gigantic pillars with the proportions of the Doric order
at Paestum.[59] Here, the brutal, severe concrete evokes the moving but
austere language of signs and symbols that held sway during the Rev-
olution. Entering the large *mise en scène* of the exhibition space, the vis-
itor experiences the sense of the French Revolution as a place of
clinical confinement, cold stone, controlled but passionate emotion and
intellectual ambition. This gallery houses several vast nineteenth-cen-
tury canvases, on long-term loan from the Louvre and other major
French museums, enabling the paintings here additionally to bear wit-
ness to the importance of the first French Revolution to the history
of nineteenth-century France. The scenography of showing the French
Revolution comes to incorporate here not just the moments in history,
the politics and the arts of the decade of revolution but also subsequent
developments in history, politics and the arts. The *grandes machines* of the
nineteenth-century Paris Salon exhibition are exemplified by Charles
Müller's major exhibit of 1850, *L'Appel des dernières victimes de la Terreur*
(8.5).[60] In this prison scene, the figure of the poet André Chénier is
seated, isolated centre stage as he hears, amongst the tumult and an-

guish of his fellow prisoners, his own name being read out as one of the last victims of the guillotine. Anti-republican and Catholic in sentiment, Müller's work has the tragic scope, histrionic breadth and sentimental pathos of a novel by Dickens. The viewer is faced here not with a pedagogical display of historical artefacts but with an object as artwork in a space and environment that exert a powerful pull towards the dramatization of history.

Within the managed spaces of the collection, the exhibits have been displayed in carefully handled choreographies that are subject to change and to the potential for changing interpretations over time. The busts of both Mirabeau by Tessier and of Robespierre by Deseine have been displayed at the entrance to a room on the first floor, as if greeting the visitor. Within this arrangement, larger statements to do with the overall theme of the museum and about how that theme can be understood by the visitor are being articulated. We have been, for instance, confronted by an unfolding of time within space, with notions of progress and technological advance and with the control of nature. Questions about how a desire for abstraction and the rhetoric of virtue can come up against the demands of necessity have come to be embedded within the very fabric of the display space. From behind concrete and glass, Mirabeau, who died in April 1791 and was soon discredited for having secretly corresponded with the King, enters into a dialogue across time with us and also with Robespierre who went to the guillotine in 1794. The juxtaposition of the sculpted busts makes tangible and visible what in history and memory has become abstract and invisible. The terracotta and plaster busts were displayed in such a way as to present the viewer with constructed presences, consciously created in time and space. Sharing a historical space, these models were made to exist as oppositional leaders of different parties. Critical linking narratives could be woven from these presences that offered the potential for meaningful re-assessments of preconceived notions in line with the sort of definitions for the making of history espoused by Lionel Gossman.

Several other recent major purchases and long-term loans acquired by the museum reveal just how complex the artistic engagement with the French Revolution has been over the subsequent periods since the 1790s. There are some nightmarish scenes, such as that of a painting of around 1833 entitled *Capet, lève-toi!* by Emile Mascré. Here, in a cell eerily illuminated by moonlight, the rough shoemaker and prison guard Simon rudely awakens the young, vulnerable boy Dauphin in an episode that harks back to the 1483 murder of the young princes in the Tower of London. As one progresses through the collections it is clear that the iconographies of both the scurrilous journalist Jean-Paul Marat and of his assassin, Charlotte Corday, are particularly prolific

and diverse. At certain key points in the subsequent history of France, Jean-Paul Marat and Corday meet again and again but under various guises and for different ends.

One of the most successful recent temporary exhibitions held in the museum has been of the works of the contemporary artist, Sigmar Polke. During the bicentennial, two exhibitions of Polke's works on the theme of the French Revolution were held in Paris and these paintings and drawings were gathered together for the show at Vizille in 2001.[61] In many of these powerful exhibits, humour and irony contributed to a rather terrifying vision of time, history and the French Revolution. In the painting *Jeux d'enfants* (Paris, Centre Georges Pompidou, Musée National d'Art Moderne), for instance, two children play with a severed soldier's head in a green, gold and flower-filled killing field. By locating this contemporary work of art, if only temporarily, within the collection of Vizille, its paternity, a print entitled *D'autres cruautés à Paris le 2 sept. 1792* (Vienna, Historisches Museum), is acknowledged in the present.[62] Past art is actively being commemorated within a present need for meaning.

The installations and their scenography remain, nonetheless, closer to the constructions of conceptual art than they are to the thrills and spills of the theme park. There is nothing of a Madame Tussaud's at Vizille and whilst some of the views on offer may have something of a chamber of horrors about them, the museum itself steadfastly rejects the spectacles of staged guillotinings or of daily tumbrel rides. Entrance is free to visitors, not customers.

An unusual feature of the museum's set up is the continuing interface that exists between the institution's public, national orientation and its provincial, regional funding and backing. The judicious collecting and exhibiting policy of those in charge of the day-to-day running of the museum has consistently fostered the raising of the department's profile as culturally forward looking. Tensions can, though, arise in having a museum with a major national remit located in a small town. On the one hand, local interests and priorities need to be articulated, and, on the other, sufficient scope must be given to the notion of the French Revolution as a national cause, that can also radiate high quality artworks outwards from Paris. A series of temporary exhibitions on the Perier dynasty and its activities have helped to bridge this divide.

Thanks to the support of the Department of Isère and of the French State, a magnificent purpose built, open access library and information centre opened in 2001 in two storeys of the north wing of the château of Vizille. This centre of documentation is devoted to the history of the French Revolution and the cultural activity of Europe at that time and complements the permanent display of objects and the

temporary exhibitions, housed in other parts of the building. These fa-
cilities give students and researchers the opportunity of assessing, ver-
ifying and further disseminating the fine art premises and provenances
of the museum's collections. Such an invaluable research asset does
not, though, exist in isolation. Besides consciously legitimating the work
of the Musée de la Révolution française, the regional authority has pro-
vided a forum and focus for scholarship and debate so that the prem-
ises on which the institution has been founded can continue to be
re-viewed critically in art and in history. Several distinguished historians
of the French Revolution such as Albert Soboul, Jacques Godechot
and Jean-René Suratteau have also left their libraries and specialist book
collections to this fledgling arena. Their bequests bring visitors to the
town for the benefit of scholarly enquiry and for open debate about the
sets of circumstances and concepts that have given rise to the work of
their lives.

By offering the facility of an ongoing research archive, the library
makes of the museum a centre of documentation. By linking critique
with object, the museum exceeds the brief of being a commemorative
monument to a past epoch as well as of being a monument to its own
making. The political events of the French Revolution remain central
to the whole enterprise but this enterprise does not merely document
or teach. The showing of fine art works within a finely handled scenog-
raphy of circumstances prompts reflection on how and why a particu-
larly turbulent past continues to be meaningful in the present. Even
though discourses on war and terror have now become only too per-
vasive it is still possible to view the blend of art with politics at Vizille
not with equanimity but without feeling ever more oppressed and ter-
rorized because of the past. This is because at Vizille we have been
asked to think, respond and make connections for ourselves.

9

NOSTALGIA
The identification of the nostalgic
Ihab Saloul

The day Israel celebrates annually as its Day of Independence, Palestinians commemorate as their day of catastrophe (or *al-nakba*, 1948). To most Palestinians, *al-nakba* represents the climactic formative event of their lives. In the aftermath of *al-nakba*, Palestinian society was transformed from a thriving society into a *nation of refugees*, dispersed across multiple geo-political places. Following the events of 1948, *al-nakba* emerged in Palestinian culture as a concept that both signifies an unbridgeable break between the past and the present, and one that romanticizes the Palestinians' loss of their homeland as 'a loss of paradise'. This articulation of the lost homeland as a lost paradise, I submit, signifies a 'nostalgia' for a relatively distant past. It is my argument that such a nostalgia informs the Palestinians' experience as well as their cultural memory of loss, through which their identification with the lost homeland is constructed.[1]

Nostalgia, however, has often been criticized in contemporary theory as a negative sentiment that entails an emotional addiction to an unreliable and idealized past. According to its critics, nostalgia makes the past appear more attractive to live in than the present, and hence can make people want to re-live the past and invent allegedly 'ancient traditions' while turning away from the present. According to this view, nostalgia is seen as the opposite to the idea of progress. It supposedly emerges because of an identity crisis or a lack of self-confidence in the present, paralysing political agency in the present, and by and large remaining a sentiment to be shunned. Yet, it seems to me that such critiques do not address several important issues the term 'nostalgia' calls forth, particularly the question of how the past is transmitted into the present, and how this transmission might be productively used in order

to specify notions of cultural memory and a sense of self of the people involved.[2]

Instead, therefore, I take *the nostalgic* as an emotion that allows for a form of cultural transmission of memory. Within such transmission historical and political purposes can vary, and thus the emotion can bear a complex and potentially productive relationship to the past. In this view, understanding the dynamics of transmitting past into present necessarily entails, as Nanna Verhoeff argues in her book, *The West in Early Cinema: After the Beginning*, studying a sentiment that is more specific than the general term 'nostalgia' suggests. According to Verhoeff, 'instead of dismissing nostalgia as sentimental and escapist, we should understand that sentiment as historically relevant and culturally helpful.'[3] Moreover, rather than perceiving nostalgia as a romantic longing for the past in order to escape the present, one should perceive it as a longing that attempts to deal with a problematic present. In other words, Verhoeff continues, 'where the present is in crisis, the recent past whose loss partly accounts for that crisis can be invoked, absorbed and integrated within the present … Thus, the present and the past become unified in a nostalgia that functions as an investment of the past *in* the present.'[4] Unlike what has generally been allowed in recent discussions, Verhoeff's view puts forward a distinctively different conceptual notion of nostalgia. Her view reconceives nostalgia, not as an opposite to the idea of progress, but as a special case of it.[5] In what follows, I will reconsider, with the assistance of Verhoeff's view, the possibilities of the nostalgic as a form of cultural transmission in the Palestinian context.

In order to do so, I will chart some of the different senses through which nostalgia travels in Palestinian culture, from derogatory to productive. The focus of my discussion, therefore, will be on the dynamics of the Palestinians' nostalgia for the lost homeland and its past, in relation to other, related concepts such as 'memory', 'exile' and 'identification' with the lost homeland, as presented in the writings of 'the first generation of post-*nakba* Palestinians'.[6] The object of analysis will be Jabra Ibrahim Jabra's novel *The Ship*, which I take as an example of this literature. In *The Ship*, the story of the exiled Palestinian Wadi Assaf, particularly his experience and memory of *al-nakba*, serves to buttress the novel's account of the Palestinians' nostalgia for the past in general and their cultural memory of *al-nakba* in particular. A close reading of *The Ship*, primarily Wadi's narrative, will demonstrate that Jabra's novel, as a literary narrative written from the point of view of the first generation of post-*nakba* Palestinians, functions as a medium that transmits the cultural memory of *al-nakba* and details a specific and a productive

form of nostalgia for the past around which a sense of attachment and identification with the lost homeland emerges.[7]

Departure

The Ship is a novel about a group of people on a sea cruise.[8] The story begins as the ship departs the land, and has two main narrators, Isam al-Salman (an Iraqi engineer), and Wadi Assaf (a Palestinian merchant), plus a secondary narrator, Imilia Franesi (an Italian divorcee). All three narrators are also major characters in the novel. While Isam and Wadi alternate in their narration of most of the sections in the novel, Imilia only speaks once. Each narrates different parts of the action that takes place on the ship. The story that unfolds is one of loss, agony and nostalgia for a relatively distant past. While the characters suffer in the present, their suffering emanates from a past agony that shapes a memory as nostalgic yearning.

Indeed, in its narrative's emphasis on the past, *The Ship* seems to turn sharply toward a nostalgia that exhibits an overtly Palestinian longing for a lost homeland and its good times. The novel ends with a description of the past, and its final scene is set in the homeland. The past of the homeland, however, through which *The Ship* works its way, is a very troubled one. *The Ship*'s nostalgia for this past is not conventional. It is not a nostalgia that aims at regaining the lost past as an idealized site of origin. Rather, the concern of the novel as it returns to the relatively distant Arab past in general, and to 1948 in particular, from the vantage point of the Arab condition in the late 1960s, is the question of how cultural memory is transmitted. As such, the novel portrays the agonized self, its political and ideological distortions, and the variety of nostalgias through which the Arabs in the 1960s, particularly Palestinians, apprehended their past.

The Ship, therefore, presents a nostalgia that is built on a juxtaposition of past and present, the pre-agonized self and the present one in its hesitations and anxieties. Within such a nostalgia, the past constantly inhibits the present. I will argue that central to *The Ship*'s conception of how the past inhibits the present is the concept of trauma. In my discussion, I adopt a discursive notion of trauma that I treat as a signifier of loss. Articulations of loss, however, can vary between two extremes, depending on whether the loss corresponds to the death of a significant other, or to the experience of separation from this significant other. In my analysis of *The Ship*, I take both articulations of loss as cases of trauma. In both articulations, however, trauma is not only determined by the 'character' of the loss that triggers it, but also by the structure in which this loss is experienced and perceived. In other words, trauma is not characterized by the extremity of loss that takes place. Rather, loss becomes traumatic for a person only when this person's symbolic

order fails to provide consistent frames of reference through which such loss can be experienced. Such a discursive notion of trauma not only enables us to distinguish between trauma and nostalgic memory as analytical concepts, but also helps us to assess trauma as a disorder of both memory and time.[6]

Particularly in relation to *The Ship*, such a notion of trauma can be productive in assessing the precise problems with which the characters of the novel have to struggle in their return to the past, as they are confronted by both trauma and nostalgic memory. The novel returns to the past, not as an ideal wholeness and comfort, but as a site of *catastrophe*, social disorder and cultural trauma. Moreover, the moment from the past around which nostalgia takes place in *The Ship* is a moment that stands for traumatic 're-enactments'. Those re-enactments persistently leap forward into the present and impose themselves on the agonized self. And yet, as *The Ship* narrates, within the return of the traumatic re-enactments of the past into the present, a moment of salvation emerges. This moment is synchronized with the traumatic re-enactments by means of nostalgia through which such re-enactments bring back with them a nostalgic memory of a past prior to the moment of trauma.

The Ship's portrayal of the consistency of 'trauma' and 'salvation' evokes a cultural and political urgency, particularly in relation to Palestinians, through which the 'ideal past' that existed, as well as the traumatic moment through which that past ceased to exist, can be loosened, opened up and become subject to change. Such a contingency, however, not only arises through a nostalgic return to the moment prior to a past trauma, but also by transmitting the memory of that particular moment. Thus, the nostalgic return to, and *of*, the past as a site of both catastrophe and salvation is an essential condition of possibility both for dealing with the present and the construction of the future. This nostalgic return, in addition, always takes specific cultural forms. Particularly in relation to Palestinians, these cultural forms include their suffering in exile, their attempts to establish a link with the lost homeland, and their inability to reclaim the lost land. Hence, the aim behind the nostalgic return to the past presented in *The Ship* is not to recover the 'ideal past' of the homeland. Rather, it is a transmission of nostalgic memory that aims at bridging the gap between the subject (the Palestinians) and the object (the lost homeland) of loss. In this sense, nostalgia is put to work as a cure.

Escape and the sea

In the beginning of the novel, each of the characters attempts to escape his or her past as a way of healing past wounds, only to find that escape

is nothing but an illusion. This is so, simply because there is nowhere to escape; hence, the setting on a ship. The opening sentence of *The Ship*, uttered by Isam, contains the following description:

> The Sea is a bridge to salvation—the soft, the hoary, the compassionate sea. Today, it has regained its vitality. The crash of its waves is a violent rhythm for the sap that sprays the face of heaven with flowers, large lips, and arms reaching out like alluring snares. Yes, the sea is a new salvation. (p. 1)

This statement reveals an obvious gendering of the sea. Such gendering comes about through the use of images such as 'flowers', 'large lips' and 'arms'. As a result, a feminine image of the sea emerges. Yet, what looks like a poetic description of its beauty turns into a statement on the theme of the impossibility of escape. This impossibility is presented through the use of imagery of seduction and capture. In the beginning of the passage, the sea is a possible 'bridge' that may lead to salvation. This possibility of salvation is employed by the (material) personification of the sea, as a soft and a compassionate entity that embraces people without a home.

Yet the sea is neither soft nor compassionate. It is ever changing, and 'today, it has regained vitality'. The vitality of the sea is determined by its unstable cosmic rhythms. Because of its vitality, the sea is not only a place for compassion, but it can be also a place that harbours and produces 'a violent rhythm'. This violent rhythm, in turn, contains contradictory forces; beauty on one hand and danger on the other. At the end of the passage, the violent rhythm of the waves produces a vital force that 'sprays the face of heaven'. The spray of the sea contains a beauty—'flowers and large lips'—that entices a person into its seductive trap of 'alluring snares', from which it is difficult to escape. Through the imagery of the 'alluring snares', the sea not only becomes a confining or undesirable contrivance from which escape or relief is difficult, but it also becomes a potent symbol of being lost and *trapped*.

The sea, therefore, does not appear as a 'new salvation' at the end of the passage. Rather, its image as a dangerous trap makes it appear as a void, as a non-place. This emptiness, potentially infinite, causes the escapee's feelings and thoughts to be caught in a nostalgic reminiscence that revolves around a past and a particular place left behind. As a result, the past from which the characters seek to escape constantly impinges on the present in front of which they stand helpless and which they cannot change. Hence, the sea foregrounds the uselessness of escape.

Mr Palestine

The first time we are introduced to him by Isam, Wadi is described as a man who 'would talk and laugh with gusto, and when he stopped talking, all other voices sounded like croaking noises' (p. 18). Moreover, Wadi is one of the few characters in *The Ship* whose physical appearance is described in detail: 'He was tall, and his shoulders were bent forward in eager anticipation of whatever lay ahead. His thick black hair was almost perfectly combed and betrayed a sense of elegance and a care of his personal appearance' (p. 18). This detailed description of Wadi, I contend, involves more than an introduction of a character in the novel: Wadi is a character with a Palestinian specificity.

This specificity emerges in the novel through a complementarity between Wadi's physical appearance and his spoken accent. While, in his comment on Wadi's appearance, Isam makes clear that this influences his intuition of Wadi's identity, it is Wadi's Palestinian accent that provides confirmation of this:

> I could sense right away that he was a Palestinian, and my intuition proved right when I heard his accent. He reminded me of many Palestinian students I had met in England. One thing has always surprised me about the Palestinians: their love for words, even when they speak in English. (p. 18)

As this passage suggests, Isam is not only correct in his intuition of where Wadi comes from, but Wadi is also given specific Palestinian characteristics, particularly his 'accent' and his 'love for words'. This love for words and talking becomes, in fact, a remarkable technical feature of the novel. For example, in the conversation reported by Isam, Wadi's share amounts to about one third. As a result of this substantiality and specificity, Wadi becomes a figure who bears the trappings of 'the Palestinian'.[10]

Wadi's Palestinian specificity and his strong vocal presence serves, I submit, as a narratological device which facilitates a different internal focalization in the novel, particularly in relation to the past and the decision to escape one's land and roots. This internal focalization mediates between Wadi's personal memories and a more general Palestinian cultural memory. On a narratological level, the mediation between individual and collective memories is a significant one, particularly in relation to cultural memory. As Mieke Bal puts it in her book, *Acts of Memory: Cultural Recall in the Present*, the term 'cultural memory signifies that memory can be understood as a cultural phenomenon as well as an individual or social one.'[11] Thus, by having a free space to speak up with

a Palestinian accent, Wadi becomes an individual who belongs to a particular group (the Palestinians). Therefore, he becomes a more qualified individual to address the Palestinian loss of the homeland in a collective manner. In other words, Wadi's specificity, as an allegorical figure of 'the Palestinian', gives his character an advantage over the other characters in *The Ship*. Thanks to that special status, his nostalgic return to the Palestinian past not only reflects an individual narrative, but also represents a collective one. Hence, Wadi's memories, opinions and stories of the past, primarily because of their Palestinian specificity, need not only be understood as an individual memory, but can also be read as a Palestinian cultural memory of the past.

The past between truth and lies

Having pointed out the centrality of Wadi's character in the novel as an allegorical figure of 'the Palestinian', I will now examine the ways in which Wadi focalizes the past. In his return to the past, Wadi, like Isam, also sees it as a place of cultural disorder. Yet, unlike Isam, Wadi does not see this disorder as a distinctive characteristic of the Arab world in itself. Rather, Wadi narrates the cultural disorder of the Arab past in inclusive terms, primarily as part of the cultural disorder of the world in general. By doing so, Wadi not only offers a different interpretation of the past and its chaos, but also stabilizes his own position as a composite focalizor, a narrator and a transmitter of the story.

In Wadi's account, the chaos of the past is due to certain political betrayals. In his view, such political betrayals are inevitably linked to bodily and moral ones. In the beginning of the novel, while Wadi is involved in a discussion about the notions of 'truth' and 'lies', he connotes the cultural disorder of the past as an epistemological failure of exactly such notions. In order to describe such a failed epistemology, Wadi takes both the 'shameful meaning of the body' and its 'animalistic nature' as his points of departure:

> You see when it comes to love and sex, I'm a romantic. If you come with me when we get to Naples, you will understand what I mean. I am on vacation now … In Naples … you'll understand the meaning of the body. It is a shameful meaning. And why? Because it's the animal in you. The body is the only irrefutable truth. The thing which connects you and me with beasts…. The only truth, the ultimate boredom. Because truth is ultimately boring. I always prefer liars. Liars are aristocrats. They're rebels in their own way, and rebellion is always aristocratic. (p. 19)

In the beginning of this passage, Wadi sees the meaning of the body through its physicality as morally shameful, but also as 'irrefutably true'. However, through its physicality that 'connects us with beasts', this irrefutable truth is a 'boring truth'. Such boredom makes the 'irrefutable truth' of the body, primarily through its physicality, appear redundant. Moreover, because of this boredom, Wadi, at the end of the passage, ultimately connects the irrefutable truth of the body with lies.

Paradoxically, while Wadi is talking about the meaning of truth, he lies himself. His lie appears in his description of his reasons for being on the ship as being on 'a long vacation' (p. 20). Wadi's lie is manifested by the fact that later in the same monologue he describes himself as being exiled, 'I was forced out of my country' (p. 20). Yet, by lying about his status, by claiming to be 'on vacation' rather than exiled, Wadi consequently creates an epistemological confusion between what is true and what is not. It is exactly this confusion that Wadi seeks to comment upon and to push aside from the body. As a result of this confusion, the irrefutable truth of the body, despite its physical visibility, appears as a *blur*. In other words, this irrefutable truth becomes as vague and indeterminate as the vulnerable existence of the body itself. Moreover, the confusion between truth and lies, and the consequent blurring of the body are interminable and cannot be avoided. Because of this interminability, Wadi's preference seemingly, at the end of the passage, is for lies and liars. Romantically, he describes lies as a rebellion and an aristocracy. Yet, by doing so, his description produces another confusion, this time of lying itself. For one cannot be an aristocrat and a rebel at the same time, since these two meanings are opposed, and have historically and socially emerged as contradictory categories.[12]

Such a confusion of truth and lies leads Wadi to a denial of such categories, particularly 'truth'. For him, truth does not exist, and therefore he 'never wants to know it' (p. 19). And even if truth exists, then it exists as '[a] beggar, a monk, a heretic, a despot, a son of bitch' (p. 19). Wadi's admonition of impositions of notions of truth and lies, and perhaps by implication of all conceptual subdivisions and values, is enforced by the employment of all the negative categories of his milieu —'a beggar, a monk'—that function as the opposite of the romantic rebel and aristocrat. In Wadi's view, all forms of valuing become equally guilty. They constitute forms through which the world (or its experience) is not encountered on its own terms, but instead on the contested 'subjectivizing' value of such terms.[13] Moreover, such forms of valuing contribute to the construction of a representation whose reality replaces that of the world itself. The reality of such a representation is exactly similar to the reality of anyone who claims truth, 'either deluded and does not know it or a liar and knows it' (p. 19).[10]

Wadi's view of the failure of impositions of notions of truth and lies, together with the asymmetry of the body, is employed in *The Ship* as an interpretation of the disorder of the past. In his narrative, Wadi validates such interpretation by pointing out how such notions (truth and lies) equally failed to represent the reality of the Palestinian past, particularly the loss of the homeland:

> We [Palestinians] spoke the truth till our throats grew hoarse, and we ended up as refugees in tents. We fancied the world community cherished the truth, and turned out to be the victims of our own naiveté. We came to realize all this both as a nation, and as individuals. This is why, as an individual, I don't care what people say any longer. The only thing that matters for me is my feelings and intuition. Long live liars, dissemblers, and impostors! At least, I'm safe from their harm because I'm a master at their game. As I told you, *I am on a vacation*; and hope it'll last a year or two ... *I was forced out of my country*, and yet I've managed to make money in Kuwait, I still make enough, thank God. (p. 20, my emphasis)

In Wadi's account, the failure of truth is manifested through the lack of response (both morally and physically) to what happened to the Palestinians in the past, particularly the catastrophic fall of the land in 1948. According to Wadi, the Palestinians spoke the truth, but the world community did not respond. The Palestinians' collective belief that the world community 'cherished the truth', turned out to be a 'naiveté' through which they were victimized and exiled. It is precisely through this 'naiveté' that the failure of truth turns into a metaphor that oscillates between victimization and protest, and can be linked with or articulated by either. Because of this failure, caused by a mismatch between his expectation (the response) and the loss precipitated by the event itself, Wadi ultimately experiences the past as a betrayal. Thus, as an individual who was betrayed, Wadi does not believe anyone any more. Victimized despite telling the truth, he now prefers liars. He learned their profession, and is now capable of lying exactly like them. When he lies 'I am on a vacation' meaning 'I am in exile', he is also saying he is on vacation from the truth.

Nostalgia for Jerusalem

Now that Wadi has mastered the profession of lying, he can go on with his life sublimating the loss of the homeland with trade and works of art, 'poetry' (p. 20). Yet, these sublimational works neither ease the pain of the past loss, nor do they bring relief in the present. This is primarily so because Wadi's present is 'plagued by painful memories' (p. 20) from the past.

Those memories that haunt Wadi's present continuously evoke both the beauty of the homeland and its past tragedy:

> After all, all Palestinians are poets by nature … because they have experienced two basic things: the beauty of nature and tragedy. Anyone who combines these two must be a poet … You were probably too young when the Zionist monster gobbled up the most beautiful half of the most beautiful city [Jerusalem] in the world … But I walked up and down all its hills, among its houses built of stone—white stone, pink stone, red stone—castle-like houses … You'd think they were jewels … [They] remind me of flowers in its valleys, of spring … Flowers like children's eyes spring up from beneath the stones and around the barren roots of trees … This is why nights bring back to me memories of Jerusalem, and I grieve and rage and cry. (p. 20)

As this passage suggests, for Wadi, both experiences of 'beauty' and 'tragedy' are essential ones that produce artistic language (poetry). This beauty, though, is a specific beauty; it is the beauty of the lost homeland. In order to articulate this beauty, Wadi returns to the past, through which its sweet images can emerge. The sweetness of the homeland is symbolized through comparison and personification, such as houses that look like 'jewels'. The spring of the homeland is so beautiful that even the 'barren roots of trees' feel it and thus flourish with flowers like 'children's eyes'.

Wadi remembers scenes from his childhood in Jerusalem. In those memories, he nostalgically elaborates on its charms and beauty. Yet, Wadi's nostalgic return to the past not only evokes beauty, but it also contains trauma, namely *al-nakba*—when 'the Zionist monster gobbled up the most beautiful half'. In this return to the past, the traumatic re-enactments of *al-nakba* are unleashed first, and those re-enactments, paradoxically, trigger his sweet memory of the homeland's houses, hills and seasons. In other words, it is through Wadi's traumatic re-enactments of the loss of the homeland that his memory of the sweetness and the beauty of that land is activated. This telescoping of idealization through catastrophe makes the evocation nostalgic. Moreover, this nostalgic evocation takes the form of a 'flow of memories' wherein each element activates the memory of what follows. Temporally, however, Wadi's flow of memories is an incoherent one; it is not governed by a chronological order, primarily because the catastrophe (or the loss) of the homeland precedes its beauty.

On a narratological level, the incoherence of Wadi's memories, I submit, produces particular effects in the novel. Firstly, by making the traumatic re-enactments of the loss of the land precede the memory of its

beauty, Wadi's nostalgia achieves a causal relationship through which the catastrophe becomes encompassing and irreversible and at the same time the major cause of the destruction of the beauty of the homeland. When Wadi says: 'this is why nights bring back to me memories …,' his rage and tears are not about the beauty itself so much as the loss and destruction of that beauty caused by *al-nakba*.

Secondly, such incoherence not only establishes *al-nakba* as the major cause of the termination of the beauty, but also turns it into an experience which signifies an intense loss that cannot be easily sublimated. This effect emerges in the novel through Wadi's description of time as an entity continuously marked and enforced by loss:

> That was many years ago. Others wrote poetry instead of crying. But who can compose words that are the product of thirty years of experience in the most beautiful of God's cities? Our creative attempts are merely tranquillizers, a kind of weeping. Yet, nothing in life can take the place of large flowing tears. Time, in any case, is a horrible thing … In the end, it leaves you nothing of any worth. Time has trampled down everything I see and left it faded and dull … Time is the enemy. Live, if you wish; stay alive as long as you can. But you'll have nothing else; a big black smudge filling the fabric of your life, with a red spot here and there; the trivia that come your way whether you want them to or not, without your ever being able to achieve that *great relentless experience which is the product of choice and will* … We survive in spite of ourselves. It is a kind of passive survival, something we accept, but cannot control … I won't put up with passive survival. (p. 21, my emphasis)

In the beginning of the passage, the loss of the homeland may be sublimated, according to Wadi, by writing 'poetry'. But Wadi chooses 'crying' over writing poetry, because, in his view, the sweet experience of living in the homeland for a finite time, 'thirty years', cannot be put into words. Therefore, if that 'great relentless experience' cannot be articulated because it has been ended, then neither can the loss of that experience. In view of this finitude, marked and enforced by loss, Wadi interprets the sublimational works, 'our creative attempts', as nothing but 'tranquillizers'.

These tranquillizers may temporarily ease the pain of the loss, but they can never substitute the 'flowing tears', and therefore cannot relieve Wadi in the present. Poetry cannot offer relief in the present, because time, 'the enemy', in its progression tramples such creative attempts and leaves them 'faded', 'dull' and worthless. For Wadi, then, language becomes shattered and limited in its comprehension of both the experience of living in the homeland and the loss of it. This is pre-

cisely why, unlike those who 'wrote poetry', Wadi refuses to compose any poems since 'words deflate his resolve' (p. 21). Wadi's dismissal of language, as a sublimation of loss, is further enforced by his preference of tears, which 'yet, nothing can take'. As a result, tears, not language, become a mnemonic compensation for the absence of land and its sweet experience.

Similar to his view of the insufficiency of language, Wadi, later in the same monologue, equally discredits 'trade' as a method of sublimation. Trade, which he both inherited 'in spite of himself' and 'was rewarded with for his exile' (p. 38) cannot sublimate the loss of the homeland. While Wadi would do anything and 'would travel a thousand miles' for money, in the end he 'tramples it under his foot' (p. 21). By discrediting sublimational works (poetry and trade) through the nostalgic evocation of the homeland and its loss, Wadi not only exchanges aesthetic and commercial estates for a mental one, but potentially grounds and interiorizes the one in the other.

The nostalgic evocation of the lost past has another consequence in the way it impinges on the present. According to Wadi, as the above quoted passage suggests, time in its progression not only shatters language and makes sublimational works useless, but also life itself, through time, becomes a kind of 'passive survival, something we accept, but cannot control'. This passivity of living is determined by the lack of 'choice and will' in the present. Indeed, one could attempt to continue living (particularly after loss) but at the end, one will have nothing but a trivia, 'a big black smudge filling the fabric of life'. In other words, because of the lack of choice and will in the present, one cannot 'recreate' the past 'great relentless experience' of living. This is so because this experience, like other human experiences, has proven materially transitory and does not endure into the present. It is an experience that is always lived for some time, but after exhausting its time, its material reality disappears. By means of this analysis of time, Wadi not only performs nostalgia, but also ruthlessly indicates its uselessness. Yet, Wadi comes up with an alternative to nostalgic longing alone. This alternative is memory, seen as an act.

From nostalgia to memory

For Wadi, the passivity of living manifests itself in the fact that humans have no control over time. Yet, Wadi rejects this: 'I won't put up with passive survival' (p. 21). For him, the point is not to establish the reality of those experiences from the past through time. The truth of human experience is not determined in its transitory existence in time. Rather, the truth of any experience is in its memory:

> The only real thing is my memory of it, a memory that is trans-
> formed into something resembling music. Daily happenings re-
> cede into the dark tunnels of time, leaving behind waves of music
> in the mind. Everything is transitory except these waves, not only
> metaphorically but physically as well. (p. 22)

As this passage suggests, according to Wadi, daily experiences pass and
vanish in time. Yet, they always leave their memory behind 'waves of
music in the mind'. The memory of experience is like music, containing
both 'joy and sorrow' (p. 22). For Wadi, the truth of experience lies in
those tunes as well as the feelings they contain. Hence, the truth of ex-
perience is in its memory, rather than its material happening.

Moreover, for Wadi, the memory of experience is like a 'story' (p. 22);
it has a beginning and an end. The beginning, in turn, always precedes
the ending, and therefore is always located, due to its happening, at *the
past side of the present* of the ending. This analogy between experience
and its memory as a form of a story with both a beginning (past) and
an ending (present), is significant, particularly in relation to the mode
of cultural memorization. This mode is a present-oriented one, prima-
rily because cultural memory is an activity that concerns the past, yet it
always takes place in the present. Thus, it is the present that the indi-
vidual (or group) uses to recompose an image of the past. Such an
image is continuously, therefore, in tune with the necessities of the in-
dividual's present.[14]

In *The Ship*, this present-oriented mode can be seen in Wadi's story
with his friend Fayez. In the novel, Fayez is Wadi's childhood best
friend. For Wadi, Fayez represents everything that is innocent and beau-
tiful. What initially brings them together is both a shared fascination
with the beauty of the homeland and an attempt to articulate this
beauty. It is precisely through attempting to articulate the beauty of
their homeland that Wadi's relationship with Fayez becomes constituted
both as a dear childhood friendship and as a learning relationship.
Through his relation with Fayez, Wadi not only learns how to paint
scenes of the homeland, but also learns how to articulate the homeland
as a specific place from 'whose firm surface we extracted our gorgeous
vegetables and sweet-smelling fruit' (p. 55). In other words, for Wadi the
land becomes more than a place whose beauty is to be enjoyed; it is
also a place that represents a source of life.

Wadi's relationship with Fayez, however, does not last as it is inter-
rupted by war and subsequent death. During the 1948 war, while they
are fighting to defend their city, Fayez gets shot and dies in front of
Wadi's eyes. This death becomes a synecdoche for the death of the
homeland. Describing the moment of Fayez's death, Wadi says:

But there was no need to look [for water]. He started shaking un-
controllably; I could not stop him. His mouth kept opening and
closing in jerks in a desperate quest for air or water or both. I kept
shouting, 'Fayez, Fayez…' Then a thin trickle of blood flowed
out of the corner of his mouth, and his eyes remained fixed on the
walls of Jerusalem like two glittering stones. My friend had been
killed, and I had stood there by him as helpless as a child. (p. 61)

For Wadi, the moment of death represents an apocalyptic moment that
contains an incomprehensible violence. Standing there 'helpless' in
front of his dying friend, Wadi finds himself stricken and shattered be-
yond the limits of human comprehension. For him, the moment of
Fayez's death is the moment of the death of human relations, through
which he is 'abandoned by God and man' (p. 62). This focalization of
Fayez's death imprints itself on the larger moment, *al-nakba*, through
which Fayez's death occurred. In the context of such focalization, death
itself becomes an affirmation, even a *mortalization,* of the loss of the
homeland. As a result, the larger moment of death, *al-nakba*, not only
becomes a signifier of the death of human relationships, but also the
central signifier of Wadi's memory wherein the loss of the homeland
is firmly anchored.

For Wadi, this occurrence of *al-nakba*, as a moment of loss (or
trauma), will always remain a transitory happening that exhausted its
material time; what remains is its re-enactment, that Wadi 'remember[s]
every day, and have remembered for over fifteen years' (p. 64). Paradox-
ically, while Wadi is capable of re-enacting *al-nakba*, he does not name
it. Instead, Wadi describes it as a date, *1948*. Wadi's un-naming of *al-
nakba* is particularly significant in relation to the concept of trauma. In
one sense, by not being named, *al-nakba*, resulting in the loss of the
homeland, is signified as a traumatic event that resists integration into
Wadi's symbolic order. It is thus, a 'failed experience' through which
this event becomes impossible voluntarily to remember. Yet, in another
sense, by not naming *al-nakba*, Wadi does not put into language the
shattering of language, and he does not put into humanity the death of
it. He does so, not to master this event, not even to document it as
truthful, but, on the contrary, to depict it as *indefinable* and to bear wit-
ness to its incomprehensibility. Hence, through not giving it a name,
al-nakba is focalized in Wadi's narrative as a death beyond human com-
prehension, and as the indefinable non-name of this incomprehensible
death; a case of trauma and the loss of language it entails.[15]

Memorization, exile and nostalgic identification

This is the way in which the past, particularly *al-nakba*, is focalized through Wadi's narrative. As I have suggested, however, the mode of cultural memorization in the novel is a present-oriented one through which the image of the past is shaped in relation to the present and its necessities. Indeed, Wadi, in the novel, performs a nostalgia that invokes the past, yet such nostalgia takes place in and for a problematic present. According to his analogy of experience and memory as a form of a story with a beginning and an ending, while Wadi can usually re-enact the beginning (the traumatic event in the past), it is the ending (or the not-chosen present) that is problematic. He says: 'I can usually remember the beginning, but it is the ending which gives me problems' (p. 22). Wadi's present is problematic because it, in itself, contains another trauma caused by forced exile. Forced exile is particularly traumatic because the departure from the homeland is involuntary and the return to it is impossible. Hence, there simply is no ending.[13]

Commenting on his exile, Wadi describes the homeland as a paradise shaped through personification: 'nothing is equal to that red rocky land that greets your feet like a lover's kiss' (p. 24). To be in exile, therefore, is like 'a curse, the most painful curse of all' (p. 24). This curse takes the form of temporal infinitude. In the context of such infinitude, the convention of time personified becomes intensified and problematized as a property of exile. Exile, as a result, not only represents a major consequence of the traumatic loss of the homeland, but it also becomes a symptom of this trauma's inability to end through which 'the tragedy of the past renews itself' (p. 25). For example, in *The Ship*, Wadi's nostalgic memory of the sweet past of the homeland is activated when he begins questioning his present exile. It is only when Wadi asks ' why was I uprooted and cast about under hoofs and fangs, driven into flaming deserts and screaming oil cities?' (p. 25), that his traumatic re-enactments of *al-nakba* burst into the present, bringing back with them a nostalgic memory of the moment before (the sweetness of the homeland). It is precisely through Wadi's questioning of the present of exile that the mode of his nostalgic memory becomes present-oriented, and through which the image of the past is mediated in and by the present.

At this point, through Wadi's internal focalization, the reader sees the past in *The Ship* as a place of catastrophe and loss. Yet, unlike the other characters in the novel, Wadi introduces a different focalization, particularly in relation to the decision to escape the homeland. In Wadi's narrative, the catastrophic moment contains the revelation that all social structures and all human, culturally inflected acts and desires are subject to violence and death. At this same catastrophic moment, however, Wadi depicts alternatives which entail neither the passive withdrawal

of Dr Falih's suicide at the end of the novel, nor escaping the homeland as in Isam's case. While the first of these alternatives is an attempt to narrate the loss of the homeland as a way of working through its trauma and its present symptomatic reincarnations, the second entails a recurring vision of salvation through which the possibility of returning to the lost homeland emerges. These alternatives are what, in fact, inform *The Ship's* nostalgia.

Wadi's first alternative appears in the novel through his relationship with Isam. Before meeting Wadi, we see Isam in the novel as a broken person whose failed love story with Luma leads him to a point of resignation and quietism in which he decides to escape his land. Yet, the moment he meets Wadi, Isam's understanding of his loss changes. This change, however, is not determined by Isam's ability to narrate his loss to Wadi. Rather, it is due to his ability to listen to Wadi's narrative. Isam describes both his listening and Wadi's narration as follows: 'I listened as the words poured out of his mouth like incessant rain, like a never-ending storm' (p. 18). In this statement, while 'incessant rain' serves as a metaphor for the impact of Wadi's narration on Isam's personal growth, it also symbolizes catastrophe. Such symbolism is enforced by the imagery of the 'never-ending storm'.

Through Wadi's uninterrupted narration, at the end of the novel, not only Isam changes his mind about escaping the land—'I am going back to Baghdad' (p. 198)—but Wadi also finds himself a way of healing, resembling the Freudian process of 'working through' wherein he learns to substitute a narrative remembering of loss for a symptomatic repetition. By revealing his 'secret' (p. 67) to Isam, Wadi integrates the repressed material, 'the grief he stifled' (p. 64) at the moment of Fayez's death, with the past as a contemporary experience. Thus, instead of remembering the catastrophe as something that belongs to the past, Wadi, through his narration, elaborates it in his present exile.

By incorporating *al-nakba* in his exilic present, Wadi not only attempts to overcome the past loss of the homeland in the present, but, in fact, also manages to destabilize this present together with its cultural forms, namely Palestinian displacement and exile. In pointing out such a destabilization of the present of exile in Wadi's narrative, I am not arguing that the imaginative existence of *al-nakba* was subsumed in order to construct the future as a projected idealized image of the lost homeland. Rather, I am arguing that *al-nakba* was subsumed in order to construct the future through projecting the present of exile as a consequence of the loss of that homeland. Hence, the construction of the future becomes possible only when the present of exile ends. Wadi's destabilization of the present of exile, then, is meant to criticize the suffering which 'the Palestinian' endures as an exile, simply because

he can never, by definition, reach backward or forward to the lost homeland.

Part of *The Ship*'s project seems to be, then, to represent, through Wadi's first alternative, the transmission of the loss of the past, and to suggest a method of coming to terms with such loss in the present. In the novel, however, the traumatic loss of the homeland is not all that returns from the past. *The Ship* also describes a second alternative that contains a vision of salvation through which the possibility of returning to the homeland emerges. Such a vision emerges with the moment of catastrophe and inevitably returns with it in the present. While Wadi is carrying Fayez's corpse in his arms, he takes an oath and swears on the rock that he will always return to the homeland: 'I swore that I would come back, somehow, as an invader, as a thief, as a killer; I would come back, even as a casualty' (p. 64). For Wadi, the land represents everything and is the secret of his life. Therefore, his return to the land is inevitable, because no matter how far he goes, 'the land will drag [him] back to it' (p. 76).

In his narrative, not only does Wadi articulate the inescapable return to the homeland, but also suggests a model for such a return. This model can be seen in his actions: Wadi transfers money to Jerusalem and buys a piece of land near Hebron. He is also planning to buy another piece of land in Jerusalem, and all that he wants is to build a house and to cultivate the land with his own hands. This is his model for the return, as 'only on this basis can I [Wadi] be happy with anything' (p. 200). Wadi's model not only brings about a vision of salvation, but also turns into a model of identification with the lost homeland. Such identification finds its expression through perceiving the homeland as a metamorphic landscape replacing both the metaphor of the sea (as a seduction to escape) and the metonymy of the land (as a figure that drags back). This identification, in addition, entails more than an awareness of how life in the homeland used to be before it was lost; it also includes processes of material attachment to this land in the present.

In *The Ship*, Wadi's vision of salvation as well as his model of identification bring about a possibility of returning to the lost homeland. Yet, at the end of the novel, this possibility turns out to be merely consolatory and difficult to realize given that Jerusalem is occupied and the Palestinians are barred from returning to their homeland. *The Ship*'s nostalgia, then, is for sites of unrealized possibility. It is a nostalgia that, similar to the cultural traumas surrounding it, returns of its own accord, together with these traumas, and opposes them. Such a *modified* form of nostalgia does not return to an ideal state of wholeness. Instead, the unrealized possibility of social harmony and justice symptomatically re-

turns providing an alternative and a motive for changing the existing conditions of both loss and exile. Such a nostalgia returns, and is returned to, in and *by* the present, but at the same time it entails the effort to work through the cultural trauma as a way of constructing the social harmony to which it aspires. Hence, *The Ship's* nostalgia is, in fact, a future-oriented one that gives a new political and cultural meaning to the pain of the returning past. Such a nostalgia need not be always reactionary and escapist, but can also travel as a reconstitution of injured subjectivities. This is so because the novel's nostalgia emerges directly out of the moment of catastrophe itself.

Finally, despite the apparent reunion between Isam and Luma, as well as Wadi's possible return to the lost homeland with which the novel ends, their problems remain unresolved. For example, while the tribalism which separated Isam and Luma still exists, Wadi's return is not certain. Yet, in *The Ship*, at least, one thing is certain: Wadi's form of witnessing—as a figure who stands for the first generation of post-*nakba* Palestinians—is meant to be transmitted as it is, 56 years later, to the reader, who, seeing the Palestinian past through Wadi's focalization, could feel liberation of the moment of return, and the 'unjustified faith' (p. 79) that anything is possible and that nothing could stand in the way of the return on the ship. Within such a transmission of nostalgic memory, the contours of the past loss of the homeland would be determined for the reader by his or her perceived distance, coded as exile, from this homeland, wherein *al-nakba* becomes portable and interiorized and therefore can be regarded as a fixed point of reference and a matrix of identity. In this matrix of identity, distance and loss become the prevailing articulations of the past that constantly, through nostalgic memory, reaffirm the reader's identification with the lost homeland.

PEDAGOGY

It all adds up … in audit culture
Sue Wilks

Parents' evenings—a step by step summary
Read and analyse reports. Set targets and agree actions
Discuss targets
Review comments. Refine and agree targets and list actions
Monitor progress regularly
Seek help if necessary

Edexcel[1]

I received the information shown above in a leaflet titled *Making the Most of Parents' Evening* that was given to my child (then aged nine) at school. The process that parents are being advised to follow is derived from the 'audit culture',[2] and I present this institutional circulation in order to demonstrate the extent to which a managerialist ethos pervades all levels of the English education sector, a decade following its imposition upon further education.[3]

Although the leaflet is described as being 'for parents by parents'[4] there is no mistaking the frame within which those who compiled it were working. The language presented is blatantly that of 'new managerialism';[5] it could have been taken from any of the many contemporary public sector strategic documents in existence. In this instance, an official guide sets out a structure for educational relations between parents, carers, and their children of primary education level (aged 7–11 years). This leaflet is a government publication, designed to supplement the national home-school agreement document, which 'became a mandatory requirement for all schools in England from September 1999'.[6] It is expected that this agreement will be signed by both carer

and child, if the child 'is old enough to understand it'.[7] Compliance within an auditable structure requires a mark of accountability.

A managerial ethos has deluged the education sector at all levels, and here it can be viewed in a continual mode of expansion as it leaks out from the frame of the formal learning environment into the private spaces of, and relations between, carer and child. Although this spillage might initially seem innocuous, the document is specific to the context of its production and, therefore, it offers an opportunity to investigate the structures that spawned it. I should point out that these are the same structures that in 2001 generated an 'average annual per capita spend on art materials per child aged 7–11 years of £1.29'.[8]

English educational policies demand that auditable standards of learning are achieved at specific ages and (key) stages of development. Funding initiatives and coercive strategies (such as performance-related pay and short-term contracts of employment) ensure that policies are adhered to by institutions and their employees. The signing of the home-school agreement is currently beyond the range of mandatory enforcement, because carers are not employees nor do they receive funding. Coercive strategies continue to be active, however, and simply adapt from being explicit to subtle, slipping towards the social realm through specific discourse such as that presented on the government internet site *The Parent Centre*: 'The Parent Centre is for all parents and carers who want to help their child or children to learn.'[9] This text elevates those who advocate the active pursuit of contemporary educational strategies into a hierarchy of those who care about their children's education, and those who do not. By implication, the sentence imposes a position of cultural morality, the social perception, perhaps, of a professional, middle-class, individual.

I have chosen not to sign the home-school agreement contract, nor will I rigidly adhere to the strategic process set out in the parents evening leaflet. My hope is that you may be able to trust my assertion, when I say that I am a devoted and responsible carer for my children (with many of the failings that such a role entails). Trust is of critical importance with regard to the issues with which I am concerned.

In chapter eight of her book *Travelling Concepts in the Humanities* Mieke Bal writes in support of a critical pedagogy that counters the lack of trust, and the fear of risk, that act as barriers to learning and teaching. Titled 'Critical Intimacy',[10] this chapter details how the concept of critical intimacy (which is concerned with relations between teachers and learners), emerged from Bal's (critically intimate) relations with Catherine Lord (her former student) who wrote *The Intimacy of Influence*.[11] The concept is also formed in part from Mieke Bal's own critically intimate

experiences of reading Gayatri Chakravorty Spivak's book, *A Critique of Postcolonial Reason: Toward a History of the Vanishing Present*.[12] Bal says:

> Spivak engages intimately with men—who could only be men—of a different time than hers. Lord staged an intimacy between three women, each situated at a different moment. I engage with two other women, Spivak and Lord, situated in the same moment.[13]

Mieke Bal's concept of critical intimacy supplements and enriches existing knowledge relating to critically pedagogic practices, and yet while her concept is vital to furthering understanding of the dynamic nature of working relations between learners and teachers, I think it is necessary to acknowledge that educational institutions neither accommodate nor support the development of critically intimate relations between staff and students. Indeed, methods of working in the contemporary education sector actively deter the formation of critically intimate relations. This problem is underpinned by the lack of trust, and fear of risk, that are inherent to institutionalized audit regimes that seek to control and measure the educational process itself. Employment laws cannot facilitate critically intimate relations between staff and students, nor between employers and employees, because trust, and risk (which are vital elements of critically intimate relations) are not economically viable and auditable factors.

Critical intimacy does not present a schematic pedagogic methodology. It is described by Mieke Bal as being 'a concept [that] stands for the methodological position that [she has] been advocating',[14] which, 'points to a relationship blatantly opposed to (classical academic and pedagogical) "distance".'[15] Bal refers to productive and creative relations between learners and teachers that are critical, intimate and multiple, and through which mistakes and misreadings become potential learning advances rather than judgemental dictates. There is nothing *easy* about the concept of critical intimacy because it is grounded in the activity of effort through work. Negatives cannot become productive positives without critical consideration having taken place, and this requires endeavour, which is in turn enabling. The responsibility for this endeavour is shared by all those involved with this pedagogic process, in which students and teacher study together *with* the object of knowledge rather than simply studying about it.

This approach demonstrates aspects of the work of people such as Augusto Boal who wrote *Theatre of the Oppressed*,[16] and also Paulo Freire, author of *Pedagogy of the Oppressed*.[17] In these books, both writers respectively advocate the benefits of developing dialogic learning rela-

tions with others and of sharing knowledge (and power). Both, how-
ever, also tend to position *oppressor* and *oppressed* roles according to lib-
ertarian ideals, whereas Mike Bal rigorously clarifies how we are, each
of us, complicit within our situations. As Val A. Walsh writes, 'feminist
pedagogy embodies opposition to the subject-object dualism which
underpins white Western thought, and unavoidably also risks being per-
ceived as non-academic and non-professional.'[18] She goes on to add
that 'feminist process is integrative, and highlights the connections and
continuities between different cultural practices and areas of social
life.'[19] These quotes are pertinent to Mieke Bal's critical investigations
into cultural analysis, the academic field from which she enables her
concepts to travel.

Teachers cannot simply become the transmitters and receivers of a
totally accountable and conclusive knowledge base. Self-reflexive and
critical practice is a way of life for those who ascribe an immeasurable
value to the role of education in human development. Critical feminist
pedagogies develop collaboratively rather than competitively and they
require a profoundly responsible and ethical approach towards the
Other, who has to be trusted not to respond disingenuously. It is diffi-
cult and dangerous for a teacher to work in a manner that requires both
the relinquishing of power and a welcoming approach towards the un-
predictable. It is also risky and difficult for students to open up to such
methodologies. If employers were to support such a practice their
teaching staff would need to be trusted to behave appropriately and
with integrity, but student, teacher and employer relations are asym-
metrical, and this option does not exist within the contemporary main-
stream education sector.

Despite employer attempts to minimize critically active teaching
practices by imposing audit regimes that demand *specific evidence* in rela-
tion to the prescribed quality of teaching delivery, such practices have
not been completely eradicated. Programmes of study do exist, partic-
ularly in the fields of women's studies, gender studies, and feminist the-
ory, that work hard, if surreptitiously, to provide an environment that
feels safe to learners, so that self-critical and creative educational prac-
tices can be maintained and developed. I attended such a programme
of study in 1996, at a time when the audit culture was hovering around
the peripheries of the higher education sector.[20] The teaching that I re-
ceived and the learning that I gained were absolutely transformative,
both personally and academically, and I was not alone in my experi-
ences. The programme of study to which I refer has trails of people all
over the world who testify to the transformative potential, and to the
productive learning that they accessed through engaging with this par-
ticular pedagogic process. Our personal testimonies are not compatible

with regimes of audit, however, and are therefore considered irrelevant in relation to value for money assessment strategies.

Ensuring that we testify to our specific lived experiences and bear witness to those of others is vital to furthering our understanding of the effects that politically and ideologically imposed forces can have on subjectivity. Personal, self-critical contributions bring substance to an intangible political sphere constructed of spin, and can generate profound and continual affective outcomes. Valerie Walkerdine discusses the importance of acknowledging and including subjective influences as an active element of research practices and methodologies in her book *Daddy's Girl*:

> I [will] suggest that it is an impossible task to avoid the place of the subjective in research, and that, instead of making futile attempts to avoid something which cannot be avoided, we should think more carefully about how to utilise our subjectivity as a feature of the research process.[21]

Mieke Bal proposes a way in which the concept of critical intimacy might function within the confines of the contemporary educational sector when she suggests an alternative form to traditional auditing strategies. She writes, 'the interaction between students and teacher around the latter's authority could, in fact, offer an alternative model for the academic review.'[22] Bal applies an intersubjective approach to misreading Spivak's *Critique of Postcolonial Reason* in three ways, in order 'to persuade [my] readers that critical intimacy is a productive—perhaps the most productive—mode or attitude for reading scholarly texts'.[23] She describes philosophy as being the (ex-) master discourse, 'isolated and superior'[24] of Hegel, Kant, and Marx (the men with whom Spivak engages):

> the 'last Three Wise Men of the Continental (European) tradition' (*CPR* III), whose basic concepts laid the foundations for what is now the object of critique in Spivak's own critical intimacy: post-colonial reason.[25]

Bal offers Spivak's misreading of Kant as an example of how productive a misreading can be in revealing the dynamics of (supposed) rationality at work in empirical discourses. In her book *Feminisms in Education* Gaby Weiner writes, 'if, [then], reason is value-laden and the truth, socially produced, discursive authority (who controls the agenda) is of paramount importance.'[26] The voice that resonates from *The Parent Centre* internet site is the same imperial voice of (economically-founded)

reason that emanates from governmental education policies, and which pervades all levels of the educational system. 'His Master's Voice'[27] of empirical discourse has become the liberal, rational, voice of authority. It is the patriarchal, capitalist voice of moral and economic reason that fixes the narrative structure to which people must adhere: plan, implement, monitor, review, and evaluate. The language used may vary slightly between differing institutions, but the structure is consistently rigid in demanding the (managerially coupled) outcomes of 'economic efficiency and good practice'[28] while simultaneously refusing to tolerate critique.

A decade ago in England the Department for Education, under the then ruling Conservative Party, published *The Charter for Further Education* in which the Secretary of State, John Patten, wrote:

> everyone has the right to expect good service from further education. Better information and improved choice will help everyone make the most of what colleges offer. That is good for individuals and for the country as a whole. We must enable people to make the most of their potential, and get full value from the money we spend.[29]

In *The Charter for Higher Education*, published during the same year, Patten altered his address only slightly:

> The Charter explains how these bodies [such as student grants, loans and the national admissions system] are making everyone more aware of what is provided for the large amount of public money that goes into higher education. It also points out the steps that are being taken to secure better value for money, for example in the way that quality will affect funding for courses.[30]

Both these charters entwine the linguistics of finance with moral reasoning, in blatant support of a predetermined and fixed notion of *value*. The social and cultural concept of ensuring that *good* value is exchanged for *monetary* value held a primary role when privatized methods of working were introduced into the further education sector, and this supported divisive social models such as those of *good* and *bad* teachers and institutions. 'Value For Money Auditing'[31] is a practice that originated in the financial sector and was enthusiastically embraced by the Conservative government during the 1980s. It has since been applied and perpetuated by the New Labour government (a political regime that has actively sought to deregulate the public sector services) as a predominant moral and socio-economic rationale. The need for evi-

denced accountability produced through audit procedures has not simply developed out of the lack of trust that employers have for their employees, but also from the employers' need to generate ever more productivity (for less expenditure) from their workers. Despite the rhetoric, the policies, and the European Union restrictions on working hours, the situation has not improved. Limited student grants have disappeared, course hours have been cut, staff are overworked, tuition fees have been established, student loans proliferate and funding is constrained by initiatives (such as those designed to widen participation and access to higher education). Target setting in relation to economic outcomes is altogether different from the humanist aim that people might come out of university empowered, having experienced a personal transformation through an encounter with critically pedagogic processes and practices.

Ideologically, the New Labour government has applied value-based, economic reasoning in support of the drive to widen participation in higher education. This is underpinned by a retroactive moral rationale for the mid-nineteenth century social-realist, romantic ideal, of 'changing human nature through education'.[32] The political appropriation of stereotypes is a familiar ruse that is often applied to distract attention from actuality, and when ideology took shape in the form of performance targets (designed to support the rapid increase of enrolments into higher education of people under thirty years of age to 50 per cent), it prompted an article in *The Guardian* saying:

> Blairite modernisation stops short of any aspiration to promote intellectual, still less cultural, revolution. Its social inclusion agenda is driven primarily by the need to integrate under-achievers into a modern labour market and only secondarily, if at all, by a raw desire to dispense social justice to the dispossessed.[33]

We should not waste our time, however, in lamenting the loss of past moral arguments, neither should we passively accept the government's economic policies, which are mainly concerned with 'producing a flexibly-skilled workforce to serve the needs of an ever shifting labour market'.[34] Instead we should look to the past, for critical guides to the present.

When she was Minister for Lifelong Learning and Higher Education, Margaret Hodge wrote:

> [O]ur competitors recognise the value of a highly skilled workforce. The US, Canada and Japan already have more people qualified to degree level than the UK. If we want to close the

productivity gap we must close the skills gap, and that in part is about higher education … Promoting an ambitious increase in the number of young people going to university is not therefore a matter of political correctness, but an economic imperative. Having said that, of course we also have ambitions to build a more equal and inclusive society.[35]

The contemporary voice of reason is powerful. It does not accommodate or negotiate, and it firmly asserts that no 'pedagogy is too unique to be absorbed and measured'.[36] There is no place for the immeasurable in the audit culture, although that which refuses to fit needs, in certain circumstances, to be forced. Ideologically it may all appear to add up …

… But does it?

I would like to present one such example of forcible adaptation in the form of the GNVQ (General National Vocational Qualification) in Art and Design. This qualification was introduced as having the potential to compete with A Levels (advanced level examinations), on the basis that it could provide an alternative, but equivalent, route into higher education, and would therefore significantly support the drive to widen participation. The approach taken was to compress vocational programmes of study into modular units of learning with auditable outcomes produced at every stage of the learning process. Policy determined that funding would be withheld from those institutions that did not offer the new qualification, and to those that did, funding would be made available (in stepped payments) according to specific outcomes, which would then be measured and determined in relation to achievement rates.

The subject area of art and design proved particularly problematic for the specialist professionals who were recruited to compile the GNVQ Art and Design examination question and answer papers. The examinations were an unwelcome addition to students and an additional administrative burden for staff. The value of such tests was held in little regard by either group because the questions were self-contradictory and confusing, and moreover, the tests could be re-sat time and again, (at a price), until passed. I would like to present a question (10.1) from the intermediate level GNVQ *2D Visual Language paper*, September 1997.

The question asks, 'What BEST describes the marks made with this pencil?'[37] The instructions given to students on the front of the exam paper state, 'Each question has FOUR possible answers; a, b, c, and, d. Only ONE is correct.'[38] The *one correct* answer is somewhere among the choices given: even black shading, dark-textured shadows, lines of vari-

146 CONCEPTUAL ODYSSEYS

INTERMEDIATE ART & DESIGN
2D VISUAL LANGUAGE
SEPTEMBER 1997
Page 7 of 11

8

What BEST describes the marks made with this pencil?
a even black shading
b dark-textured shadows
c lines of variable thickness
d very fine lines

10.1 Figure 01, *2D Visual Language Examination Paper: Question 8*, U1021061, 1997, print on paper, 29.7 × 21 cm, Edexcel, United Kingdom.

able thickness, or, very fine lines. Surely, however, the marks that this (linear representation of a drawing) implement might make are dependent on a wide and variable range of factors? For example: how the instrument is being used, the hypothetical grade of lead in this particular pencil, the amount of pressure being applied by the person holding it, their possible motivation and concept and so on?

There cannot be only one correct answer to this question or to the others like it. They present the struggle that examiners have in trying objectively to measure learning in art education. As a result, the questions asked in the exam paper need to follow a more ambiguous format, relying upon semi-auxiliary verbs for support. For example, what *best* describes…?, or, which medium is *most* likely to…? This examination question offers an example of the tensions that exist between art education and the audit culture. These contradictions were present before the paper was compiled, and the people who devised this question simply provided the problem with a particular form.

The process of creative, qualitative learning cannot be reduced to multiple-choice question formulae and quantitative outcomes. Art education resists (so-called) objective measures, in a similar manner to that by which people resist when the 'fragile texture of human subjectivity is reduced to cold calculus'.[39] Of course while creative, critical pedagogies cannot do anything other than resist being objectively formatted, human subjects can (to some extent) choose how to respond to audit regimes. Choices, however, are not only limited, but are formed within the confines of discursive constraints. Critical art pedagogies transgress fixed categorizations because they accommodate mistakes and risks, the potential outcomes of which are absolutely unpredictable and, therefore, cannot be reduced to definitive responses. In the context

of critical pedagogy every aspect of the educative process is open to question rather than legislation, and cultural, social, political, economic forces—in other words human influences—are acknowledged. The contrary of this is the way in which there is 'no lived embodiment in formulaic responses'.[40]

The immeasurable is invaluable

In 1977, when I was 17 years of age, my career prospects were limited. I had spent the previous year living in a care home for dysfunctional children, having ended my compulsory schooling without any qualifications, and with a reputation for being *thick but good at art*. During my eighteenth year I worked as an unskilled labourer, packing and displaying meat products for a large retail outlet, but although I was socially isolated, financially deprived and felt trapped by my circumstances I never lost hope in this unfortunate situation. My hopes lay with the enormous enthusiasm I had for making art. I would console myself with the knowledge that I had completed one of the three required years, in which mature students had to live alone and support themselves in order to be entitled to the mandatory grant needed to attend art college. Fortunately, formal qualifications were not essential at that time (if you were deemed to have a *strong* portfolio of work), and eventually, two years later at the age of 19, I was able to cease packing meat and embark upon an art education. My longing to learn about (and to do) art has been a steadfast feature throughout my life, and following years of personal and practical struggles, I was eventually able to become a lecturer in art and design myself. I am trying to explain, without portraying my journey in detail, how I have developed a profound belief in the positive and personally transformative power of education, a belief that sustains my subjectivity. The mobilizing potential of education to which I refer is connected with the multiple benefits that can be accessed and generated through extending self-awareness and critical understanding. Bearing witness to the transformation of others through sharing the learning that I have gained with students and academics has confirmed my belief in the importance of critically pedagogic processes, both to individuals and to society.

This personal belief contributed strongly towards my response when, nineteen years later in 1996, I was to experience the deregulation of the English further education sector as being particularly violent and cruel in its consumptive disregard, both for my subjectivity, and for the educational potential of my taught area of study, visual art. Regimes of audit were implemented (simultaneously with the deregulation of the sector) that sought to control and to measure all aspects of the educational process, including myself as an employee-teacher, and stu-

dents as clients-learners.[41] The assault that critical art education has undergone as a subject area has compounded the negative impact that managerial regimes have had upon the art education sector, and yet in so doing, it has also highlighted areas that are crucial and particular because they resist mortification by the ideological language and methodologies of the audit culture.

The conflicts that erupted between my managers and myself resulted from the intense collision between our opposing aims. My aims were to encourage a critical education that might prompt a personally transformative learning experience, in other words to share art as a developmental, and often risky, experimental process. The aims of management, however, were unnegotiably secured to the hierarchical role of the employer, who is subject to economic rationalization and whose focus is upon competitive financial viability. And so I found myself working in an environment that relentlessly and mercilessly subjected me to restrictive regimes to which I was ethically opposed, while my taught area of study was increasingly confined within a framework of reductive outcomes. The primary role that I held as an educator became distorted into that of an auditor, a distortion that was difficult, problematic, and ultimately so negative for myself and my family that it led to my early retirement from teaching through ill-health. This is because I was unable to substitute genuine endeavour for targeted dictates, or to substitute critical educational methodologies with skills based training. Despite the overwhelming rationale that insisted I had to completely relinquish my own pedagogic aims in order to survive in this environment, I found it impossible to do so.

There was no single individual that I might have identified as *the oppressor*, except that within myself, which drove my commitment to working well beyond my paid hours of labour so that I could meet all of my self- and institutionally-imposed responsibilities. It was a politicized frame that encouraged this excess and that then benefited by getting two workers for the price of one. Meanwhile, by consenting to politicized demands I was depriving a potential colleague from gaining employment. In their essay *Coercive Accountability* Susan Wright and Cris Shore write:

> The supposed 'self-empowerment' of [this] system rests upon the simultaneous imposition of external control from above and internalization of new norms so that individuals can continuously improve themselves. In short, external subjection and internal subjectification are combined so that individuals conduct themselves in terms of the norms through which they are governed. Audit thus becomes a political technology of the self; a means through which individuals actively and freely regulate their own conduct

and thereby contribute to the government's model of social order.[42]

I experienced the effects of these discursive forces as assaults upon my subjective identity through the lack of trust and humanity shown to me by my employers. The rationalization of labour, the workplace, and the social realm is underpinned by a rationale of expectations and moral codes, and within the contemporary educational workplace there is no room for those who do not comply with the auditing systems that seek to organize, measure, and control the targeted production of staff and students. Managerial tactics that divide and rule workers are simplistic and successful.[43] Auditing systems have massively increased administrative workloads, and in addition to this an ongoing torrent of initiatives ensures that staff are permanently struggling to maintain their positions so that they might survive in the workplace. The pressures of coping with an excessive workload means that people are literally too busy to be consistently concerned about the welfare of other individuals, they are simply trying to survive on a daily basis. Contemporary educational environments are competitive and divisive spaces and the organization within them excludes critical self-reflection without exception. Art examination systems do not recognize or accommodate unpredictability, which is perceived as being an invalid Other. It is the fear of threat towards that which is perceived as being different or unmanageable that drives the financially motivated, judgemental basis upon which these systems operate.

My concern is with those elements that are repelled by auditing systems, those things that are immeasurable and uncontrollable but which are invaluable and vital aspects of human development. These factors were important in attracting me towards becoming an art student and educator, and that continue to attract me today. My interest is in an area of learning at the level of the self, that point whereby subject (self), and object (critical art practice), resist the imposition of auditable confines and extend beyond given norms. That which is local and personal may then be able to contribute towards critical discussion around the effects of audit regimes upon lived existence, an area of major cultural and societal concern.

An intense personal notion of resistance has been a key feature throughout my research, because together with art practice it has proved to be a consistent and significant part of my life experiences. My childhood was difficult, and I resisted parenting strategies that I perceived to be oppressive and autocratic in extreme ways that eventually led to my institutionalization in local authority care. As a teenager I resisted all those people whom I perceived to be rigidly authoritarian, including the staff who ran the care-home and their associated colleagues,

such as the child psychologists and psychiatrists who sought to support, or rather, contain me. Discursive forces (social, political and institutional), together with unknown psychical activities, work interrelationally and dynamically in positioning subjectivities (as much through resistance and conflict, as through compliance), and can become indicative of the ways in which sentient childhood memories structure adult subjectivities. I was to unexpectedly experience the return of this powerful sense of resistance in response to the political reforms that brought about the economizing of the education sector.

My demise as a professional educator was accompanied by the demise of my mental health, as both aspects were interdependent areas that my adult self relied upon for support and self-esteem. Having retired through ill-health I found that without a societal role, (and its attendant status), I felt worthless, helpless, and overwhelmed. Even worse than this, because audit cultures are so notoriously slippery and difficult to challenge, critique, or oppose, I felt hopeless in relation to the immense power of the state. I reported my employers' misconduct to the Health and Safety Executive (HSE), a regulatory body with the power to prosecute and to enforce penalties on those employers who do not protect the occupational health and safety of their employees. The HSE, however, sees its initial task as being to remind employers of their responsibilities, and if necessary, to check that policy statements and procedures are appropriate in content and number. When the HSE did this on my behalf, my employers were able to satisfy the HSE that they had the appropriate number of charters and policies in place, and that they have a continuing programme of health and safety implementations.

This is an example of conventional so-called ethical behaviour in action, whereby an institution declares that its ethical purpose (or job) is 'to protect everyone in Great Britain against risks to health or safety arising out of work activities'.[44] And yet, the reality is that due to its own ever-expanding responsibilities and limited resources, the HSE has had to adopt a 'discretionary approach, targeted primarily on those whose activities give rise to the most serious risks'.[45] The HSE simply cannot fulfil its intention to protect everyone in Great Britain against occupational risks and, therefore, it has had to extend its duties (and dilute its power to act) by adapting a monitoring position, checking that risk assessment policies and preventative codes of practice are in place, rather than acting as the enforcers of legal discipline in response to those who fail to protect their workers. And so while an ethical code of conduct was agreed between my employers and the HSE (and then proclaimed through the language of policies and statements), the practice of occupational abuse was only superficially contained. While, as

a worker, I was the object of officially agreed policy making, as a person, I was the subject of its excess. I exceeded the situation because my actual need for support was not attended to through the existing protective framework, and I became the by-product of a grievance procedure that had no active ethical concerns whatsoever for my welfare, but that actively worked (severely) to constrain my already limited power to contend my employers' behaviour. This is where the corruption lies, in a structure that works as a defence against ethical transformation by perpetuating the damage caused by those whom it purports to regulate. The politically and institutionally corrupt ethical declarations that colonized my workplace presented a form of epistemic violence, whereby '*one* explanation and narrative of reality was established as the normative one'.[46] In such a situation, alternative narratives (to the master narrative) are perceived to present a threat, rather than to offer the potential to make a positive and productive contribution. My sole consolatory thought (in citing an excessive workload as being the cause of my ill-health), was that at the very least I had added myself onto the official public health statistics that provide data relating to the effects of the audit culture upon workers. During the past decade stress related to the workplace has reached epidemic proportions, particularly in the education sector and also across the health and police services.

Although my circumstances engulfed me, and even though I was ill, I had a need to record my experiences and concerns about the effects of educational policies upon my subjectivity. I was devastated by the lack of trust and humanity being demonstrated by my employers, and feeling unable to contend with their pervasive authority I adopted a self-protective approach toward their oppressive actions by gathering and archiving all manner of professional documents (detailing the unreasonable managerial demands being made upon me), together with urgently scribbling down my thoughts and feelings about the situation at work in an attempt to allow my emotions some kind of release. These notes provided me with a space, just a space, but one to which I repeatedly returned because it facilitated a kind of subjective articulation at a time when my subjectivity was being severely constrained. I also began to develop an experimentally performative form of art practice that sought to function as a pedagogic prop, both to raise political awareness of educational policies and practices and as a critical aid to teaching and learning. This work was to later establish the structure for my PhD research degree *Feda: Between Pedagogy and Politicised Art Practice*,[47] which, although it is based in an aesthetic field, seeks to operate in relational contexts, its intended purpose being to share experiences and understanding through critical engagements and aesthetic encounters.

While the concept of critical intimacy has its permanent residence in the field of cultural analysis, the concept is not rigidly confined to its disciplinary boundaries. As one of Mieke Bal's travelling concepts, it is presented in order to be engaged and worked with. In (mis-)reading Bal's work on critical intimacy, I recognized aspects of the intersubjective relations that I was seeking to develop with audiences. Through mistranslating the concept from its theoretical frames of reference, 'postcolonial theory and politics',[48] into the language of art practice, the concept is being worked through application and I have gained clarification in my art thinking.

Bal presents a case for thinking and writing through art practice in her book *Louise Bourgeois' Spider: The Architecture of Art-Writing*, in which she discusses the need for close engagements with works of art in terms of 'what the work *is, means,* and *does* in the present time of viewing'.[49] This different coherence, (which cannot be resolved or measured), is presented by Bal when she refers to that which the psychoanalyst Christopher Bollas termed:

> 'the unthought known'. Something the subject senses and upon which it acts but which it cannot articulate in a fully rational discourse—the intellectual discourse of artist's statements, for example. If the subject could just say it, what would be the point of making art, of saying it through art? Yet at the same time, this 'unthought known' is something the subject knows, and needs to make and mould, so that it can actively—but outside of intellectual discourse—participate in the cultural process that leads to knowledge.[50]

By using my art practice as a means through which to research the effects of the audit culture upon subjectivity and art education, I am applying an already transgressive form through which to invite multidirectional and critically intimate working relations with others, the outcomes of which are unpredictable and immeasurable.

THE EFFICACITY OF META-CONCEPTUAL PERFORMATIVITY
Or, we just do not *know* what we are talking about
Jennifer Tennant Jackson

It is not that words are imperfect, or that, when confronted with the visible, they prove insuperably inadequate. Neither can be reduced to the other's terms; it is in vain that we say what we see; what we see never resides in what we say.

Michel Foucault[1]

The *ultimate* knowledge concerning the objects of nonclassical theories becomes no longer possible, while the existence of these unknowable objects or what they idealize and their impact upon what we know is indispensable … Nonclassical theories however allow us rigorously to infer the existence of this unknowable … and explain its significance for what we can know … while this cannot be done by means of classical theories.

Arkady Plotnitsky[2]

We do not really, we really do not, *know* what we are talking about. It is central to art history, and to visual culture, that when we talk about images, we think we are explaining them. It is just as central to know that when we do, we do not actually know the thing we talk about. This is not just me. See what Michel Foucault says in the epigraph.

Now, if we take what Michel Foucault says seriously, what happens? If we, like Foucault, are not afraid to find cultural ideas in the field of physics, then we could consider what it is we can and cannot know. Eventually, by the end of this paper, as I track through the words I have chosen for the title, we might see a useful play between the words written and the things they purport to describe, in terms of something I call the efficacity of meta-conceptual performativity.

Mieke Bal tracks and analyses the interdisciplinary use of concepts common to cultural analysis.[3] Using Bal's concepts of performance/ performativity as a springboard, this paper is not about how concepts *change* as they move through the disciplines, but how apparently totally different areas of sciences and arts share the same conceptual imagination. Moreover, this shared epistemology comes to the same conclusion, namely, that in the case of some things, we just do not *know* what we are talking about. That is, however, a very enabling realization.

On performance and performativity, Bal writes thus: 'while obviously the two are related, they are also clearly in tension. For, while *performance* is grounded in a 'score' anterior to the actuality of the performance, *performativity* lives by the present and knows no anteriority.'[4]

Bal admits to the struggle to keep the two separate and suggests a 'productive confusion of concepts', 'a conceptual messiness'.[5] She suggests that by looking at what a concept can mean, we can see what it would do, and shows this in case studies. This paper takes her confusion as a starting point, not to explain or to find a truth, as it were, but to write something related. Yet it is a departure to a distinctly different thing; a change, incorporating dimensions beyond the parallel; indeed, this is a meta-paper.[6] I shall focus on 'performativity' rather than 'performance', and investigate 'performativity' from another point of view, one that I term a 'meta-conceptual performativity'.

The investigation travels, not along the surface—horizontally, metaphorically, tracking the changes in the use of a concept, as Bal does—but vertically, metonymically, to see how a particular conceptual imagination recurs without change in many different disciplinary fields, namely those of science, philosophy, history and art. My paper is a challenge to art history, and to art theory and art criticism. Indeed, rather than to believe that art can be *explained* by language, it is to regard the space between art and language as *performativity* generating new knowledge.

There is something in the way that both French philosophy and quantum theory thinks the unthinkable, seeks the unknowable, and accepts that there are things we just do not know that I wish to negotiate here. For me, performativity is the unknowable, though it can be 'known' by its effects. The power or agency of those effects, its efficacity, will, however, always remain hidden. Reading Bal's struggle with the concept 'performativity' suggests a desire for meaning. A nonclassical epistemology, on the other hand, does not seek meaning *per se*, but addresses the efficacity of performativity as invaluable. Such engagement with the 'unknowable' is enabling as it generates new knowledge.

Efficacity

My definition of 'effect' and 'efficacity' derives from the work of Arkady Plotnitsky. In his book *The Knowable and the Unknowable*, Plotnitsky explains the distinction between classical and nonclassical thought in science:

> Nonclassical thought defines one of the most significant and controversial strata of modern philosophical thinking, and its role in the humanities is not unlike that of quantum theory in the discipline of physics.[7]

The limits of classical theories have also been questioned in the humanities, by nonclassical thinkers such as Nietzsche, Lacan, Foucault, Derrida, and Deleuze, and bear a close resemblance to the ideas of quantum theory in physics. I believe we need to reframe our investigations, allowing our thinking to travel across disciplinary, or even subject, boundaries.[8] Indeed Niels Bohr, the Danish physicist was, amongst others in the debate of last and present century, one of the most important thinkers in considering the similarities between different fields of knowledge. Plotnitsky quotes him thus:

> We are not dealing here with more or less vague analogies, but with an investigation of the conditions for the proper use of our conceptual means of expression … [which will] not only make us familiar with the novel situation in physical science, but might on account of the comparatively simple character of atomic problems be helpful in clarifying the conditions for objective description in wider fields.[9]

In the sciences and the humanities, classical theories contain elements of causality and determinism.[10] Classical theories can give excellent descriptions of the objects they study. They can explain the cause and can predict the outcomes of experiments. Nonclassical theories, however, according to Bohr and explained by Plotnitsky, cannot provide us with details and descriptions of the things they study, but can only 'describe the effects of these objects and their interaction with the measuring instruments'.[11]

In classical theory, then, we look for the thing or person that caused the effect; in nonclassical theory, we can never, ever, find out the source, the thing that did it. What we can do is think about the action that was implicated in the effect we see. Now this action, this efficacity, is the result of two things that cannot be separated. It is the result of something producing an effect, some-thing we will never 'know', combined with

the means we have to measure that effect. An effect, then, is something brought about by a cause or an agent that can be known. An efficacity is the action of an unknowable that affects the knowable effect.

Plotnitsky defines 'efficacity' as the 'power or agency producing effects but, in this case, without the possibility of ascribing this agency causality'.[12] He explains that: 'nonclassically we cannot speak of the "quantum world" itself (for example, as "the quantum world") but only of the *effects* of the interaction between "quantum objects" and measuring instruments, which interaction initiates the efficacity of these effects.'[13] Thus we can know the effects but not the 'ultimate nature of their efficacity'.[14]

To simplify, and I hope not to oversimplify, imagine a footprint in the snow. From a classical point of view we might look for the foot that caused it, the agent that caused the effect. From a nonclassical position, however, we would be interested in 'efficacity'. Efficacity, however, is the agency, or, rather, not agency as a thing but agency as a power or action that we could call power-producing effects. This is the aspect of efficacity that interests me: the power-producing effects, the absolute knowledge of which is unknowable.

To return to the example of the footprint in the snow, I add a demonstration by Pooh, 'a bear of very little brain'.[15] Pooh tracks a circuitous trail of prints, and is joined in the hunt by Piglet. From the point of view of a classical epistemology, they look for who or what made the prints in the snow. Is it a Woozle? From a nonclassical point of view, we see the print may well be produced by an agency, and yet who or what made the print is unknowable because, as we measure and record the effect, the print in the snow, the instruments we use to measure it will change the appearance of the thing, change the result. That is what happens if we have to stand on the snow in order to measure the print. That is what Pooh and Piglet do, as measuring instruments; each circuit of the search adds their own prints to the snowy ground. Thus the mark is not directly related to the thing that created it, which we will never know, but only correlates to some happening, some interference. Nonclassically, we will never know the cause, and thereby the effect is likewise 'unknowable', in any conventional sense. The 'efficacity' is ultimately unknowable also, but it is interesting to study, in the way it impacts on the knowable. And the way it impacts on this particular 'knowable' is to invent a Woozle.

The analogy is limited, somewhat. In our example, we will stick to Pooh's puzzlement, rather than take it to its classical conclusion. In the end, Christopher Robin shows Pooh that as he wanders thoughtfully round and round, he has been following his own tracks. There is no imaginary Woozle. In nonclassical theory, there is not, nor ever will be,

a Christopher Robin to sort things out. We look at the impact of the effects in the snow. Just as with an electron in a bubble chamber, quanta cannot be known; they can only be studied through their actions as effects. The concern of this study, however, as in nonclassical theory, is with 'the ultimate "efficacity" of the impact of the unknowable objects in question upon what we can know—the effects of the nonclassical on the classical'.[16]

Rather than expect to provide a direct relation between the images we see and the way in which we make sense of them through words of explanation, text and image, at best, are only co-related. This is precisely the distinction made in theoretical physics, as Plotnitsky summarizes:

> We can describe the impact of effects, of quantum processes upon our measuring instruments in a reasonably (indeed in Bohr's interpretation, strictly) classical manner, but, in accordance with nonclassical epistemology, not the ultimately [*sic*] efficacity of such effects. In other words, while in classical physics observable phenomena (in the usual sense) can be properly *related* to the observable properties of actual objects, in quantum mechanics, in Bohr's interpretation, observable phenomena can only be *correlated* with the behaviour of quantum objects.[17]

Sometimes classical theory may describe the subjects of study, but characteristically, they attempt to be predictive. This is the 'knowable.' Bohr's interpretation of quantum theory is nonclassical. It does not describe the object of its study; it does not predict how the object of study will behave, or what is the outcome of the study. Nonclassical theories can only describe the effects of the object *as it encounters the measuring instruments*. Efficacity is the inferred, unknowable power. I return to Plotnitsky again, to distinguish between the knowable and the unknowable:

> The classical is the knowable … what is available to knowledge, representation, conceptualization, theorization, and so forth … By contrast, the ultimate 'objects' of nonclassical theories are irreducibly, in practice and (this defines the difference between classical and nonclassical thinking) in principle, inaccessible, unknowable, unrepresentable, inconceivable, untheorizable, undefinable and so forth by any means that are or ever will be available to us, including, ultimately, as 'objects' in any conceivable sense of the term.[18]

Unknowable knowledge is unavailable to classical and nonclassical theorists alike. For classical theorists, there are things that are unknown

that become known. What traditional art historians do, I argue, is pro-
ceed *classically* as if they could know the unknowable, the art object.
For nonclassical theorists, however, there are things that can never be
known. The 'nonclassical' is defined by the interaction between what is
knowable by classical means and what is unknowable by any means,
classical or nonclassical.[19]

On the surface, the 'unknowable' could be depressing. However, the
situation is more subtle than that, because, and this is the crux, the
value of nonclassical thinking is the impact it has on the classical. I em-
phasize again, it 'concerns the ultimate "efficacity" of the impact of the
unknowable objects in question upon what we can know'. The value of
this different way of thinking is in the knowledge it gives us *about*
knowledge. It questions the very nature of what we know, as Plotnitsky
states:

> [N]onclassical theories, however allow us rigorously to infer the
> existence of this unknowable (rather than merely imagine its ex-
> istence) on the basis of the phenomena that they consider, and
> explain its significance for what we can know, and utilise the (man-
> ifest) effects of this interaction, while this cannot be done by
> means of classical theories.[20]

To progress, I turn to the works of the French philosopher and
thinker Michel Foucault, who can best be described by a title he once
wrote for his chair, Professor of History of Systems of Thought.

The paper will now explain how the efficacity of what is not known,
what is not said, can be applied to the analysis of visual culture through
an understanding of Foucault's thoughts on the way in which knowl-
edge is produced and produc*ing*, in particular with reference to how
statements, *énoncés*, form the discursive field, and then, how the fold/ab-
sence supports the discursive apparatus, the *dispositif*.[21]

Performative *énoncés* of knowledge

Referring only to Foucault's book, *The Order of Things* (1966) Plotnitsky
nevertheless recognizes that Foucault demonstrated nonclassical think-
ing. Through a reading of Foucault's later book, *The Archaeology of
Knowledge* (1969), I propose that this text is also situated firmly in non-
classical thought.[22] Indeed, Pamela Major-Poetzl wrote that atomic
physics and theories of space science share a common imaginative
structure with Foucault's *The Archaeology of Knowledge*, though very few
other writers have acknowledged this.[23] Deleuze's study, *Foucault* (1986),
adequately demonstrates the 'archaeology' as nonclassical thinking.[24]

In my forthcoming book, I work between Foucault's writing and current scientific theory to suggest that understanding the basic conceptual similarity of thought between Foucaultian 'archaeology' and the theories of atomic and sub-atomic physics clarifies the understanding of the structure and function of evidence in art-historical discourse, to show how 'fact' is produced, and how certain elements in discourse come to be accepted as evidence.[25] Such ideas become a challenge to art-historical practice because the application of Foucault's archaeology/genealogy to historical material has met with criticism. Here I refine and clarify the use and practice of a Foucaultian approach and apply it to the canonical telling of art history through emphasizing the action, rather than the identification, of statements (énoncés) in the discursive field.

Thus it is a metathesis; this work is not a matter of discovering something new to add to art history, but describing, unfolding, perhaps discovering, the process of knowing, and doing so through the imaginative structure of atomic physics and cosmology. A discursive field of a great painting has actively constructed a privileged form of viewing, a position in which the viewer/reader is rigidly held. Different dimensions of possible viewings are folded out of sight and the writing on the painting becomes fixed in a certain discursive way. Other possible readings are therefore hidden in the fold.

Through three case studies—of Foucault's reading of Velázquez's *Las Meninas* (1656, Museo del Prado, Madrid), and my own analysis of the discourses surrounding Courbet's *l'Atelier du peintre* (1855, Musée d'Orsay, Paris), and Botticelli's *Venus and Mars* (c.1483, National Gallery, London)—I show how art-historical 'fact' is produced by means of a set of repeated statements that become the evidence supporting the 'fact' as its effect, while occluding—history in the fold—other potential, suppressed or unacknowledged meanings. What becomes accepted, repeated and thus reinforced as the determinate fact—*énoncés*—that frame the interpretation of significant paintings is the *dispositif* that fixes the ways Courbet's or Botticelli's paintings are seen. In the case of Courbet the *énoncés* forming the *dispositif* might be identified as 'Courbet was a Realist', 'Courbet was a socialist'. These become the mask of the artist that stands before the painting and produces interpretations in their light. A third *énoncé* 'Courbet had a mistress and son', however, is reduced to background and not allowed to affect the interpretation despite internal evidence in the painting to its active pertinence.

In the case of Botticelli a different mechanism operates through an absence. This results from censorship that precludes, because of real social pressures, what can and cannot be said, by acknowledging the

ways that laws and attitudes towards homosexuality and homosociality have suppressed certain iconographical interpretations of the painting. Foucault's own plotting of *Las Meniñas* from which his statement 'we cannot say what we see' is derived, literally finds folds, volutes of space, at work within the painting's production, not so much as a fixable meaning but in the very ambiguity of representation as representation itself.

In conclusion, my study shows that art history is a rather 'Heath Robinson' construction; a large and complex discursivity built around a virtual absence. This is emphatically not a critique of individual authorship, but an analysis at the level of power/knowledge. In order to be able to see the construction of evidence, one must think differently about the power/knowledge structure. A hint of the complexity of the discursive field is given here. Words and things never match; the active production of knowledge lies in the space betwixt painting and writing, in the efficacy of performativity.

In the discursive field of art history, historical evidence is produced within discourse. For Foucault, the discursive field is made up of groups of words, or statements: *énoncés*. A statement is formed and transformed, produced by and produces the 'archive' or discursive field.[26] Close reading reveals the 'statement' to be both an object *and* an action in a discursive formation, which we can approach in the following way. When Foucault says 'describe a statement', we look for a thing, object, group of words, unit, and so on. Here the statement is a thing. When he says 'describe enunciative function', 'of which they are the bearers', we regard the statement as an action. When he says 'to describe the domain that this function presupposes', we look for the field of activity or possibility for the statement-as-action. Finally when he says describe 'the way in which those domains are articulated', we seek the ways in which the fields are joined to, or divided from, other fields of discursive activity.[27]

In observing, studying and writing art history, which is composed of created and repeated statements made about art works and artists, I think of the statement (*énoncé*) as an atomic particle, behaving sometimes as a wave and sometimes as a particle.[28] By using this analogy, I argue, Foucault regards the statement (*énoncé*) as both a thing and an action. It has a recognizable materiality, as does the linguistic sentence and the logical proposition, yet the statement (*énoncé*) is distinguished from both because it is also an energy that works to generate meaning within an active field of discourse: 'We will say that an enunciation takes place whenever a group of signs is *emitted*.'[29]

We speak of electrons, charged atomic particles, as being 'emitted' too. In order to calculate the predictable future path of a particle, one

has to measure its present position, and shine light on it. As this beam of light must be at least one quantum, however—equal to or exceeding the size of the smallest particle—it will disturb the very particle it is exposing, thereby making the future path of that particle unpredictable. We can never estimate, therefore, the trajectory of a particle for certain. We can only estimate a number of possible paths it might take, and this is called the uncertainty principle.[30] Statements, for Foucault, also appear to have the characteristics of 'chance', of uncertainty.

Not only is a charged particle unpredictable, but also, even though it appears to oscillate between matter and energy, it is in fact a simultaneous existence and one that is difficult to comprehend. One of the most puzzling experiments to grasp in particle physics is where *one* electron, light 'particle', is sent through *two* slits at the same time, and appears in the form of a wave pattern. In order to travel thus, the electron must be able to exist as wave (action) and particle (material) at one and the same time. It is a particle *and* a wave, a thing *and* an action.

I am drawn here to Bal's description of 'travelling concepts': 'concepts are, or rather *do*', concepts 'distort, unfix, and inflect the object'.[31] While I am not equating Bal's term 'concept' with the Foucaultian 'statement' (*énoncé*), Bal does recognize something of the actions and effects of words in discourse. I add that *énoncés* 'are' *and* 'do'. Part of the struggle to relate text to images is in this dynamic. How can a statement (*énoncé*) have a meaning without also, at the same time, having an action, an influence, and an unpredictable trajectory, in total, a performativity? The statement (*énoncé*) is not, therefore, either a thing or action. It is, simultaneously, both thing *and* action. Merely to facilitate understanding, it seems better to separate the two states, while remembering that in practice they cannot be separated: 'Performance—the unique execution of a work—is of a different order from performativity; an aspect of a word that *does* what it says ... but keeping them apart isn't easy either, as my own attempts have proved.'[32]

The state of the statement (*énoncé*), as matter or wave, depends on the spatio-temporal position and influence of the observer-recorder, and is not a matter of fact, cognitively knowable. It also involves an energy that is intuitively unknowable. An 'enunciative function' is that which actively 'performs' the discourse, and thus is the performativity of the discursive field. In translation the word 'statement' implies certainty, and rigidity, so rather than use the English translation I revert to Foucault's term, *énoncé*, to retain the idea of the concept being a thing and an action, and to retain the notion of uncertainty.

The uncertainty principle refutes prediction, hence the predictability of history as continuity is challenged and discredited by the performativity in its performing. The function of *énoncés* in the making of knowl-

edge is the efficacity of their performativity. Like the effects associated, or correlated with, the efficacity of subatomic particles, an *énoncé* cannot be isolated, and can only be described, as Foucault writes, by 'defining the conditions in which the function gave a series of signs … an existence, and a specific existence can operate'.[33] That is what I term its efficacity.

It is imperative here to summarize what this paper has established so far, before moving on. A group of words active in discourse are statements: *énoncés*. They are characterized by their behaviour as both and simultaneously 'thing' and 'action' and they produce a result. We call the result 'knowledge.' How we see the result, knowledge, can be as 'effect', that is if we look for a cause. This is the classical approach. Or, we can see the result as efficacity, that is, there is no 'cause' as such, merely a possibility of choices, with a result that has no 'origin', no knowable aspect of causality. It is an unpredictable emergence out of some chances, an efficacity. Our approach to the result is what matters. I am choosing the nonclassical approach to consider efficacity rather than effect. By involving the conceptual imagination of atomic physics, we can see that the energy of a discursive field, and the statements within it, behave rather like the electrons in a magnetic field. Of course, this idea of the structure and action of discourse of art history and visual analysis is hard to explain, so I use the conceptual imagination of physics not to fix meaning but to emphasize that we have to keep the notions of unpredictability, uncertainty and the unknowable in play. More than a mere metaphor, then, we are dealing with metonymy: an allegorical, spatial play.

To understand what the discipline of art history, and the general analysis of visual culture, *does* in its texts and comments, we need look at the discursive fields differently: we need a paradigm shift. Just as I keep the word *énoncé* to remind the reader of the both/and thing/action characteristic of the Foucaultian statement, I also use the word 'performativity' rather than 'performance' for the following reason. Classically, the relations between the textual and the visible in art-writing are understood as performance; an interpretation of authorial intent, perhaps, of an actor/artist that we, as educated observers, can explain or critique. I am suggesting here that the result of the relations between the textual and the visible itself produces, as a performativity, as unknowable *affect*, the play on imaginative facilities, and that performativity is the result of unknowable 'chance' actions. Those chance actions are *énoncés* in the field of discourse.

In the discipline of art history, however, we have tended to treat all *énoncés* as facts. I suggest, instead, that they should also be treated as the possibilities of becoming results, and as results of undeterminable

origins, unknowable but recordable. They constitute and activate the discourse. *Énoncés* are not to be regarded as a mere performance of knowledge, but as a dynamic performativity of knowledge, with multidimensional effects and actions, played out in the peristalsis of *dispositif* and the 'fold'.

Dispositif and the fold

What sorts of relations and conditions can we assume that *énoncés* act out in the discursive field? How do *énoncés* group? What *is* their efficacity but a performativity divorced from the materiality of performance? In what way can we 'see' them as performativity? Performance can be known, somewhat. Performativity is an energy that makes the effect we register, the reaction to an artwork or performance that we cannot describe, or comprehend. It is unknowable. Yet we proceed as if we do know it. In some way we do, because we enter the discursive field, talk through the *dispositif* and the result is we think we understand what we are seeing. So, I will now proceed to explain fully what I have just written.

I am concerned here with my interpretation of Foucault's concept *dispositif*. It should be pointed out that my use of the *dispositif* is not the Foucaultian use of the term in film theory, such as occurs in *Screen* in the 1980s, but specifically a re-reading of *The Archæology of Knowledge* as an example of nonclassical thought. The term is not used in *The Archæology of Knowledge*, although throughout the study Foucault works through an embryonic enquiry into the processes involved in the structural formation of the discursive field, which he will go on to name as *dispositif*. The term *dispositif* does not easily translate. In 'The Confession of the Flesh' Foucault gives his most comprehensive explanation of the terms he is working with: episteme and *dispositif*. An 'episteme' is a strategic apparatus 'which permits of separating out from among all statements which are possible those that will be acceptable within … a field of scientificity, and which it is possible to say are true or false'.[34] A *dispositif* is a more generalized, heterogeneous collection of discursive and non-discursive elements, including a strategic element that was once called an episteme. Whereas an episteme distinctly is concerned with what may or may not be said, the *dispositif* is a later development and tends to be more general, but none the less powerful; an arrangement or apparatus of power/knowledge. *Dispositifs* disperse power as networks in the field of knowledge. In simplified terms, which may belie their complexity, we could say they become what we can 'know'. They are the rules of the discourse, constructions that frame discourses and practices. The *dispositif* involves the notion of a discursive field produced by and producing *énoncés*. The *dispositif* occurs as the knowable

measurable apparatus, always in conjunction with the unknowable efficacity that is 'the fold'. Similar to the rules of discourse that Foucault explores in the *The Archaeology of Knowledge*, the *dispositif* operates at the level of what can and cannot be said. Out of everything that can be said, '*everything* is never said'.[35]

In looking at art, for example, we cannot say what we see, even with the use of metaphor or imagery. There is no isomorphic relation between figure and text. There is, however, an archival relation between them in the violence of their juxtaposition, their coming together as overlaps and slithers, and in the unexpected chidings and scoldings or opposing explanations. So, it is in the negotiation between the statement and the visibility that we get to the 'truth'; but a *history* of truth, not a static one. The battle is not equivocal; the statement always has primacy over the visible.[36]

It is important here to recall Plotnitsky's remarks that nonclassical epistemology cannot provide us with details and descriptions of the things it studies, but can only 'describe the effects of these objects and their interaction with the measuring instruments'. I propose that the text accompanying the artwork is the measuring instrument that affects the thing it measures. Such study, to quote Plotnitsky again, 'concerns the ultimate "efficacity" of the impact of the unknowable objects in question upon what we can know', and in this context requires the Foucaultian 'concept' of the *dispositif* and the fold.

In *Quoting Caravaggio*, Bal briefly mentions the concept of *dispositif*. It is used in reference to the painting of garments of 'foaming whites': 'critical potential of the fold as a theoretical figure, as *dispositif*'.[37] In her eloquent writing on the depiction of folds in the baroque, Bal uses the fold itself as a *dispositif*, but for this paper I use the two concepts differently. I suggest a somewhat different take on both terms. For me, the fold is not a literal tangible fold, but rather, the opposite. It is the invisible, *and the unknowable*, that is the fold.

The conceptual framework of this paper, as I have shown, is located in patterns, visual structures and spaces, which is a thought system common to physics. Foucault, too, is a spatial thinker. Of the *dispositif*, he writes, 'it can function as a means of justifying or masking a practice which itself remains silent.'[38] For the purpose of demonstrating the spatial relationship of *dispositif* and fold, the *dispositif* is the concrete effect produced by the process of forming apparatuses. Take a line and fold it, pleat it, concertina it up, and look at it from the side where the edges are pressed together. Like the fingertips of the hand, or the points of the villi that form a surface, it hides the depths to which the fold penetrates. The *dispositif* is the seen edge; the rest is hidden in the fold, as a skein.

If the *dispositif* is formed by what is said, and the fold by what is not, then it is at this disjuncture of words and things that the discourse of art history rules, like the painter in *Las Meniñas*, of whom Foucault writes: 'He rules at the threshold of two incompatible visibilities.'[39] The rules of discourse, as *dispositif*, structure how we see the world, and ourselves, in relation to knowledge that is power. The power of the *dispositif* is its efficacity: that which sustains it is the 'fold'. The fold is the effect of the unthought on the thought, the affect. Thus I see Foucault as interested in the specific *conditions* of thought, the *conditions* of becoming or the *processes* of formation of those histories by interplay of both statements of language governing the way we think, and by visibilities illuminating our modes of behaviour.

In his opening chapter to *The Order of Things*, Foucault demonstrates how the painting, *Las Meniñas*, is a poignant illustration of thinking at the beginning of what he terms the classical episteme.[40] Foucault argues that the way we see the world is not continuous; ontologically changing suddenly, disconnectedly and irrationally, it results in a different perception of life, labour, and language that is very dissimilar to our own contemporary understanding. This has major implications for the history of systems of thought. These major discursive fields of knowledge are historically identified as epistemes. The 'classical' episteme begins after the 'Renaissance' episteme in the mid-seventeenth century, and ends at the beginning of the 'modern' episteme at the turn of the nineteenth century. Knowledge is based on classificatory differences. What we can know and what we can say are not founded on substantial 'facts' but on arrangements of discursive structures of knowledges that organize what is possible and permissible to think, and thereby making other things unthinkable.[41] What we understand by 'love' or 'madness', for example, may vary at certain ages or epistemes. In *Understanding Foucault*, Geoff Danaher, Tony Schirato and Jen Webb clearly explain that principles of ordering and exclusion, of truth and of knowledge, appear to be built on solid foundations, but for Foucault, these foundations are nothing but 'thin air'.[42] Being historically based they must, and do, change. The classical age is one of ordering knowledge through observation; the nature of things understood by looking and comparing. Thus, *Las Meniñas* demonstrates the central tenet of the classical episteme, in which the thing and its representation cannot occur in the same space; Man and his representation are separate. The nature of the world is observed and ordered by man, but the topic of investigation is not turned inwardly. Man himself may be the subject of knowledge, but is not yet the object. Man in the episteme of Velázquez cannot exist in the same 'space' as his representation. Knowledge is the ordering of difference of the Same and Other. In *Las Meniñas* Man and

his image are in a relationship, as Foucault terms it, of 'pure reciprocity'.[43]

Although Foucault does not say as much, in the painting of *Las Meniñas*, Velázquez *visibly* demonstrates the fold and the *dispositif*. It is also a performativity, between words and things, implicating the viewer in her dimension of being. Looking at the picture we can see everything that is painted. We can write about everything that is offered to be seen. It is not about that, but about power. The discourse of art history acts to construct everything that we see because the alignments of the discourse, becoming canonical knowledge, are *dispositifs* that present themselves clearly as description in, and of, the painting. On the other hand, that which is in the interstices also constructs the discourse, though it cannot be directly referred to and is (pre-) visible; it is the fold. It must still be present in order to make the discourse active. If the *dispositif* is the tangible spatial structure, it must also harbour the unspoken in the fold: *dispositif* and fold as the outside and the outside curved inside. The present is the *dispositif*, and the absent/present is the fold. The fold is actually demonstrable in *Las Meniñas*. It is the very hidden part of the canvas that only the painter describing the seen/scene can see. What is on the great canvas whose reverse side faces us in the painting? It is a blind spot: 'an essential hiding place'.[44] It is the 'fold'. The process of subjectivization, or the epistemic placing of subjectivization is within the discursive structure and known through addressing power/knowledge. It is between words and things—in the fold.

For example, in the early 1970s, Foucault was interviewed and replied:

> People have often reproached me for these spatial obsessions, which have indeed been obsessions for me. But I think through them I did come to what I had basically been looking for: the relations that are possible between power and knowledge.[45]

The text folds. The painting folds, not in the rhetoric or metaphorics of art-historical writings, not in the actual depiction of the folds, but in the inference, the action, the (in)visibility, the wave/particle, in the sense of space-time dimensions within dimensions. The complexity of trying to write down, clearly, everything that the 'play' of the picture does, instantly, is an apt demonstration of the impossibility of matching 'words' and 'things'.

Foucault himself finally gives in to *Las Meniñas*:

> It is not that words are imperfect, or that, when confronted with the visible, they prove insuperably inadequate. Neither can be re-

duced to the other's terms; it is in vain that we say what we see; what we see never resides in what we say.[46]

And we do it anyhow.

(Efficacity of) performativity

(Efficacity of) performativity is revealed when fragments of words and pictures are placed side-by-side, working to create an idea in the developing understanding that leads to something we did not know when we started to do it. It does not reveal the past, but is constructed in the present. It has, therefore, an unpredictable outcome, like painting itself.

Bal writes: 'performativity misses its effectivity if the effect is not cushioned in a culture that remembers what that act can do.'[47] I want to emphasize, and perhaps even push, Bal's concept of performativity a bit further into the nonclassical thinking, to consider an efficacity of performativity. To clarify my position, we need to remember that Bal's 'effectivity' is not 'efficacity'.

In *Travelling Concepts*, Bal refers back to *Quoting Caravaggio*, and is prompted by Caravaggio's painting of 'foaming whites' to read little fragments of association brought to the surface and emerging in memory. She writes:

> The point of these stains, or rather the performativity of these images-without-image, is that they make you think of something, something that is culturally embedded, so that the sequence of the subsequent images will confirm or infirm this association.[48]

She also suggests that the viewer is part of the performance; 'memory is the stage director' and '[t]his is what makes the viewer the performer'; 'The viewer is the agent of the performance. But, at the same time, the play performed by the viewer is not pre-scripted, prescribed, for the white images refuse to articulate. Seeing cannot be referential.' She explains this by using the words 'seeing-through' or 'seeing-in', a process which is not only directed by the viewer's memory *per se*, but rather the 'images direct the memory work'.[49]

Still trying to get at the meaning of performance/performativity, it seems to me that Bal struggles with the explanation until she gets to something she can state. This, I agree, is the struggle. Trying to articulate the unknowable is trying to describe the efficacity rather than the effect. The struggle resolves into classical thought. Or rather, Bal is describing the resulting *effect* and not the process/action of efficacity.

This paper builds on, and differs from, Bal's analysis, and in that sense it is a meta-paper. I agree with the point Bal makes about '[P]erformance meeting performativity on the site, and under the direction, of memory'.[50] Yet I still think of memory as constructed in the present, somehow. Becoming monumentally fixed, memory becomes *dispositif*. But what of the fold? It is the uncanny aspect of memory that cannot be known.

This is just how Foucault describes a statement:

> The statement, then, must not be treated as an event that occurred in a particular time and place, and that the most one can do is recall it—and celebrate it from afar off—an act of memory ... But neither is it an ideal form that can be actualised in any body, at any time, in any circumstances and in any material conditions ...[51]

Judith Butler states:

> it is important to distinguish performance from performativity: the former presumes a subject, but the latter contests the very notion of the subject ... This is the moment in which discourse becomes productive in a fairly specific way. So what I'm trying to do is think about the performativity as *that aspect of discourse that has the capacity to produce what it names*. Then I take a further step, through the Derridian rewriting of Austin, and suggest that this production actually always happens through a certain kind of repetition and recitation. So if you want the ontology of this, I guess performativity is the vehicle through which ontological effects are established. Performativity is the discursive mode by which ontological effects are installed. Something like that.[52]

Bal takes inspiration from reading Derrida's *Margins of Philosophy*, in which he deconstructs Austin's 1962 lectures. We can see Derrida undoing classical thought with a nonclassical epistemology, raising the 'problematic of the *performative*'.[53] Yet I have shown here that Foucault had already addressed this very problem of the performative in 1969 in *The Archaeology of Knowledge*. I have argued that his move from a static meaning of statement-as-thing to a condition of the statement that can be both statement-as-thing and statement-as-action is crucial to understanding the *dispositif* and 'fold', hence I have retained the French term *énoncé* in order to emphasize that action, an action lost in the translation to English.

For Austin there are two types of locution: 'constatives', which are classical and factual; and 'performatives', which incite action, such as questions and promises. The performative differs from the classical utterance, which is concerned with transmitting facts, in that it induces action, 'it produces or transforms a situation, it operates.'[54] Derrida's argument is that if Austin persists in considering every act as communication, analysing perlocution and illocution in terms of communication, that act automatically infers intention. Thus, Derrida sees that, for Austin, 'performative communication once more becomes the communication of intentional meaning, even if this meaning has no referent in the form of a prior or external thing or state of things.'[55]

So, has Austin moved the performative into nonclassical thought after all? Derrida writes that although it appears he has, indeed Austin has not. Affecting a performative act for Austin, as Derrida explains, always evokes a conscious or intentional presence. The performative collapses back into intention, and as such into classical thought. Derrida, however, presents the performative as an event-like statement in the general space of its possibility, divorced from origin or intent. Austin's speech acts remain intentional, and classical, whereas both Derrida and Foucault remove authorial intention. Derrida's *différance* is nonclassical.[56] Foucault's power/knowledge is nonclassical. Importantly for art history, I maintain it is the latter that shows *how* history works its material, through the efficacity of another sort of performativity.

It is obvious here that Derrida is close to my understanding of Foucaultian *énoncés*, as the statement-as-thing, and the statement-as-action are something other than the origin, intent or consciousness of the utterer.[57] What I am adding here is a position *beyond* the performative, where intention, truth and origin do not come into play: a position where the *énoncé acts as if of its own volition* in the discursive field, as an act of *pure performativity*.

Performativity is the power of the *dispositif*, which itself relies on the struggle of the unsaid, in the fold. The *dispositif* is what we think, the material of memory; the fold is the untold action.

We, art historians, do not know what we are talking about

While both use nonclassical epistemology, Foucault and Derrida have different ways of writing about the effects of an action. I think the difference is this: Bal, through Derrida, emphasizes the 'play' of the surface, telling a story about it, addressing the outcomes, the effects, whereas I, through my reading of Foucault, am addressing the *efficacity*.

I cannot *know* the efficacity of the action of quanta/*énoncés*, but I can describe the means by which they are measured, the measuring in-

struments, which construct a *dispositif*, and the processes of assessment which at the same time *interfere with the actual result of the action of the event* history/art, and by relating the event *as it plays; as performativity*. If efficacity is the power of such effects, it is also power/knowledge. Effect, by definition, is something brought about by a cause or an agent: a result. Efficacity goes beyond performance/performativity, into the *power* of performativity, as the power of the fold acting on the *dispositif*. That which we cannot know influences what we do know. This kind of knowledge/history, as archaeology, seeks not to know the past, not to describe the outcome as an effect on the viewer, but addresses how the means of measuring both hide the event and yet allow the event to become to be known to the aware observer. It does so by giving as much attention to the process of measurement (methods of analysis in the case of art history and its accumulated interpretations) as to the so-called initial event and its interpretation. It also addresses the extent to which the measuring instruments, or interpretive texts, are implicated in the observable effects of the performance. To the aware observer, this kind of knowledge produces performativity between the thing as artwork and the words of writing about it: it is the efficacity of the performativity. Its description (for want of a better word) is meta-conceptual because it lies alongside, beyond, behind and transcending the parallel, in the multiplicity of dimensions offered by what has already been said.

The hidden history of the artwork is like the hidden world of quanta. The marks of the maker and the observer are indistinguishable and are never available to knowledge. Yet knowing this has an impact on what we do know, and furthermore, on whom we are. In the process of writing about art, we change it. Knowing and coming to knowledge is in the performativity of the writing and the visible juxtaposed: the ultimate efficacity.

Nonclassical epistemology, this paper suggests, enables a different approach to critical theories and histories of art. The *dispositif* fixes what we do know, but much of history conceals a lack. No documentation exists for the 'other' history, of secrets hidden, of lies told, of evidence falsified, of documentation lost, of remains unrecognized. Such evidence, and evidence it is, remains hidden in the fold. The performativity of the 'other' is in the realm of the unknowable, of which memory may be only fractional, distorted, (un)recorded, not deterministic or causal. Memory is only possible as fixed, as *dispositif*, as monument to the past, not its documentation. In the realm of explanation/understanding memory must not be allowed to direct the stage.

Queer theory, feminism and Marxism, which fuelled the search for a way to tell the 'unsaid' tales, should not only look to Derrida and Lacan, but can also benefit from this rereading of Foucault's work, in

particular *The Archaeology of Knowledge*. Such a rereading incorporates the shared, transdisciplinary, imaginative structure of theoretical physics. These histories demand that we 'know' the unknowable—unknowable, that is, by the way we measure knowledge.

We will never know, as in quantum theory, what the materiality of truth is, but we can trace the efficacity of the unknown through performativity. That is, the meaning of something gone before, the cause and effect, cannot be stated, as in a text, but we can trace the efficacity of the unknown through performativity, playing art and words alongside each other metonymically.

It is probably nearer the 'truth' to say that in making art, the relation between intention and outcome is not a direct one. It is more of a correlation. Art practice is a process of making, developing and performing with a result. It has a fragmented effect, whose efficacity may be driven by some bit of possible intention, some things from elsewhere, often unknown even to the artist, and to the viewer, and to the writer: an efficacity of performativity produced by doing both the art work and the writing about it. Doing produces. The efficacity is that which is unknown. We do not really, we really do not, know what we are talking about. Such an acknowledgement would allow the performativity of words and things to activate, and enable a new sort of knowledge.

12

COMMITMENT
Cornelia Gräbner

The consequences of social, political and cultural globalization, and re-
lated issues like migration, immigration, cultural identity and cultural
difference are hotly debated in contemporary politics. Concepts like
hybridity, globalization and transculturality are closely related to these
issues. This interconnection between political issues and theoretical
concepts raises the question of whether, as a theorist, one can discuss
the above concepts without making explicit one's own position in the
political debate. The answer seems obvious: one cannot, and one prob-
ably should not. For, as has been argued previously, if one evades a de-
bate, one does not contest the victory of the opponent. In the current
situation it seems irresponsible to not speak up in favour of a society
that is open towards, and seeks to accommodate, cultural difference.
Many theorists share with other groups of their societies the desire to
contribute to the construction of a 'new geography' that is based on
solidarity, tolerance and engagement with different cultures.

Unfortunately, the theory and the research that speak in favour of
this desire are met by politics that enforce precisely the opposite. Bor-
ders are being closed down in a very violent manner and those that are
'culturally different' are being subjected to policies of 'integration' that
bear a worrying resemblance to repression and assimilation. At the
same time, the politics of education enforce the separation between
North and South rather than working against it; they encourage the pri-
vatization and the brain drain, and a streamlining of the contents of
curricula and research that exclude precisely theory that comes from the
South.

These developments are the result of, and help to perpetuate, a
geopolitics that plainly disrespects any scientific finding and any result
of critical thought. The invasion of Iraq was the most obvious evidence
of that. Those in power simply declared inconvenient scientific findings
to be untrue, blatantly defying any rules of science. The protest against

the war, which was the outcome of critical thinking and questioning of the states' actions by their citizens, was met with disregard and insult, and in some countries, with repression. As a consequence of these developments, theorists that are committed to developing critical thought and analysis as a tool for personal and civic empowerment see themselves faced with the question of how they can practise this commitment within an institutional context.

This raises the further question of the meaning of the concept of 'commitment' itself, and the way it can or cannot travel between theory and practice. This article is trying to make a contribution to this necessary rethinking of the practice of commitment, in particular within the disciplines of the humanities. I will discuss articles by several thinkers who have tackled the question of commitment at different times. A particular focus of the analysis will be the relationship between commitment and political action that these articles suggest. Departing from Homi K. Bhabha's 'The Commitment to Theory', I will problematize the conflation of committed theory and political action it suggests, and will look at other articles that respond to similar concerns as Bhabha. These articles vary from a sharp distinction between traditional and committed intellectuals in Gramsci's text 'The Intellectuals', to Adorno's analysis of the different functions of committed and autonomous works of art in 'Commitment', in which the autonomous work of art emerges as inherently political. I then problematize the applicability of Adorno's concepts to contemporary theory by engaging Judith Butler's application of performativity to political language in *Excitable Speech* with the Subcomandante Insurgente Marcos's analysis of the appropriation of language and its performative functions by those in power in 'Another Geography'. Timothy Brennan's discussion of 'committed theory' in relation to creative and civic agency in 'Cosmo-Theory' finally outlines some of the consequences of the conflation between committed theory and political action.

Bhabha's 'The Commitment to Theory', published in *The Location of Culture*, puts forward one particular theorization of the connection between theory, commitment and political action that is embraced by many of those who move in contemporary progressive academic circles. He offers a model that integrates political commitment and theory, and thus makes theory a performance of one's political commitment. In this essay, Bhabha suggests that by situating itself in a particular space, theory puts political commitment into practice. Crucial for his argument is that the act of situating oneself is the expression and the performance of a political commitment. Through this argument, Bhabha establishes a connection between a performance of political commitment by way of theory and political action.

The act of situating oneself in a 'third space' is crucial for Bhabha's argument, and he suggests a double use of the concept. Firstly, he uses it as a cultural concept: the third space has developed in the interstices between different cultures and is characterized by the cultural hybridity of its inhabitants. Secondly, he uses the term to designate a space where theory and practice merge because they are both driven by commitment.

The two uses of 'third space' are related to each other, as Bhabha explains early on in his article:

> I want to take my stand on the shifting margins of cultural displacement—that confounds any profound or 'authentic' sense of a 'national' culture or an 'organic' intellectual—and ask what the function of a committed theoretical perspective might be, once the cultural and historical hybridity of the postcolonial world is taken as the paradigmatic place of departure.[1]

Implicitly at stake in these argumentative moves that are based on spatial metaphors is Antonio Gramsci's differentiation between the 'traditional' and the 'organic' intellectual. In 'The Intellectuals', published in the *Prison Notebooks*, Gramsci introduces the difference between '"traditional" intellectuals' and '"organic" intellectuals'. The 'organic' intellectuals develop out of a particular social group:

> Every social group, coming into existence on the original terrain of an essential function in the world of economic production, creates together with itself, organically, one or more strata of intellectuals which give it homogeneity and an awareness of its own function not only in the economic but also in the social and political fields.[2]

Gramsci argues that each social group needs intellectuals to theorize its identity and its function. The 'organic' intellectuals fulfil this function from within their group:

> The mode of being of the new intellectual can no longer consist in eloquence, which is an exterior and momentary mover of feelings and passions, but in active participation in practical life, as constructor, organizer, 'permanent persuader' and not just a simple orator.[3]

Thus, the 'organic' intellectual has a very specific function and certain responsibilities within her social group. These include her participation in this group's social and political aspirations.

The 'traditional' intellectuals do not evolve out of any particular so-
cial group, even though they have emerged as a by-product of several,
at times competing, social groups. However, they form a group in
themselves:

> Since these various categories of traditional intellectuals experi-
> ence through an *'ésprit de corps'* their uninterrupted historical con-
> tinuity and their special qualification, they thus put themselves
> forward as autonomous and independent of the dominant social
> group.[4]

When Bhabha suggests that 'the shifting margins of cultural displace-
ment' confound 'any profound sense of an authentic "national" culture
or an "organic" intellectual', he is implicitly suggesting that the—class-
based—concept of the 'organic' intellectual is tied up with the idea of
a national culture. However, the clear-cut identification of an authentic
national culture nowadays loses its meaning because the recent devel-
opments of cultural displacement make people part of not one authen-
tic, but of a hybrid culture; the concept of an '"organic" intellectual'
loses its meaning as well, presumably because the shifts caused by cul-
tural displacement make it impossible for anyone to emerge out of one
particular social group.

I have outlined above that the 'organic intellectual' in the Gramscian
sense takes an active part in the organized politics of the class that has
produced her. She is not only a producer of knowledge, but also an or-
ganizer. Thus, the political commitment of the 'organic' intellectual
emerges out of where the 'organic' intellectual situates herself. It is also
inseparable from concrete political action.

At first sight Bhabha seems to be in line with Gramsci. He, too, sug-
gests that the spaces of the theorist and the activist are not separate,
and that the theorist is to an extent a product or spokesperson of her
environment. Gramsci and Bhabha differ, however, when it comes to
assigning one's commitment to a particular cause. Bhabha refuses early
on in his essay to align himself with any concrete political objective:

> At this stage in the argument, I do not want to identify any special
> 'object' of political allegiance—the Third World, the working class,
> the feminist struggle. Although such an objectification of political
> activity is crucial and must significantly inform political debate, it
> is not the only option for those critics or intellectuals who are
> committed to progressive political change in the direction of a so-
> cialist society.[5]

Bhabha argues that there is a way for the theorist to practise her political commitment without belonging to any particular social group or taking any concrete political action. He considers this project of his a sign of political maturity: 'It is a sign of political maturity to accept that there are many forms of political writing whose different effects are obscured when they are divided between the "theoretical" and the "activist".'[6]

The option that Bhabha suggests is 'the process of "intervening ideologically".'[7] He argues with Stuart Hall that

> the notion of hegemony implies a politics of *identification* of the imaginary. This occupies a discursive space which is not exclusively delimited by the history of either the right or the left. It exists somehow in-between these political parties, and also between the familiar divisions of theory and political practice.[8]

The emergence of such a 'politics of the identification of the imaginary' relies on a dynamic whose identification Bhabha traces back to the 'rule of repeatable materiality',

> which Foucault describes as the process by which statements from one institution can be transcribed in the discourse of another. Despite the schemata of use and application that constitute a field of stabilization for the statement, any change in the statement's conditions of use and reinvestment, any alteration in its field of experience or verification, or indeed any difference in the problems to be solved, can lead to the emergence of a new statement: the difference of the same.[9]

Here, Bhabha draws attention to the structure of iteration. In iteration a social norm or political concept is being cited, i.e. performed or quoted. In the moment of citation the agent who is citing has the possibility of altering the meaning of the norm he is citing, and can thus open up a space for the emergence of a new dimension of meaning.[10] Bhabha explains iteration as a possibility to subvert the existing system by appropriating the terms, concepts and norms it offers. This is part of the subversive and democratizing appeal of the concepts of performativity and of iteration itself. Following this logic, a practice of theory that situates itself in a certain cultural space, and that uses the function of iteration to change people's ideas and perceptions of a political reality, would be a form of political action, argues Bhabha. The necessity for this argumentative move seems obvious: it is difficult to find a context for concrete political action if one cannot or does not want to work on a long-term basis in a certain place and with a certain

group. An intellectual who is not tied to a particular place or to a particular group within a certain society, but nevertheless wants to practise his political commitment, should be able to do so. Bhabha's model seems to provide a possibility for this. However, the model also has its pitfalls.

Due to space constraints I will limit myself to discussing only two of these pitfalls. One is related to the metaphors of space that Bhabha employs, most notably in defining the 'third space of theory'. The other is related to Bhabha's use of iteration.[11]

To explain how the first pitfall functions it will be useful to engage Bhabha's proposition of a third space of theory with Adorno's analysis of 'commitment' in autonomous and committed works of art in his article of the same title, 'Commitment'.[12] Discussing Sartre, Adorno argues against a reductive and in fact oppressive division between art and theory on the one hand, and political action on the other. He decries—and rightly so—a peculiar complicity between committed works of art and attitudes that enable totalitarianism. The works of art that are produced with this type of commitment endorse a particular ideological position and seek to impose it on the recipient:

> The latter [committed works] can all too readily claim all the noble values for themselves and do with them as they please ... In Germany commitment in art amounts primarily to parroting what everybody is saying, or at least what everybody would like to hear. Hidden in the notion of a 'message', of art's manifesto, even if it is politically radical, is a moment of accommodation to the world; the gesture of addressing the listener contains a secret complicity with those being addressed, who can, however, be released from their illusions only if that complicity is rescinded.[13]

Committed works of art, argues Adorno, do not seek to emancipate the recipients so that they can decide whether they want to support a particular cause or not. On the contrary, in order to persuade the recipient of the cause they champion, they seek to construct another 'illusion' in which they want the recipient to remain, so that he supports the cause without questioning it.

So-called autonomous works of art function in an entirely different way: 'In dismantling illusion they explode art from the inside, whereas proclaimed commitment only subjugates art from the outside, hence only illusorily. Their implacability compels the change in attitude that committed works only demand.'[14] This implacability is achieved by a refusal to 'accommodate the world' as it is. Such works of art do not attempt to persuade the recipients that they should change their attitude

towards certain things. Engaging with the work itself effects this change, without obliging the recipients to commit themselves to any particular cause or ideology. This analysis emerges from a specific context, as Adorno himself indicates: 'The current deformation of politics, the rigidification of circumstances that are not starting to thaw anywhere, forces spirit to move to places where it does not need to become part of the rabble.'[15]

During the Cold War period the two opposing systems sought to make any refusal to participate in the 'rabble' impossible. In the middle of this onslaught the truly committed work of art 'is charged with wordlessly maintaining what politics has no access to'.[16] As it refuses to be taken over or instrumentalized by either of the competing ideologies, it becomes itself inherently political *because* of its refusal: 'This is not the time for political works of art; rather, politics has migrated into the autonomous work of art, and it has penetrated most deeply into works that present themselves as politically dead …'[17]

It is these 'politically dead' works that are not complicit with a world in which two ideologies were fiercely competing for world domination. Both ideologies, argues Adorno, use similar strategies: instead of empowering the subject, they try to manipulate it; instead of engaging with thought, they try to channel it. Adorno suggests that the only way to counter such a prescriptive mode of thinking and to create and live an alternative one is to withdraw into a 'third', autonomous space.

In Adorno's scenario—a world in which everyone had to choose for one ideology or the other—the construction of such a space was a political decision of resistance to an all-consuming system. The autonomous space, denounced as the site of 'spectatorlike neutrality' by those that were out to catch souls by depriving people of the possibility to choose anything other than the ideology on offer, would indeed be a site of intellectual independence and critique.

Bhabha's notion of commitment is in many ways related to Adorno's notion of autonomy. Bhabha seeks to recover the notion of commitment as a form of struggle against a reduction and limitation of the human subject, against channelling and simplification, and against a profoundly anti-intellectual and uncritical attitude. In this sense Bhabha argues for what can be called an 'autonomous commitment'. Whereas Adorno sees commitment as always connected with a cause, Bhabha argues that it does not need to be. The committed theory that Bhabha talks about would be a performance of the resistance of critical thought against all-consuming ideologies, whichever ideology that would be. In this sense it is also committed, but autonomous of any ideology.

However, I contend that Bhabha's proposition does not hold in the early twenty-first century and did not even hold in the mid-1990s, be-

cause it is not a response to its political and social context, whereas Adorno's notion of autonomy was precisely that. The following example will demonstrate this.

In his article 'Another Geography' the Subcomandante Insurgente Marcos, spokesman for the Ejército Zapatista para la Liberación Nacional (EZLN),[18] describes a scenario in which one power seeks to subsume all spaces into one homogeneous space. This power is identified as the ideology of neoliberalism. Marcos uses the metaphor of the Tower of Babel to explain his contention. The Tower of Babel, he argues, could only be constructed because of the homogeneity among people. The moment that they started speaking different languages and become heterogeneous the construction of the Tower of Babel became impossible. Neoliberalism is reviving this project:

> Neoliberalism's project for the world is nothing more than a refashioning of the Tower of Babel. According to the book of Genesis, men, in their striving to reach the heights, agreed on a colossal project: building a tower that was so high it would reach the heavens. The Christian god punished their pride with diversity. Speaking different languages, the men could no longer continue with the building, and they disbanded. Neoliberalism is attempting to erect the same edifice, not in order to reach an unlikely heaven, but in order to free itself once and for all from diversity, which it considers a curse, and in order to ensure that the Powers never stop being Powers.[19]

It is important to note that the basis on which neoliberalism wants to erect the Tower of Babel differs profoundly from that of the biblical peoples: 'While unanimity was possible in the prehistoric Tower of Babel because of common speech (the same language), consensus is obtained in neoliberal history through the arguments of force, threats, arbitrariness, war.'[20]

In Adorno's and Bhabha's model we have two powers or cultures that oppose each other. The third space emerges out of the friction between them. In Marcos's model, we have only one power that imposes its own culture. This power does not even bother to oppose those that are different; it simply swallows them up.

After swallowing up all other spaces, neoliberalism organizes the emerging new, single space in a hierarchical manner. In its analysis of the way in which the proponents and politicians of neoliberalism do this, Marcos's article deploys a pronounced spatial metaphor. This helps him to demonstrate the interconnectedness between the architectural endeavour of constructing the new Tower of Babel as a location with

an above and a below, the geographical vision that neoliberalism proposes, and the geopolitics that enforce this vision of geography:

> Those who reside in the North do not do so in the geographical
> North, but in the social North, that is, they are above. Those who
> live in the South are below. Geography has been simplified: there
> is an above and a below. The space above is narrow and has room
> for just a few. The one below is so broad that it takes in every place
> on the planet and has room for all of humanity.[21]

Marcos's choice of words, his mixture of images from unrelated areas—architecture and geography—that suddenly condition each other, demonstrates how bizarre such a view of the world is. Talking about world geography one should not even be able to apply the terms 'above' and 'below' because geographically they do not make any sense: the world is round, therefore there is no above or below.

The geography that neoliberalism imposes, however, is inherently hierarchical. It has nothing to do with the scientific facts of geography; it is constructed by human beings in order to impose a hierarchy. In this scenario there is no second homogeneous space that allows for a third space to emerge out of a friction between the two. Thus—and this is one of the most horrifying and claustrophobic aspects of this system—there is no point to which one can withdraw. The system leaves no space outside of it. It subsumes any possibility of autonomous space into its hierarchical geography.

The construction of the 'geography of power', as Marcos calls it, is related to the function of iteration. This is the second pitfall in Bhabha's argument. In iteration, the author loses some control over the effect that her text has on others. This is part of its subversive and democratizing appeal. Bhabha does not take into account, however, the possibility that the dynamic can backfire, depending on who is using it. This is precisely the point that Marcos makes.

Marcos sees the construction of any space as taking effect through words. To achieve their aim of complete domination, those in power need to achieve homogeneity. One of their means of doing so—apart from sheer force and oppression—is the appropriation of the meaning of concepts. Those in power do so by modifying the meanings of these concepts to support their purposes. They have, for example, managed to conflate 'equality' and 'homogeneity':

> That equality which destroys heterogeneity is equality with a
> model. 'We are equal to that', the new religion of money tells us.
> Human beings do not look like themselves, nor like each other,

but rather like a conception which is imposed by he who exercises dominion, he who orders, he who is on top of that power which is the modern world. Those who are different are below. And the only equality which exists on the lower floors is that of renouncing being different, or of opting for being so in a shameful manner.[22]

Equality, however, is not just any concept. Together with fraternity and liberty it was one of the three concepts of the French revolution and has ever since been an extremely powerful term in political struggles. It was once suggested to me that certain terms—like liberty, fraternity, equality, democracy, justice, dignity—are terms of struggle (*Kampfbe-griffe*). Terms of struggle are terms that enable those who use them to recognize, demand and defend their rights. They empower and legitimize; thus, they become weapons in a struggle. As terms, they can become the means of travel between theoretical concepts and actions; thus, between theory and practice.

Marcos describes a process in which power takes over terms of struggle and gives them a fixed meaning that makes them meaningless for the struggles that depend on these concepts to articulate their own meaning. What happened to the concept of 'equality' is just one aspect of a strategy that affects language as such:

> Without caring whether or not we are aware of it, the Power is constructing and imposing a new geography of words. The names are the same, but what is being named has changed. And so mistakes are political doctrine, and what is true is heresy. The different is now the opponent, the other is the enemy. Democracy is the unanimity in obedience. Liberty is only the liberty to choose the manner in which we conceal our difference. Peace is passive submission. And war is now a pedagogical method for teaching geography.[23]

The new meanings of these terms do not permit any protest against the system that has established their meaning. Neither is it possible to change their meaning again because the new meaning deprives anyone but power of agency. Thus, the terms are stripped of a flexibility that is essential for the democratic use of iteration.

Judith Butler refers to a similar process in *Excitable Speech*. Analysing the Nobel laureate speech by Toni Morrison she comes to the conclusion that 'Language remains alive when it refuses to "encapsulate" … or "capture" … the events and lives it describes. But when it seeks to effect that capture, language not only loses its vitality, but acquires its own violent force …'[24]

All the terms of struggle whose appropriation by power Marcos describes above have a violent force in their neoliberalist version; they silence, deprive of agency, and oppress. In appropriating them, however, power has also appropriated their moral weight. The terms of struggle that power has appropriated are now terms of war. The word—or concept—of equality for example is so powerful that it can legitimize the annihilation of difference in its name. Note what I just wrote: the word *legitimizes*; the word commits an action. Marcos's understanding of language is performative. In his interrogation of the function of the word 'equality' he does not ask what the word means, but what it does. A certain interpretation of the concept of 'equality' has enabled those in power to eradicate difference and to establish homogeneity in the place of diversity and pretend that they did it for the good of everyone. *But*, it was not the word that committed the deeds.

Marcos points out something very important: words and concepts are at the beginning of a chain of events. In that sense they are powerful because they can set events in motion and because they enable and legitimize certain actions. However, they do not *commit* these actions. Human beings do. Marcos describes a perlocutionary speech act. Butler explains the perlocutionary speech act as follows:

> Perlocutionary acts ... are those utterances that initiate a set of consequences: in a perlocutionary speech act, 'saying something will produce certain consequences,' but the saying and the consequences produced are temporally distinct; those consequences are not the same as the act of speech, but are, rather, 'what we bring about or achieve by saying something' ...[25]

The system that Marcos describes has combined the possibilities of iteration with the possession of state power, economic power, military power, and control over the media and education. Thus, 'the powerful' have found a way to control the perlocutionary speech act *as well as* its consequences. By way of this combination they have used iteration to impose a system that allows them to deprive language of its flexibility, a system that has thus done away with the possibility of iteration, and in doing so has managed to make words and concepts unavailable for anyone who disagrees with the worldview that has become a very part of the meaning of said words and concepts. The concepts 'the powerful' appropriate then become unavailable for those who struggle against the power that determines the meaning of these concepts; if one demands 'equality' one demands 'homogeneity', even if this is not what one means.

In this scenario words do no longer serve as a means for communication. Instead, they serve to construct what Marcos calls 'another ge-

ography', which is 'the geography of power'. For if the different becomes the opponent and what is other becomes the enemy, then the annihilation of the different is legitimate, and its replacement by the model of those who determine first the meaning of words and then map out geopolitics becomes desirable.

How to counter such a development? One of Marcos's most important projects and one of the Zapatistas' major achievements has been their constant work with language. They have managed to restore some flexibility to language and in doing so, to recuperate many concepts for a vocabulary of dissent and protest. They are capable of doing so because by way of political action they have effectively contested the sole authority of economic and political forces over the determination of the meaning of words and concepts. Thus, they have managed to create spaces in which the meanings of words and concepts can be discussed and redefined, and in which the flexibility of iteration becomes again available for a large group of people.

Bhabha, in contrast, does not account for exterior forces that can interfere with the process of iteration. He assumes that theory can negotiate its relationship with political action on its own terms, staying at home so to speak. However, he does not take into account that the meaning of the terms that are used to negotiate this relationship might be determined by an outside force. He cannot take this into account because he refuses to address the context of the third space in which theory is to be spoken. Thus, there are no other forces but theory and political action in the negotiation that Bhabha suggests. As a consequence, severe problems arise for the conception of agency.

To illustrate the precise nature of these problems I will turn to one particular case, the discourse of transculturality and its pitfalls. Timothy Brennan explores this both in his book *At Home in the World*[26] and in his article 'Cosmo-Theory'. In 'Cosmo-Theory' he notes that the discourse of Cosmo-Theory 'is a discourse of "processes," "movements," unfoldings rather than designs, projects, or campaigns. Life is described as what happens to people.'[27]

Brennan argues that diasporic situations do not simply evolve, but that they are the result of designs, projects, campaigns, or policies, usually of oppression, displacement and exploitation. Diasporic situations usually exist because people see themselves forced to leave their homes, not because they want to leave. Cultural theorists tend to neglect this violent origin of cultural hybridity. Instead, they uncritically embrace the result: 'The culture of diasporic subjects is usually given a positive inflection in cultural theory without remarking on its coercive nature— that people often do not want to be diasporic.'[28]

Because certain parts of cultural theory do not investigate or even address the reasons for the emergence of 'cultural hybridity' they end

up describing 'life as what happens to people'.[29] But what does this en-
tail for the concept of agency? Brennan writes:

> It is not as though there were no role for agency in such theories,
> which on the contrary rely on excited exaggerations of activity,
> creativity and plebeian initiative. But agency is almost never seen
> in moments of civic participation. It is primarily about subject for-
> mation. Agency, in fact, tends to be seen as a gradual process of
> coming to accept a *fait accompli*, and learning to mobilize it.[30]

If one treats the diasporic situation that produces hybridity as a fait ac-
compli, then one forecloses the question of what happened to the peo-
ple who created this situation, for what reasons they did it, and whether
they might even continue the projects that led to the creation of dias-
poric situations. Thus, it becomes impossible to ask the question of
how these powers might still impact on the framework of the third
space, whether they might impose rules, constraints, or whether they
might implement strategies that limit hybridity to the third space in
order to make sure that it does not spill over into the first and the sec-
ond space, which conceivably also exist but that Bhabha does not in-
vestigate. The cultural hybridity Bhabha writes about is developed in a
space whose margins have been decided upon not by the people who
inhabit it, but by somebody else. In other words, the third space is a fait
accompli and those inhabiting it are making the best of their situation.

To contest its situation of a fait accompli, as the location of cultural
hybridity, Bhabha's third space would have to address its relationship to
its surroundings, but this is precisely what Bhabha declines to do. Sim-
ilarly, Bhabha's third space of theory does not deal with how its sur-
roundings impact on it. Bhabha posits the intellectual in the third space
as autonomous from the dominant social movement, as Gramsci's tra-
ditional intellectual perceived himself. Brennan demonstrates how the
concept of civic agency breaks down if one supports the emergence of
a space in which agency is conceived of as primarily creative agency. In
Bhabha's third space, theory and political action are conflated to a point
that they become indistinguishable, and at this point Bhabha manages
subtly to write activism out of the equation. Theory becomes a form
of activism, but activism is never acknowledged as a form of theory, or
even as informing theory. In fact, activism becomes obsolete because,
according to Bhabha's argument theory already effects political change,
and hence, there does not seem to be any need for activism. However,
the line between theory and political change has never been as direct as
Bhabha suggests. There have always been people who have taken it
upon themselves to create conditions under which certain theories

could become widely known and effective and were translated (more or less faithfully) into concrete political measures and actions. Not to acknowledge this step is not only disrespectful and offensive towards many people who did just that, it also means that theory becomes ineffective.

Does this mean that, if we as theorists do feel committed to the ideal of a society that engages and accommodates cultural difference and want to see this idea become reality, we need to take to the streets and become members of social movements? I do not think that this is the only contribution we can make. At stake is not whether theory can substitute for activism or activism for theory. At stake is the dynamic relationship, the 'travel' between the two.

Returning to the metaphors of geography I would like to suggest for both theorists and activists to travel and visit each other in their territories. The borders between the two fields should be maintained but not policed; as long as communication between them works well, and as long as the borders can be easily crossed, the different strategies of theorists and activists can be enriching and can complement and inspire each other. For such an interaction,

> a little respect is needed for the other who is resisting someplace else in his otherly self, as well as a lot of humility in order to remember that much can still be learned from that otherly self, and wisdom to not copy, but produce, a theory and a practice which does not include arrogance in its principles, but which recognizes its horizons and the tools that serve for those horizons.[31]

This respect requires that academics take the risk of identifying concrete causes, movements and struggles as ways towards their horizon and that they commit themselves to them. Furthermore, academic theorists need to acknowledge the intellectual sophistication of many movements and activists. I have never heard of an activist who would commit herself to the 'Third World', as Bhabha suggests, because such a commitment makes no sense in the praxis of political activism. Academic theorists as well as activists need to acknowledge that their methods and their language might differ due to the fact that each of them is 'resisting someplace else in this otherly self', but that their respective methods and language can be understood and responded to. This is an issue of language, conceived of as performative: communication needs to be respectful and clear, informed by the knowledge of oneself, by respect for the approach of the other and by the desire to be honest and open with one another. This respectful and open mode of communication is not a goal. It is a continuous dynamic practice, and it is the

only way to survive in a dignified and responsible manner in a situation in which politics strangle and channel critical thinking and critical analysis, the motors of both theory and activism.

Academic theory can only get to a point at which it can start this process by investigating its own relationship with its surroundings. Academics need to address questions like those Brennan raises in 'Cosmo-Theory', and which for reasons of space constraints I could not address. How are the concepts we develop and the results of our investigations used, and by whom? Who commissions them, who uses them, and how and to what end? Do our approaches support civic agency or do they work to its detriment? How do we negotiate creative agency and civic agency with each other? If we want to write theories that contribute to the construction of societies that engage cultural differences and that accommodate them, but which are also willing to leave them their own spaces, we need to interrogate not only the words we use and the concepts we develop, but also their lives outside the university.

NOTES

Editor's Preface

1 Mieke Bal and Inge Boer (eds), *The Point of Theory: Practices of Cultural Analysis* (Amsterdam: Amsterdam University Press, 1994); Mieke Bal, *The Practice of Cultural Analysis: Exposing Interdisciplinary Interpretation* (Stanford: Stanford University Press, 1999).

2 Bal: *The Practice of Cultural Analysis*, p. 1.

3 Mieke Bal, *Travelling Concepts in the Humanities: A Rough Guide* (Toronto: University of Toronto Press, 2002).

Chapter 1. Working with Concepts

1 Jonathan Culler, 'Philosophy and Literature: The Fortunes of the Perfomative', *Poetics Today* 21/3 (2000), p. 504.

2 Mieke Bal, *Travelling Concepts in the Humanities: A Rough Guide* (Toronto: University of Toronto Press, 2002).

3 Mieke Bal, *The Practice of Cultural Analysis: Exposing Interdisciplinary Interpretation* (Stanford: Stanford University Press, 1999).

4 *Longman Dictionary of the English Language*, 2nd edn, s.v. 'concept'.

5 Gilles Deleuze and Félix Guattari, *What Is Philosophy?* [1991], trans. Hugh Tomlinson and Graham Burchill (London: Verso, 1994), p. 3.

Chapter 2. Framing

1 See Judith Fetterley, *The Resisting Reader: A Feminist Approach to American Fiction* (Bloomington and London: Indiana University Press, 1978); Jonathan Culler, 'Reading as a woman', in *On Deconstruction: Theory and Criticism After Structuralism* (London: Routledge & Kegan Paul, 1983), pp. 43–64; Roberta Krueger, *Women Readers and the Ideology of Gender in Old French Courtly Verse Romance* (Cambridge: Cambridge University Press, 1993); Tova Rosen, *Unveiling Eve: Reading Gender in Medieval Hebrew Literature* (Philadelphia: University of Pennsylvania Press, 2003).

2 Mieke Bal, *Travelling Concepts in the Humanities: A Rough Guide* (Toronto: Toronto University Press, 2002), pp. 133–73, especially p. 135. I would like to thank Mieke Bal and Griselda Pollock for their comments on an earlier version of this essay, and Medieval and Renaissance Texts and Studies for permission to rewrite research, part of which was published as Eva Frojmovic, 'Reframing Gender in

Medieval Jewish Images of Circumcision', in R. Voaden and D. Wolfthal (eds), *Framing the Family: Narrative and Representation in the Medieval and Early Modern Periods* (Tempe: Arizona Center for Medieval and Renaissance Studies, 2005), pp. 221–43.

3 As laid out in the introduction of Krueger: *Women Readers and the Ideology of Gender*.

4 Rosen: *Unveiling Eve*; Krueger: *Women Readers and the Ideology of Gender*.

5 The feminist concept of the resisting reader was introduced by Judith Fetterley in *The Resisting Reader*. In this foundational book, she analysed the process of emasculation that the resisting feminist reader has to counter. For a critique of Fetterley's formulation of resistance from outside the 'closed system' of literature, and the development of feminist theory of reading, see Shoshana Felman, *What Does a Woman Want?: Reading and Sexual Difference* (Baltimore: Johns Hopkins University Press, 1993), especially pp. 4–6. My thanks to Griselda Pollock for bringing this work to my attention. Also important has been Culler: 'Reading as a Woman'.

6 This form of reading can lead to rewriting. Let me mention the well-known Judeo-Provençal prayer-book in the Cecil Roth Collection in Leeds, where the text of the controversial morning blessing 'Blessed are you Lord of the universe who has made me according to your will' is replaced by 'who has made me a woman'. It is of course not completely clear what this means, but the one thing it means to me is that here was someone who did not want her prayer-book to say 'who as made me according to your will'. As long as we search for the meaning in the text only we cannot arrive at an incontrovertible feminist interpretation (i.e. one could always argue that the new blessing means the same thing as the standard blessing). A feminist interpretation is only possible through an implied woman reader. In this case clearly implied by the dedication frontispiece page, and the vernacular language. The manuscript still awaits a full (feminist) analysis.

7 Elisheva Baumgarten, 'Circumcision and Baptism: The Development of a Jewish Ritual in Christian Europe', in E. Wyner Mark (ed), *The Covenant of Circumcision: New Perspectives on an Ancient Jewish Rite* (Hanover: University Press of New England, 2003), 114–27. Elisheva Baumgarten, *Mothers and Children: Jewish ritual in Medieval Europe* (Princeton: Princeton University Press, 2004), appeared after the completion of the present essay. See also Simha Goldin, *Alamot ahevukha, al-mot ahevukha* [*The Ways of Jewish Martyrdom*] (Lod: Devir, 2002) [Hebrew]; Lawrence A. Hoffman, *Covenant of Blood: circumcision and gender in rabbinic Judaism* (Chicago: University of Chicago Press, 1996).

8 We know very little about synagogue architecture and the social organization of worship before the twelfth century, though we know about liturgical texts.

9 Z. Ameisenowa, *Biblja hebrajska XIV-go wieku w Krakowie i jej dekoracja malarska* (Cracow, 1929); E. Róth, *Hebräische Handschriften*, vol VI/2 (195) of H. Striedl (ed), *Verzeichnis der orientalischen Handschriften in Deutschland* (Wiesbaden: Steiner, 1965). During the preparation of that catalogue, the manuscript still lay unrecognized in Hanau; B. Narkiss, *Hebrew Illuminated Manuscripts* [1969] (Jerusalem: Keter, 1992), p. 98. The manuscript is now in the Israel Museum, Jerusalem, founded 1965; K. Dachs and F. Mütherich (eds), *Regensburger Buchmalerei. Von frühkarolingischer Zeit bis zum Ausgang des Mittelalters* (München: Prestel-Verlag, 1987), cat. no. 68, pp. 87–8; R. Suckale, 'Über den Anteil christlicher Maler an der Ausmalung he-

bräischer Handschriften der Gotik in Bayern', in M. Treml and J. Kirmeier (eds), *Geschichte und Kultur der Juden in Bayern* (München: Haus der Bayerischen Geschichte, 1988), pp. 123–34.

10 The thirteenth-century synagogue of Regensburg, although destroyed in 1519 to make way for a Marian pilgrimage church, was immortalized by Albrecht Altdorfer in two engravings made just before the demolition. Recent excavations of this building have confirmed its monumental size and the quality of its workmanship.

11 The method of adding separate picture sections not covered with text and bound to a separately produced text is a widespread phenomenon known especially in Latin illuminated Psalters of the thirteenth century. It also occurs in manuscripts of the moralistic treatise Somme le Roi, first illuminated c.1270–80 by the Parisian Master Honoré. Hebrew manuscripts of the Passover Haggadah employ this technique in French-influenced northern Spain from c.1300. However, the Regensburg Pentateuch is likely to pre-date them.

12 'And Abraham circumcised his son Isaac being eight days old, as God had commanded him.' Genesis 21: 4.

13 N. H. Ott, 'Literatur in Bildern. Eine Vorbemerkung und sieben Stichworte', in E. C. Lutz, J. Thali, and R. Wetzel (eds), *Literatur und Wandmalerei I: Erscheinungsformen höfischer Kultur und ihre Träger im Mittelalter*; Freiburger Colloquium 1998, (Tübingen: Niemeyer, 2002), pp. 153–97.

14 These kinds of symbolic links have been amply demonstrated in Goldin: *Alamot ahevukha* and S. Einbinder, *Beautiful Death: Jewish Poetry and Martyrdom in Medieval France* (Princeton: Princeton University Press, 2002). Some aspects were also previously researched in Shalom Spiegel, *The Last Trial: On the Legends and Lore of the Command to Abraham to Offer Isaac as a Sacrifice* (Philadelphia: Jewish Publication Society, 1967).

15 See Baumgarten: 'Circumcision and Baptism'; Hoffman: *Covenant of Blood*; Goldin: *Alamot ahevukha*.

16 Jacob ha-Gozer, *Zikhron berit la-rishonim* [*Memory of the Covenant of the Ancients*], ed Y. Glasberg (Berlin: T. H. Itskovski, 1892) [Hebrew]. A single undated manuscript of this text is extant in the library of Jews' College, London. This text is discussed in S. Goldin, 'The Role of Ceremonies in the Socialization Process: The Case of Jewish Communities of Northern France and Germany in the Middle Ages', *Archives des Sciences Sociales des Religions* 95 (1996), pp. 163–78, especially pp. 166–71. However, I disagree with Goldin, who equates the prescriptive with a descriptive dimension, i.e. does not in this instance posit a tension between norm and practice.

17 The figure of the witness/viewer brings to mind the Christian martyrdom scenes and the way they seek to establish an identification between the witness within the image with the viewer outside it. My point here is to argue that the women in this miniature are not just affirmative, but also potentially critical witnesses.

18 I am relying here on Einbinder's *Beautiful Death*, which has been of paramount importance for my research. Einbinder finds similar patterns in French and German Hebrew poetry. In a recent conference paper, Katrin Kogman-Appel has drawn attention to objections against the practice of *Kidush ha-Shem*. Katrin Kogman-Appel, '"The Firm Believer Discerned Thy Truth": Abraham as a role model for the persecuted believer', paper presented at conference Illuminating Narrative: Vi-

sual Storytelling in Medieval Manuscripts, 9–10 July 2005, Courtauld Institute, London.

19 An extract of the biblical text is re-transcribed in the margins around the minia-
 ture. This extract consists of, in the top margin, Genesis 21: 4–5 ('And Abraham
 circumcised Isaac…'), followed by Genesis 21: 7–9. Genesis 21: 6, Sarah's inter-
 pretation of Isaac's name as 'God has laughed at/with me,' is omitted. This omis-
 sion calls for further interpretation. The bottom margin is inscribed with Genesis
 22: 2–5. The hand appears to be neither that of the Massorete nor that of the
 scribe's colophon, but looks contemporary, added after the delivery of the out-
 sources miniatures.
20 Felman: *What Does a Woman Want?*, p. 6.
21 For the homosocial community of Torah study, see Daniel Boyarin, *Carnal Israel:
 Reading Sex in Talmudic Culture* (Berkeley: University of California Press, 1993),
 and Daniel Boyarin, *Unheroic Conduct: the Rise of Heterosexuality and the Invention of
 the Jewish Man* (Berkeley: University of California Press, 1997).

Chapter 3. Visual Agency

1 Giovanni Careri, 'Mutazioni d'affetti, Poussin interprete del Tasso', in O. Bonfait
 (ed), *Poussin et Rome: Actes du colloque de l'Académie de France à Rome* (Paris: RMN,
 1996), pp. 353–6. My approach differs from the interpretation of the aesthetic of
 dual gender as a merging, indefinable subject, for this argument see Fredrika H.
 Jacobs, 'Aretino and Michelangelo, Dolce and Titian: *Femmina, Maschio, Grazia*',
 Art Bulletin 82 (2000), pp. 51–67.
2 Michel Foucault, *The Order of Things: An Archaeology of the Human Sciences* [1966],
 3rd edn (London: Routledge, 2002), pp. 20–1, 140–3; David Freedberg, *The Eye
 of the Lynx: Galileo, his friends and the beginnings of modern natural history* (Chicago: Uni-
 versity of Chicago Press, 2002).
3 Louis Marin, *Sublime Poussin*, trans. Catherine Porter (Stanford: Stanford University
 Press, 1999), p. 165; Armida's gaze upon the sleeping Rinaldo figures the 'viewer's
 own gaze … playing out on the sleeping body of the work'; Giovanni Careri has
 commented that the soul of viewer submits to the effects of the work and is lan-
 guid like Armida's left hand, see Careri: 'Mutazioni degli affetti', p. 357.
4 Dirk Pels, Kevin Hetherington and Fédéric Vandenberghe, 'The Status of the
 Object: Performances, Mediations and Techniques', *Theory, Culture & Society* 19
 (2002), pp. 1–21.
5 Igor Kopytoff, 'The cultural biography of things: commoditization as process',
 in Arjun Appadurai (ed), *The Social Life of Things: Commodities in Cultural Perspective*
 (Cambridge: Cambridge University Press, 1986), pp. 64–91; Rupert Shepherd, 'II.
 The life of the object', *Renaissance Studies* 19 (2005), pp. 619–20.
6 Hans Georg Gadamer, *Truth and Method* [1965] (Guildford: Sheed and Ward,
 1975), pp. 333–41; Georgia Warnke, 'Hermeneutics, Ethics, Politics', in Robert J.
 Dostal (ed), *The Cambridge Companion to Gadamer* (Cambridge: Cambridge Univer-
 sity Press, 2002), pp. 79–101. See also Mieke Bal, *Travelling Concepts in the Human-
 ities: A Rough Guide* (Toronto: University of Toronto Press, 2002), pp. 12–24, for
 an indication of the relationship of these ideas to the project of working with
 concepts.

7 Michael Ann Holly, *Past Looking: Historical Imagination and the Rhetoric of the Image* (Ithaca: Cornell University Press, 1996), pp. xv–28.

8 Dominick LaCapra, 'Rethinking Intellectual History and Reading Texts', *History and Theory* 19 (1980), pp. 245–76. See especially p. 264: 'recreate the dialogue of others'; p. 265: 'the reconstruction of the dialogues of the dead should be self-consciously combined with an interpretative attempt to enter into an exchange with them that is itself dialogical only insofar as it actively recognizes the difficulties of communication across time and the importance of understanding as clearly and as fully as possible what the other is trying to say.' See also Gadamer: *Truth and Method*, p. 340; Warnke: 'Hermeneutics', pp. 92–3.

9 Mieke Bal, *Reading Rembrandt: Beyond the Word/Image Opposition* (Cambridge: Cambridge University Press, 1991), pp. 258–9.

10 Gadamer: *Truth and Method*, pp. 333–41, 360.

11 Richard Wollheim, *Painting as an Art* (London: Thames and Hudson, 1987), pp. 195–6; Giovanni Careri, 'Le Retour du geste antique: amour et honneur à la fin de la Renaissance', in Giovanni Careri (ed), *La Jérusalem délivrée du Tasse: poésie, peinture, musique, ballet: actes du colloque* (Paris: Klincksieck, 1999), pp. 49–50; Michel Régis, *Posséder et détruire: Stratégies sexuelles dans l'art d'Occident* (Paris: RMN, 2000), pp. 89–93.

12 Marin: *Sublime Poussin*, pp. 152–3, 165. The masculine viewer is established in the chapter through an initial identification with Acteon. On the notion of the bourgeois 'monad' subject as part of residual modernist culture see Frederic Jameson, 'Postmodernism, or the Cultural Logic of Late Capitalism', *New Left Review* 146 (1984), pp. 61–4.

13 The literature on this subject is vast; the influential texts on my thinking have been Jane Gallop, 'Annie LeClerc writing a letter, with Vermeer', *October* 33 (1985), pp. 103–8; Jane Gallop, *Feminism and Psychoanalysis: The Daughter's Seduction* (London: Macmillan, 1982); Germaine Greer, *The Whole Woman* (London: Anchor, 2000), pp. 380–98.

14 Gadamer: *Truth and Method*, pp. 270–3.

15 Lucrezia Marinella, *The Nobility and Excellence of Women, and the Defects and Vices of Men [1601]*, trans. and ed. Anne Dunhill (Chicago: University of Chicago Press, 1999), p. 139.

16 Michael P. Carroll, *Veiled Threats: The Logic of Popular Catholicism in Italy* (Baltimore: John Hopkins University Press, 1996), p. 25; Adrian Randolph, 'Renaissance Household Goddesses: Fertility, Politics and the Gendering of Spectatorship', in Anne McClanan and Karen Rosoff Encarnación (eds), *The Material Culture of Sex, Procreation and Marriage in Premodern Europe* (New York: Palgrave, 2001), pp. 173–4. On this gesture in Poussin's work see Richard Verdi, *Nicolas Poussin: Tancred and Erminia* (Birmingham: Birmingham Museums and Art Gallery, 1992), pp. 14–15.

17 Torquato Tasso, *Gerusalemme Liberata [1581]*, ed. Fredi Chiapelli (Milan: Rusconi, 1982), canto XII, stanza 52, line 1, p. 67. The warrior Chlorinda is fought by Tancred thinking her to be a man. He only discovers her true identity when he removes her helmet.

18 Marinella: *The Nobility and Excellence of Women*, pp. 80, 139.

19 In fact, this belief was widely sustained in order to justify aristocratic women in-

habiting positions of authority when there was no male heir. In Tasso's book *Discorso della virtù femminile e donnesca*, for example, he distinguished between the feminine virtues of a 'female citizen, a private gentlewoman, [and] an industrious mother of a family' and those of the noble lady who shared the 'virile virtues of all her glorious ancestors': Torquato Tasso, *Discorso della virtù femminile e donnesca*, ed. Maria Luisa Doglio (Palermo: Sellerio Editore, 1997), p. 62.

20 'su la vaga fronte/ pende omai sì che par Narciso al fonte'.

21 'sotto biondi/ capelli e fra sì tenere sembianze canuto senno e cor virile ascondi'. The metaphor suggests that Armida sees her masculine qualities in Rinaldo. This connotation prefigures the recuperation of his masculinity during the final reiteration of the mirroring scene, see Jo Ann Cavallo, 'Tasso's Armida and the Victory of Romance', in Valeria Finucci (ed), *Renaissance Transactions: Ariosto and Tasso* (Durham, NC: Duke University Press, 1999), p. 95.

22 Gabriele Paleotti, 'Discorso intorno alle imagini sacre e profane', in *Trattati d'Arte del Cinquecento*, ed. Paola Barocchi (Bari: Laterza, 1961), vol. 2, p. 148: 'il dilettare, l'insegnare, e commovere'; Rensselear W. Lee, 'Ut Pictura Poesis: The Humanistic Theory of Painting', *Art Bulletin* 22 (1940), pp. 226–8; Phillip Salman, 'Instruction and Delight in Medieval and Renaissance Art Criticism', *Renaissance Quarterly* 32 (1979), pp. 303–32; Giulio Mancini, *Considerazioni sulla Pittura*, ed. Adriana Marucchi, (Rome: Accademia Nazionale dei Lincei, 1956), vol. 1, p. 142: 'non solamente dovrà esser distintion di luogo, ma in farle vedere da questa o quell'altra sorte d'huomini, secondo la complessione e passion d'animo, età, sesso, costume, genere di vita che si desidera conservare o aumentare, o veramente sminuire e corregger e converter al contrario.' See David Freedberg, *The Power of Images: Studies in the History and Theory of Response* (Chicago: Chicago University Press, 1989).

23 Lee: 'Ut Pictura Poesis, p. 218; Denis Mahon, *Studies in Seicento Art and Theory* (London: Warburg, 1947), pp. 148–51; Jennifer Montagu, *The Expression of the Passions: The Origin and Influence of Charles Le Brun's 'Conférence sur l'expression générale et particulière'* (New Haven: Yale University Press, 1994), p. 67.

24 Moshe Barasch, *Giotto and the Language of Gesture* (Cambridge: Cambridge University Press, 1987); Michael Baxandall, *Painting and Experience in Fifteenth-Century Italy*, 2nd edn (Oxford: Oxford University Press, 1988), pp. 61–70.

25 Giovanni Paolo Lomazzo, *Trattato dell'arte della pittura, scoltura, et architettura* (Milan: Gottardo Pontio, 1585), p. 105: 'una pittura rappresentata come dianci diceva con moti al naturale ritratti far senza dubbio ridere, con chi ride, pensare con chi pensa, ramaricarsi con chi piange, rallegrarsi e gioire con chi s'allegra, e oltre di ciò maravigliarsi con chi si maraviglia'; pp. 118–19.

26 James Clifton, 'Gender and Shame in Masaccio's *Expulsion*', *Art History* 22 (1999), p. 642; Baxandall: *Painting and Experience*, p. 70; Paolo Berdini, 'Women under the Gaze: A Renaissance Genealogy', *Art History* 21 (1998), p. 572; Kim M. Phillips, 'Bodily Walls, Windows and Doors: The Politics of Gesture in Late Fifteenth-Century English Books for Women', in Jocelyn Wogan-Browne *et al.* (eds), *Medieval Women: Texts and Contexts in Late Medieval Britain* (Turnhout: Brepols, 2000), pp. 185–98.

27 Gaspare Colombina, *Discorso distinto in IV capitoli* (Padua: Tozzi, 1623), folio 6v.

28 Tasso: *Gerusalemme Liberata*, p. 596: 'di nemica ella divenne amante' (my emphasis).

29 Leonardo da Vinci, *The Literary Works*, trans. and ed. J. P. Richter, 3rd edn (Lon-

don: Phaidon, 1970), vol. 1, pp. 53, 60; see Lee: 'Ut Pictura Poesis', p. 266. In his much later *Observations on Painting*, Poussin engaged verbally with debates around *ut pictura poesis*, see A. Blunt, 'Poussin's Notes on Painting', *Journal of the Warburg Institute* 1 (1937–8), pp. 344–51. See also Careri: 'Mutazioni d'affetti', p. 356.

30 For other influences of Marino on Poussin see Andrea Moschetti, 'Dell'Influsso del Marino sulla Formazione Artistica di Nicola Poussin', in *Atti del Congresso internazionale storia dell'arte* (Rome: Magliore and Strini, 1922), pp. 356–84; Antonio Colantuono, *The Tender Infant: Invenzione and Figura in the Art of Poussin* (unpublished PhD dissertation, Johns Hopkins University, 1986); Elizabeth Cropper and Charles Dempsey, *Nicolas Poussin: friendship and the love of painting* (Princeton: Princeton University Press), pp. 261–78. On Poussin's relationship with Marino see Jane Costello, 'Poussin's Drawings for Marino and the New Classicism: I—Ovid's *Metamorphoses*', *Journal of the Warburg and Courtauld Institutes* 18 (1955), pp. 296–317.

31 James V. Mirollo, *The Poet of the Marvelous: Giambattista Marino* (New York: Columbia University Press, 1963), pp. 75–6, 87, 118–19, 182–3; Marino rendered Petrarch's fairly tame image of a woman squeezing her beloved's heart as: 'Her eyes armed with fire and her breast with ice, the amorous murderess opened my heart.'

32 Giambattista Marino, *Dicerie Sacre e le Strage degli Innocenti [1614]*, ed. Giovanni Pozzi (Turin: Einaudi, 1960), pp. 151–3; Giambattista Marino, *La Galeria [1619]*, ed. Marzio Pieri (Padua: Liviana, 1979), vol. 1, p. 7; Gianni Eugenio Viola, *Il verso di Narciso. Tre tesi sulla poetica di GB Marino* (Rome: Cadmo, 1978), p. 47; Francesco Guardiani, 'L'idea dell'immagine nella Galleria di G. B. Marino', in Antonio Franceschetti (ed), *Letteratura Italiana e Arti Figurative* (Florence: Olschki, 1998), vol. 2, p. 651.

33 Emmanuele Tesauro, *Il Cannocchiale Aristotelico [1670]* (Berlin: Verlag Gehlen, 1968), pp. 293–4: 'una singola parola, contenute due contrari concetti; come l' *Antifrasi*; Figura quanto più brieve più acuta' and p. 301, translated in Mirollo: *The Poet of the Marvelous*, p. 118. For Tesauro's links with Cassiano dal Pozzo, Poussin's major patron at this time see, F. Solinas, (ed), *I Segreti di un collezionista: Le straordinarie raccolte di Cassiano dal Pozzo 1588–1657* (Rome: Edizione de Luca, 2001), pp. 161–2.

34 Tesauro: *Il Cannocchiale*, p. 301.

35 Tesauro: *Il Cannocchiale*, p. 448: '*Nec Mas nec Foemina, sed uterque*'; Lorraine Daston and Katherine Park, *Wonder and The Order of Nature 1150–1750* (New York: Zone, 1998), pp. 192, 200, 203.

36 Bal: *Reading Rembrandt*, pp. 258–9.

37 For this view in Poussin scholarship see: Charles Dempsey, 'Book review of Todd P. Olson: *Poussin and France*', *Burlington Magazine* 144 (2002), pp. 632–4.

38 Bal: *Travelling Concepts*, pp. 133–73.

39 For an outline of this research, see Phillippa Plock, 'Nicolas Poussin's representations of femininity in 1620s' Rome', *Papers of the British School at Rome*, 74 (2006), pp. 250–1.

40 Benedetta Borello, *Trame sovrapposte: La socialità aristocratica e le reti di relazioni femminili a Roma (XVII–XVIII secolo)* (Naples: Edizioni Scientifiche Italiane, 2003), pp. 198–201; see also, though for an earlier period, Lauro Martines, 'A way of

looking at women in Renaissance Florence', *The Journal of Medieval and Renaissance Studies* 4 (1974), pp. 15–28.

41 Joan Kelly, *Women, history & theory: the essays of Joan Kelly* (Chicago: University of Chicago Press, 1984), pp. 19–50; see also Judith C. Brown, 'A Woman's Place was in the Home: Women's Work in Renaissance Tuscany', in Margaret W. Ferguson, Maureen Quilligan and Nancy J. Vickers (eds), *Rewriting the Renaissance: The Discourses of Sexual Difference in Early Modern Europe* (Chicago: University of Chicago Press, 1986), pp. 206–24.

42 Biancamaria Cacherano, *Lettere della Signora Biancamaria Cacherano dal Pozzo al Signor Cavaliere Cassiano suo figliuolo*, Rome, Biblioteca dell'Accademia Nazionale dei Lincei, Archivio Dal Pozzo, manuscript XXIV/21, folio 3r: 'non vo[g]lio met[t]er[e] mano sensa [sic] ordine suo' (6.11.1620); folio 10r: 'il tut[t]o rimeto a lei poiche non e piu mio ma suo' (30.11.1620), 15r: 'andero tratenendo le cose sino a n[u]ovo avisso' (17.1.1621); folio 18r: 'non faro nul[l]a sensa [sic] vostro concelio' (1.4.1622); folio 64r: 'per conto delli red[d]iti di Milano cui quello mi scrive se la sita sta salda di redimeter [sic] vedo per fa penciero [sic] di rimet[t]erli a fiorenza pero il tut[t]o mi rimet[t]o solo li diro che in tempo di mio marito che sia in gloria se voleva far[e] r[i]sponder[e] danari aveva del[l]i stenti et fastidi pero del tut[t]o mi rimet[t]o a chi sa piu di me' (8.5.1622); cf. folio 65r: 'lei sa che li danari di S[ign]or Mar[chese] che sono costi non rendano piu di 4 e mezzo persenti [sic], io per me credo che in milano o a genova troverete inpego [sic], pero di n[u]ovo vi dico che il tut[t]o rimet[t]o al[l]a sua prudenssa [sic]' (22.5.1622).

43 Cacherano: *Lettere*, folio 23r: 'Mi dispiace … di veder ch non resta sodisfato… adeso che sono passati li giorni santi daro principio al indico deli libri e lo mandero' (26.9.1621); folio 55r: 'Dela setimana pasata non scrito poiche mi innazio tanto trascaliata e stiaca del mal di vostro fratelo ateso il pericolo che a di una febre … per la sua [lettera] deli 17 per la quale vedo che [sina valia?] perche sono neglig[e]nte nel scriver pero vi prego ala siamo questo travalio' (6.3.1622).

44 Cacherano: *Lettere*, folio 55r: 'vi prego a las[c]iarmi que[s]to travalio a me poiche io vo[g]lio amar[e] e non vo[g]lio esser[e] amata' (6.3.1622).

45 Tomasso Stigliani, *Dello Occhiale: Opera difensiva scritta in riposte al Cavaliere GB Marino* (Venice: [n.pub.], 1627), pp. 112–13: 'al grado, all'età, alla coplessione, al sesso, al genere, all'uffizio e alla nazione'; 'Cosi la guasta l'Adone ne qual sì rado riguardo alle sette differenze sopratocche, ma fa parersi … femmina il maschio.'

46 Stigliani: *Dello Occhiale*, p. 20: 'non è un solo poema, ma un groppo di poemi ammassati insieme, il cui mostruosa congiunzione s'assomiglia propriamente à quella di quei due fanciulli gemelli, ch'oggidì vivono attaccati per pancia, e vannosi da'padre mostrando à prezza per le città italiane.'

47 Darin Strauss, 'Happy Together?: Ladan and Laleh Bijani', *Guardian*, 8 July 2003, <http://www.guardian.co.uk/health/story/0,3605,993526,00. html>.

48 Mirollo: *The Poet of the Marvelous*, p. 87.

49 Giacinto Gigli, *Diario Romano (1608–1670)*, ed. Giuseppe Ricciotti (Rome: Tumminelli, 1958), p. 70.

50 Ovid: *Metamorphoses*, vol. 4, pp. 300–86.

51 Marino: *La Galeria*, p. 17: 'Sì come di Salmace/ aveano in sé l'acque tranquille e chiare/ virtù d'innamorare,/ così per l'arte tua la lor sembianza,/ CARRACCI, ha in sé possanza/ di far meravigliare:/ ma non si sa, qual perde, o qual avanza:/ il

miracol d'Amore,/ o quel de lo stupore./ Quello in un corpo sol congiunse dui,/ questo divide da se stesso altrui' [*Just as the tranquil and clear waters/ of Salmacis had in themselves/ the power to make one enamoured,/ so through your art,/ CARRACCI, their appearance has in itself the power/ to make one marvel:/ but one does not know which loses or which advances: / the miracle of Love / or that of wonder./ Love in one single body conjoined two,/ wonder separates one from oneself*]. I am grateful to Brian Richardson for help with this translation.

52 Christine Battersby, *Gender and Genius: Towards a Feminist Aesthetic* (London: Women's Press, 1989); Juliana Schiesari, *The Gendering of Melancholia: Feminism, Psychoanalysis, and the Symbolics of Loss in Renaissance Literature* (Ithaca: Cornell University Press, 1992).

53 Stephen Orgel, 'Gendering the Crown', in Margreta de Grazia, Maureen Quilligan and Peter Stallybrass (eds), *Subject and Object in Renaissance Culture* (Cambridge: Cambridge University Press, 1996), pp. 133–65.

54 The ecstatic process of bodily completeness compared to aesthetic experience that is described in the poem elucidates a comment of Girolamo Aleandro—a close associate and mentor of Cassiano dal Pozzo during the 1620s—that the marvellous poetic formulas employed by Marino made 'the heart of every gentleman sweetly drunk', see Girolamo Aleandro, *Difesa dell'Adone per risposta all'Occhiale del Cav. Stigliani*, (Venice: Scaglia, 1629–30), vol. 1, p. 33: 'il cuore d'ogni galant huomo di nobil maraviglia dolcemente inebriano.'

55 Gayatri Chakravorty Spivak has argued that a similar process occurs in the poems of Dante where Beatrice is used as a figure that seemingly castrates the writer, removing his responsibility for his actions, whilst remaining firmly under his control; see Gayatri Chakravorty Spivak, 'Finding Feminist Readings: Dante-Yeats' in Ira Konigsberg (ed), *American Criticism in the Post-Structuralist Age* (Ann Arbor: University of Michigan, 1981), pp. 47–55. A similar motif of the male subject surrendering to a feminine force occurs in later literature on landscape and the sublime. However, as Carole Fabricant has pointed out, the male spectators of the landscape are very much still in control; theirs is only 'a titillating flirtation with surrender'; see C. Fabricant, 'The Aesthetics and the Politics of Landscape in the Eighteenth Century', in Ralph Cohen (ed), *Studies in Eighteenth Century British Art and Aesthetics* (Berkeley: University of California Press, 1985), p. 73.

56 Foucault: *The Order of Things*, pp. 20–1, 140–3. I differ from Foucault and see these epistemes competing in the seventeenth century; see Mark Bevir, 'A humanist critique of the archaeology of the human sciences', *History of the Human Sciences* 15 (2002), p. 123. See also Freedberg: *The Eye of the Lynx*, p. 406.

57 N. C. Fabri de Peiresc, *Lettres à Cassiano dal Pozzo, 1626–1637*, ed. J. F. Lhote and D. Joyale (Clermont-Ferrand: Adosa, 1989), pp. 130, 195–9, 206–7.

58 Freedberg: *The Eye of the Lynx*, p. 183. Foucault: *The Order of Things*, p. 20; Daston and Park: *Wonder and The Order of Nature*, p. 225; Federico Cesi, 'Osservazioni Fisiche [1624]', in Enrico Falqui (ed), *Antologia Della Prosa Scientifica Italiana del Seicento*, (Florence: Vallecchi, 1943), vol. 1, pp. 83–4.

59 Freedberg: *The Eye of the Lynx*, pp. 183, 244, 277, 283, 363, 371. In 1604 members of the Lincei academy had written to Caspar Bauhin, a famous researcher of hermaphrodites, to get advice on taxonomic issues.

Chapter 4. Mirror

1 All biblical references in this chapter are drawn from the anglicized edition of the New Revised Standard Version (NRSV) Bible.

2 A characterization borrowed from Susan Haskins, *Mary Magdalen: Myth and Metaphor* (London: HarperCollins, 1993). In 2005, this book was republished under the title of *Mary Magdalen: Truth and Myth* (London: Pimlico).

3 In the history of art, representations before Savoldo had ranged from Donatello's emaciated *The Penitent Magdalene* (1457, wood with polychromy and gold, Museo dell'Opera del Duomo, Florence), to the fleshy and provocative interpretation by Titian, *Penitent Magdalene* (c.1530–5, oil on wood, Palazzo Pitti, Florence); and in modern day popular culture, the saint's representations have ranged from Martin Scorsese's film 'The Last Temptation of Christ' (1988) to the saint's recent notoriety in her mystical secret identity as the Holy Grail in Dan Brown, *The Da Vinci Code* (London: Corgi, 2004). These examples, of course, refer to representations referring to the Magdalene of the Gospels, not taking into account the whole culture of the redeemed fallen woman, or virgin prostitute with flaming red hair, which form part of the saint's wider visual and cultural legacy. For one of the most comprehensive serious accounts of the history of the Magdalene's representation in culture, see Haskins: *Mary Magdalen.*

4 The Magdalene was initially portrayed as a redeemed prostitute due to confusion with other biblical women, and this image was imposed upon her by a Catholicism determined to portray the Magdalene as the lesser counterpoint to the perfection of the Virgin (see Marina Warner, *Alone of All her Sex: The Myth and the Cult of the Virgin Mary* (London: Weidenfeld and Nicolson, 1976)) and to neutralize some of the traces of influence she retained from her important role in Gnosticism.

5 References are from Mary Pardo, 'The Subject of Savoldo's Magdalene', *Art Bulletin* 71/1 (1989), pp. 70–1. These comments all refer to the Berlin version of the painting, which lacks the ointment jar present in the London versions. This might have increased the secularity of these interpretations.

6 Pardo: 'Subject of Savoldo's Magdalene', p. 90

7 Mieke Bal, *Quoting Caravaggio: Contemporary Art, Preposterous History* (Chicago: University of Chicago Press, 1999), p. 260.

8 Pardo dismisses, on formal grounds, the more erotically charged interpretations of the painting. Specifically, she argues that a combination of portrait and religious narrative leads to a confusion of genres.

9 James M. Robinson (ed), *The Nag Hammadi Library* (San Francisco: HarperCollins, 1990).

10 The Magdalene has recently been portrayed as Jesus's wife and the mother of his child in popular non-fiction and fiction, from M. Baigent, R. Leigh and H. Lincoln, *Holy Blood, Holy Grail* (London: Arrow, 1996), to Brown: *The Da Vinci Code.*

11 'Noli me Tangere' refers to the scene in John: 20, where the Magdalene meets Jesus in the garden, in the early morning when he has risen from the dead. It is traditionally translated as 'Do not touch me' although a more literal translation would be 'Do not hold on to me.'

12 Carmen L. Robertson, *Gender Relations and the Noli me Tangere Scene in Renaissance Italy* (Unpublished MA thesis, University of Victoria, 1993), p. 2.

13 Examples include Fra Bartolommeo, *Lamentation* (Palazzo Pitti, Florence); at Jesus's feet in Moretto da Brescia (c.1498–1554), *Pietà* (National Gallery of Art, Kress Collection, Washington D.C.); at the foot of the cross embracing Jesus' feet in Bramantino's *Crucifixion* (c. 1520, Brera, Milan); and alone at the foot of the cross in Giulio Clovio (1498–1578), *Crucifixion with Mary Magdalene* (Uffizi, Florence). Also see Moshe Arkin, '"One of the Marys…": An Interdisciplinary Analysis of Michelangelo's Florentine Pietà', *Art Bulletin* 79/3 (1997), for a fascinating reinterpretation of Michelangelo's *Pietà* (c.1550, marble, Museo dell'Opera del Duomo, Florence), along these lines, which identifies the Magdalene in a privileged position in the composition, basing its argument on the influence of Vittoria Colonna.

14 Towards the end of the fifteenth century, in a painting in the Vatican collection by Giovanni Bellini (c.1430–1516)— *Pietà or Lamentation* (oil, Vatican, Pinacotheca, Rome)—which depicts Jesus's anointing, as is noted in Rona Goffen, *Giovanni Bellini* (New Haven: Yale University Press, 1989), the anointing, the site of touch between the Magdalene and Jesus, receives particular emphasis as the saint, flushed and in a state of extreme emotion, sensuously rubs ointment into the wounds on Jesus's hands. The painting evokes an almost disturbing emotional and erotic power.

15 The Magdalene's ecstasy is contextualized largely in terms of her time in the desert, as recounted in Jacobus de Voragine, *The Golden Legend, or Lives of the Saints* [1275], ed. F. S. Ellis (London: Temple Classics, 1900), available at <http://www. fordham.edu/halsall/basis/goldenlegend/index.htm> (accessed 26 April 2007). While fifteenth-century themes were still prevalent by the sixteenth and seventeenth centuries (for example, Francesco Trevisani (1656–1746), *The Magdalene at the foot of the Cross* (oil, Florence, Palazzo Pitti)), the focus had shifted in line with Counter-Reformation emphasis on the Sacraments, in particular penitence, hence the popularity of this strain of Magdalene imagery. The intercessory power of the saints was also strongly promoted, which necessitated, in particular, the dramatization of the suffering and torture undergone for their faith, as Emile Mâle summarizes: 'After the Council of Trent, the martyrs struggle beneath our gaze; we must see their blood flowing, and bear witness to their painful agony.' Emile Mâle, *L'art religieux après le Concile de Trente: Etude sur l'iconographie de la fin du XVIe siècle, du XVIIe, du XVIIIe siècle, Italie, France, Espagne, Flandres* (Paris: Armand Colin, 1932), p. 147. This new emphasis on making visible every aspect of the saints' experience, combined with the *Spiritual Exercises* of St Ignatius of Loyola, published in 1548, and the popularity of the writings of the mystics such as St Teresa of Avila and St John of the Cross, led to mystical ecstasy being more and more in demand as a subject for works of art.

16 See n. 3.

17 Quoted in Frank Sommer, 'The Iconography of Action: Bernini's Ludovica Albertone', *Art Quarterly* 33 (1970), p. 31.

18 Andrew Greeley, 'Erotic Desire in Art: A Catholic Perspective' (1995), <http:// www.agreeley.com/articles/eros_art.html> (accessed 29 November 2006).

19 Laura Mulvey, 'Afterthoughts on Visual Pleasure and Narrative Cinema', in *Visual and Other Pleasures* (Basingstoke: Palgrave Macmillan, 1989), p. 29.

20 Mulvey: 'Afterthoughts', p. 29.

21 Kaja Silverman, *The Threshold of the Visible World* (London: Routledge, 1996), chapter 1, 'The Bodily Ego'.

22 Silverman: *Threshold of the Visible World*, chapter 3, 'Political Ecstasy'.

23 Jean Habert, *Bordeaux, Musée des beaux-arts* (Paris: Réunion des Musées Nationaux, 1991), pp. 53–4, translation mine. Original French: 'Le retentissement de cette création révolutionnaire fut considérable, puisqu'il s'agit de l'oeuvre de Caravage la plus copiée, surtout dans le milieu moins inhibé des artistes du Nord travaillant en Italie, et dont le peintre flamand Louis Finson (Bruges av. 1580–Amsterdam 1617) se voulait l'interprète privilégié; mais le tableau n'eut en fait aucun postérité véritable: les copistes, et après eux les adaptateurs, n'osèrent plus présenter la sainte seule et sans attributs, et se conformèrent aux recommandations formulées en 1582 par l'évêque de Bologne, le cardinal Gabriele Paleotti (1522–97), principal avocat de la Contre-Réforme en matière iconographique, qui préconisait la représentation des saints en extase accompagnés … de leurs attributs et soutenus par des anges pour bien marquer la qualité inaccessible au commun de leur expérience mystique.'

24 de Voragine: *Golden Legend*, vol. 4.

25 The term 'ecstasy' comes from a Greek word, meaning outside of the body; to remove oneself from a place, or the alienation of the self. For clear definitions of the different meanings of 'ecstasy' see N. G. Holm, 'Ecstasy Research in the 20th century—an Introduction', in *Religious Ecstasy: Based on papers read at the Symposium on Religious Ecstasy held at Åbo, Finland, on the 26th–28th August 1981* (Stockholm: Almqvist & Wiksell, 1982), pp. 7–26.

26 The theme of the Magdalene rejecting or turning away from a mirror is very common in the iconography of the saint. See Caravaggio's *The Conversion of the Magdalene* (c.1597–8, oil on canvas, The Detroit Institute of Arts, Detroit), and Artemisia Gentileschi, *Penitent Magdalene* (1617–20, Florence). The Magdalene's female companion in the Detroit painting is Martha, traditionally cast as the Magdalene's 'sister' thanks to confusion between Mary Magdalene and Mary of Bethany, the sister of Martha and Lazarus.

27 In the myth according to Ovid, Narcissus wastes away staring at his reflection. In the Caravaggio painting, the body of Narcissus is broken up and fragmented by the contrasts of light and shade, suggesting the fragmentation of his identity in the mirror's mortal trap.

28 Bal: *Quoting Caravaggio*, p. 259.

29 Silverman: *Threshold of the Visible World*, p. 33.

30 Bal: *Quoting Caravaggio*, p. 260.

31 Bal: *Quoting Caravaggio*, p. 259.

32 Bal: *Quoting Caravaggio*, p. 260.

33 Bal: *Quoting Caravaggio*, p. 260.

34 Pardo: 'Subject of Savoldo's Magdalene', p. 90.

35 Jacques Lacan, 'God and the *Jouissance* of The Woman', in Juliet Mitchell and Jacqueline Rose (eds), *Feminine Sexuality: Jacques Lacan and the École Freudienne* (London: Macmillan, 1982), p. 147.

36 A famous seventeenth-century example of a mirror being at the heart of a play of gazes between painter, depicted subject, and viewers both within and outside

of the painted surface occurs in Velázquez's *Las Meninas*, (c.1656, oil on canvas, Prado Museum, Madrid).

37 This phrase is taken from the Marquis de Sade's description of Bernini's *St Teresa in Ecstasy* in *Voyage d'Italie*: 'It is a masterpiece by Bernini. This piece is sublime because of the air of truth which characterizes it, but it is only necessary to remind oneself deeply, when seeing it, that it is a saint, because from the ecstatic appearance of Teresa, from the fire which embraces her features, it would be easy to be mistaken.' Cited in Jean-Noël Vuarnet, *Extases féminines* (Paris: Hatier, 1991), p. 122, translation mine.

38 Bal describes Caravaggio's Rome *Magdalene* as 'sleeping'. Bal: *Quoting Caravaggio*, p. 260.

39 Looking more deeply into the network, Savoldo's remarkable and innovative symbolic use of drapery throughout his oeuvre, as well as his metaphorical exploration of the mirror in other works (such as Savoldo's *Portrait of a Man in Armour* (so-called *Gaston de Foix*), (c.1530, oil, Paris, Louvre)) may have been an actual influence on the young Caravaggio during his training in Lombardy.

40 John 20: 14.

41 John 20: 15.

42 John 20: 16–17.

43 John 20: 29.

44 Robinson (ed): *Nag Hammadi*, Gospel of Mary, p. 525.

45 Lewis Carroll, *Through the Looking Glass* (Salt Lake City: Project Gutenberg, 1991), p. 80, <http://www.gutenberg.org/catalog/world/readfile?fk_files=34643&pageno=80> (accessed 26 April 2007).

46 Carroll: *Through the Looking Glass*, p. 4, <http://www.gutenberg.org/catalog/world/readfile?fk_files=34643&pageno=4> (accessed 26 April 2007).

Chapter 5. Trauma

1 A recent example is the catalogue of the 2006 itinerant exhibition of Elsheimer's (almost) complete works, Michael Maek-Gerard (ed), *Adam Elsheimer 1578–1610* (Edinburgh: National Galleries of Scotland, 2006).

2 Some useful remarks about the concept of trauma in general and its uses in history can be found in Dominick LaCapra, *History in Transit: experience, identity, critical theory* (Ithaca: Cornell University Press, 2004), chapters 2–3.

3 Cathy Caruth, *Unclaimed Experience: Trauma, Narrative and History* (Baltimore: Johns Hopkins University Press, 1996), p. 57. LaCapra: *History in Transit*, p. 121 criticizes Caruth for conflating the event that causes trauma and the traumatic experience itself, and the quote above seems to exemplify such a confusion.

4 In fact, LaCapra: *History in Transit* repeatedly points out that in spite of the great utility that trauma studies can have for historiography, the latter discipline has yet to use trauma extensively, due mainly to positivistic tendencies and to disciplinary impermeability.

5 Caruth: *Unclaimed Experience*, pp. 6, 11, 37, 91–2.

6 See in particular LaCapra: *History in Transit*, p. 117.

7 LaCapra: *History in Transit*, p. 105, suggests that psychoanalysis can be used as a working concept when 'construed not simply as individual self-understanding or therapy but as a mode of critical theory'.

8 In some cases, the subject-matter of the cultural artefact *is* trauma and/or its psy-
 chological therapy, and in this case this question becomes relevant again, though
 even then it has to be discussed together with—and not instead of—the repre-
 sentational strategies employed in the artifact itself.
9 Mieke Bal, Personal communication, 2004.
10 Michel Foucault, *Les Mots et les Choses* (Paris: Gallimard, 1966); Walter Benjamin,
 Ursprung des Deutschen Trauerspiels (Frankfurt am Main: Suhrkamp Verlag, 1996);
 Gilles Deleuze, *Le Pli: Leibniz et le Baroque* (Paris: Les éditions de Minuit, 1988);
 Hans Blumenberg, *Die Legitimität der Neuzeit* (Frankfurt am Main: Suhrkamp Ver-
 lag, 1966); William J. Bouwsma, *The Waning of the Renaissance 1550–1640* (New
 Haven: Yale University Press, 2000). Of course, these are just examples of the rich
 historical and philosophical literature about the period in question; the art-histor-
 ical research is just as wide, but works combining both aspects, visual and textual,
 are quite scarce.
11 See Elaine Scarry, *The Body in Pain: the Making and Unmaking of the World* (Oxford:
 Oxford University Press, 1985), pp. 60–157.
12 This viewpoint is strongly present in our own contemporary art world; the typical
 example would be the 2002 Documenta in Kassel, where art was, implicitly and
 at times explicitly, characterized as being 'about' information rather than about im-
 ages (in an oral presentation by the curator Okwui Enwezor). See *Documenta
 11_Platform 5: Exhibition: Catalogue* (Ostfildern-Ruit: Hatje Cantz, 2002), in partic-
 ular Okwui Enwezor, 'The Black Box', pp. 42–55. The five 'platforms' of which
 the project was constituted are called 'domains of knowledge and artistic produc-
 tion, circuits of research' (where knowledge comes first!), and as 'an open *encyclo-
 pedia* for the analysis of late modernity … an open form for *organizing knowledge…*'
 (p. 49, my emphases).
13 Frances A. Yates, *The Art of Memory* (London: Pimlico, 1992). For the issue of
 memory and knowledge, in particular in Elsheimer's paintings, see Itay Sapir,
 'Narrative, Memory and the Crisis of Mimesis: the Case of Adam Elsheimer and
 Giordano Bruno', *Collegium (Journal of the Helsinki Collegium for Advanced Studies)* 1
 (2006), <http://www.helsinki.fi/collegium/e-series/volumes/volume_1/001_
 07_sapir.pdf>
14 Georges Didi-Hubermann, *Devant L'image: Question Posée aux Fins d'une Histoire de
 L'art* (Paris: Les éditions de Minuit, 1990), pp. 273–318. A somewhat modified
 English version of the same text appeared as 'The Art of not Describing: Ver-
 meer, the Detail and the Patch', *History of the Human Sciences* 2/2 (1989), pp. 141–
 69.
15 This *pan* is inherited from Proust's famous '*pan de mur jaune*' that the writer
 Bergotte sees in Vermeer's *View of Delft* (Mauritzhuis, the Hague). Bergotte de-
 sires it and ends up being consumed by this desire.
16 Didi-Huberman's first published book established this same field in greater detail;
 see Georges Didi-Huberman, *Invention de l'hystérie: Charcot et l'iconographie pho-
 tographique de la Salpêtrière* (Paris: Macula, 1982). See also Ulrich Baer, *Spectral Evi-
 dence: the photography of trauma* (Cambridge, MA: MIT Press, 2002) for a further
 discussion of hysteria, symptom and image.
17 Didi-Huberman: *Devant l'image*, pp. 307–8 (my translation).
18 Frank P. Tomasulo, 'I'll see it when I believe it': Rodney King and the Prison-

House of Video' in Vivian Sobchack (ed), *The Persistence of History: Cinema, Television and the Modern Event* (London: Routledge, 1996), pp. 69–88.

19 Apostles, 28: 1–3.

20 Ernst van Alphen, 'Symptoms of Discursivity: Experience, Memory, and Trauma' in Mieke Bal, Jonathan Crewe and Leo Spitzer (eds), *Acts of Memory: Cultural Recall in the Present* (Hanover: University Press of New England, 1999), pp. 24–38. Van Alphen names four problems in narration that render an experience traumatic: ambiguous actantial position; total negation of any actantial position or subjectivity; lack of a plot or narrative frame, by means of which the events can be narrated as a meaningful coherence; and unacceptable plots or narrative frames that are inflicted (p. 28).

21 A rare example of a discussion of the size of artworks, and their status as (almost always) smaller-than-life-size representations, is to be found in the first chapter of Claude Lévi-Strauss, *La Pensée Sauvage* (Paris: Plon, 1962). This chapter is extremely important in this context, although Lévi-Strauss's conclusions, according to which the small size of representation makes it easier to perceive and to know, are almost opposed to mine.

22 For a selection of interpretations of Poe's short story, see John P. Muller and William J. Richardson (eds), *The Purloined Poe: Lacan, Derrida, and Psychoanalytic Reading* (Baltimore: Johns Hopkins University Press, 1988).

Chapter 6. Life-Mapping

1 Walter Benjamin, 'Berlin Chronicle', in *One-Way Street*, trans. Edmond Jephcott and Kingsley Shorter (London: Verso, 1979), p. 295.

2 *Worlding* is a phrase borrowed by Spivak from Heidegger and used in postcolonial discourse, see Gayatri Chakravorty Spivak, 'The Rani of Sirmur: An Essay in Reading the Archives,' *History and Theory: Studies in the Philosophy of History*, 24/3 (1985), pp. 247–72.

3 Charlotte Salomon is currently known for one major art work, titled by the artist *Leben? Oder Theater? [Life? Or Theatre?]*. Selections from this work were exhibited around the world in the 1970s and 1980s in museums of Jewish history and interest. This was supported firstly by a selective publication of the work as a diary introduced by Paul Tillich, and then in 1981 by a major facsimile of the entire painted work (without the text overlays) edited by Judith Herzberg and Gary Schwartz. Interest in the work grew as a result of these publications, as well as the appearance in 1994 of Mary Lowenthal Felstiner's historical biography, *To Paint Her Life: Charlotte Salomon in the Nazi Era*. In 1996, following his more theoretically informed analyses of this archive and oeuvre, Ernst van Alphen advised Cathérine de Zegher on a selection of work from *Leben? Oder Theater?* to be included in a major feminist exhibition of women artists of the twentieth century, titled *Inside the Visible: an elliptical traverse of twentieth century art in, of and from the feminine*. This exhibition came to London and enabled Monica Bohm-Duchen to realize a long-held ambition to curate a major, art-historical exhibition of *Leben? Oder Theater?* Shown first at the prestigious Royal Academy in London in 1998, the show toured to the Art Gallery of Ontario, Toronto, the Museum of Fine Arts, Boston and the Jewish Museum in New York, and new shows have since been curated in Amsterdam, Paris and Israel. The present essay, anticipating my

own full length book on the artist *Theatre of Memory: Allothanatography, Trauma and Representation in the work of Charlotte Salomon* (Yale University Press, forthcoming 2008), is but another element of this burgeoning literature whose variety performs the problematic of framing that is the focus of this discussion.

4 For a development of related ideas in recent literature, notably post-Holocaust, see Christopher Gregory-Guider, *Autobiogeography and the art of peripatetic memorialization in works by W.G. Sebald, Patrick Modiano, Iain Sinclair, Jonathan Raban, and William Least Heat-Moon* (Unpublished DPhil thesis, University of Sussex, 2006). Articles by the same author, who has coined the term *autobiogeography*, are Christopher Gregory-Guider, 'The "Sixth Emigrant": Travelling Places in the Works of W. G. Sebald', *Contemporary Literature* 46/3 (2005), pp. 422–49; Christopher Gregory-Guider, 'Sinclair's *Rodinsky's Room* and the Art of Autobiogeography', in *Literary London: Interdisciplinary Studies in the Representation of London* 3/2 (2005), <http://www.literarylondon.org/london-journal/september2005/guider.html> (accessed 4th January 2007); Christopher Gregory-Guider, '"Deep Maps": William Least Heat-Moon's Psychogeographic Cartography', in *E-Sharp* 4 (2005), <http://www.sharp. arts.gla.ac.uk/issue4.php> (accessed 4th January 2007).

5 Giorgio Agamben, *Remnants of Auschwitz: The Witness and the Archive* [1998], trans. Daniel Heller-Roazen (New York: Zone, 1999); Giorgio Agamben, *Homo Sacer: Sovereign Power and Bare Life* [1995], trans. Daniel Heller-Roazen (Stanford: Stanford University Press, 1998); Primo Levi, *If this is a Man* [1958], trans. S. Woolf (London: Abacus, 1991); Primo Levi, *The Drowned and the Saved* [1986], trans. Raymond Rosenthal (London: Abacus, 1989).

6 The term 'concentrationary universe' was first used by the French political deportee, David Rousset, in his 1946 memoir of his time in German camps, to encompass the whole process of alienations from exclusion to ghettoization to the labour, slave and extermination camps. See David Rousset, *The Other Kingdom*, trans. Ramon Guthrie (New York: Reynal and Hitchcock, 1947).

7 See Michael André Bernstein, *Foregone Conclusions: Against Apocalyptic History* (Berkeley: University of California Press, 1994).

8 Mark Roseman, *The Villa, The Lake, The Meeting: Wannsee and the Final Solution* (London: Penguin, 2002).

9 Marion A. Kaplan, *Between Dignity and Despair: Jewish Life in Nazi Germany* (Oxford: Oxford University Press, 1998); Victor Klemperer, *I Shall Bear Witness: The Diaries of Victor Klemperer 1933–1941*, ed. Martin Chalmers (London: Phoenix, 1999).

10 Ernst van Alphen, 'Autobiography as Resistance to History', in *Caught by History: Holocaust Effects in Contemporary Art, Literature and Theory* (Stanford: Stanford University Press, 1997), pp. 65–92; Ernst van Alphen, 'Salomon's Work', *Journal of Narrative and Life History* 3/2–3 (1993), pp. 239–54.

11 Benjamin: 'Berlin Chronicle', p. 295.

12 Walter Benjamin, *Charles Baudelaire: A Lyric Poet in the Age of High Capitalism* [1955], trans. Harry Zohn (London: New Left, 1973).

13 Griselda Pollock, 'Modernity and the Spaces of Femininity', in *Vision and Difference: Feminism, Femininity and the Histories of Art* (London: Routledge, 1988).

14 Julia Kristeva, 'Women's Time', in Toril Moi (ed), *The Kristeva Reader* (Oxford: Blackwell, 1986), pp. 187–213.

15 I am indebted to the following scholars and works: Judith Herzberg and Gary Schwartz effected the publication of a facsimile edition of the selected paintings with transcribed texts, Charlotte Salomon, *Charlotte: Life or Theatre?: an autobiographical play*, trans. Leila Vennewitz (New York: Viking, 1981), also C. Salomon, *Leben oder Theater?: ein autobiographisches Singspiel in 769 Bildern* (Cologne: Kiepenheuer & Witsch, 1981); Mary Lowenthal Felstiner, *To Paint her Life: Charlotte Salomon in the Nazi Era* (New York: HarperCollins, 1994); Ernst van Alphen: 'Autobiography as Resistance'; Ernst van Alphen: 'Salomon's Work'; and Monica Bohm-Duchen, see n. 3.

16 Griselda Pollock, 'Theater of Memory: Trauma and Cure in Charlotte Salomon's Modernist Fairytale', in Michael P. Steinberg and Monica Bohm-Duchen (eds), *Reading Charlotte Salomon*, (Ithaca: Cornell University Press, 2006), pp. 34–72.

17 Benjamin: 'Berlin Chronicle', 314.

18 Benjamin: 'Berlin Chronicle', 316, emphasis added.

19 Of all the curious features of this work, the careful application of small strips of tape sometimes over eyes and mouths of painted characters, other times in patterns of X across the page is one of the most intriguing. The paintings remain but they are rendered unusable by what was a time-consuming process of disabling them. I shall be discussing the rejected works in my forthcoming book.

20 An interesting comparison with this tone is Horst Rosenthal's opening of his graphic novel: 'One day in year II of the national revolution …' See Pnina Rosenberg, 'Mickey Mouse in Gurs: humour, irony and criticism in works of art produced in Gurs internment camp', *Rethinking History* 6/3 (2002), pp. 273–92.

21 The significance of the monogram merits more attention. Marcia Pointon pointed out to me the possible ironic reworking of or response to the swastika created by the varied manners in which the artist graphically combines the letters of her chosen authorial persona: CS.

22 See the clarification of these necessarily distinct identities in Felstiner: *To Paint her Life*.

23 It is not possible to illustrate all the relevant images. I reference them according to the catalogue numbers of the Jewish Historical Museum, Amsterdam, which are used on the CD-ROM published by the museum which provides easy access to the entire work.

24 The following figures are in blue: Herr and Frau Knarre, an elderly couple; Franziska and Charlotte, their daughters; Doctor Kann, a medical doctor; Charlotte, his daughter; Paulinka Bimbam, a singer; Dr Singsang, a versatile person; Professor Klingklang, a well-known conductor; a drawing instructor, Professor and Students of an Art Academy. In red, in the main part: Amadeus Daberlohn, a singing teacher; his bride a sculptor; Paulinka Bimbam; Charlotte Kann. In yellow in the epilogue are Frau Knarre, Herr Knarre, and Charlotte Kann. It will require further work to analyse the significance of this three-part colouration, the relation of the colours to the spaces, and times and the transformations indicated by the transition of Charlotte Kann from blue to red to yellow.

25 Most Jewish doctors were driven into private practice because of the discrimination against such preferment in the universities. Sigmund Freud was a case in point.

26 Some scholars have questioned the religious dimension of Salomon's Jewish identity. Paula Lindberg was the daughter of a rabbi, and introduced Reform Jewish observance into the Salomon household. She regularly sang for the Liberaal Gemeinde in Berlin, of which recordings survive. There is one painting by Salomon that clearly indicates that she had a bat-mitvah and a major celebration (JHM 4207).

27 *Des peintres au camp des Milles: septembre 1939–été 1941: Hans Bellmer, Max Ernst, Robert Liebknecht, Leo Marschutz, Ferdinand Springer, Wols* (Aix en Provence: Actes Sud, 1997). Hans Reichel was also in Gurs and produced a volume of abstract-organic drawings during his time there. A Haggadah was produced in Gurs with illustrations, Bella Gutterman and Naomi Morgenstern (eds), *The Gurs Haggadah: Passover in Perdition*, (Jerusalem: Devora Publications and Yad Vashem, 2003). See also Rosenberg: 'Mickey Mouse in Gurs'.

28 I am following Sigmund Freud, 'Beyond the Pleasure Principle' (1920: SE XVIII) and 'Moses and Monotheism' (1939: SE XXIII) and the commentaries in Cathy Caruth, *Trauma: Explorations in Memory* (Baltimore: Johns Hopkins University Press, 1995). This has been defended against recent attacks from Ruth Leys by both Shoshana Felman, *The Juridical Unconscious: Trials and Traumas in the Twentieth Century* (Cambridge: Harvard University Press, 2002), and Richard Bernstein, *Freud and the Legacy of Moses* (Cambridge: Cambridge University Press, 1998).

29 Charlotte Salomon painted a great many landscapes and portraits in Villefranche. Most were thought lost after Ottillie Moore, who bought many, returned to the United States. The Holocaust Art Museum at Yad Vashem has recently acquired a number which include gouache paintings of this garden.

30 The historical sociology and feminist analysis of the prevalence of suicide amongst acculturated German-Jewish men and women in the Wilhelmine and Weimar periods is the subject of a major study by Darcy Buerkle, *Facing German Jewish Suicide* (Unpublished PhD thesis, Claremont Graduate University, 2002), and the suicide epidemic is discussed in some statistical detail in Felstiner: *To Paint her Life*, pp. 15–17.

31 A detailed analysis of this sequence will appear as Griselda Pollock, 'What does a Woman Want? Art Investigating Death in Charlotte Salomon's *Leben? Oder Theater?* 1941–2', *Art History* 30/3 (2007), pp. 383–405.

32 Stephen Heath, 'Narrative Space,' in *Questions of Cinema* (Basingstoke: MacMillan, 1981).

33 The trope of a woman at a window has a considerable pedigree in the visual arts, from Caspar David Friedrich's painting known to Salomon, through to the work of Marc Chagall *At the Window* (1927–8, Antwerp), and passing through the work of Matisse, whose 1914 *Porte-Fenêtre à Collioure* (Centre Georges Pompidou, Paris), also dares to refuse the usual luminosity of the world seen through the window. Chagall uses blue for night scenes.

34 Tom Stoppard, *Rosencrantz and Guildenstern are Dead* (London: Faber and Faber, 1967), pp. 90–1.

35 Conrad Scheurmann and Ingrid Scheurmann, *Dani Karavan, Hommage an Walter Benjamin: der Gedenkort "Passagen" in Portbou* [*Dani Karavan, homage to Walter Benjamin: "Passages", place of remembrance at Portbou*] (Mainz: P. von Zabern, 1995).

36 Gershom Sholem, *Walter Benjamin: The Story of a Friendship*, trans. Harry Zohn (New York: Schocken, 1981), p. 226.

37 This point is powerfully made in Felstiner: *To Paint her Life*, pp. 207–8.

Chapter 7. Puncture/Punctum

1 From the song *Picture This*, Chrysalis Records, 1978. Lyrics by Deborah Harry, Chris Stein and Jimmy Destri.

2 'The Start of Something Pretty: All the News for Resort/Warm Weather', *Vogue Allure*, November 1980, pp. 362–3.

3 See Barthes's discussion of the grammar of the image in the interview, Roland Barthes, 'On Photography' in *The Grain of the Voice: Interviews 1962–1980*, trans. Linda Coverdale, (Berkeley: University of California Press, 1985), p. 356.

4 For Benjamin's discussion of the optical unconscious see Walter Benjamin, 'A Small History of Photography', in *One-Way Street and Other Writings*, trans. Edmund Jephcott and Kingsley Shorter (London: Verso, 1997), p. 243.

5 Such a photograph—or all photographs if every instant is a death—provides the impossible possibility for any spectator of seeing death before and after itself. This possible as impossible would be similar to the experience of death meeting itself as it is described by Jacques Derrida's companion piece to Maurice Blanchot's *The Instant of my Death*, see Jacques Derrida, *Demeure: Fiction and Testimony* [1998], trans. Elizabeth Rottenberg (Stanford: Stanford University Press, 2000), pp. 64–5. It might also be possible to argue in this context that the young man who is brought before a firing squad and then is not executed—the story that forms Blanchot's *The Instant of my Death*—the young man who dies and does not die, is a man who becomes in a sense photographic.

6 Susan Sontag, *On Photography* (London: Penguin, 1979), p. 70.

7 Perhaps we need to think of the time of the photograph as suspended time. Sylviane Agacinski has suggested that we conceive of time as an '*infinite spiralling curl*', a description which captures well the heterogeneous experience of our times. Time whorls inwards yet sometimes winds outwards again, twisting back over its tail. The photograph however would be like a ball in a roulette wheel without centre that drops and refuses to drop; it follows the spiral but also leads the spiral back to its moment of genesis, back to its insertion into the vortex, back to the moment of its taking. For Agacinski's arguments about time see S. Agacinski, *Time Passing*, trans. Jody Gladding (New York: Columbia University Press, 2003).

8 Marianne Thesander, *The Feminine Ideal* (London: Reaktion, 1997), p. 201. See pp. 201–3. for a fuller account of the changed status of the body in 1980s fashion.

9 Of course this body is not just any body but a Western body, and not just any Western body but one with particular characteristics—a slim and supple body—which if you were not born with you were led to assume you could attain by other means. The belief in this potential becoming was perhaps best exemplified by the popularity of Jane Fonda's then hegemonic workout: Jane Fonda, *Jane Fonda's Workout Book* (New York: Simon & Schuster, 1981) was a bestseller. The video released in 1982 was number one on the video sales chart in the United States for three consecutive years.

10 Or perhaps I—as the one interpreting the image—want to take Carangi's clothes

off without my knowing it. In reading the image I am reading myself. All interpretation resembles the accidental untucking that has taken place in this photograph; without always wanting to, we reveal a part of ourselves in our readings.

11 For a discussion of 'exposure' in relation to theories of recognition see Judith Butler, *Giving an Account of Oneself: A Critique of Ethical Violence* (Amsterdam: Koninklijke van Gorcum, 2003), pp. 24–6.

12 Benjamin: 'A Small History of Photography', p. 256.

13 Stephen Fried, *Thing of Beauty: the tragedy of supermodel Gia* (New York: Simon & Schuster, 1993), p. 361.

14 An excellent example of a Foucaultian approach to reading photographs is provided in John Tagg, *The Burden of Representation: essays on photographies and histories* (Minneapolis: University of Minnesota Press, 1993). See in particular the Introduction and chapter 3.

15 Of course the phrase 'no places' cannot help but connote Marc Augé's 'non-places', but Augé's non-places are precisely the opposite of spaces outside words—they are in fact characterized by a surfeit of words—and are rather places where the individual is encouraged to interact solely with words. See M. Augé, *Non-Places: Introduction to an Anthropology of Supermodernity* (London: Verso, 1995), p. 96. Augé's non-places cease to be no places the moment he describes them.

16 Roland Barthes, *Camera Lucida* [1980], trans. Richard Howard (London: Vintage, 1993), pp. 26–7.

17 Barthes: *Camera Lucida*, p. 26.

18 On the subject of the asemantic aspect of punctuation see Giorgio Agamben, 'Absolute Immanence', in *Potentialities*, trans. Daniel Heller-Roazen (Stanford: Stanford University Press, 1999), pp. 220–39, particularly p. 223.

19 The horizon beyond any writing about an image, whilst impossible to ever write to (impossible ever to reach), provides a point of reference for that writing. It is that necessary end in/of sight which prevents a radical openness of interpretation from leading to the implosion of meaning. As such it might be likened in some way to the horizon in Ernesto Laclau and Chantal Mouffe, *Hegemony and Socialist Strategy* (London: Verso, 2001), see p. 188.

20 Fried: *Thing of Beauty*, p. 246.

21 For a good description of life as a model during this period see Janice Dickinson, *No Lifeguard on Duty: The Accidental Life of the World's First Supermodel* (New York: Regan, 2002). For Dickinson's discussion of her friendship with Gia Carangi see pp. 126–7, 159–63.

22 Francesco Scavullo and Sean Byrnes, *Scavullo Women* (New York: Harper & Row, 1982), p. 33.

23 Mieke Bal, *Travelling Concepts in the Humanities: A Rough Guide* (Toronto: University of Toronto Press, 2002), p. 227.

24 For Barthes's acknowledgement of the power of expansion of the punctum see *Camera Lucida*, p. 45. Mieke Bal also brings out this metonymic potential of the punctum during her reading of a Rembrandt *Self-Portrait* (1658) from the Frick Collection. See Mieke Bal, *Reading Rembrandt: Beyond the Word-Image Opposition* (Cambridge: Cambridge University Press, 1991), p. 254.

25 The Israeli singer Ofra Haza died on 23 February 2000. Shortly afterwards,

Ha'aretz published reports that the singer had died of an AIDS-related illness. There is, of course, important work already in print exploring aspects of the relationships that exist between women, AIDS and representation, including: Nancy L. Roth and Katie Hogan (eds), *Gendered Epidemic: Representations of Women in the Age of AIDS* (London: Routledge, 1998); Gabriele Griffin, *Representations of HIV and AIDS: Visibility Blue/s* (Manchester: Manchester University Press, 2000), in particular chapter 7, 'Safe and sexy? Lesbian erotica/porn in the age of HIV/AIDS'. Unfortunately these works have attained only a limited visibility, and I must add that I also have severe reservations about how representative they are of the women who are most likely to become seropositive.

26 A photograph about which Barthes writes in *Camera Lucida*, pp. 58–9.

27 It could be said that we have developed an *aesthetic fixation* around particular forms of representation of AIDS. There is a risk that those forms are now anachronistic. I draw on Agacinski's ideas about the emotional attachment to form here. See Agacinski: *Time Passing*, particularly pp.118–20.

28 See Judith Butler, 'Violence, Mourning, Politics' in *Precarious Life: The Powers of Mourning and Violence* (London and New York: Verso, 2004), pp. 19–49, in particular pp. 34–5.

29 For a poignant critique of the myth that the spread of Industrial Capitalism and the growth of a global economy has engendered 'development' in so-called third-world countries see James Ferguson, *Expectations of Modernity: Myths and Meanings of Urban Life on the Zambian Copperbelt* (Berkeley: University of California Press, 1999).

30 We should also be sceptical of the $15 billion pledged by President Bush to fight AIDS in Africa, as decisions about how US aid money is spent are often taken by NGOs. These NGOs often have a conservative religious agenda and award money to the faith-based charities who direct its programmes for it. These charities often have religious objections to distributing condoms and prefer to promote sexual abstinence. This contentious approach to fighting AIDS is particularly unuseful given the demographics of the epidemic in Africa. For instance, it is not easy for women to refuse sexual intercourse in a patriarchal society where they often depend upon a man for their livelihood. As Paul Farmer incisively points out, it is first necessary to help poor women gain control of their lives before even beginning to think about asking them to change their lifestyle. (See Paul Farmer, *Infections and Inequalities: The Modern Plagues* (Berkeley: University of California Press, 2001), chapter 3, 'Invisible Women'.) The high level of importance given by George W. Bush to this pandemic is demonstrated by his announcement shortly after taking office that he intended to close the White House AIDS office. He was unable to follow this intention through because of the outcry generated. See Douglas Crimp, *Melancholia and Moralism: Essays on AIDS and Queer Politics* (Cambridge, MA: MIT Press, 2002), p. 17.

31 For a useful discussion of this potential freeing of responsibility—which could be understood as a disburdening of conscience—see my interview with Geoffrey Hartman, 'The Struggle Against the Inauthentic', *parallax* 30 (2004), pp. 72–7.

32 John Paul Ricco, *The Logic of the Lure* (Chicago: University of Chicago Press, 2002), p. 40.

Chapter 8. History

This contribution is dedicated to the memory of Annick Le Gall† who installed the library in the study centre at Vizille.

1 R. Chagny, 'Vizille, Les usages d'un haut lieu', in J. Davallon, P. Dujardin, and G. Sabatier (eds), *Politique de la Mémoire: Commémorer la Révolution* (Lyon: Presses Universitaires de Lyon, 1993), p. 47.

2 L. Gossman, 'Towards a Rational Historiography', *Transactions of the American Philosophical Society* 79/3 (1989), pp. 1–68.

3 See further Mieke Bal, 'Memories in the Museum: Preposterous Histories for Today', in M. Bal, J. Crewe, and L. Spitzer (eds), *Acts of Memory: Cultural Recall in the Present* (Hanover: University Press of New England, 1999), pp. 171–90.

4 P. Nora, 'Entre Mémoire et Histoire: La problématique des lieux', in P. Nora (ed), *Les Lieux de mémoire* (Paris: Gallimard, 1984), pp. xvii–xlii.

5 R. Chagny, V. Chomel and M. Vovelle, 'Avant-projet: Pour un musée national de la Révolution française au château de Vizille' (unpublished document, Vizille, Musée de la Révolution française, 1982), p. 3.

6 A summary of these four major moments may be found in P. Bordes, *Premières Collections* (Vizille: Conseil Général de l'Isère, 1985), p. 12.

7 '[E]*st un pari sur la décentralisation culturelle, mais un pari justifié par l'héritage historique de ce lieu, et par le cadre lui-même de ce château et de son parc.*' M. Vovelle, 'Discours', in *Une Dynastie bourgeoise dans la Révolution: les Perier* (Vizille: Conseil Général de l'Isère, 1984), p. 10.

8 For the painting by Alexandre Debelle see Bordes: *Premières Collections*, p. 104.

9 Bordes: *Premières Collections*, p. 104.

10 For the work by Auguste Couder, see further M. Marrinan, *Painting Politics for Louis-Philippe: Art and Ideology in Orléanist France 1830–1848* (New Haven: Yale University Press, 1988), pp. 121–5. Marrinan suggests that the initiative of Couder's painting belongs to the promotion of Orléanist policies.

11 For the project by David, see P. Bordes, *Le Serment du Jeu de Paume de Jacques-Louis David* (Paris: Editions de la Réunion des Musées Nationaux, 1983).

12 See R. Chagny, 'La Marianne de Vizille: Le Monument Commémoratif de l'Assemblée de Vizille', in *Entre Liberté, République et France: Les Représentations de Marianne de 1792 à nos jours* (Paris: Musée de la Révolution française et Réunion des Musées Nationaux, 2003), pp. 28–60.

13 Chagny: 'Vizille, Les usages d'un haut lieu'.

14 Bordes: *Le Serment du Jeu de Paume*, p. 14.

15 Chagny: 'Vizille, Les usages d'un haut lieu', p. 36.

16 Chagny, Chomel, and Vovelle: 'Avant-projet', p. 4.

17 Chagny: 'Vizille, Les usages d'un haut lieu', p. 49.

18 Chagny: 'Vizille, Les usages d'un haut lieu', p. 19.

19 '[T]he very cradle of the great movement of 1789.' P. Fertaille, 'L'Avenir du Domaine de Vizille', *Gazette des Alpes* 132 (1924).

20 Chagny, Chomel, and Vovelle: 'Avant-projet', pp. 1–2.

21 Chagny, Chomel, and Vovelle: 'Avant-projet', pp. 3–4.

22 See, for instance, M. Vovelle, *Idéologie et Mentalités* (Paris: F. Maspero, 1982); M.

Vovelle, *La mentalité révolutionnaire: société et mentalité sous la Révolution française* (Paris: Editions sociales, 1985).

23 Chagny, Chomel, and Vovelle: 'Avant-projet', p. 7.
24 Chagny, Chomel, and Vovelle: 'Avant-projet', p. 7.
25 Chagny, Chomel, and Vovelle: 'Avant-projet', p. 4.
26 Chagny, Chomel, and Vovelle: 'Avant-projet', p. 6. The bicentennial as heritage industry could account for the low profile of the museum during these celebrations. See the last section of this chapter for the museum's alternative postmodern approach.
27 *Une Dynastie bourgeoise*, pp. 28–34.
28 *Une Dynastie bourgeoise*, pp. 39–81.
29 *Une Dynastie bourgeoise*, pp. 79–117.
30 *Une Dynastie bourgeoise*, pp. 102–3.
31 For some of the difficulties and objections to the founding of the museum in the 1970s, see Bordes: *Premières Collections*, pp. 12–13.
32 *Une Dynastie bourgeoise*, p. 5.
33 '[F]ruit of a perpetual tension between the past and the preoccupations of the present.' *Une Dynastie bourgeoise*, p. 7.
34 *Une Dynastie bourgeoise*, p. 6.
35 F. Furet, *Interpreting the French Revolution*, trans. E. Forster (Cambridge: Cambridge University Press, 1981), pp. 5–6.
36 S. Kaplan, *Farewell Revolution*, (Ithaca and London: Cornell University Press, 1995), vol. 1, pp. 45–6.
37 Furet: *Interpreting the French Revolution*, p. 16.
38 Kaplan: *Farewell Revolution*, vol. 1, pp. 55–6.
39 Kaplan: *Farewell Revolution*, vol. 2, pp. 12–13.
40 Kaplan: *Farewell Revolution*, vol. 2, pp. 12–13.
41 M. Vovelle, 'Hommage à Albert Soboul, Jacques Godechot et Jean-René Suratteau', in R. Chagny (ed) *La Révolution française: Idéaux, singularités, influences* (Grenoble: Presses Universitaires de Grenoble, 2002), pp. xi–xix. I thank Philippe Bordes for this reference.
42 See further M. Bal, 'Visual essentialism and the object of visual culture', *Journal of Visual Culture* 2 (2003), pp. 5–32.
43 See E. Hooper-Greenhill, *Museums and the Interpretation of Visual Culture* (London: Routledge, 2000).
44 Hooper-Greenhill: *Museums*, p. 49.
45 Hooper-Greenhill: *Museums*, p. 110.
46 '[T]he greatest historian of our people.' *Une Dynastie bourgeoise*, p. 7.
47 *Une Dynastie bourgeoise*, p. 7.
48 Hubert Landais, Letter to Louis Mermaz, 10 January 1983 (archives of Musée de la Révolution française, Vizille).
49 Pascal de la Vaissière, Letter to Jean-Pierre Laurent, 15 December 1980 (archives of Musée de la Révolution française, Vizille); 'Procès-verbal de la Réunion du 26 mai 1981 sur l'aménagement d'un musée de la Révolution française au Château de Vizille' (Préfecture de l'Isère, unpublished minutes, Musée de la Révolution française, Vizille).

50 For eighteenth-century France, see Colin Bailey, *Patriotic taste: collecting modern art in pre-revolutionary Paris*, (New Haven, Yale University Press, 2002).

51 E. de Goncourt and J. de Goncourt, *Histoire de la Société Française pendant la Révolution* (Paris: Charpentier, 1854; edn. 1907), p. 353.

52 H. Honour, *Neo-classicism* (Harmondsworth: Penguin, 1968), pp. 78–80.

53 P. Bordes, 'Avant-propos' in *Catalogue des peintures, sculptures et dessins* (Vizille: Conseil Général de l'Isére en co-édition avec la Réunion des Musées Nationaux, 1996), pp. 7–8.

54 Bordes: *Premières Collections*, p. 14,

55 See *Les Faïences Révolutionnaire de la Collection Louis Heitschel* (Paris: ARTS EXPO, 1985).

56 *Catalogue des peintures, sculptures et dessins*, pp. 169–70.

57 *Catalogue des peintures, sculptures et dessins*, pp. 169–70.

58 J-L. Taupin, 'Le musée de la Révolution française de Vizille', *Monuments Historiques* 161 (1989), pp. 100–4.

59 Taupin: 'Le musée de la Révolution française'.

60 See T. J. Clarke, *Image of the People: Gustave Courbet and the 1848 Revolution* (London: Thames and Hudson, 1973), p. 131.

61 *Sigmar Polke et la Révolution française* (Vizille: Musée de la Révolution française, 2001).

62 *Sigmar Polke*, pp. 88–9.

Chapter 9. Nostalgia

1 In her research on Palestinian refugees in Lebanon, Rosemary Sayigh described their feeling of being expelled from paradise, a sentiment that is not particular to this segment of Palestinians. See Rosemary Sayigh, *Palestinians: From Peasants to Revolutionaries* (London: Zed, 1979), pp. 3–16.

2 Examples of such criticism of nostalgia as a derogatory concept include, among others: Fred Davis, *Yearning for Yesterday* (New York: Macmillan, 1979); Christopher Shaw and Malcolm Chase (eds), *The Imagined Past: History and Nostalgia* (Manchester: Manchester University Press, 1989); and David Lowenthal, *The Past is a Foreign Country* (Cambridge: Cambridge University Press, 1985).

3 Nanna Verhoeff, *The West in Early Cinema: After the Beginning* (Amsterdam: Amsterdam University Press, 2006), p. 149.

4 Verhoeff: *The West in Early Cinema*, pp. 150–1.

5 My use of the term 'nostalgic' is based on Verhoeff's conceptualization of the term 'instant nostalgia'. See Verhoeff: *The West in Early Cinema*, pp. 148–57.

6 My use of the term 'the first generation of post-*nakba* Palestinians' refers to those Palestinians who lived and witnessed the events of 1948. Examples of Palestinian literary representations of *al-nakba* in the sense of 'paradise lost' include, among others, Aref Al Aref's (1891–1960) six photographic volumes *Nakbat Filisteen* (Palestine's Catastrophe, 1956–60); and Abd Al Kareem Al Karmy's (1907–80) poetry such as his poem *Sawfa Na'oud* (We Will Return, 1951).

7 Jabra Ibrahim Jabra (1920–94) lived in Iraq after eviction from Palestine in 1948, and is one of the most distinguished Palestinian writers who lived and died in exile.

8 Jabra Ibrahim Jabra, *The Ship*, trans. Adnan Hayder and Roger Allen (Washington:

Three Continents, 1985). Page references are given in the text. In writing this chapter, I also consulted the original version of the novel, Jabra Ibrahim Jabra, *Al Safina* (Beirut: Dar Al Adab, 1970).

9 For a detailed discussion of trauma as a discursive concept, see Ernst van Alphen, *Caught by History: Holocaust Effects in Contemporary Art, Literature and Theory* (Stanford: Stanford University Press, 1997). In his discussion, van Alphen explains trauma in terms of the impossibility of the event. However, for the sake of my argument in this paper, I chose to discuss trauma in terms of the loss that is precipitated by the event (*al-nakba*). Hence, my point here is not loss per se, but rather its symbolic and discursive significations; that is, both its happening and its experience.

10 For a detailed discussion of Wadi's large share of the dialogue as a narrative technique in the novel, see Walid Hamarneh, 'The Construction of Fictional Worlds and the Problem of Authenticity: Jabra Ibrahim Jabra, and Fathi Ghanim', *Style* 25/2 (1991), pp. 223–36.

11 Mieke Bal, Jonathan Crew and Leo Spitzer (eds), *Acts of Memory: Cultural Recall in the Present* (Hanover: University Press of New England, 1999), p. vii.

12 The contrast between a rebel and an aristocrat can be seen in their meanings: while being an aristocrat signifies an elite where power rests, being a rebel signifies an opposition or a resistance to such power.

13 My use of the term 'subjectivizing' is a reference to Martin Heidegger's aphorism in his 'letter on Humanism' that 'every valuing, even where it values positively, is a subjectivizing. It does not let beings be. Rather, valuing lets beings be valid … solely as the subject of its doing' Martin Heidegger, 'Letter on Humanism', in *Basic Writings*, ed. David Farrell Krell (New York: Harper and Row, 1977), p. 228.

14 For more discussion on the present-oriented mode of cultural memorization, see Bal, Crew and Spitzer (eds): *Acts of Memory*, pp. i–vii; and Mieke Bal, *Quoting Caravaggio: Contemporary Art, Preposterous History* (Chicago: University of Chicago Press, 1999), pp. 90–116.

15 See, on the issue of trauma as a 'failed experience', Ernst van Alphen, 'Playing the Holocaust', in *Mirroring Evil: Nazi Imagery/Recent Art* (New Jersey: Rutgers University Press, 2002), pp. 65–83.

16 For a discussion of the traumatic aspects of forced exile, see Annette Månsson, *Passage to a New Wor(l)d: Exile and Restoration in Mahmoud Darwish's Writings 1960–1995* (Uppsala : Uppsala Universitet, 2003), pp. 30–7.

Chapter 10. Pedagogy

1 Department for Education and Skills, *Making the Most of Parents' Evenings*, Reference HYCL/1 (United Kingdom: Department for Education and Skills, 2003), p. 12.

2 Marilyn Strathern, 'New Accountabilities: Anthropological Studies in Audit, Ethics and the Academy', in Marilyn Strathern (ed), *Audit Cultures: Anthropological Studies in Accountability, Ethics and the Academy* (London: Routledge, 2000), p. 2.

3 1996 was a year that witnessed the rapid advancement of radical reforms throughout the UK Further Education sector (in which I was previously employed as a lecturer in art and design). These reforms, initially introduced in 1992 through the Further and Higher Education Act were mobilized by political educational poli-

cies, and implemented through managerial discourses that entwined the language of finance with moral reasoning in support of predetermined value regimes.

4 Department for Education and Skills: *Making the Most of Parents' Evenings*, p. 12.
5 Cris Shore and Susan Wright, 'Coercive Accountability: The Rise of the Audit Culture in Higher Education', in Marilyn Strathern (ed), *Audit Cultures: Anthropological Studies in Accountability, Ethics and the Academy* (London: Routledge, 2000), p. 58.
6 Department for Education and Skills, *Home-School Agreements: What Every Parent Should Know*, Reference PPY986 (United Kingdom: Department for Education and Skills, 1998), p. 2.
7 Department for Education and Skills: *Home-School Agreements*, p. 7.
8 John Crace, 'Painting by numbers', *Guardian*, 3 July 2001, p. 2. <http://education.guardian.co.uk/egweekly/story/0,,515683,00.html>.
9 Department for Education and Skills, *The Parent Centre: Help Your Child to Learn*, <http://www.parentcentre.gov.uk> (accessed 15 December 2003).
10 Mieke Bal, *Travelling Concepts in the Humanities: A Rough Guide* (Toronto: University of Toronto Press, 2002), p. 286.
11 Catherine Lord, *The Intimacy of Influence: Narrative and Theoretical Fictions in the Works of George Eliot, Virginia Woolf and Jeanette Winterson* (Amsterdam: ASCA Press, 1999).
12 Gayatri Chakravorty Spivak, *A Critique of Postcolonial Reason: Toward a History of the Vanishing Present*, (Cambridge: Harvard University Press, 1999).
13 Bal: *Travelling Concepts*, p. 294 n. 11.
14 Bal: *Travelling Concepts*, p. 289.
15 Bal: *Travelling Concepts*, p. 289.
16 Augusto Boal, *Theatre of the Oppressed* [1974], trans. C. A. McBride and M. O. Leal McBride (London: Pluto, 1979).
17 Paulo Freire, *Pedagogy of the Oppressed* [1968], trans. M. B. Ramos (New York: Continuum, 1993).
18 Val A. Walsh, 'Eyewitnesses, Not Spectators—Activists, Not Academics: Feminist Pedagogy and Women's Creativity', in Katy Deepwell (ed), *New Feminist Art Criticism* (Manchester: Manchester University Press, 1995), p. 55.
19 Walsh: 'Eyewitnesses, Not Spectators', p. 56.
20 I attended the MA Feminist Theory, History and Criticism in the Visual Arts course at the University of Leeds in 1996–8. On this course I engaged with contemporary art practices that were concerned with social-change and political activism, where the politics of lived experience were not excluded, denied or repressed, and where artists were working through a wide and varied range of processes and modes for production, often in conjunction with their audiences. Sadly the course closed in 2005 as a result of institutional reorganization, although individual modules of study from the programme continue to be delivered.
21 Valerie Walkerdine, *Daddy's Girl: Young Girls and Popular Culture* (London: Macmillan, 1997), p. 59.
22 Bal: *Travelling Concepts*, p. 317.
23 Bal: *Travelling Concepts*, p. 292.
24 Bal: *Travelling Concepts*, p. 294.
25 Bal: *Travelling Concepts*, p. 293.

26 Gaby Weiner, *Feminisms in Education: An Introduction* (Buckingham: Open University Press, 1998), p. 100.

27 Bal: *Travelling Concepts*, p. 294.

28 Strathern: 'New Accountabilities', p. 1.

29 Department for Education and Skills, *The Charter for Further Education: Further Choice and Quality* (United Kingdom: Department for Education and Skills, 1993), p. 3.

30 Department for Education and Skills, *The Charter for Higher Education: Higher Quality and Choice* (United Kingdom: Department for Education and Skills, 1993), p. 1.

31 Shore and Wright: 'Coercive Accountability', p. 60.

32 Donald Drew Egbert, *Social Radicalism and the Arts: A Cultural History From the French Revolution to 1968* (New York: Alfred A. Knopf, 1970), p. 411.

33 Peter Scott, 'High Wire: No less than desire for cultural revolution should fuel the drive to expand higher education', *Guardian*, 4 December 2001, p. 13. <http://education.guardian.co.uk/egweekly/story/ 0,,610959,00.html>

34 Weiner: *Feminisms in Education*, p. 94.

35 Margaret Hodge, 'Elitism never made a nation rich: educating more people to degree level is an economic necessity', *Guardian*, 6 November 2001, p. 13. <http://education.guardian.co.uk/egweekly/story/0,,588001,00. html>.

36 Eleanor Rimoldi, 'Generic Genius—How Does It All Add Up?' in Marilyn Strathern (ed), *Audit Cultures: Anthropological Studies in Accountability, Ethics and the Academy* (London: Routledge, 2000), p. 93.

37 Edexcel, *2D Visual Language, Question 8*, BTEC/GNVQ Intermediate Level Art and Design Examination Paper, Reference U1021061, (United Kingdom: Edexcel, 1997), p. 7.

38 Edexcel: *2D Visual Language*, p. 7.

39 Griselda Pollock, Personal discussion, 25 November 2003.

40 Griselda Pollock, Personal discussion, 25 November 2003.

41 Farzana Shain writes the 'marketisation of FE [Further Education] cannot be understood without reference to wider educational reforms, including the sustained attack on public sector professionalism from the late 1970s and the shift towards managerial control of teachers' work.' Farzana Shain, 'Changing Notions of Teacher Professionalism in the Further Education Sector', paper presented at the British Educational Research Association Annual Conference, Queen's University of Belfast, Northern Ireland, 27–30 August 1998. <http://www.leeds. ac.uk/educol/documents/000000939.htm> (accessed 14 June 2005).

42 Shore and Wright, 'Coercive Accountability', p. 61.

43 My experiences of the audit culture have been documented fully in my PhD in fine art practice; this documentation is accessible online at: <http://www.feda. co.uk/fartthrosilka/index.shtml> (accessed 14 June 2005).

44 Health and Safety Executive, *About Us*, <http://www.hse.gov.uk/aboutus/hsc/ index.htm> (accessed 15 June 2005).

45 Health and Safety Executive, *Thirty Years On and Looking Forward—The Development and Focus of the Health and Safety Executive in Great Britain*, <http://www.hse.gov.uk/ aboutus/reports/30years.pdf > (accessed 15 June 2005).

46 Spivak: *Critique of Postcolonial Reason*, p. 267.

47 Sue Wilks, *Feda: Between Pedagogy & Politicised Art Practice*, <http://www.feda.co.uk/index.shtml> (accessed 14 June 2005). My website presents a virtual research dossier that tracks the progress of my project as an ongoing process of personal and academic development. It documents the ways in which my experimental methodologies for the production of art practice have evolved and shifted as I worked my way through specific learning experiences, and has been constructed as a sort of independent personal exhibition space.

48 Bal: *Travelling Concepts*, p. 292.

49 Mieke Bal, *Louise Bourgeois' Spider: the architecture of art-writing* (Chicago: University of Chicago Press, 2001), p. xii.

50 Bal: *Louise Bourgeois' Spider*, p. 39.

Chapter 11. Efficacity

1 Michel Foucault, *The Order of Things: An Archaeology of the Human Sciences* [1966], trans. Tavistock Publications (London: Routledge, 1974), p. 9.

2 Arkady Plotnitsky, *The Knowable and the Unknowable: Modern Science, Nonclassical Thought, and the "Two Cultures"* (Michigan: University of Michigan Press, 2002), pp. 7–8, 10.

3 Mieke Bal, *Travelling Concepts in the Humanities: A Rough Guide* (Toronto: University of Toronto Press, 2002).

4 Bal: *Travelling Concepts*, p. 17.

5 Bal: *Travelling Concepts*, p. 17.

6 To clarify the distinction between *meta* and *para* here: whereas *para* can be defined as alongside, beyond, beside, resembling, as in 'parallel' meaning alongside one another, *meta* relates to, applies to a thing, or an action, yet makes a departure from it to a distinctly different thing. *Meta* here denotes a development incorporating change, alteration or effect generally.

7 Plotnitsky: *The Knowable and the Unknowable*, p. 22.

8 Plotnitsky: *The Knowable and the Unknowable*, p. 22. Plonitsky is aware of the fashion for 'the risky term "interdisciplinarity"' and explains at length that his study, and indeed mine, 'pursues certain specific—nonclassical—epistemological configurations rigorously shared by different fields, where they may have different roles to play, rather than certain interactions between such fields themselves for their own sake, be they more or less rigorous or more or less loose. Such interactions and our views of them have sometimes been too loose and superficial or, one might say, lacking in discipline (in either sense), often in the name of interdisciplinarity.'

9 Plotnitsky: *The Knowable and the Unknowable*, p. 23.

10 Plotnitsky: *The Knowable and the Unknowable*, pp. 2–3. 'In general, classical theories, as here defined, need not entail causality. Classical physics, however, is virtually uniformly causal, although not always deterministic, while nonclassical theories are neither causal, nor deterministic, nor realist as concerns their ultimate object.'

11 Plotnitsky: *The Knowable and the Unknowable*, pp. 2–3. '[C]lassical physics is, thus, by definition, realist and usually causal … one can combine theory … and experimental data so as to construct models, *classical* models, each comprising a set of idealized objects, whose causal behaviour the theory describes.'

12 Plotnitsky: *The Knowable and the Unknowable*, p. 3.

NOTES TO CHAPTER 11

13 Plotnitsky: *The Knowable and the Unknowable*, pp. 9–10.
14 Plotnitsky: *The Knowable and the Unknowable*, pp. 9–10.
15 Milne, A.A., *Winnie-The-Pooh* [1926] (London: Methuen, 1948), pp. 32–41.
16 Plotnitsky: *The Knowable and the Unknowable*, p. 3.
17 Plotnitsky: *The Knowable and the Unknowable*, p. 34.
18 Plotnitsky: *The Knowable and the Unknowable*, pp. 2–3.
19 Plotnitsky: *The Knowable and the Unknowable*, p. 10.
20 Plotnitsky: *The Knowable and the Unknowable*, p. 10.
21 Foucault does not initially use the term *dispositif*, preferring *episteme*, but continually develops it throughout his writing, as meaning an apparatus of discourse in the formation of power/knowledge. He clarifies the term in Michel Foucault, 'The Confession of the Flesh', in *Power/Knowledge: Selected Interviews and Other Writings 1972–77*, ed. Colin Gordon, (London: Harvester Wheatsheaf, 1980), p. 197.
22 Michel Foucault, *The Archaeology of Knowledge* [1969], trans. A. M. Sheridan Smith (London: Routledge, 1972).
23 Pamela Major-Poetzl, *Michel Foucault's Archaeology of Western Culture: Toward a New Science of History* (Chapel Hill: University of North Carolina Press, 1983).
24 Gilles Deleuze, *Foucault* [1986], trans. and ed. Seán Hand (Minneapolis: University of Minnesota Press, 1988).
25 Jennifer Tennant Jackson, *Evidence as a Problem. Foucaultian Approaches to Three Canonical Works of Art: Courbet's* L'Atelier, *1855; Velázquez'* Las Meninas, *1656; Botticelli's* Venus and Mars, *circa 1483* (Unpublished PhD Thesis, University of Leeds, 2001), pp. 33–5.
26 Foucault analyses the 'statement' in *The Archaeology of Knowledge*. It is a group of words, or even an inference. It is not equivalent to a sentence, or a proposition, or a speech act. When accepted within the discipline as a fact it proves the discourse. Statements form the '*historical a priori*' of the discourse. For example, the statements such as 'Courbet was a socialist' or 'Courbet was a Realist' construct the art-historical references made to the works of Gustave Courbet, 1819–77, through which the art works are read. Tennant Jackson: *Evidence as a Problem*.
27 Foucault: *The Archaeology of Knowledge*, p. 115, emphasis added.
28 Stephen Hawking, *A Brief History of Time: From the Big Bang to Black Holes* (London: Bantam, 1988), p. 56.
29 Foucault: *The Archaeology of Knowledge*, p. 101.
30 Hawking: *A Brief History of Time*, pp. 54–5.
31 Bal: *Travelling Concepts*, pp. 22–3. Concepts need to be 'explicit clear and defined. In this way everyone can take them up and use them. This is not as easy as it sounds, because concepts are flexible: each is part of a framework, a systematic set of distinctions, *not* oppositions, that can sometimes be bracketed or even ignored, but that can never be transgressed or contradicted without serious damage to the analysis in hand…. [C]oncepts are not simply labels easily replaced by more common words…. Concepts, in the first place look like words … "Meaning" is a case of just such an ordinary word-concept that casually walks back and forth between semantics and intention … concepts are not ordinary words, even if words are used to speak (of) them.'
32 Bal: *Travelling Concepts*, p. 175.

33 Foucault: *The Archaeology of Knowledge*, p. 108.
34 Foucault: *Power/Knowledge*, p. 197. See also Michel Foucault, *The History of Sexuality Volume I: The Will to Knowledge* [1976], trans. Robert Hurley (Harmondsworth: Penguin, 1978).
35 Foucault: *The Archaeology of Knowledge*, p. 118.
36 Tennant Jackson: *Evidence as a Problem*, p. 30. With reference to Deleuze: *Foucault*, pp. 62, 67.
37 Bal, Mieke, *Quoting Caravaggio: Contemporary Art, Preposterous History* (Chicago: Chicago University Press, 1999), pp. 51, 245. 'This critical potential of the fold as a theoretical figure, as dispositif, is more precisely filled out with thought in the way it connects with violence, the body, and death to eroticism and pleasure, but without merging these in its sadistic opportunity. For these folds envelop the body … wrapping has a way of unveiling, and that this is 'only' a performance.'
38 Foucault: *Power/Knowledge*, pp. 194–6.
39 Foucault: *The Order of Things*, p. 4.
40 Foucault: *The Order of Things*, p. 4.
41 Geoff Danaher, Tony Schirato and Jen Webb, *Understanding Foucault* (London: Sage, 2000), p. 16.
42 Danaher, Schirato and Webb: *Understanding Foucault*, p. 29.
43 Foucault: *The Order of Things*, p. 4.
44 Foucault: *The Order of Things*, p. 4.
45 Foucault: *Power/Knowledge*, p. 69. See also p. 149, in conversation with Jean-Pierre Barou and Michelle Perrot, where Foucault says he wants to reinstate space as an important project, to resurrect it from the secondary place it has occupied since science took it out of philosophical discourse and left the philosophers to the contemplation of time. In the early 1970s he said: 'Anchorage in space is an economico-political form which needs to be studied in detail.' See Tennant Jackson: *Evidence as a Problem*, p. 44.
46 Foucault: *The Order of Things*, p. 9.
47 Bal: *Travelling Concepts*, p. 176.
48 Bal: *Travelling Concepts*, p. 186. Bal refers to her previous work *Quoting Caravaggio*.
49 Bal: *Travelling Concepts*, p. 186.
50 Bal: *Travelling Concepts*, p. 187. 'While the viewer performs the inarticulate act of looking, glued to an image of nothing, the relationship between words and images that underlies theatre comes to the fore as the bridge between performance and performativity.'
51 Foucault: *The Archaeology of Knowledge*, p. 104.
52 Judith Butler, 'Gender as Performance: An Interview with Judith Butler', by Peter Osborne and Lynne Segal, *Radical Philosophy* 67 (1994), p. 33. Excerpts available at <http://www.theory.org.uk/but-int1.htm> (accessed 25 April 2007).
53 Jacques Derrida, 'Signature—Event—Context', in *Margins of Philosophy* [1972], trans. Alan Bass (Chicago: University of Chicago Press, 1982), p. 321. Derrida recognizes Austin's classical thinking: 'Austin had to free the performative from the authority of the *value of truth*, from the opposition true/false, at least in its classical form, occasionally substituting it for the value of force.'
54 Derrida: 'Signature—Event—Context', p. 321.

55 Derrida: 'Signature—Event—Context', p. 322.
56 Derrida: 'Signature—Event—Context', p. 327. *Différance* is the Derridean term for language that defers to the original and differs from it at one and the same time.
57 Derrida: 'Signature—Event—Context', p. 327. Derrida writes: '*Différance*, the irreducible absence of intention or assistance from the performative statement, from the most "event-like" statement possible'. He is not saying here that there is 'no effect of the performative' but that the effect is not directly related to intention, but may relate to the effects of the speech act 'in dissymmetrical fashion, as the general space of their possibility'.

Chapter 12. Commitment

The first version of this article was started before, and finished after, the First Conference for Activist Investigations in Barcelona, January 2004. The conversations and debates held during this congress influenced and enriched the development of this paper considerably. My thanks go to the organizers and participants.

1 Homi K. Bhabha, *The Location of Culture* (London: Routledge, 1994), p. 21.
2 Antonio Gramsci, 'The Intellectuals', in *Selections from the Prison Notebooks*, ed. and trans. Quintin Hoare and Geoffrey Nowell Smith (London: Lawrence and Wishart, 1971), p. 9.
3 Gramsci: 'The Intellectuals', p. 10.
4 Gramsci: 'The Intellectuals', p. 7.
5 Bhabha: *The Location of Culture*, p. 21.
6 Bhabha: *The Location of Culture*, p. 21.
7 Bhabha: *The Location of Culture*, p. 21.
8 Bhabha: *The Location of Culture*, p. 21.
9 Bhabha: *The Location of Culture*, p. 22.
10 For a more detailed account of the structure of iteration see for example Judith Butler, *Bodies that Matter* (London: Routledge, 1993) and Jacques Derrida, 'Signature Event Context', in *Limited Inc* (Evanston IL: Northwestern University Press, 1988), pp. 1–23.
11 My discussion of the relationship between language, power and spaces has benefited immensely from discussions with Octavi Comeron on this same subject, and the co-organized workshop entitled 'Language, Power, Spaces', held at the CASA meeting in July 2004.
12 The title of the German original, published in *Noten zur Literatur*, is '*Engagement*'. The German word '*Engagement*' has a different connotation from the English 'commitment'. '*Engagement*' always refers to political or social issues, and it has the connotation of action. One cannot be *engagiert* to an ideology. Someone who is *engagiert* is always actively working for her cause.
13 Theodor Adorno, 'Commitment', in *Can One Live After Auschwitz?* ed. Rolf Tiedemann, trans. Rodney Livingstone *et al.* (Stanford: Stanford University Press, 2003), p. 257.
14 Adorno: 'Commitment', p. 254.
15 Adorno: 'Commitment', p. 258.
16 Adorno: 'Commitment', p. 258.

17 Adorno: 'Commitment', p. 258.

18 The EZLN first became internationally known for the Chiapas uprising in 1994.
 The uprising took place in protest against the North American Free Trade Agree-
 ment NAFTA and its foreseeable consequences. For information on the EZLN
 and the texts that they and the Subcomandante Marcos have published see
 <http://www.ezln.org> (some texts are available in English translation) and
 <http://flag.blackened.net/revolt/mexico/ezlnco.html> (collection of texts by
 the EZLN and the Subcomandante Insurgente Marcos in English translation).

19 Subcomandante Insurgente Marcos, 'Another Geography', in *Revista Rebeldía* 5
 (2003), web edition <http://www.revistarebeldia.org>, no page numbers (ac-
 cessed January 2004).

20 Marcos: 'Another Geography'.

21 Marcos: 'Another Geography'.

22 Marcos: 'Another Geography'.

23 Marcos: 'Another Geography'.

24 Judith Butler, *Excitable Speech: A Politics of the Performative* (London: Routledge,
 1997), p. 9.

25 Butler: *Excitable Speech*, p. 17.

26 Timothy Brennan, *At Home in the World: Cosmopolitanism Now* (Cambridge MA:
 Harvard University Press, 1997).

27 Timothy Brennan, 'Cosmo-Theory', in *South Atlantic Quarterly* 100/3 (2001), pp.
 677–8.

28 Brennan: 'Cosmo-Theory', p. 674.

29 Brennan: 'Cosmo-Theory', p. 677.

30 Brennan: 'Cosmo-Theory', p. 674. Brennan indicates, but does not explore the pe-
 culiar affinity of left-wing cultural theory with art over activism. I would suggest
 that this affinity is due to the situation during the Cold War and is reflected in
 Adorno's discussion of autonomy and its application to theory. For an analysis
 of the interaction between theory, politics and art see Octavi Comeron, *La fábrica
 transparente: Arte y trabajo en la época postfordista* (Barcelona: Universitat Autónoma
 de Barcelona, 2007).

31 Subcomandante Insurgente Marcos, 'The World: Seven Thoughts in May of
 2003', in *Revista Rebeldía* 7 (2003), web edition <http://www.revistarebeldia.org>,
 no page numbers (accessed January 2004).

SELECT BIBLIOGRAPHY

Agacinski, Sylviane, *Time Passing*, trans. Jody Gladding (New York: Columbia University Press, 2003).

Agamben, Giorgio, *Homo Sacer: Sovereign Power and Bare Life*, trans. Daniel Heller-Roazen (Stanford: Stanford University Press, 1995).

—— *Potentialities*, trans. Daniel Heller-Roazen (Stanford: Stanford University Press, 1999).

—— *Remnants of Auschwitz: The Witness and the Archive*, trans. Daniel Heller-Roazen (New York: Zone Books, 1999).

Alphen, Ernst van, *Caught by History: Holocaust Effects in Contemporary Art, Literature and Theory* (Stanford: Stanford University Press, 1997).

—— 'Playing the Holocaust', in *Mirroring Evil: Nazi Imagery/Recent Art* (New Jersey: Rutgers University Press, 2002), pp. 65–83.

—— 'Salomon's Work', *Journal of Narrative and Life History* 3/2–3 (1993), pp. 239–54.

—— 'Symptoms of Discursivity: Experience, Memory, and Trauma', in Mieke Bal, Jonathan Crewe and Leo Spitzer (eds), *Acts of Memory: Cultural Recall in the Present* (Hanover: University Press of New England, 1999), pp. 24–38.

Augé, Marc, *Non-Places: Introduction to an Anthropology of Supermodernity* (London: Verso, 1995).

Baer, Ulrich, *Spectral Evidence: the Photography of Trauma* (Cambridge: MIT Press, 2002).

Baigent, M., Leigh, R., and Lincoln, H., *Holy Blood, Holy Grail* (London: Arrow, 1996).

Bailey, Colin, *Patriotic Taste: Collecting Modern Art in Pre-revolutionary Paris* (New Haven, Yale University Press, 2002).

Bal, Mieke, *Louise Bourgeois' Spider: the Architecture of Art-writing* (Chicago: University of Chicago Press, 2001).

—— *The Practice of Cultural Analysis: Exposing Interdisciplinary Interpretation* (Stanford: Stanford University Press, 1999).

—— *Quoting Caravaggio: Contemporary Art, Preposterous History* (Chicago: University of Chicago Press, 1999).

—— *Reading Rembrandt: Beyond the Word-Image Opposition* (Cambridge: Cambridge University Press, 1991).

—— *Travelling Concepts in the Humanities: A Rough Guide* (Toronto: University of Toronto Press, 2002).

—— 'Visual essentialism and the object of visual culture', *Journal of Visual Culture* 2 (2003), pp. 5–32.

Bal, Mieke and Boer, Inge (eds), *The Point of Theory: Practices of Cultural Analysis* (Amsterdam: Amsterdam University Press, 1994).

Bal, Mieke, Crew, Jonathan, and Spitzer, Leo (eds), *Acts of Memory: Cultural Recall in the Present* (Hanover: University Press of New England, 1999).

Barasch, Moshe, *Giotto and the Language of Gesture* (Cambridge: Cambridge University Press, 1987).

Barthes, Roland, *Camera Lucida*, trans. Richard Howard (London: Vintage, 1993).

——*The Grain of the Voice: Interviews 1962–1980*, trans. Linda Coverdale (Berkeley: University of California Press, 1985).

Battersby, Christine, *Gender and Genius: Towards a Feminist Aesthetic* (London: Women's Press, 1989).

Baumgarten, Elisheva, 'Circumcision and Baptism: The Development of a Jewish Ritual in Christian Europe', in E. Wyner Mark (ed), *The Covenant of Circumcision: New Perspectives on an Ancient Jewish Rite* (Hanover: University Press of New England, 2003), pp. 114–27.

—— *Mothers and Children: Jewish ritual in Medieval Europe* (Princeton: Princeton University Press, 2004).

Baxandall, Michael, *Painting and Experience in Fifteenth-Century Italy*, 2nd edn (Oxford: Oxford University Press, 1988).

Benjamin, Walter, 'Berlin Chronicle', in *One-Way Street*, trans. Edmond Jephcott and Kingsley Shorter (London: Verso Books, 1979), pp. 293–348.

—— *Charles Baudelaire: A Lyric Poet in the Age of High Capitalism* [1955], trans. Harry Zohn (London: New Left, 1973).

—— 'A Small History of Photography', in *One-Way Street and Other Writings*, trans. Edmund Jephcott and Kingsley Shorter (London: Verso, 1997), pp. 240–57.

—— *Ursprung des Deutschen Trauerspiels* (Frankfurt am Main: Suhrkamp Verlag, 1996).

Berdini, Paolo, 'Women under the Gaze: A Renaissance Genealogy', *Art History* 21 (1998), pp. 565–90.

Bernstein, Michael André, *Foregone Conclusions: Against Apocalyptic History* (Berkeley: University of California Press, 1994).

Bernstein, Richard J., *Freud and the Legacy of Moses* (Cambridge: Cambridge University Press, 1998).

Bevir, Mark, 'A Humanist Critique of the Archaeology of the Human Sciences', *History of the Human Sciences* 15 (2002), pp. 119–38.

Blumenberg, Hans, *Die Legitimität der Neuzeit* (Frankfurt am Main: Suhrkamp Verlag, 1966).

Blunt, Anthony, 'Poussin's Notes on Painting', *Journal of the Warburg Institute* 1 (1937–8), pp. 344–51.

Boal, Augusto, *Theatre of the Oppressed* [1974], trans. C. A. McBride and M. O. Leal McBride (London: Pluto, 1989).

Bordes, Philippe, 'Avant-propos', in *Catalogue des peintures, sculptures et dessins* (Vizille: Conseil Général de l'Isére en co-édition avec la Réunion des Musées Nationaux, 1996).

—— *Catalogue des peintures, sculptures et dessins* (Vizille: Conseil Général de l'Isére en co-édition avec la Réunion des Musées Nationaux, 1996).

—— *Premières Collections* (Vizille: Conseil Général de l'Isère, 1985).

—— *Le Serment du Jeu de Paume de Jacques-Louis David* (Paris: Editions de la Réunion des Musées Nationaux, 1983).

Borello, Benedetta, *Trame sovrapposte: La socialità aristocratica e le reti di relazioni femminili a Roma (XVII–XVIII secolo)* (Naples: Edizioni Scientifiche Italiane, 2003).

Bouwsma, William J., *The Waning of the Renaissance 1550–1640* (New Haven: Yale University Press, 2000).

Boyarin, Daniel, *Carnal Israel: Reading Sex in Talmudic Culture* (Berkeley: University of California Press, 1993).

—— *Unheroic Conduct: the Rise of Heterosexuality and the Invention of the Jewish Man* (Berkeley: University of California Press, 1997).

Brown, Judith C., 'A Woman's Place was in the Home: Women's Work in Renaissance Tuscany', in Margaret W. Ferguson, Maureen Quilligan and Nancy J. Vickers (eds), *Rewriting the Renaissance: The Discourses of Sexual Difference in Early Modern Europe* (Chicago: University of Chicago Press, 1986), pp. 206–24.

Careri, Giovanni, 'Mutazioni d'affetti, Poussin interprete del Tasso', in O. Bonfait (ed), *Poussin et Rome: Actes du colloque de l'Académie de France à Rome* (Paris: RMN, 1996), pp. 353–66.

—— 'Le Retour du geste antique: amour et honneur à la fin de la Renaissance', in Giovanni Careri (ed), *La Jérusalem délivrée du Tasse: poésie, peinture, musique, ballet: actes du colloque* (Paris: Klincksieck, 1999), pp. 41–65.

Carroll, Lewis, *Through the Looking Glass* (Salt Lake City: Project Gutenberg, 1991), p. 80, <http://www.gutenberg.org/catalog/world/readfile? fk_files=34643& pageno=80> (accessed 26 April 2007).

Carroll, Michael P., *Veiled Threats: The Logic of Popular Catholicism in Italy* (Baltimore: John Hopkins University Press, 1996).

Caruth, Cathy, *Trauma: Explorations in Memory* (Baltimore: Johns Hopkins University Press, 1995).

—— *Unclaimed Experience: Trauma, Narrative and History* (Baltimore: Johns Hopkins University Press, 1996).

Cavallo, Jo Ann, 'Tasso's Armida and the Victory of Romance', in Valeria Finucci (ed), *Renaissance Transactions: Ariosto and Tasso* (Durham: Duke University Press, 1999), pp. 77–111.

Chagny, R., 'La Marianne de Vizille: Le Monument Commémoratif de l'Assemblée de Vizille', in *Entre Liberté, République et France: Les Représentations de Marianne de 1792 à nos jours* (Paris: Musée de la Révolution française et Réunion des Musées Nationaux, 2003), pp. 28–60.

Chagny, R., Chomel, V., and Vovelle, M., 'Avant-projet: Pour un musée national de la Révolution française au château de Vizille' (unpublished document, Vizille, Musée de la Révolution française, 1982).

Chase, Malcolm, and Shaw, Christopher (eds), *The Imagined Past: History and Nostalgia* (Manchester: Manchester University Press, 1989).

Clarke, T. J., *Image of the People: Gustave Courbet and the 1848 Revolution* (London: Thames and Hudson, 1973).

Clifton, James, 'Gender and Shame in Masaccio's *Expulsion*', *Art History* 22 (1999), pp. 637–55.

Colantuono, Antonio, *The Tender Infant: Invenzione and Figura in the Art of Poussin* (unpublished PhD dissertation, John Hopkins University, 1986).

Costello, Jane, 'Poussin's Drawings for Marino and the New Classicism: I— Ovid's *Metamorphoses*', *Journal of the Warburg and Courtauld Institutes* 18 (1955), pp. 296–317.

Crace, John, 'Painting by numbers', *Guardian*, 3 July 2001, p. 2. <http://education.guardian.co.uk/egweekly/story/0,,515683,00.html>.

Crimp, Douglas, *Melancholia and Moralism: Essays on AIDS and Queer Politics* (Cambridge, MA: MIT Press, 2002).

Cropper, Elizabeth and Dempsey, Charles, *Nicolas Poussin: Friendship and the Love of Painting* (Princeton: Princeton University Press).

Culler, Jonathan, 'Philosophy and Literature: The Fortunes of the Perfomative', *Poetics Today* 21/3 (2000), pp. 48–67.

—— 'Reading as a woman', in *On Deconstruction: Theory and Criticism After Structuralism* (London: Routledge & Kegan Paul, 1983), pp. 43–64.

Daston, Lorraine and Park, Katherine, *Wonder and The Order of Nature 1150–1750* (New York: Zone, 1998).

Davis, Fred, *Yearning for Yesterday* (New York: Macmillan, 1979).

Deleuze, Gilles, *Foucault* [1986], trans. and ed. Seán Hand (Minneapolis: University of Minnesota Press, 1988).

—— *Le Pli: Leibniz et le Baroque* (Paris: Les éditions de Minuit, 1988).

Deleuze, Gilles, and Guattari, Félix, *What Is Philosophy?* [1991], trans. Hugh Tomlinson and Graham Burchill (London: Verso, 1994).

Department for Education and Skills, *The Charter for Further Education: Further*

Choice and Quality (United Kingdom: Department for Education and Skills, 1993).

—— *The Charter for Higher Education: Higher Quality and Choice* (United Kingdom: Department for Education and Skills, 1993).

—— *Home-School Agreements: What Every Parent Should Know*, Reference PPY986 (United Kingdom: Department for Education and Skills, 1998).

—— *Making the Most of Parents' Evenings*, Reference HYCL/1 (United Kingdom: Department for Education and Skills, 2003).

—— *The Parent Centre: Help Your Child to Learn*, <http://www.parentcentre.gov.uk>.

Derrida, Jacques, *Demeure: Fiction and Testimony* [1998], trans. Elizabeth Rottenberg (Stanford: Stanford University Press, 2000).

—— 'Signature—Event—Context', in *Margins of Philosophy* [1972], ed. Alan Bass (Chicago: University of Chicago Press, 1982).

Dickinson, Janice, *No Lifeguard on Duty: The Accidental Life of the World's First Supermodel* (New York: Regan Books, 2002).

Didi-Hubermann, Georges, 'The Art of not Describing: Vermeer, the Detail and the Patch', *History of the Human Sciences* 2/2 (1989), pp. 141–69.

—— *Devant L'image: Question Posée aux Fins d'une Histoire de l'Art* (Paris: Les éditions de Minuit, 1990).

—— *Invention de l'hystérie: Charcot et l'iconographie photographique de la Salpêtrière* (Paris: Macula, 1982).

Documenta 11_Platform 5: Exhibition: Catalogue (Ostfildern-Ruit: Hatje Cantz, 2002).

Edexcel, *2D Visual Language, Question 8*, BTEC/GNVQ Intermediate Level Art and Design Examination Paper, Reference U1021061, (United Kingdom: Edexcel, 1997).

Egbert, Donald Drew, *Social Radicalism and the Arts: A Cultural History From the French Revolution to 1968* (New York: Alfred A. Knopf, 1970).

Einbinder, S., *Beautiful Death: Jewish Poetry and Martyrdom in Medieval France* (Princeton: Princeton University Press, 2002).

Fabricant, Carole, 'The Aesthetics and the Politics of Landscape in the Eighteenth Century', in Ralph Cohen (ed), *Studies in Eighteenth Century British Art and Aesthetics* (Berkeley: University of California Press, 1985), pp. 49–81.

Farmer, Paul, *Infections and Inequalities: The Modern Plagues* (Berkeley: University of California Press, 2001).

Felman, Shoshana, *The Juridical Unconscious: Trials and Traumas in the Twentieth Century* (Cambridge: Harvard University Press, 2002).

—— *What Does a Woman Want?: Reading and Sexual Difference* (Baltimore: Johns Hopkins University Press, 1993).

Felstiner, Mary Lowenthal, *To Paint her Life: Charlotte Salomon in the Nazi Era* (New York: HarperCollins, 1994).

Fertaille, P., 'L'Avenir du Domaine de Vizille', *Gazette des Alpes* 132 (1924).

Fetterley, Judith, *The Resisting Reader: A Feminist Approach to American Fiction* (Bloomington and London: Indiana University Press, 1978).

Foucault, Michel, *Archaeology of Knowledge* [1969], trans. A. M. Sheridan Smith (London: Routledge, 1972).

—— *The History of Sexuality Volume I: The Will to Knowledge* [1976], trans. Robert Hurley (Harmondsworth: Penguin, 1978).

—— *Les Mots et les Choses* (Paris: Gallimard, 1966).

—— *The Order of Things: An Archaeology of the Human Sciences* [1986], 3rd edn (London: Routledge, 2002).

—— *Power/Knowledge: Selected Interviews and Other Writings 1972–77*, ed. Colin Gordon (London: Harvester Wheatsheaf, 1980).

Freedberg, David, *The Eye of the Lynx: Galileo, his friends and the beginnings of modern natural history* (Chicago: University of Chicago Press, 2002).

—— *The Power of Images: Studies in the History and Theory of Response* (Chicago: Chicago University Press, 1989).

Freire, Paulo, *Pedagogy of the Oppressed* [1968], trans. M. B. Ramos (New York: Continuum, 1993).

Fried, Stephen, *Thing of Beauty: the Tragedy of Supermodel Gia* (New York: Simon & Schuster, 1993).

Frojmovic, Eva, 'Family and Memory: Reframing Gender in Medieval Jewish Images of Circumcision', in R. Voaden and D. Wolfthal (eds), *Framing the Family: Narrative and Representation in the Medieval and Early Modern Periods* (Temple: Arizona Center for Medieval Studies, 2005), pp. 221–43.

Furet, F., *Interpeting the French Revolution*, trans. E. Forster (Cambridge: Cambridge University Press, 1981).

Gadamer, Hans Georg, *Truth and Method* (Guildford: Sheed and Ward, 1975).

Gigli, Giacinto, *Diario Romano (1608–1670)*, ed. Giuseppe Ricciotti (Rome: Tumminelli, 1958).

Goffen, Rona, *Giovanni Bellini* (New Haven: Yale University Press, 1989).

Goldin, Simha, *Alamot ahevukha, al-mot ahevukha* [*The Ways of Jewish Martyrdom*] (Lod: Devir, 2002) [Hebrew].

—— 'The Role of Ceremonies in the Socialization Process: The Case of Jewish Communities of Northern France and Germany in the Middle Ages', *Archives des Sciences Sociales des Religions* 95 (1996), pp. 163–78.

Goncourt, E. de, and Goncourt, J. de, *Histoire de la Société Française pendant la Révolution* (Paris: Charpentier, 1854; edn. 1907).

Gossman, L., 'Towards a Rational Historiography', *Transactions of the American Philosophical Society* 79/3 (1989), pp. 1–68.

Greer, Germaine, *The Whole Woman* (London: Anchor, 2000).

Gregory-Guider, Christopher, *Autobiogeography and the art of peripatetic memorialization in works by W.G. Sebald, Patrick Modiano, Iain Sinclair, Jonathan Raban,*

and William Least Heat-Moon (Unpublished DPhil thesis, University of Sussex, 2006).

——— '"Deep Maps": William Least Heat-Moon's Psychogeographic Cartography', in *E-Sharp* 4 (2005), <http://www.sharp.arts.gla.ac.uk/issue4.php> (accessed 4 January 2007).

——— 'Sinclair's *Rodinsky's Room* and the Art of Autobiogeography', in *Literary London: Interdisciplinary Studies in the Representation of London* 3/2 (2005), <http://www.literarylondon.org/london-journal/september2005/guider.html> (accessed 4 January 2007).

——— 'The "Sixth Emigrant": Travelling Places in the Works of W. G. Sebald', *Contemporary Literature* 46/3 (2005), pp. 422–49.

Griffin, Gabriele, *Representations of HIV and AIDS: Visibility Blue/s* (Manchester: Manchester University Press, 2000).

Gutterman, Bella, and Morgenstern, Naomi (eds), *The Gurs Haggadah: Passover in Perdition*, (Jerusalem: Devora Publications and Yad Vashem, 2003).

Habert, Jean, *Bordeaux, Musée des beaux-arts* (Paris: Réunion des Musées Nationaux, 1991).

Hamarneh, Walid, 'The Construction of Fictional Worlds and the Problem of Authenticity: Jabra Ibrahim Jabra, and Fathi Ghanim', *Style* 25/2 (1991), pp. 223–36.

Haskins, Susan, *Mary Magdalen: Myth and Metaphor* (London: HarperCollins, 1993).

Hawking, Stephen, *A Brief History of Time: From the Big Bang to Black Holes* (London: Bantam, 1988).

Heath, Stephen, 'Narrative Space,' in *Questions of Cinema* (Basingstoke: MacMillan, 1981).

Heidegger, Martin, 'Letter on Humanism', in *Basic Writings*, ed. David Farrell Krell (New York: Harper and Row, 1977), pp.189–242.

Hodge, Margaret, 'Elitism never made a nation rich: educating more people to degree level is an economic necessity', *Guardian*, 6 November 2001, p. 13. <http://education.guardian.co.uk/egweekly/story/0,,588001,00.html>.

Hoffman, Lawrence A., *Covenant of Blood: Circumcision and Gender in Rabbinic Judaism* (Chicago: University of Chicago Press, 1996).

Holly, Michael Ann, *Past Looking: Historical Imagination and the Rhetoric of the Image* (Ithaca: Cornell University Press, 1996).

Holm, N. G., 'Ecstasy Research in the 20th century—an Introduction', in *Religious Ecstasy: Based on papers read at the Symposium on Religious Ecstasy held at Åbo, Finland, on the 26th–28th August 1981* (Stockholm: Almqvist & Wiksell, 1982), pp. 7–26.

Hooper-Greenhill, E., *Museums and the Interpretation of Visual Culture* (London: Routledge, 2000).

Jabra, Jabra Ibrahim, *Al Safina* (Beriut: Dar Al Adab, 1970).

—— *The Ship*, trans. Adnan Hayder and Roger Allen (Washington: Three continents, 1985).

Jacobs, Fredrika H., 'Aretino and Michelangelo, Dolce and Titian: *Femmina, Maschio, Grazia*', *Art Bulletin* 82 (2000), pp. 51–67.

Jameson, Frederic, 'Postmodernism, or the Cultural Logic of Late Capitalism', *New Left Review* 146 (1984), 53–92.

Kaplan, Marion A., *Between Dignity and Despair: Jewish Life in Nazi Germany* (Oxford: Oxford University Press, 1998).

Kaplan, S., *Farwell Revolution* (Ithaca and London: Cornell University Press, 1995).

Kelly, Joan, *Women, History & Theory: the Essays of Joan Kelly* (Chicago: University of Chicago Press, 1984).

Klemperer, Victor, *I Shall Bear Witness: The Diaries of Victor Klemperer 1933–1941*, ed. Martin Chalmers (London: Phoenix, 1999).

Kogman-Appel, Katrin, '"The Firm Believer Discerned Thy Truth": Abraham as a role model for the persecuted believer', paper presented at conference *Illuminating Narrative: Visual Storytelling in Medieval Manuscripts*, 9–10 July 2005, Courtauld Institute, London.

Kopytoff, Igor, 'The Cultural Biography of Things: Commoditization as Process', in Arjun Appadurai (ed), *The Social Life of Things: Commodities in Cultural Perspective* (Cambridge: Cambridge University Press, 1986), pp. 64–91.

Kristeva, Julia, 'Women's Time', in Toril Moi (ed), *The Kristeva Reader* (Oxford: Blackwell, 1986), pp. 187–213.

Krueger, Roberta, *Women Readers and the Ideology of Gender in Old French Courtly Verse Romance* (Cambridge: Cambridge University Press, 1993).

Lacan, Jacques, 'God and the *Jouissance* of The Woman', in Juliet Mitchell and Jacqueline Rose (eds), *Feminine Sexuality: Jacques Lacan and the École Freudienne* (London: Macmillan, 1982).

LaCapra, Dominick, *History in Transit: experience, identity, critical theory* (Ithaca: Cornell University Press, 2004).

—— 'Rethinking Intellectual History and Reading Texts', *History and Theory* 19 (1980), pp. 245–76.

Laclau, Ernesto, and Mouffe, Chantal, *Hegemony and Socialist Strategy* (London: Verso, 2001).

Lee, Rensselear W., 'Ut Pictura Poesis: The Humanistic Theory of Painting', *Art Bulletin* 22 (1940), pp. 197–269.

Levi, Primo, *The Drowned and the Saved* [1986], trans. Raymond Rosenthal (London: Abacus, 1989).

—— *If this is a Man* [1958], trans. S. Woolf (London: Abacus, 1991).

Lévi-Strauss, Claude, *La Pensée Sauvage* (Paris: Plon, 1962).

Lord, Catherine, *The Intimacy of Influence: Narrative and Theoretical Fictions in the*

Works of George Eliot, Virginia Woolf and Jeanette Winterson (Amsterdam: ASCA Press, 1999).

Lowenthal, David, *The Past is a Foreign Country* (Cambridge: Cambridge University Press, 1985).

Maek-Gerard, Michael (ed), *Adam Elsheimer 1578–1610* (Edinburgh: National Galleries of Scotland, 2006).

Mahon, Denis, *Studies in Seicento Art and Theory* (London: Warburg, 1947).

Major-Poetzl, Pamela, *Michel Foucault's Archaeology of Western Culture: Toward a New Science of History* (Chapel Hill: University of North Carolina Press, 1983).

Mâle, Emile, *L'art religieux après le Concile de Trente: Etude sur l'iconographie de la fin du XVIe siècle, du XVIIe, du XVIIIe siècle, Italie, France, Espagne, Flandres* (Paris: Armand Colin, 1932).

Mancini, Giulio, *Considerazioni sulla Pittura*, ed. Adriana Marucchi (Rome: Accademia Nazionale dei Lincei, 1956), vol. 1.

Marin, Louis, *Sublime Poussin*, trans. Catherine Porter (Stanford: Stanford University Press, 1999).

Marinella, Lucrezia, *The Nobility and Excellence of Women, and the Defects and Vices of Men [1601]*, trans. and ed. Anne Dunhill (Chicago: University of Chicago Press, 1999).

Marrinan, M., *Painting Politics for Louis-Philippe: Art and Ideology in Orléanist France 1830–1848* (New Haven: Yale University Press, 1988).

Martines, Lauro, 'A Way of Looking at Women in Renaissance Florence', *The Journal of Medieval and Renaissance Studies* 4 (1974), pp. 15–28.

Michel, Régis, *Posséder et détruire: Strategies sexuelles dans l'art d'Occident* (Paris: RMN, 2000).

Milne, A. A., *Winnie-The-Pooh* [1926] (London: Methuen, 1948).

Mirollo, James V., *The Poet of the Marvelous: Giambattista Marino* (New York: Columbia University Press, 1963).

Montagu, Jennifer, *The Expression of the Passions: The Origin and Influence of Charles Le Brun's 'Conférence sur l'expression générale et particulière'* (New Haven: Yale University Press, 1994).

Moschetti, Andrea, 'Dell'Influsso del Marino sulla Formazione Artistica di Nicola Poussin', in *Atti del Congresso internazionale storia dell'arte* (Rome: Magliore and Strini, 1922), pp. 356–84.

Muller, John P., and Richardson, William J. (eds), *The Purloined Poe: Lacan, Derrida, and Psychoanalytic Reading* (Baltimore: John Hopkins University Press, 1988).

Mulvey, Laura, 'Afterthoughts on Visual Pleasure and Narrative Cinema', in *Visual and Other Pleasures* (Basingstoke: Palgrave Macmillan, 1989).

Narkiss, B., *Hebrew Illuminated Manuscripts* [1969] (Jerusalem: Keter, 1992).

Nora, P., 'Entre Mémoire et Histoire: La problématique des lieux', in P. Nora (ed), *Les lieux de mémoire* (Paris: Gallimard, 1984), pp. xvii–xlii.

Orgel, Stephen, 'Gendering the Crown', in Margreta de Grazia, Maureen Quilligan and Peter Stallybrass (eds), *Subject and Object in Renaissance Culture* (Cambridge: Cambridge University Press, 1996), pp. 133–65.

Ott, N. H., 'Literatur in Bildern. Eine Vorbemerkung und sieben Stichworte', in E. C. Lutz, J. Thali, and R. Wetzel (eds), *Literatur und Wandmalerei I: Erscheinungsformen höfischer Kultur und ihre Träger im Mittelalter*, Freiburger Colloquium 1998, (Tübingen: Niemeyer, 2002), pp. 153–97.

Paleotti, Gabriele, 'Discorso intorno alle imagini sacre e profane', in *Trattati d'Arte del Cinquecento*, ed. Paola Barocchi (Bari: Laterza, 1961), vol. 2, pp. 117–509.

Pardo, Mary, 'The Subject of Savoldo's Magdalene', *Art Bulletin* 71/1 (1989), pp. 67–91.

Pels, Dirk, Hetherington, Kevin and Vandenberghe, Fédéric, 'The Status of the Object: Performances, Mediations and Techniques', *Theory, Culture & Society* 19 (2002), pp. 1–21.

Phillips, Kim M., 'Bodily Walls, Windows and Doors: The Politics of Gesture in Late Fifteenth-Century English Books for Women', in Jocelyn Wogan-Browne *et al.* (eds), *Medieval Women: Texts and Contexts in Late Medieval Britain* (Turnhout: Brepols, 2000), pp. 185–98.

Plock, Phillippa, 'Nicolas Poussin's representations of femininity in 1620s' Rome', *Papers of the British School at Rome*, 74 (2006), pp. 250–1.

Plotnitsky, Arcady, *The Knowable and the Unknowable: Modern Science, Nonclassical Thought, and the "Two Cultures"* (Michigan: University of Michigan Press, 2002).

Pollock, Griselda, 'Modernity and the Spaces of Femininity', in *Vision and Difference: Feminism, Femininity and the Histories of Art* (London: Routledge, 1988).

——— 'Theater of Memory: Trauma and Cure in Charlotte Salomon's Modernist Fairytale', in Michael P. Steinberg and Monica Bohn-Duchen (eds), *Reading Charlotte Salomon*, (Ithaca: Cornell University Press, 2006), pp. 34–72.

——— 'What does a Woman Want? Art Investigating Death in Charlotte Salomon's *Leben? Oder Theater?* 1941–2', *Art History* 30/3, pp. 383–405.

Randolph, Adrian, 'Renaissance Household Goddesses: Fertility, Politics and the Gendering of Spectatorship', in Anne McClanan and Karen Rosoff Encarnación (eds), *The Material Culture of Sex, Procreation and Marriage in Premodern Europe* (New York: Palgrave, 2001) pp. 163–90.

Rimoldi, Eleanor, 'Generic Genius—How Does It All Add Up?' in Marilyn Strathern (ed), *Audit Cultures: Anthropological Studies in Accountability, Ethics and the Academy* (London: Routledge, 2000).

Robertson, Carmen L., *Gender Relations and the Noli me Tangere Scene in Renaissance Italy* (Unpublished MA thesis, University of Victoria, 1993).

Robinson, James M. (ed), *The Nag Hammadi Library in English* (San Francisco: HarperCollins, 1990).

Roseman, Mark, *The Villa, The Lake, The Meeting: Wannsee and the Final Solution* (London: Penguin, 2002).

Rosen, Tova, *Unveiling Eve: Reading Gender in Medieval Hebrew Literature* (Philadelphia: University of Pennsylvania Press, 2003).

Rosenberg, Pnina, 'Mickey Mouse in Gurs: humour, irony and criticism in works of art produced in Gurs internment camp', *Rethinking History* 6/3 (2002), pp. 273–92.

Roth, Nancy L., and Hogan, Katie (eds), *Gendered Epidemic: Representations of Women in the Age of AIDS* (London: Routledge, 1998).

Rousset, David, *The Other Kingdom*, trans. Ramon Guthrie (New York: Reynal and Hitchcock, 1947).

Salman, Phillip, 'Instruction and Delight in Medieval and Renaissance Art Criticism', *Renaissance Quarterly* 32 (1979), pp. 303–32.

Salomon, Charlotte, *Charlotte: Life or Theatre?: an autobiographical play*, trans. Leila Vennewitz (New York: Viking, 1981).

Sayigh, R., *Palestinians: From Peasants to Revolutionaries* (London: Zed, 1979).

Scarry, Elaine, *The Body in Pain: the Making and Unmaking of the World* (Oxford: Oxford University Press, 1985).

Scavullo, Francesco, and Byrnes, Sean, *Scavullo Women* (New York: Harper & Row, 1982).

Scheurmann, Conrad, and Scheurmann, Ingrid, *Dani Karavan, Hommage an Walter Benjamin: der Gedenkort "Passagen" in Portbou* [*Dani Karavan, homage to Walter Benjamin: "Passages", place of remembrance at Portbou*] (Mainz: P. von Zabern, 1995).

Schiesari, Juliana, *The Gendering of Melancholia: Feminism, Psychoanalysis, and the Symbolics of Loss in Renaissance Literature* (Ithaca: Cornell University Press, 1992).

Shain, Farzana, 'Changing Notions of Teacher Professionalism in the Further Education Sector', paper presented at the British Educational Research Association Annual Conference, Queen's University of Belfast, Northern Ireland, 27–30 August 1998. <http://www.leeds.ac.uk/educol/documents/000000939.htm> (accessed 14 June 2005).

Shepherd, Rupert, 'II. The life of the object', *Renaissance Studies* 19 (2005), pp. 619–20.

Sholem, Gershom, *Walter Benjamin: The Story of a Friendship*, trans. Harry Zohn (New York: Schocken, 1981).

Shore, Cris and Wright, Susan, 'Coercive Accountability: The Rise of the Audit Culture in Higher Education', in Marilyn Strathern (ed), *Audit Cultures: Anthropological Studies in Accountability, Ethics and the Academy* (London: Routledge, 2000).

Sommer, Frank, 'The Iconography of Action: Bernini's Ludovica Albertone', *Art Quarterly* 33 (1970), pp. 30–8.

Sontag, Susan, *On Photography* (London: Penguin, 1979).

Spiegel, Shalom, *The Last Trial: On the Legends and Lore of the Command to Abraham to Offer Isaac as a Sacrifice* (Philadelphia: Jewish Publication Society, 1967).

Spivak, Gayatri Chakravorty, *A Critique of Postcolonial Reason: Toward a History of the Vanishing Present*, (Cambridge: Harvard University Press, 1999).

—— 'Finding Feminist Readings: Dante-Yeats' in Ira Konigsberg (ed), *American Criticism in the Poststructuralist Age* (Ann Arbor: University of Michigan, 1981), pp. 42–65.

—— 'The Rani of Sirmur: An Essay in Reading the Archives,' *History and Theory: Studies in the Philosophy of History*, 24/3 (1985), pp. 247–72.

'The Start of Something Pretty: All the News for Resort/Warm Weather', *Vogue Allure*, November 1980.

Strathern, Marilyn, (ed), *Audit Cultures: Anthropological Studies in Accountability, Ethics and the Academy* (London: Routledge, 2000).

Tagg, John, *The Burden of Representation: Essays on Photographies and Histories* (Minneapolis: University of Minnesota Press, 1993).

Tasso, Torquato, *Discorso della virtù femminile e donnesca*, ed. Maria Luisa Doglio (Palermo: Sellerio Editore, 1997).

—— *Gerusalemme Liberata [1581]*, ed. F. Chiapelli (Milan: Rusconi, 1982).

Taupin, J-L., 'Le musée de la Révolution française de Vizille', *Monuments Historiques* 161 (1989), pp. 100–4.

Tennant Jackson, Jenny, *Evidence as a Problem. Foucaultian Approaches to Three Canonical Works of Art: Courbet's* L'Atelier, *1855; Velázquez'* Las Meninas, *1656; Botticelli's* Venus and Mars, *circa 1483* (Unpublished PhD Thesis, University of Leeds, 2001).

Thesander, Marianne, *The Feminine Ideal* (London: Reaktion, 1997).

Tomasulo, Frank P., 'I'll see it when I believe it': Rodney King and the Prison-House of Video' in Vivian Sobchack (ed), *The Persistence of History: Cinema, Television and the Modern Event* (London: Routledge, 1996), pp. 69–88.

Verdi, R., *Nicolas Poussin: Tancred and Erminia* (Birmingham: Birmingham Museums and Art Gallery, 1992).

Viola, Gianni Eugenio, *Il verso di Narciso. Tre tesi sulla poetica di GB Marino* (Rome: Cadmo, 1978).

Vovelle, M, 'Discours', in *Une Dynastie bourgeoise dans la Révolution: les Perier* (Vizille: Conseil Général de l'Isère, 1984).

—— *Idéologie et Mentalités* (Paris: F. Maspero, 1982).

—— *La mentalité révolutionnaire: société et mentalité sous la Révolution française* (Paris: Editions sociales, 1985).

Vuarnet, Jean-Noël, *Extases féminines* (Paris: Hatier, 1991).

Walkerdine, Valerie, *Daddy's Girl: Young Girls and Popular Culture* (London: Macmillan, 1997).

Walsh, Val A., 'Eyewitnesses, Not Spectators—Activists, Not Academics: Feminist Pedagogy and Women's Creativity', in Katy Deepwell (ed), *New Feminist Art Criticism* (Manchester: Manchester University Press, 1995), pp. 51–60.

Warner, Marina, *Alone of All her Sex: The Myth and the Cult of the Virgin Mary* (London: Weidenfeld and Nicolson, 1976).

Warnke, Georgia, 'Hermeneutics, Ethics, Politics', in Robert J. Dostal (ed), *The Cambridge Companion to Gadamer* (Cambridge: Cambridge University Press, 2002), pp. 79–101.

Weiner, Gaby, *Feminisms in Education: An Introduction* (Buckingham: Open University Press, 1998).

Wilks, Sue, *Feda: Between Pedagogy & Politicised Art Practice*, <http://www.feda.co.uk/index.shtml>.

Wollheim, Richard, *Painting as an Art* (London: Thames and Hudson, 1987).

Yates, Frances A., *The Art of Memory* (London: Pimlico, 1992).

CONTRIBUTORS

Mieke Bal is Dutch Royal Academy of Sciences Research Professor of Theory of Literature at the University of Amsterdam, and founding director of the Amsterdam School for Cultural Analysis, Theory and Interpretation (ASCA) at the University of Amsterdam. Her most recent publications include *Travelling Concepts in the Humanities* (2002) and *Quoting Caravaggio: Contemporary Art, Preposterous History* (1999). Among her many other books are *Narratology: An Introduction to the Theory of Narrative* (2nd edition, 1997), *The Mottled Screen: Reading Proust Visually* (1997), *Double Exposures: The Subject of Cultural Analysis* (1996), and *Reading 'Rembrandt': Beyond the Word–Image Opposition* (1991 [1994]). She has also edited a programmatic volume, *The Practice of Cultural Analysis: Exposing Interdisciplinary Interpretation* (1999), which gives a good idea of the nature and practice of cultural analysis. The breadth of Mieke Bal's research contributions is also acknowledged by *Looking In: the Art of Viewing* (2001), essay and afterword by Mieke Bal, with a commentary by Norman Bryson. Her areas of interest include literary theory, semiotics, visual art, cultural studies, postcolonial theory, feminist theory, French, the Hebrew Bible, the seventeenth century, and contemporary culture.

Nicholas Chare is Associate Lecturer in History of Art at the University of Reading and Visiting Lecturer in Art History at City University, London. He has also previously taught on the MA in Psychoanalytic Studies at Leeds Metropolitan University. He is a former editor of the journal *parallax*. His work has appeared in a number of journals including *Angelaki*, *Cultural Critique*, *parallax*, *Sign Language Studies* and *The Year's Work in Critical and Cultural Theory*.

Eva Frojmovic is the Director of the Centre for Jewish Studies, and a lecturer in Art History at the University of Leeds. She is one of the

deputy directors of the Centre for Cultural Analysis, Theory and History, University of Leeds, and is the Jewish Studies strand co-ordinator on the Programming Committee of the International Medieval Congress. Trained as a medievalist, she is the author of *Hebraica and Judaica from the Cecil Roth Collection* (1997), and the editor of *Imagining the Self, Imagining the Other: Visual Representation and Jewish-Christian Dynamics in the Middle Ages and Early Modern Period* (2002). She is currently writing a book on *Cultural Negotiation in the Hebrew Illuminated Manuscripts in Medieval Germany*.

Cornelia Gräbner holds an MA in Comparative Literature from the University of Bonn, Germany. She wrote her dissertation entitled 'Off the Page and Off the Stage: The Performance of Poetry and its Public Function' at the Amsterdam School for Cultural Analysis (ASCA) and is about to start a post as lecturer in Hispanic Studies at Lancaster University.

Her main research interests lie in performances of poetry, in the relationship between poetic and political language, in the relationship between theory and political action, in urban culture, and in Latin American cultural theory. She has published several articles on the performance of poetry and its political implications.

Valerie Mainz has worked as a theatre administrator in both the commercial and subsidized sectors. She obtained degrees in the History of Art from Birkbeck College, University of London and from University College, University of London. Her PhD thesis is entitled 'History, History Painting and Concepts of *Gloire* in the Life and Work of Jacques-Louis David', University College London, 1992.

Her research focuses on relationships between media and between the verbal and the visual, in history. She has published work on the image of the Jew in the early modern period and in 1999 she curated the exhibition 'L'Image du Travail et la Révolution française' at the Museum of the French Revolution, Vizille, France. Her current research interests include the representation of the military in late eighteenth-century France and the interfaces between history and history painting.

In 2006, she organized with Dr Simon Burrows (School of History, University of Leeds) a conference on the eighteenth-century French cross-dressing diplomat and spy, the Chevalier D'Eon and she co-curated with Dr Richard Williams (Department of Classics and Ancient History, University of Durham) an exhibition entitled *Paper, Stone, Flesh and Blood: Transforming Views of Sculpture in French Revolutionary Prints* at the Henry Moore Institute, Leeds.

Phillippa Plock completed her PhD in July 2004, entitled 'Regarding Gendered Mythologies: Nicolas Poussin's Mythological Painting and Practices of Viewing in Seventeenth-Century Rome', at the University of Leeds. As Rome Fellow, British School at Rome 2004–5, she continued her investigation into the relationship between Poussin's depictions of women regarding men and his Roman patrons' familial interests by conducting archival research on the women of these families and connections between paintings and the lives of the people lived out beneath them. She has since worked as a Research Assistant cataloguing paintings in West Yorkshire and Merseyside for the National Inventory Research Project; she has also taught at the School of Fine Art, History of Art and Cultural Studies at the University of Leeds. She is currently employed as a Senior Research Fellow at the University of Warwick. This position entails cataloguing four volumes of French, Italian and German trade cards from the seventeenth and eighteenth century, kept at Waddesdon Manor, as part of a Leverhulme funded project entitled 'Selling Consumption in the Eighteenth Century'.

Griselda Pollock is Professor of Social and Critical Histories of Art and Director of the Centre for Cultural Analysis, Theory and History at the University of Leeds. Author of over twenty books and many articles on feminist cultural theory and aesthetics, as well as nineteenth- and twentieth-century art, she is currently working on a trilogy on trauma and representation in the wake of the Holocaust and has recently published on Eva Hesse, Agnes Martin, Amedeo Modigliani and Christine Taylor Patten. Recent edited publications include *Encountering Eva Hesse* (2006), *Psychoanalysis and the Image* (2006), and, with Joyce Zemans, *Museums after Modernism* (2007). New monographs include *Encounters in a Virtual Feminist Museum: Time, Space and the Archive* (2007), and a book on Charlotte Salomon's *Leben? Oder Theater?* is also forthcoming from Yale University Press (2008).

Ihab Saloul studied English Literature at Birzeit University in Palestine, and English Literature and Cultural Analysis at the University of Amsterdam. He is currently a research fellow at the Amsterdam School for Cultural Analysis (ASCA), University of Amsterdam. His research concerns contemporary Palestinian cultural identity, with special reference to the concept of catastrophe (*al-nakba*, 1948).

Itay Sapir is currently writing his doctoral dissertation on *Early Baroque Tenebrist Painting: an Epistemological Interpretation* at the Amsterdam School of Cultural Analysis (ASCA), under the supervision of Mieke Bal, and in the École des Hautes Études en Sciences Sociales (EHESS), Paris, where he works with Danièle Cohn.

Previously, he studied early modern history at Tel Aviv University, where he finished his MA in 2000. He then started working with the late Daniel Arasse (EHESS, Paris) on his PhD thesis in art history.

Victoria Turvey Sauron is a doctoral candidate at the University of Leeds. She completed Part I of a degree in Anglo-Saxon, Norse and Celtic at the University of Cambridge, including a dissertation on the concept of the soul in early medieval Scandinavian literature. Part II in History of Art led to a focus on the High Renaissance and Baroque, and an interest in religious iconography in particular. She completed a 'Diplôme d'Etudes Approfondies' in History of Art at the University of Toulouse in France before arriving in Leeds.

Victoria has presented papers at seven international conferences with several publications forthcoming, and was a co-convenor (with Griselda Pollock) of the international symposium 'The Sacred and the Feminine: Image, Music, Text and Space' at the University of Leeds in January 2005.

Her research focuses on representations of the religious ecstasy of female saints in Baroque art, and in particular the way in which the re-clining or convulsing body of the ecstatic saint operates as a multivalent, undecidable signifier of disparate states such as pleasure and pain, presence and absence.

Jennifer Tennant Jackson is Senior Lecturer in Historical and Critical Studies at The Leeds School of Contemporary Art and Graphic Design, Leeds Metropolitan University and Visiting Fellow at the Centre for Cultural Analysis, Theory and History, University of Leeds. After a career in scientific research as a biomedical scientist in oncology, she studied art histories and theories, and wrote her doctoral thesis through a Foucaultian analysis of the historiography of canonical works of art. Her current research is in the field of art and complexity science.

Sue Wilks was born in Iraq although she has lived in the UK since 1968. She studied at Leeds College of Art and Design during the 1980s and following this she was employed for nine years as a lecturer in art and design at Leeds College of Technology. Sue graduated from the MA Feminist Theory, History and Criticism in the Visual Arts pro-gramme at the University of Leeds in 1998, and completed her PhD in Fine Art Practice, also at the University of Leeds, in July 2006.

An online dossier of Sue's PhD research project titled *Feda: Between pedagogy and politicised art practice* can be accessed at <http://www.feda.co.uk/>.

INDEX OF AUTHORS AND ARTISTS

Names of people (real or fictional) featured as subjects in artistic works are listed in the index of subjects and concepts, which also includes names of patrons. Page numbers in italics refer to illustrations.

Adorno, Theodor 173, 177–8, 179
Agamben, Giorgio 64
Alphen, Ernst van 58, 65
Austin, J.L. 168, 169

Bakhtin, Mikhail 5
Bal, Mieke 11–12, 44–5, 54, 164
 on critical intimacy 139–41, 142, 151–2
 on memory 99, 125
 on performance/performativity 154, 161, 167–8, 169
Barthes, Roland 92, 96
Baumgarten, Elisheva 13, 14
Benjamin, Walter 63, *64*, 85–7
 on life-maps 65–7
 on photography 94
Bernini, Gian Lorenzo 40, 41–2, 46
Bhaba, Homi K. 173–4, 175–7, 178–9, 180, 183, 184–5
Boal, Augusto 140
Bohr, Niels 155
Bollas, Christopher 152
Botticelli 159–60
Brennan, Timothy 173, 183–4, 186
Butler, Judith 100, 168, 173, 181–2

Cacherano, Biancamaria 31–2

Caravaggio, Cecco del 46–7
 Conversion of the Magdalene 44, *45*
 Magdalene 44, 45–6
 Magdalene in ecstasy *38*, 40, 43
Carracci, Agostino 33
Carroll, Lewis 48
Caruth, Cathy 52
Cesi, Federico, prince 35
Chagny, Robert 107, 108–9
Couder, Auguste 105–7, *106*
Courbet, Gustave 159
Culler, Jonathan 1, 2

Da Vinci, Leonardo 29
Danahar, Geoff 165–6
David, Jacques-Louis 107, 112
de Goncourt, Edmond and Jules 112
de Voragine, Jacobus 43–4
Debelle, Alexandre 105–7, *106*
Deleuze, Gilles 4, 158
Derrida, Jacques 168, 169
Deseine, Claude-André *114*, 115
Didi-Huberman, Georges 56–7

Einbinder, Susan 13
Elsheimer, Adam
 The baptism of Christ *50*, 51, 60–2
 St Paul on Malta *50*, 51, 57–60

Finson, Ludovicus *38*, 40
Foucault, Michel 153, 167–8
 on classification 25
 on dispositif 163–7, 170–1
 on performance/performativity
 158–63, 168, 169
Freire, Paulo 140

Godechot, Jacques 119
Goldin, Nan 99–100
Goldin, Simha 13, 18
Goncourt, Edmond and Jules de 112
Gossman, Lionel 103
Goya 112
Gramsci, Antonio 173, 174–5
Greeley, Andrew 41–2
Guattari, Félix 4

ha-Gozer, Jacob 19
Habert, Jean 43
Hall, Stuart 176
Harry, Debbie 91
Hodge, Margaret 144–5
Hoffmann, Lawrence 13
Honour, Hugh 112
Hooper-Greenhill, Eleanor 111
Huxley, Aldous 40

Jabra, Jabra Ibrahim 121–37
Jacob ben Meir 15
Jacob ha-Gozer 19
Jacobus, de Voragine 43–4

Kaplan, Steven 110–11
Karavan, Dani 86
Kristeva, Julia 67
Krueger, Roberta 13

Lacan, Jacques 46
LaCapra, Dominique 26
 and trauma 52–3
Landais, Hubert 112
Lanfranco, Giovanni 43
Leonardo, da Vinci 29
Lord, Catherine 139, 140

Major-Poetzl, Pamela 158

Maplethorpe, Robert 100
Marcos, Subcomandante Insurgente 173,
 179–81, 182–3
Marinella, Lucrezia 27–8
Marino, Giambattista 32–4
 influence on Poussin 29–30
Mascré, Emile 117
Meir, Jacob ben 15
Mermaz, Louis 110, 111
Michelet, Jules 111
Müller, Charles-Louis *116*, 116–17
Mulvey, Laura 42

Nora, Pierre 104

Ott, Norbert 17

Pardo, Mary 36–8, 45
Patten, John 143
Plotnitsky, Arkady 153, 155, 156, 157–8,
 164
Polke, Sigmar 118
Pollock, Griselda 3
Poussin, Nicolas *24*
 composition techniques 25
 influence of Marino 29–30
 simultaneity 26–7, 29, 30, 34, 35
 use of gestures 27–9

Ricco, John Paul 102
Robertson, Carmen 39
Rosen, Tova 13

Salomon, Charlotte *64*, 73–5, 83–5,
 87–8
 Kristallnacht 83
 Leben? Oder Theater? 63–4, 65, 67–
 72, *69*, 75–83, *76*, *77–8*, *83*,
 84–5
Savoldo, Giovanni 36–8, *37*, 45, 47
Scarry, Elaine 55
Scavullo, Francesco *90*, 91–2, 93–5, *94*,
 97, *98*, *99*
Schirato, Tony 165–6
Sholem, Gershom 85
Shore, Cris 148
Soboul, Albert 119

Spivak, Gayatri Chakravorty 139–40, 142
Stigliani, Tommaso 32
Suratteau, Jean-René 119

Tasso, Torquato 27, 28, 29
Taupin, Jean-Louis 115
Tesauro, Emmanuele 30
Tessier 117
Tomasulo, Frank 57

Velázquez 159, 160

Verhoeff, Nanna 121
Voragine, Jacobus de 43–4
Vovelle, Michel 105, 108–9, 111

Walkerdine, Valerie 142
Walsh, Val A. 141
Webb, Jen 165–6
Weiner, Gaby 142
Wright, Susan 148

Yates, Francis 56

INDEX OF SUBJECTS AND CONCEPTS

Names of people (real, fictional or mythological) featured as subjects in artistic works are included here. Page numbers in italics refer to illustrations.

academic communities, use of language 5–7, 174–5
Accademia dei Lincei 34–5
acquired immuno-deficiency syndrome (AIDS) 95, 99–101
actions. *see* efficacity; énoncés
Acts of memory: cultural recall in the present 125
Adone 32
agency 26, 184
agreement 3
AIDS 95, 99–101
airbrushing 97–9, 102
Akedah 15, 16–18, 19–20, 20–2
al-nakba (catastrophe) 120–2, 128–31, 132–5, 137
allo-thanatography 65, 72. *see also* life-maps
ambiguity. *see also* flexibility, of concepts of concepts 5–9, 57
and gender 35
American Vogue. see Start of something pretty, The
Another geography 179–81, 182–3
Appel des dernières victimes de la Terreur 116, 116–17
Archaeology of knowledge, The 158, 164–5
architecture 115–18
Armida *24,* 25–7, 28, 30–1, 34, 35

art
 GNVQ curriculum 145–7
 and politics 119, 147–51, 177–9
art history 56–7, 103–4, 162–3
Assaf, Wadi 121, 125–37
Assemblée des trois ordres du Dauphiné réunie dans la salle du jeu de paume du château de Vizille, le 21 juillet 1788 105–7, *106*
Atelier du peintre 159
audit culture 138–9, 141–2, 143–5, 146–8, 149
autonomy 177–8. *see also* commitment
Autres cruautés à Paris le 2 Sept. 1792 118

Baptism of Christ, The 50, 51, 60–2
Baroque period 55–7
Beata Ludovica Albertoni 40
Berlin 66
Binding of Isaac 15, 16–18, 19–20, 20–2
Blondie 91, 101–2
blot ('pan') 56–7, 59–60, 61
body 43–4, 126–7
Britain, educational policies 138–9, 142–5, 147–51

Cacherano, Biancamaria 31–2
Camera lucida 92
Capet, lève-toi! 117

Carangi, Gia *90*, 91–2, 93–5, *94*, 97–9, *98*, *99*, 102
Caravaggesque 41, 43, 46–7
Casimir-Perier family 105, 107–8, 109
Catalogue des peintures, sculptures, dessins 115
catastrophe 120–2, 128–31, 132–5, 137
censorship 43, 97–9, 102, 159–60
chain of readings 12
chaos, as metaphor 58, 59–60
Charter for further education 143
Charter for higher education 143
Chénier, André *116*, 116–17
Christ. *see* Jesus
circumcision ceremonies 13–14, 17, 18–19, 19–20
*Circumcision of Isaac (*Regensburg *Pentateuch)* 15
classification 25–6, 34–5
close reading 104, 111, 152, 160
 definition 2
Coercive accountability 148
colour, use of 68, 69, 82–3, 84–5
commitment 173–4, 175–9, 183–6
 definition 172
Commitment to theory, The 173–4
communication (speech acts) 168–9, 182–3
composition
 Baptism of Christ, The 60–1
 images 16–18, 93–5
 Leben? Oder Theater? 75–80
 Poussin, Nicolas 25
 Regensburg *Pentateuch* 16–18
 St Paul on Malta 58–60
concentration camps 64–5, 83–5
concepts 1–9. *see also* individual concepts, e.g. trauma
 ambiguity 5–9, 57
 definition 3–4
 travel metaphor 1–2, 5–9, 52, 53–4, 161
conjoined twins 32–3
Conversion of the Magdalene 44, *45*, 46–7
Corday, Charlotte 117–18
critical intimacy 139–41, 142, 151–2
Critique of postcolonial reason, A 139–40, 142

cultural analysis 56–7
 definition 1–2
 interpretation theories 12–13
 methodology 2–3, 5, 7
 and travelling concepts 1–2
cultural bio-geography. *see* life-maps

Daddy's girl 142
darkness, as metaphor 58–9
Dauphin 117
death 75–9, 80–1, 92–3, *94*–5, 132–3
death-maps 65. *see also* life-maps
deformity 32–3
design, GNVQ curriculum 145–7
detail 56, 57, 59–60
Devant l'image 56–7
diaspora 183–4
dispositif 163–7, 168, 170, 170–1
dogmatism 8
drugs 97, 98
duality. *see* simultaneity

Ecstasy of St. Teresa 41–2, 46
ecstasy, religious 39–40, 41–3, 44, 47
education. *see* Britain, educational policies; pedagogy
efficacity 155–8, 162, 167–70, 169–70
emotions, depiction of 29, 70
empathy 53
employer-employee relationships 140, 143–4, 150–1
énoncés 158–63, 168, 169–70
epistemic transition 55–7
equality 180–1
erasure 100–2, 113. *see also* airbrushing
eroticism 36, 39, 41–2
escape 123–4
ethics 150–1
examinations 145–6
Excitable speech 181
exile 134–6

Fayez 132–3
Feda: between pedagogy and politicised art practice 151
females. *see* women
Feminisms in education 142

film 57, 76
flexibility, of concepts 4, 6, 180–2. *see also* ambiguity
folds 164–7, 168
footprints 156–7
foreground 60–1
forgetting. *see* memory
framing
 definition 2, 11, 12
 énoncés 159
 Leben? Oder Theater? 73–6, 81–2
 marginal spaces 12
 Musée de la Révolution française 111, 115–17
 Regensburg *Pentateuch* 14, 19–20, 21–2
 Rinaldo and Armida 31–5
French Revolution 108, 109, 110–11. *see also* Musée de la Révolution française

Galeria, La 30
gender
 and gestures 29
 and images 100
 and resistance 14, 18
 right/left-hand symbolism 27–8
 and space 67
General National Vocational Qualification, Art and design. *see* GNVQ in Art and design
geography, as political metaphor 179–81, 182–3, 185–6
Gerusalemme liberata 28, 29
gestures, use of 27–9
Gilles and Gotscho 99–100
globalization 172
Gnostic gospels 39, 48
GNVQ in Art and design 145–7
godmothers, role in circumcision ceremony 13–14, 18–19, 19–20
grief 21–2, 70–1, 100, 130–1
groping for meaning 2–3, 167
Grunwald, Marianne Benda 75
Gurs (concentration camp) 83–5

hand gestures, use of 28–9

hermaphrodites 30, 33–4. *see also* simultaneity
history. *see also* nostalgia
 definition 104
 and narrative structure 103
 and politics 108, 109, 110–11
 as trauma 112
 and travelling concepts 6, 53–4
History in transit 52
Holocaust 64–5, 83–5, 87
home-school agreements 138–9
homeland 122, 128–9, 130, 134–7
homogeneity 180–1
horror 118. *see also* violence
humans, position in Nature 59–60
hybridity 5–6, 183–4

identity 42, 125–6, 137
images
 composition 16–18, 93–5
 and gender 100
inequality 100–2
inscribed female viewers. *see* women, inscribed viewers
intellectuals, social importance 174–5
interactivity 5
intersubjectivity 3, 142
Intimacy of influence, The 139–40
irrationality 34
Isaac 15, 16–18, 19–20, 20–2
Isam 125, 135
iteration 176–7, 180, 181, 182

Jerusalem 128–31
Jesus
 baptism *50*, 51, 60–2
 and Mary Magdalene 39–40, 47, 48
Jeux d'enfants 118
Jewish space/women's time 67
Jews. *see also* *Leben? Oder Theater?*
 circumcision ceremonies 13–14, 17, 18–19, 19–20
 Holocaust 64–5, 83–5, 87
 martyrdom 18, 21

Kann, Fransciska 75–80

Kidush ha-Shem 21. *see also* martyrdom
King, Rodney 57
Knowable and unknowable, The 155
knowledge
 Mary Magdalene 39, 48
 and paradigm shifts 58–9
 theories of 155–69
Kristallnacht 83
Kvatterin 19. *see also* godmothers, role in circumcision ceremony

landscape 59–60
language, variations in 5–7
learning and teaching. *see* pedagogy
Leben? Oder Theater? 63–4, 65, 67–72, *69,* 75–83, *76, 77–8, 83,* 84–5
 composition 75–80
 framing 73–6, 81–2
 narrative structure 71–2
left hand, symbolism of 27–8
lies 126–8
Lieux de mémoire, Les 104
life-maps 63, 65–7
Lindberg, Paula 69
Location of culture, The 173–4
loss 122–3, 130–1, 132–3
Louise Bourgeois' spider 152

Magdalene 44, *45,* 45–6
Magdalene in ecstasy (Caravaggio) *38,* 40, 43
Magdalene in ecstasy (Lanfranco) 43–4
managerialism 138–9
Marat à son dernier soupir 112
Marat, Jean-Paul 117–18
Margins of philosophy 168–9
martyrdom 18, 21
Mary Magdalene (Savoldo) 36–8, *37,* 41, 45, 47
meaning 126–8
 change 5–7, 180–3
 as concept 4, 7
 groping for 2–3, 167
melancholia 33–4, 80, 82
memory 72, 99, 125, 170
 definition 104, 168
 and life-maps 66–7

and photographs 95–6, 97–9, 100–2
Renaissance-Baroque transition 56
as trauma 112, 128–33
men
 and gestures 27–8, 29
 as readers/viewers 33–4
Meniñas, Las 159, 165–7
methodology 2–3, 7
 and interactivity 5
Mirabeau, vicomte de 117
mirrors 37–8, 41–3, 44–7
Mort de Bara 112, 113
Mort de Brutus 113
mourning 21–2, 70–1
Musée de la Révolution française 103, 108–19
 collections 111–15, *114*
 exhibitions 109–10, 116–18
 galleries *114,* 115–18
 library 118–19

nakba (catastrophe) 120–2, 128–31, 132–5, 137
narrative 71–2, 103
Nature, and chaos 59–60
neoclassicism 112
neoliberalism 179–80
Nobiltà et eccellenza delle donne, La 27–8
nostalgia 120–2, 128–31, 134, 136–7

objects
 agency of 26
 definition 2
 interpretation 103–4, 111, 115–17, 152, 160
omission 100–2
oppression 140–1, 147–51, 179–81, 182–3
oratory, and gestures 28–9
Order of things, The 165–7

paintings, size of 60
Palestinians 125–6. *see also* Assaf, Wadi al-nakba. *see* al-nakba (catastrophe) homeland 122

'pan' (patch/blot) 56–7, 59–60, 61
paradigm
 definition 8
 Renaissance-Baroque transition 55–
 7
past 126–8. *see also* history; memory; nostalgia
Paul, saint *50*, 51, 57–60
pedagogy
 assessment methods 145–7
 audit culture 138–9, 141–2, 143–5,
 146–8, 149
 and critical intimacy 139–41, 142,
 151–2
 and oppression 140–1
 self-critical practice 141–2, 149
Pedagogy of the oppressed 140
Pentateuch, Regensburg *10*, 15, 16–22
performance/performativity
 Bal, Mieke 154, 161, 167–8, 169
 definition 154
 Foucault, Michel 158–63, 168, 169
Perier family 105, 107–8, 109
Peuple française éclairant le monde 113
photography 92–6, 97–100, 102
 Benjamin, Walter 94
physics 155, 157–8, 160–1
Picture this 91, 101–2
politics
 and art 119, 147–51, 177–9
 and commitment 172, 173–4, 175–
 9, 183–6
 and globalization 172
 and history 108, 109, 110–11
post-traumatic stress disorder (PTSD)
 52, 56
poverty 100–2
power, abuse of. *see* oppression
Pozzo, Cassiano dal 34–5
Prison notebooks 174–5
psychology, travelling concepts 53–4
PTSD (post-traumatic stress disorder) 52
punctum 96–7, 100

quantum theory 155, 157–8, 160–1

Quoting Caravaggio 44, 164

reading, visual 12
reflection theory 12
refugees 183–4
 Jews 79, 83–4
 Palestinians 120
Regensburg *Pentateuch* *10*, 15, 16–22
religion
 circumcision ceremonies 13–14, 17,
 18–19, 19–20
 and ecstasy 39–40, 41–3, 44, 47
 and eroticism 36, 39, 41–2
Renaissance-Baroque watershed 55–7
resistance 7, 94, 149–50, 181–2, 183,
 185–6
 inscribed viewers 14–15, 20–1
 of readers/viewers 11, 13, 22
respect 185–6
return, possibility of 136–7
right hand, symbolism of 27–8
rigidity 8
Rinaldo and Armida 24, 25–7, 28, 30–1,
 34, 35
Robespierre, Maximilien *114*, 115, 117

Salmacis and Hermaphroditus 33–4
Salomon, Fränze Grunwald 75, 80–1
salvation 124, 136–7
Sandeket 19. *see also* godmothers, role in
 circumcision ceremony
Sarah, death of 18, 19, 20–2
sea 124
self-critical practice 141–2, 149
Serment du Jeu de Paume à Versailles, Le 105,
 106, 107
Ship, The 121–37
 nostalgia 122, 128–31, 134, 136–7
shot reverse-shot 76
sign theory 12–13
simultaneity 26–7, 29, 30–1, 33–4, 34–5,
 39
situating, as political commitment 173–
 4, 175–9
size, of paintings 60

skills gap 144–5
slow motion 57
space
 and gender 67
 Musée de la Révolution française
 115–18
 as political metaphor 173–4, 175–
 81, 182–3
 third space 173–4, 175–9, 184
space science 158
speech acts 168–9, 182–3
St Jean de Cap Ferrat 73–6, *74*, 82
St Paul on Malta 50, 51, 57–60
Start of something pretty, The 90, 91–2, 93–
 5, *94*, 97, *98*, *99*
statements 158–63, 168, 169–70
subjectivity 12–13, 142
suicide 75–9, 80–1
supermodels 98. *see also* Carangi, Gia
surrounding. *see* framing
symptom 56–7

teachers 141, 146–8. *see also* pedagogy
text 6–7
The baptism of Christ 50, 51, 60–2
Theatre of the oppressed 140
third space 173–4, 175–9, 184
Threshold of the visible world, The 45–6
touch 39, 95
Tower of Babel 179–80
tradition 8
transculturality 183–5
trauma 52–5, 58–60, 61–2, 84
 definition 52, 55, 122–3
 and memory 112, 128–33, 134–6
travelling concepts 1–2, 5–9, 52, 53–4,
 161

Travelling concepts in the humanities 11, 99,
 138–9
trust 139, 140, 143–4, 151
truth 126–8, 171, 172–3
twins, conjoined 32–3

uncertainty principle 161–2
Understanding Foucault 165–6
unknowable knowledge 157–8, 164–7
ut pictura poesis 28

values, in education 143–4
Venus and Mars 159
Villefranche 73–5, *74*, 87
violence 95–6, 102, 118, 124, 132–3,
 172–3. *see also* punctum; trauma
 and language 181–3
visual reading 12
Vizille, role in French Revolution 104–8.
 see also Musée de la Révolution
 française

Wadi 121, 125–37
weapons, symbolism of 27–8
West in early cinema: the beginning 121
windows, symbolism 78–9, 80–2
women
 and gestures 27–8, 29
 inscribed viewers 13, 14–15, 19–20,
 21–2, 78–9. *see also* Armida
 as readers/viewers 12–13, 31–2
workload, teachers 148–9

Young man with arm extended 100